THE CONTEMPORARY
RUSSIAN CINEMA READER
2005-2016

THE CONTEMPORARY
RUSSIAN CINEMA READER
2005-2016

EDITED BY RIMGAILA SALYS

BOSTON / 2019

Names: Salys, Rimgaila, editor.
Title: The contemporary Russian cinema reader : 2005-2016 /
 edited by Rimgaila Salys.
Description: Boston : Academic Studies Press, 2019. | Series: Film and media
 studies | Includes bibliographical references and index. Identifiers:
 LCCN 2018057555 (print) | LCCN 2018060785 (ebook) |
 ISBN 9781618119650 (ebook) | ISBN 9781618119636 (hardcover) |
 ISBN 9781618119643 (pbk.)
Subjects: LCSH: Motion pictures—Russia (Federation)—History—21st century.
Classification: LCC PN1993.5.R9 (ebook) | LCC PN1993.5.R9 R843 2019 (print) |
 DDC 791.430947/09051—dc23
LC record available at https://lccn.loc.gov/2018057555

ISBN 9781618119636 (hardcover)
ISBN 9781618119643 (pbk.)
ISBN 9781618119650 (ebook)

Cover design by Ivan Grave.
On the cover: a still from *Short Stories* (Rasskazy), 2012,
 directed by Mikhail Segal.

Published by Academic Studies Press
28 Montfern Avenue
Brighton, MA 02135, USA

P: (617)782-6290
F: (857)241-3149

press@academicstudiespress.com
www.academicstudiespress.com

CONTENTS

PREFACE

This reader is intended both for contemporary Russian cinema courses and for modern Russian culture courses that emphasize film. The collection includes films from 2005 to 2016. It does not attempt to establish a canon for the period, but seeks to provide undergraduate students with an introduction to significant Russian films that are available with English subtitles. Time will tell which of the films are masterpieces, but all are significant within the period covered by the collection. *Ninth Company* (*Deviataia rota*, 2005) and *How I Ended This Summer* (*Kak ia provel etim letom*, 2010) do not appear in this collection because they were included in volume two of *The Russian Cinema Reader*. Because the goal is to provide students with the best level-appropriate essays on the films, the collection is a mix of newly commissioned pieces and adaptations of published articles, as is the practice in this series. The length of essays varies because of authors' varying approaches. Sometimes a film is represented by two shorter essays. The editor selected subtitled films, invited authors, and added ideas to a number of essays.

Transliteration follows the simplified Library of Congress system, except for some spellings conventionally accepted in English, such as Yekaterinburg, Yeltsin. Final Cyrillic "-ий" in personal names, surnames, and place names is transliterated as "y": Anatoly, Todorovsky. Transliteration may vary slightly because of different systems used in previously published essays, the use of Library of Congress transliteration in footnotes and further reading to facilitate library research, and authors' preferred spelling of their names.

Vlad Strukov's introduction surveys recent Russian cinema in a global context as well as developments in the industry, genre, and themes, and discusses important films that are not available

with subtitles. The twenty-one essays on individual films provide background information on the director's career, a detailed analysis of the selected film, and suggestions for further reading both in English and Russian.

For students who have not taken an introductory film studies course, the Yale Film Studies film analysis website (http://filmanalysis.yctl.org) is an excellent resource for basic terms relating to mise-en-scène, cinematography, editing, sound, and analysis, accompanied by illustrations and short clips. Timothy Corrigan's *A Short Guide to Writing about Film* is a useful text, which covers film terminology, different approaches to writing about cinema, sources for research, and guidelines for writing and formatting papers.

All films have been released with subtitles by American, British, or Russian distributors. *My Good Hans* (*Milyi Khans, dorogoi Petr*) is available in the iTunes store. *The Land of Oz* (*Strana Oz*) should be available on DVD within the next year or two and may be streamed at present through the subscription service of Nonfiction.film. Sovietmoviesonline.com also adds to its collection periodically.

This reader would not have been possible without the expertise and generosity of the authors of the introduction and the individual essays. I also owe special thanks to Philip Rogers, Faith Stein, Oleh Kotsyuba, Ekaterina Yanduganova, and to Kira Nemirovsky and her staff.

Rima Salys
Boulder, 2018

RUSSIAN CINEMA
IN THE ERA OF GLOBALIZATION

Vlad Strukov

It has been customary to define Russian history and culture in terms of changes in political leadership: Khrushchev's Thaw, Brezhnev's Stagnation, Gorbachev's perestroika, and so on. The period under scrutiny—roughly 2005 to 2016—can easily be defined as the Putin era or an era of "staged democracy," "rising authoritarianism," "post-Soviet revanchism," "the new Cold War," "new imperialism," and so on. The repertoire of this alarmist terminology derived from political science and sensationalist journalism is vast. However, while it is indicative of actual negative developments such as the annexation of Crimea or attempts to recriminalize "non-traditional" sexuality, it fails again and again to explain—and, particularly, to predict—the actions of the Russian leadership. The figure of Vladimir Putin, who has occupied the position of the Russian prime minister and Russian president since 2000, is at the center of this top-down historiographic approach. I argue that it reveals much about the Western obsession with Putin and little about Russia itself, especially about contemporary Russian culture and society. This approach also robs the Russian people of agency—in effect, orientalizing them—and thus undermines the very purpose of the Western emancipatory project.[1] With regard to the cultural production in the Russian Federation, this Putin-centric approach sustains the Cold War–era binary narrative of official/unofficial, conformist and dissident realms of culture whereby the work of individuals is judged on the basis of their relationship to the Kremlin instead of their global citizenship. Instead, I suggest that we should examine Russian culture and its cinematic component using a different system of referents and cognitive procedures. I propose

[1] For a suggestion of a new project of resistance, see Vlad Strukov, "Towards a New Paradigm of Resistance," in Further Reading.

here a polycentric, multilayered reading, which is characteristic of the era of globalization. (It would also be useful to apply this approach to the study of Russian contemporary power dynamics but that is a task of another book.)[2]

Of course, Russia participated in early globalization processes. For example, Russia emerged as a result of the colonization of a Muslim entity—the Khanate of Kazan—in the sixteenth century. Russia continued the imperial logic of Western states such as Spain and England which had just embarked on the "discovery" of new worlds and on securing new spheres of influence. During the late Tsarist period, the Trans-Siberian railroad was built, linking the Russian Far East with Saint Petersburg, Warsaw, and Western Europe. Fifty years later Iury Gagarin's flight into space on the first manned mission provided the Soviets, and the whole world, with a view—and fantasy—of a single world, united in its will to overcome some of the greatest tragedies of the twentieth century—the Holocaust and Stalin's repressions. The experiments of the early Soviet filmmakers also conceptualized global visions as in, for example, Dziga Vertov's image of the modern city in *Man with the Movie Camera* (*Chelovek s kinoapparatom*, 1929) and Sergei Eisenstein's 1925 revolutionary manifesto *Battleship Potemkin* (*Bronenosets Potemkin*). Andrei Tarkovsky (*Solaris*, 1972, *The Mirror*, 1975, and *Stalker*, 1979) and Sergei Paradjanov (*Shadows of Forgotten Ancestors*, 1965 and *The Color of Pomegranates*, 1969) employed visual metaphors to convey messages about universal concepts of love, beauty, loneliness, suffering, and overcoming.[3]

However, it was only after the dissolution of the USSR in 1991 that Russia began to participate in global economic and cultural life freely, that is, unhindered by the ideological and political constraints of the Cold War. Russia's gradual involvement in global affairs was formalized as the country's entry into the World Trade

[2] An attempt to formulate this agenda can be found in Robert Saunders and Vlad Strukov, *Popular Geopolitics*, in Further Reading.

[3] Some argue that the USSR attempted to build its own form of globalization. See, for example, Alain Badiou, in Further Reading.

Organization. Russia became its 156th member in 2012 and very soon embarked on a series of actions with global consequences such as the Sochi Winter Olympics, the annexation of Crimea, and participation in the Syrian War. These events, as well as Putin's rise to power, had their origins in the late 1990s and especially in the 1998 financial crisis that bankrupted the Russian state, gave birth to a new generation of oligarchs, demoralized the Russian public, and nearly destroyed the Russian film industry. The 2000s is an era when Russia simultaneously benefited and suffered from a rapid entry into the globalized world, and its cinema of the period documents and reflects on these complex processes of adjustment, realignment and reconfiguration. From a country that was rarely thought of fifteen years ago, the Russian Federation has evolved into a phenomenon that is constantly in the headlines of global media, most recently due to the ongoing investigation into its interference in the 2016 US elections. The mediatization of Russian politics and culture is an evolving process which reveals the complexity of current renegotiations of the country's identity and vision. Russian filmmakers have been instrumental in the formulation of the new ideologemes of the Russian state[4] and in the creation of the new visual language of the Russian people. Similar trends have occurred elsewhere—for example, in China, India, and Turkey—including the rise of the new traditionalism, the attempt to "nationalize" local cultural production, and the imposition of new hegemonic regimes, which is an outcome of the implementation and adaptation of Western neoliberal policies.[5]

[4] On the conservative end, we find Nikita Mikhalkov who has been responsible for the blending of patriotic and monarchist tendencies. On the liberal end, Kirill Serebrennikov and Vasily Sigarev have promoted the values of tolerance and inclusivity in their production for cinema and theater.

[5] Ashvin Devasundaram's examination of internal politics in the Indian film industry reveals uncanny resemblances to the Russian case. Both Russian and Indian filmmakers have been compelled to produce films with a populist agenda in response to government imperatives and the rising demand among the viewers, which often overlap. See Ashvin Devasundaram, in Further Reading.

The contemporary Russian cinematic landscape is characterized by an incredibly rich mixture of production models and visual styles. Four generations of filmmakers continue to produce a robust body of work: (1) *the Soviet generation* (such as Aleksandr Sokurov, Kira Muratova,[6] Nikita Mikhalkov, Karen Shakhnazarov, Vladimir Khotinenko, Vadim Abdrashitov); (2) *the post-Soviet generation* (such as Aleksei Balabanov, Pavel Lungin, Valery Todorovsky, Aleksandr Rogozhkin, Aleksei Uchitel'); (3) *the new Russian generation* (such as Andrei Zviagintsev, Timur Bekmambetov, Renata Litvinova, Nikolai Khomeriki, Anna Melikian); and (4) *the Russian millennials* (such as Valeriia Gai Germanika, Oksana Karas´, Ivan Tverdovsky, Mikhail Mestetsky, Kantemir Balagov). I identify these "generations" not in relation to the directors' age, but rather in terms of (a) their relationship to two defining historical events—the dissolution of the USSR in 1991 and the financial crisis of 1998—and (b) the date of their entry into the film industry. (Many of these directors released their first films in the early 2000s despite the fact that they were born in different decades of the twentieth century.) It would be wrong to assume that each generation has its own unique style or themes when instead the opposite is true: unlike in Iran and Romania, no single dominant group of filmmakers has emerged, and therefore there has been nothing resembling "the Russian new wave."[7] For some time there was a discussion about the so-called "new quiet ones" (*novye tikhie*), a loose cross-generational association of filmmakers interested in reflective, slow, and socially engaged cinema. However, as a grouping or as an academic construct, it had no legacy and soon went out of use.[8] Therefore, in terms of its stories, settings, styles, production models, and audience engagement, Russian cinema—much like the new Russia—is immensely diverse, with each filmmaker providing his or her unique interpretation of what it means to live in the new globalized world.

[6] Muratova passed away in June 2018.

[7] For further discussion of this counter-position see Vlad Strukov, *Contemporary Russian Cinema*, in Further Reading.

[8] See, for example, David McVey, in Further Reading.

Nevertheless, it is possible to identify some dominant stylistic trends. In the early years of the new century, *chernukha*, or black cinema of the 1990s,[9] reemerged to include exaggerated and occasionally fantastic elements while maintaining its focus on political critique, interest in social outcasts, and violent representations of the human body. For example, we find these tendencies in the work of Aleksei Balabanov, *Dead Man's Bluff* (*Zhmurki*, 2005) and *Cargo 200* (*Gruz 200*, 2007). The release of Andrei Zviagintsev's *The Return* (*Vozvrashchenie*, 2003) marked the start of a new stylistic trend, or what I have called elsewhere the symbolic mode.[10] It is characterized by the use of highly abstract concepts and visual language, and it is often directed toward a mystical world or even an afterlife. While valuing authenticity, spontaneity, natural harshness, and uncompromising attitudes, Russian directors in this period often create and operate within abstract environments in which to explore social concerns in the symbolic mode. It is a kind of cinema that addresses big questions such as the possibility of thinking beyond dichotomies of constructed time and pure duration, continuity, and discontinuity. It stages an attack on the possibility of discourse and the probability of being by contesting and affirming the infinite. Aleksei Fedorchenko's *Silent Souls* (*Ovsianki*, 2010), Aleksandr Zel'dovich's *The Target* (*Mishen'*, 2010), Aleksandr Sokurov's *The Sun* (*Solntse*, 2005), Aleksei German's *Hard to be a God* (*Trudno byt' bogom*, 2013)—all discussed in this volume—are representative of this type of cinema along with Renata Litvinova's *Goddess: How I Fell in Love* (*Boginia: Kak ia poliubila*, 2004), Aleksandr Veledinsky's *Alive* (*Zhivoi*, 2006), Andrei Zviagintev's *Banishment* (*Izgnanie*, 2007), Aleksei Balabanov's *Morphine* (*Morfii*, 2008), Kirill Serebrennikov's *St. George's Day* (*Iur'iev den'*, 2008), Igor' Voloshin's *Nirvana* (2008), Aleksandr Proshkin's *The Miracle* (*Chudo*, 2009), Nikolai Khomeriki's *A Tale About Darkness* (*Skazka pro temnotu*, 2009), Aleksei German Jr.'s

[9] From *chernyi* (black), a slang term popularized in the late 1980s and used to describe unrelenting negativity and pessimism in the arts and in mass media.

[10] Strukov, *Contemporary Russian Cinema*, in Further Reading.

The changing geometry of human relations and cinematic language.
Film still from Zel'dovich's *The Target*.

Under Electric Clouds (*Pod elektricheskimi oblakami,* 2015),[11] and many others.

The tonality of Russian cinema changes in the early 2010s, becoming more interested in mundane situations and social conflicts as we see in Zviagintsev's *Elena* (2011) which offers a critique of the class divide in the new, globalized Russia. Another example would be Boris Khlebnikov's *Long and Happy Life* (*Dolgaia schastlivaia zhizn'*, 2013) which tells the story of Sasha, a young businessman living in a remote part of Russia, and his fight against the dishonest government that wishes to confiscate his land. With its critique of corruption and focus on the disintegration of personal relationships, *Long and Happy Life* foretells the conflicts and aesthetics of Zviagintsev's *Leviathan* (2014). To confirm, this new aesthetics of Russian cinema does not signify a return to social realism; in fact, it does not eschew cinema in the symbolic mode but rather incorporates it into its new arsenal by retooling its aesthetic potential. (This is similar to

11 The work on the film was interrupted by the death of the director's father when Aleksei German Jr. had to complete his father's project *Hard to be a God*. Therefore, *Under Electric Clouds* belongs to the earlier period of Russian cinema in the symbolic mode, and is arguably its last masterpiece.

how postmodern cinema such as Zel'dovich's *Moscow* (2000) was incorporated into the cinema in the symbolic mode, just as with his film *The Target*.) The difference between cinema in the symbolic mode and the new cinema is that the latter aims to speak to a larger audience, not the niche audience of film buffs. A good example is Zviagintsev's transition from the aesthetics of *Elena* to that of *Leviathan*: the second film includes gags, sex scenes, violence, and the use of obscene language— all those elements that we commonly associate with popular cinema. To complicate the discussion, these elements also effectively relate Zviagintsev's *Leviathan* back to the *chernukha* period and Balabanov's intensity of cinematic presentation, thus completing the circle of aesthetic exchange of the past twenty years.

An example of the use of abstraction for social critique.
Film still from Zviagintsev's *Leviathan*.

The director who best represents this shift to the new cinema is Vasily Sigarev. He is primarily known as a scriptwriter and playwright and previously worked with Yekaterinburg-based director Nikolai Koliada. Sigarev became famous after his play *Plasticine* (*Plastilin*, 2000) was staged by Serebrennikov at Moscow's Centre for Drama and Directing.[12] His work for the theater belongs to the tradition of New Drama which has "the aspiration to

[12] Tsentr dramaturgii i rezhissury.

define and form an identity ad hoc, either by analysis of precisely demarcated social groups or through aesthetic communication."[13] The hypernaturalism of New Drama lends itself to the exploration of identity, sexuality, violence, and fears associated with the sense of the disappearance of reality and its replacements with different kinds of simulacra. As a result, New Drama emerges simultaneously as a theater of hypernaturalism and hyperabstraction, focusing on complex philosophical themes such as the nature and structure of communication.[14] Sigarev's first two films *Wolfie* (*Volchok*, 2009) and *Living* (*Zhit'*, 2011) explore the child-parent relationship,[15] and the themes of love, loss, grief, and guilt, in an environment of violence, alcohol and drug abuse, sex, and death. In his later film *The Land of Oz*, Sigarev addresses the same concerns but alters the genre to a romcom that incorporates humor, breaks the story into a set of short novellas, and introduces other changes to appeal to a larger audience more accustomed to short clips on YouTube rather than the intensive, slow engagement of the cinema of the 2000s.[16] This strategy was rewarded as the film became one of the most popular releases of 2015. While employing "popular aesthetics," Sigarev maintains a high level of philosophical reflection—much like during the period of the symbolic mode—such as his interest in living after a (personal) apocalypse and finding meaning in the gaps in discourse (such as posthumous, postevental subjectivity).[17]

If Sigarev works with new audiences by adapting the style of his films, other directors employ entirely different strategies. For example, during the era of the symbolic mode, Khomeriki authored a few award-winning experimental films, most notably, *A Tale about*

13 Birgit Beumers and Mark Lipovetsky, 34, in Further Reading.

14 On Russian New Drama see Beumers and Lipovetsky, in Further Reading.

15 This is a dominant theme of Russian cinema in the twenty-first century. See Helena Goscilo and Yana Hashamova, in Further Reading.

16 On "slow cinema," see Tiago de Luca, in Further Reading.

17 For the discussion of these theoretical concepts see Strukov, *Contemporary Russian Cinema*, in Further Reading.

Darkness (*Skazka pro temnotu*, 2009) and *Heart's Boomerang* (*Serdtsa bumerang*, 2011). These films were concerned with knowledge conceived in philosophical and cinematic terms whereby knowledge as an apparatus of subjectivity deconstructs the filmic image in its relation to "what is known" and "what is seen." In the new era, Khomeriki switched to making historically themed "feel-good" blockbusters such as his 2016 *Icebreaker* (*Ledokol*). This film is based on real-life events of 1985 when the icebreaker "Mikhail Somov" was caught in the Antarctic ice and drifted for 133 days in extreme cold. In this film, which is clearly aimed at a general audience, Khomeriki maintains his focus on the psychology of his characters; however, he loses the cinematic and philosophical complexity of his earlier films in favor of basic allegories and straightforward conflicts. The portrayal of the ideological conflicts of the late socialist period—the film is set on the brink of Gorbachev's perestroika—had an unusual effect on the viewers who were still taken by the patriotic fever after the annexation of Crimea. A similar strategy was adopted by Boris Khlebnikov who, after a series of influential critiques of Russian society, released his new socially affirmative drama *Arrhythmia* (*Aritmiia*) in 2017.

For other directors, the search for a new, more appealing cinematic language has been more productive. For example, Melikian's early *Mars* (*Mars*, 2004) and *Mermaid* (*Rusalka*, 2007) addressed the problems of gender, identity, and memory through the use of complex narrative structures and somewhat esoteric visual language. In her later *Star* (*Zvezda*, 2014) and *About Love* (*Pro liubov'*, 2015), Melikian opted for more engaging, perhaps even melodramatic and sensationalist storylines: a romantic relationship between the son of an oligarch and a teenage girl who is dying of cancer (*Star*) and the sexual adventures of Muscovites (*About Love*). What for some critics is a strategy of dumbing down content, for others is an ingenious way to engage with the stylistics of contemporary everyday living such as the use of dating apps and sexting. Melikian investigates how the processes of mediation— of sex, feelings, and ultimately, of the self—have transformed our notions of identity, especially female identity. Both *Star* and *About Love* reflect on the construction of femininity in contemporary

Russia and on the impact of globalization on the Russian knowledge economy. In particular, *About Love* features a young Japanese woman whose "external" point of view is used to critique Russian men and their obsession with money. The film also showcases how women struggle—but sometimes succeed, as with Renata Litvinova's character—in finding a role in the new neoliberal economy where young people have to accept unpaid internships, work on zero-hour contracts, and engage in other forms of unsecured employment. Melikian provides both a critique of contemporary Russian society and an inspiration for young individuals and especially women, which explains why her most recent films have been so successful with Russian audiences.[18]

The imperative to speak to the generation of millennials who have their own sense of temporality due to a different media experience is one of the reasons why Russian directors have to adapt their visual strategies. Another, of course, is competition with Hollywood; in this regard, contemporary Russian cinema faces enormous challenges because it is much less protected than Chinese, French, or German cinema. Russian cinema is unquestionably dominated by Hollywood in terms of aesthetics and distribution. For example, in 2016 in Russia sixty distribution companies showed 147 films grossing US$774.8 million, and only a small proportion of them were Russian films. The two most successful companies, the US-based WDSSPR and Fox—both well-known for their extremely conservative ideological stance—accounted for the lion's share of releases: 31 films grossing US$230.37 million and 25 films grossing US$130.97 million, respectively. They are followed by the Russian company Karo Premiere with 35 films grossing US$128.27 million.[19] The majority of films shown in Russian cinemas are Hollywood

[18] For comparison, the box office of *Mars* was US$240,000 and *About Love* brought in US$750,000.

[19] Mikhail Vodop′ianov, "Rost kassovykh sborov v Rossii," *Kinodata*, January 21, 2017, accessed June 15, 2017, http://kinodata.pro/vse-o-kino/obzor-kassovyh-sborov-v-rossii/26034-rost-kassovyx-sborov-v-rossii-v-2016-godu-proizoshyol-iz-za-uvelicheniya-kolichestva-relizov-nashix-mejdzhorov.html.

productions; as few as one film made in the Russian Federation might be shown in a typical multiplex over a period of three months.[20] This is because Russia does not have a quota system, as in France, and lacks a tradition of audiences voluntarily supporting domestic productions as in, for example, Scandinavian countries. In addition, the tradition of watching international quality productions that characterized the Soviet cinema system—and is maintained in countries like Italy, France, and Spain thanks to the system of art house cinemas—has been lost almost entirely due to the privatization of the distribution networks in the 1990s and 2000s. As a result, Russian cinema must compete with Hollywood majors on the domestic markets, which is done by having an exceptionally strong supply of arthouse films and by utilizing alternative distribution platforms such as the Internet.

Major Russian film archives, collections, and distribution companies such as Mosfilm continue to make their content available online for free. Some independent directors stage premieres of their films online as this is the only opportunity for them to reach an audience. Others engage in agonizing legal battles with distribution and media companies that publish films illegally on the Internet. To be clear, these companies generate income by placing advertising alongside the illegally distributed films. In spite of these efforts, film piracy is widespread. If at the start of the century piracy helped the film industry rise from the ashes, by the end of the first decade it became apparent that piracy was the industry's major problem.[21] The government addressed these concerns by introducing new legislation and enforcing anti-piracy laws. Although the situation has improved somewhat, the Russian film market is still characterized by high levels of illegal distribution of cinematic materials, both Russian-made and international. As a result, film distribution companies have to employ ingenious methods to control the distribution of their films, including unusual screening schedules and cross-

20 Vlad Strukov, "Russian 'Manipulative Smart Power'," 37, in Further Reading.

21 On the role of film pirates, see Vlad Strukov, "Translated by Goblin," in Further Reading.

regional monitoring. In a way, in the global neoliberal fashion, the Russian government has delegated the regulation of the market and protection of revenue to the private sector. In some rare cases, the free circulation of audio-visual products on the Internet has had a positive effect for filmmakers. This is particularly noteworthy with regards to the animation industry and especially digital animation. Individual entrepreneurs such as Vladimir Nikolaev and Anatoly Prokhorov have managed to build incredibly strong brands so that now their film products are purchased in other countries for official distribution. Nikolaev's animated feature-length film *Snow Queen* (*Snezhnaia koroleva*) and its sequels were a leading audio-visual production in terms of sales to non-Russian markets in 2017. Prokhorov's *Kikoriki* (*Smeshariki*) animation series has attracted the attention of international audiences and subsequently

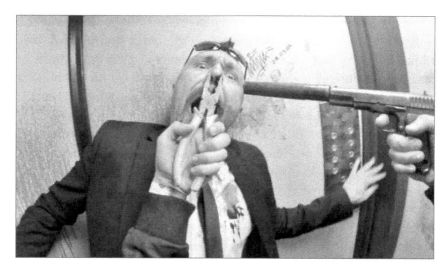

The fluidity of the digital close-up available in cine-games.
Film still from Naishuller's *Hardcore Henry.*

of the political elites in China and Russia, leading to the signing of co-production deals at the highest possible level.

Recently, by reaching out to an international audience, Russian filmmakers have been able to secure revenue to compensate for the losses on the domestic market. In this regard, 2016 was a record year

for the Russian film industry when 20 films earned US$37million on the international market.[22] The most successful films included *Hardcore Henry* (*Hardkor*) directed by Il'ia Naishuller and produced by Timur Bekmambetov. The film is a science fiction drama about a man who wakes up in a Moscow laboratory to learn that he has been brought back from the dead as a half-human, half-robotic hybrid. The story is told by means of a first-person shooter, that is, showing the events from the perspective of a computer game player. Another successful feature was *Mafia: The Game of Survival* (*Mafiia: igra na vyzhivanie*, 2016), directed by Sarik Andreasian and structured like a television show, where participants are eliminated one by one.[23] The film was inspired by the party game "Mafia," which was extremely popular in the Russian Federation and other post-Soviet countries in the 1990s; however, the film takes the game to a new level as participants are eliminated physically. For Russian audiences, the film provided a reflection on the traumatic decade after the dissolution of the USSR when crime was rampant. The success of *Hardcore Henry* and *Mafia* signals a greater convergence between the media of film and computer gaming. This is both a marketing strategy that exists in order to extend the experience of film and augment the practices of the film franchise and an aesthetic that promotes cultural and media hybridization.[24]

In spite of these successes, the Russian film industry, especially its international distribution arm, lacks coherence and coordination. For example, there are no cultural institutions like the British

[22] Sergei Lavrov, "V pervom polugodii 2017 goda rossiiskoe kino zarabotalo za rubezhom uzhe $21.5 mln," *Kinodata*, July 02, 2017, accessed April 12, 2018. http://kinodata.pro/vse-o-kino/obzor-kassovyh-sborov-v-mirovom-prokate/29566-v-pervom-polugodii-2017-goda-rossijskoe-kino-zarabotalo-za-rubezhom-uzhe-21-mln.html.

[23] It is noteworthy that the film was particularly popular in China, which means that Russian filmmakers "work" on non-Western film markets and that they can specialize in specific genres to be produced for particular markets.

[24] On the convergence of cinema and computer gaming in the Russian context, see Vlad Strukov and Stephen Norris, in Further Reading.

Council that would promote Russian films abroad. Instead, the Russian government utilizes a hybrid system by outsourcing these activities to private companies and individuals, thus employing neoliberal business models which in other countries have proven to be destructive for the institution of cinema. At the same time, the tradition of cinema-going has been replicated and reinvigorated thanks to the activities staged by cultural centers such as New Holland (Novaia Gollandiia) in St. Petersburg and the Film Club in Rostov-na-Donu. In such centers, people normally attend a screening of a classic or contemporary film in an arts or educational venue and then participate in a discussion led by an invited speaker. These types of events are frequently held in Russian urban centers and function as a form of community building and an alternative means of education in film and culture. This is the arena in which international art house films reach their audience. These events are so popular that they have been featured in Russian films as a setting or even a narrative device. For example, in Melikian's *About Love* a lecture delivered by Renata Litvinova's character provides a narrative organization to the film's five novellas, each telling a story of a different character. Conversely, many cinemas have been used to show new types of content, such as operatic and theatrical performances streamed live from the Bolshoi Theatre in Moscow or the Royal Opera House in London. The diversification of content available for demonstration in cinemas is indicative of the media convergence. It is also an attempt to speak to different kinds of audiences, and an endeavor that is in line with the global trend in working with niche audiences. Finally, it reveals a number of interconnected global flows of information and cultural exchange which exist independently from the state and are pertinent to the new, post-industrial era of economic development. In that economic system, the audiences emerge as a new kind of active cultural producers who make meaning through their consumption practice or alternative cultural products.

Since the early years of the twenty-first century, the main objective of Russian filmmakers has been to make films that would appeal to that kind of active audience. This has led to changes in how Russian films are funded and to the emergence of commercial,

popular cinema as well as an associated structure of film genres. Indeed, the development of Russian genre cinema is one of the chief outcomes of the evolution of Russian cinema between 2005 and 2016. Russian filmmakers explored the potential of different film genres gradually, often focusing on one or two genres, which meant that there were periods of "overproduction" of thrillers and melodramas. Eventually directors shifted from experimentation to consolidation, working with bigger budgets on more ambitious projects. The two genres that Russian filmmakers have recently engaged with are the biopic and science fiction.[25] Exploiting nostalgia is a common strategy for biopics in Hollywood and elsewhere. In the Russian context, we find films that aim to commemorate famous individuals on one level, and to reconstruct their artistic world on another. A good example is Andrei Khrzhanovsky's *Room and a Half* (*Poltory komnaty*, 2008), which blends different styles—including fiction, animation, historical footage, and reconstruction—to recreate the unforgettable atmosphere of Leningrad in the 1950s and 60s when the poet Joseph Brodsky (to whom the film is dedicated) lived in the USSR. We also find more credulous and innocuous exploitations of nostalgia, such as Petr Buslov's 2011 *Vysotsky. Thank God I'm Alive* (*Vysotskii. Spasibo, chto zhivoi*). Here the filmmaker is more interested in scandal—Vysotsky's alleged clinical death while on a tour in Central Asia—than in the critical examination of the late-Soviet era of which Vysotsky became a symbol. Similarly, there is more emphasis on surface, especially how to make the character look like the real Vysotsky, rather than on psychological depth or the reevaluation of his artistic canon.[26]

[25] Due to space constraints, I cannot elaborate on the genre of science fiction but here is a list of some important productions: Aleksei Fedorchenko's *First on the Moon* (2005), Filipp Iankovsky's *The Swordbearer* (2006), Fedor Bondarchuk's *Inhabited Island* (2008), Aleksandr Mel'nik's *Terra Nova* (2008), Aleksandr Zel'dovich's *The Target* (2010), Dmitry Grachev's *Calculator* (2014); Sarik Andreasian's *Mafia* (2015); and Dmitry Kisilev's *First in Space* (2017). See also Vlad Strukov and Helena Goscilo, *Russian Aviation*, in Further Reading.

[26] For an in-depth analysis of the film and the genre of biopic, see Polly McMichael,"The Singer at the Microphone: Voice, Body, Traces and the Re-

In its purest form the biopic (or a story about an extraordinary individual marked by talent that narrates their rise to stardom and uses the backdrop of the relevant industry such as music or sport) is exemplified in Nikolai Lebedev's 2013 *Legend No. 17* (*Legenda No. 17*) about Russian ice hockey legend Valery Kharlamov from early childhood, his rising to the pinnacle of the sport, and untimely death. Preempting the patriotic fervor around the Sochi Winter Olympics and the annexation of Crimea, *Legend No. 17* broke all box office records by reminding viewers that, to paraphrase Donald Trump, "Russia can be great again." However, there is a significant departure from the Cold War era propagandistic films: the emphasis is on the individual and his personal ambition, which is reflective of the extreme individualization of Russian society in the global era and indicative of Russian cinema's love affair with Hollywood. As has been noted by Stephen Norris, these ideological hybrids, or films combining Hollywood aesthetics and ideology with local political and social concerns, invite a polemic about the global circulation of cultural products and their impact on local politics. To extend Norris's point, I would argue that these events have a bounce effect on the US context, which is, of course, just one of many channels through which globalization speaks to the citizens of the new world.[27]

An individual who has been instrumental in forging links between Russian filmmakers and Hollywood is Timur Bekmambetov. The release of his *Night Watch* in 2004 created a buzz;[28] however his most recent work has not received much critical attention. Born in

creation of Vladimir Vysotskii," *Kinokultura* 42 (2013), accessed June 15, 2017. http://www.kinokultura.com/2013/42-mcmichael.shtml.

[27] On polycentric organization of the film history, see Lucia Nagib, Chris Perriam, and Rajinder Dudrah, in Further Reading; on the feedback loops of cultural production with special emphasis on Russian transnational impact, see Saunders and Strukov, "The Popular Geopolitics Feedback Loop," in Further Reading.

[28] For an in-depth analysis of his *Night Watch* and *Day Watch*, especially the child-parent dynamic and combining psychoanalysis and social history, see Vlad Strukov, "The Forces of Kinship," in Further Reading.

the eastern part of the Kazakh SSR, Bekmambetov is of Kazakh and Jewish heritage. As a teenager, he moved to Moscow and then to Tashkent, Uzbekistan, where he studied visual arts. In the late 1980s, he served in the Red Army in Turkmenistan, an experience that would inform his directorial and writing debut, *The Peshawar Waltz* (*Peshavarsky val's*, 1994). In 1999, he founded his own film company, Bazelevs, and soon gained national fame with his vampire action films *Night Watch* (*Nochnoi dozor*, 2004) and *Day Watch* (*Dnevnoi dozor*, 2006). The international success of the *Night Watch* series turned Bekmambetov into a hot commodity in Hollywood, resulting in his role as a director, producer, or writer on a number of big-budget English-language films, including *Wanted* (2008), *9* (2009), *Apollo 18* (2011), *The Darkest Hour* (2011), and *Abraham Lincoln: Vampire Hunter* (2012), as well as his continued work on Russian cinematic projects such as *The Irony of Fate 2* (*Ironiia sud'by. Prodolzhenie,* 2007) and *Tsar Christmas: 1914* (*Elki: 1914,* 2014). By 2017, Bekmambetov had directed, scripted, and produced over fifty feature-length projects on both sides of the Atlantic. He has introduced a new Russian aesthetic into Hollywood,[29] while also contributing significantly to the development of Russian commercial cinema through (1) developing the hugely popular genre of remakes; (2) promoting production of sequels and prequels; (3) supporting international distribution of Russian films, especially feature-length animation; (4) consolidating the Russian film genre system, especially in the realm of comedies, romantic comedies, fantasy, and science fiction; and (5) promoting co-productions between Russian and American studios, such as Il'ia Naishuller's *Hardcore Henry*. Bekmambetov exemplifies what has been labelled "the global Russian," a highly mobile, affluent, and influential individual with a demonstrable link to Russian culture and language. He also exemplifies how Russian agency and power operate outside the government-regulated space of cultural production. I argue that Bekmambetov has been more effective in promoting Russian cultural and economic agendas

[29] For a discussion of his influence, see Saunders and Strukov, "The Popular Geopolitics Feedback Loop," in Further Reading.

in their independent dimensions than all official government-sponsored channels, including the international broadcaster RT.

Bekmambetov's example reveals the importance of individual filmmakers and producers in the Russian film industry. On one level, it shows the strength of individual entrepreneurs' creative talent; on another, it exposes their vulnerability as they lack institutions that would support them in difficult situations, especially those that include the interests of the state. Khlebnikov and Zviagintsev have documented the struggles of Russian citizens to protect themselves against the attacks of neoliberal capitalism, the bureaucratic state and its corrupt representatives. Off screen, the House of Cinema, a museum of the history of cinematography in Russia founded by the legendary Naum Kleiman, lost a 2005 appeal against the handover of its building in the center of Moscow. The scandal escalated when a new museum director was appointed and later, the majority of research personnel resigned in protest.[30] This is one of many examples when citizens and institutions come in conflict with those who represent business and the state, and very often the amalgamation of the two. Vladimir Medinsky, the current Culture Minister, has come to symbolize this monstrously corrupt, arrogant, and subservient state-private enterprise. He is known for initiating a range of controversial policies that reveal (a) the government's growing interest in the culture sector and its attempt to reappropriate cultural production for its own objectives, and (b) the government's willingness to delegate the regulation of the cultural sector to the market, which is evident in various austerity measures. While Russian filmmakers and the cultural sector at large have been unable to depose Medinsky and other bureaucrats, they have been successful in revealing their corrupt machinations. For example, in 2014–17, it became known that Medinsky had

[30] After their departure, the group has been organizing a series of events, including film screenings and discussions, at the world famous Tret'iakov art gallery. See "Tret'iakovskaia galereia zapuskaet programmu 'Kino v Tret'iakovke,'" *Afisha Daily*, February 29, 2016, accessed April 12, 2018, https://daily.afisha.ru/news/893-tretyakovskaya-galereya-zapuskaet-programmu-kino-v-tretyakovke.

manipulated historical facts in his doctoral dissertation, while other officials under his command were accused of plagiarism and financial embezzlement.

Currently, the Russian film industry has a hybrid form of financing productions; the majority of films are produced with money received from the state and private sources (in different proportions). International co-productions are encouraged but rarely supported by the government financially. There are no restrictions on the use of foreign capital for film production (which is different from media companies that must be registered in the Russian Federation and are limited to no more than 20 percent of foreign investment). Two government institutions currently provide financial backing to Russian filmmakers: the Film Foundation and the Culture Ministry. The former is a federal center established in 1994 to support the ailing film industry. It administers finances which it receives directly from the federal budget. In 2016, the year which was designated to celebrate the art of cinema in the Russian Federation,[31] the total amount of support was over 3 billion rubles. In some cases, the money was given to the filmmakers as a grant, but in other cases the money was in the form of a loan that was expected to be repaid after the film's release. In other words, the Film Foundation uses a neoliberal model of supporting and stimulating film production with particular emphasis on the economic viability of most of the funded projects.

The role of the Culture Ministry is broader because it aims to support film production financially, as well as regulate distribution and consumption by (a) developing governmental strategies for film production; (b) supporting film festivals and the international promotion of Russian films;[32] (c) preservation and promotion of Russian cinematographic culture; (d) supporting ethnic film

[31] The Ministry dedicates every year to a particular form of art.

[32] In the original, the document uses the term "propaganda." See "Departament kinematografii," official website of the Russian Culture Ministry, accessed April 12, 2018, https://www.mkrf.ru/about/departments/departament_kinematografii.

studios and films that depict the cultures of Russian multicultural society; and (e) enabling access to audio-visual materials by all members of Russian society. In other words, the Culture Ministry has consolidated the functions of many institutions. (For example, in the British context these institutions include the British Film Commission, the British Film Institute, and the British Council.) As a result, the Culture Ministry, and personally Medinsky, have been criticized for centralizing all powers and fully controlling the Russian state-funded film market, including interventions such as changing release schedules, imposing different age rankings, and outright censorship, as with the ban of *Child 44* due to its "distortions of history." The film, an adaptation of a Tom Rob Smith novel about the search for a Soviet-era serial child killer, was taken out of Russian theaters after it was suggested that screening the film ahead of the 70th anniversary of the defeat of Nazi Germany in the Great Patriotic War (the section of WWII after Hitler's attack on the USSR) would be "impermissible."

"Morality" has often been used as a pretext to investigate a particular film project and exercise power over its production and release. For example, there was an investigation of whether Disney's *Beauty and the Beast* (2017) should be released in the Russian Federation due to its inclusion of a gay character. In the end, the Ministry granted permission for the film to be screened with a 16+ age rating because Russian law prohibits the spreading of "gay propaganda" among minors. There is an ongoing investigation of Aleksei Uchitel's film *Matilda*, which explores the love affair of Tsar Nicholas II and a Polish ballerina. The investigation started even before the film was finished due to the allegation that the film shows Nicholas II—who is now recognized as a saint by the Russian Orthodox Church—having sex outside marriage. These examples demonstrate how the Culture Ministry has been used as a controlling arm of the government and especially its conservative sections; in both cases the appeals were initiated by non-governmental organizations that promote traditionalist values. These examples illustrate how artistic creations, and especially films, have been used to stage a debate about what is permissible and therefore what the new conservative morality of the Russian state should be. For

instance, a law introduced in 2014 banned the use of four explicit swearwords and their derivatives in films, television broadcasts, theaters, and the media. After an initial outcry, the filmmakers and distributors found new ways of expression, which, bizarrely, have enriched Russian swearing repertoire. Ironically, these types of debates and associated legislation have little impact on Russian audiences who can access banned content online. Moreover, these scandals generate considerable interest and therefore can be used as a marketing strategy. For example, the scandal around *Matilda* ensured that the film was relatively successful at the box office on its debut weekend despite negative reviews from film critics such as Anton Dolin and the threats of violent reprisal from monarchist groups.[33]

In addition to direct regulation, the Culture Ministry uses indirect forms of control such as its involvement in funding competitions. The Ministry has the authority to change selection criteria and appoint loyal selection committees in order to manipulate the outcome of the competitions. The Culture Ministry also has the power to set its own agenda as it did during the so-called *Leviathan* controversy. After its premiere at the Cannes festival in May 2014, Zviagintsev's *Leviathan* received considerable media coverage in the Russian Federation; however, the public's attention was focused on events in Ukraine (including the introduction of the ruble in Crimea, preparation for local elections on the peninsula, and warfare in East Ukraine). It was only at the end of September 2014, when the Russian Oscars committee put forward *Leviathan* to represent the Federation, that the public's attention shifted to the film and the controversy it had caused in the international media. The coverage in Russia included, among other things, the public duel between Zviagintsev and Medinsky. The latter condemned the film as presenting a "simplistic and highly negative picture of contemporary Russia."

[33] In spite of a good initial performance, the film was a financial flop. See Mikhail Vodop'ianov, "Proval 'Matil'dy' oboshelsia rossiiskim nalogoplatel'schikam v 550 mln rub," *Kinodata*, November 25, 2017, accessed April 12, 2018. http://kinodata.pro/vse-o-kino/obzor-kassovyh-sborov-v-rossii/32706-proval-matildy-oboshyolsya-rossijskim-nalogoplatelshhikam-v-550-mln-rub.html.

Zviagintsev retaliated by accusing the Minister of promoting his personal views over the interests of artists and filmmakers.[34] Their duel caused an outcry in Russia with various cultural figures joining the debate concerning the role of the government in cinema and art, the future of creative works in Russia, freedom of expression, and soft power. Eventually, Medinsky retreated and issued an official apology; however, the media frenzy surrounding *Leviathan* continued to escalate, damaging the film's perception before its Russian premiere—something that Zviagintsev's producers tried to avoid by scheduling the release of his next film immediately after *Leviathan*'s premiere in Cannes in 2017. Zviagintsev became so frustrated with Medinsky that he made his last feature with no state assistance.[35]

The *Leviathan* controversy exposed another deeply rooted problem: the use of cinema for propaganda of the state agenda. This is also a global concern seen for example, in the merger between the US Department of Defense and Hollywood (the so-called militainment complex), and in Britain, where state funders back up projects that are "quintessentially British," with the *James Bond* series arguably being the most effective exercise of British soft power.[36] In the context of the Russian Federation, these concerns are mixed with fears of a possible return of Soviet-era censorship and persecution of directors. While extreme coercion seems to be a lesser issue, the power of persuasion has been used to produce an entire cinematic phenomenon, labeled by Stephen Norris as "the patriotic blockbuster," or a revival of nationalist and patriotic sentiment by applying Hollywood techniques to themes drawn from Russian history. These films are not discussed in the current collection (with the exception of *Legend No. 17*), but they represent the largest and most popular body of cinematic work in

[34] See the detailed discussion of the *Leviathan* controversy in Vlad Strukov, "Russian 'Manipulative Smart Power,'" in Further Reading.

[35] Funding was secured from transnational film distributors so the debate about "independent" filmmaking took on a new turn.

[36] See, for example, Udo Merkel, in Further Reading.

recent years. Norris claims that the first patriotic blockbuster was *Ninth Company* (*Deviataia rota*, 2005), an Afghan War film by Fedor Bondarchuk, which is discussed in *The Russian Cinema Reader*, vol. 2. The film shattered all box office records and was viewed by President Putin, himself. A decade later, Bondarchuk released another patriotic blockbuster titled *Attraction* (*Pritiazheniie*, 2017), which, in the style of Neill Blomkamp's *District 9* (2009), tells a story about an alien ship crashing in the Moscow suburban district of Chertanovo. The association with Blomkamp's film, where an alien spaceship lands in Johannesburg, is extremely important because the comparison of the two films reveals key geopolitical contrasts between Russia and the West. First, Bondarchuk articulates the perceived difference between British and Russian imperial projects: if the former worked by extermination, the latter does so by assimilation. Second, Bondarchuk visualizes the political agenda of Putin's regime after the annexation of Crimea, which presents Russia as a defender—"that which withholds," or *katechon*—of human civilization as opposed to American messianism.[37] Third, Russians from Chertanovo collaborate with the "good" aliens in order to disable "evil" humans who threaten peace and harmony, rather than destroy the evil aliens, as in Michael Bay's *Transformers* (2007). Finally, unlike its South African and US counterparts, the Russian film places a young woman at the center of the narrative, signaling a change in the gender politics of global Russia.[38]

I would describe the convergence of institutionalized political and cinematographic actors as "Kremli-wood," which differs from Russian film in the same way that the Russian people are different from the "Putin nation,"[39] or people who show their allegiance to the

[37] See, for example, Maria Engström, in Further Reading.

[38] In less than a year after the release of the film, three young women and an openly gay man put forward their candidacy for Russian presidency. Some see this as a Kremlin-inspired distraction from the figure of Putin; I argue that these events manifest a profound change in how Russians perceive their future political system.

[39] See Strukov, *Contemporary Russian Cinema*, in Further Reading.

state, not the nation. I also argue that from a patriotic blockbuster, this strand of Russian filmic work has emerged into a geopolitical cinema, or a type of movie that engages with philosophical texts (in this case, nineteenth century religious thinker Nikolai Fedorov's visions of the future);[40] ideological concepts (such as the right-wing thinker Aleksandr Dugin, whose ideas are merged with the principles of neoliberalism);[41] and cultural tactics (the film was made with the view that it would be released worldwide) in order to reconceptualize Russia's role on the global arena.

Russian cinema has gone global in a number of ways: (a) Sokurov, Zviagintsev, Serebrennikov, Popogrebsky and other directors show their works at international film festivals where they often receive top awards; (b) co-productions with China and Brazil are supported at the highest level;[42] (c) recent Russian cinema depicts Russian-speaking communities in various countries of the world, such as Petr Buslov's *Motherland* (*Rodina*, 2015) about Russians living in Goa, India; and (d) Russian films and television series have been acquired by de-territorialized streaming services such as Netflix.[43] While going global, Russian cinema is also going local. For example, films from the Republic of Yakutiia (Sakha) have attracted considerable attention both throughout Russia and internationally. With their focus on the lives of people in minority republics, these films are often labeled as cinema by and about indigenous people. The Yakut cinema may be a much larger project as it speaks about the experience of living in the globalized world when Russian modernity is one of many globalizations encountered by ordinary citizens.[44] The Yakut cinema disrupts our preconceptions about

[40] See Strukov and Goscilo, in Further Reading.

[41] See Engström, in Further Reading.

[42] In July 2017 Putin and Xi Jinping signed an agreement that enables production of a Chinese version of a Russian animated series.

[43] *Silver Spoon* (*Mazhor*, 2014) was the first Russian television series purchased by Netflix for global distribution.

[44] For example, we find a symbiosis of history, mysticism, and national epic in Sergei Potapov's films *God of Dyosegey, 24 Snows, The Boy and The Lake*.

the Russian Federation by placing emphasis on its multicultural construction and the possibility of bypassing—at least aesthetically and ideologically—the dominance of both Hollywood and Kremliwood to appeal to global citizens, not the "Putin nation" and its local equivalents in many countries of the world.

Further Reading

Badiou, Alain. *The Century*. Translated by A. Toscano. London: Polity, 2007.

Beumers, Birgit, and Mark Lipovetsky. *Performing Violence: Literary and Theatrical Experiments of New Russian Drama*. Bristol: Intellect, 2009.

Condee, Nancy. *The Imperial Trace. Recent Russian Cinema*. Oxford: Oxford University Press, 2009.

de Luca, Tiago. *Slow Cinema*. Edinburgh: Edinburgh University Press, 2015.

Devasundaram, Ashvin. "Beyond Brand Bollywood: Alternative Articulations of Geopolitical Discourse in New Indian Films." In *Popular Geopolitics: Plotting an Evolving Interdiscipline,* edited by Robert Saunders, 152–73. London: Routledge, 2018.

Engström, Maria. "Contemporary Russian Messianism and New Russian Foreign Policy." *Contemporary Security Policy* 35, no. 3 (2014): 353–79.

Goscilo, Helena and Yana Hashamova, eds. *Cinepaternity: Fathers and Sons in Soviet and Post-Soviet Film*. Bloomington, IN: Indiana University Press, 2010.

McVey, David. "Iurii Bykov: *The Major (Maior, 2013)*." *KinoKultura* 42. Accessed April 10, 2014. http://www.kinokultura.com/2013/42r-major.shtml.

Merkel, Udo, ed. *Identity Discourses and Communities in International Events, Festivals and Spectacles*. London: Springer, 2015.

Nagib, Lucia, Chris Perriam, and Rajinder Dudrah, eds. *Theorizing World Cinema*. London: I. B. Tauris, 2012.

Norris, Stephen M. *Blockbuster History in the New Russia: Movies, Memory, and Patriotism*. Bloomington, IN: Indiana University Press, 2012.

Saunders, Robert, and Vlad Strukov, eds. *Popular Geopolitics: Plotting an Evolving Interdiscipline*. London: Routledge, 2018.

Saunders, Robert, and Vlad Strukov. "The Popular Geopolitics Feedback Loop: Thinking Beyond the 'Russia against the West' Paradigm." *Europe-Asia Studies* 69, no. 2 (2017): 303–24.

Strukov, Vlad. "The Forces of Kinship: Timur Bekmambetov's *Night Watch* Cinematic Trilogy." In *Cinepaternity: Fathers and Sons in Soviet and Post-Soviet Film*, edited by Helena Goscilo and Yana Hashamova, 191–216. Bloomington, IN: Indiana University Press, 2010.

— — —. "Translated by Goblin: Global Challenge and Local Response in Post-Soviet Translations of Hollywood Films." In *Contexts, Subtexts and Pretexts: Literary Translation in Eastern Europe and Russia*, edited by B. Baer, 171–86. Amsterdam: John Benjamin, 2011.

— — —. *Contemporary Russian Cinema: Symbols of a New Era*. Edinburgh: Edinburgh University Press, 2016.

— — —. "Digital Conservatism: Framing Patriotism in the Era of Global Journalism." In *Eurasia 2.0: Russian Geopolitics in the Age of New Media*, edited by Mikhail Suslov and Mark Bassin, 185–208. Lanham: Lexington, 2016.

— — —. "Russian 'Manipulative Smart Power': Zviagintsev's Oscar Nomination, (non-) Government Agency and Contradictions of the Globalized World." *New Cinemas* 14, no. 1 (2017): 31–49.

— — —. "Towards a New Paradigm of Resistance: Theorizing Popular Geopolitics as an Interdiscipline." In *Popular Geopolitics: Plotting an Evolving Interdiscipline,* edited by Robert Saunders and Vlad Strukov, 63–82. London: Routledge, 2018.

Strukov, Vlad and Helena Goscilo, eds. *Russian Aviation, Space Flight and Visual Culture*. London: Routledge, 2016.

Strukov, Vlad and Stephen Norris, eds. *Studies in Russian, Eurasian and Central European New Media* 8, special issue *Cinegames: Convergent Media and the Aesthetic Turn*. Accessed June 15, 2017. http://www. digitalicons.org/issue08.

DEAD MAN'S BLUFF (aka BLIND MAN'S BLUFF)

Zhmurki

2005

105 minutes

Director: Aleksei Balabanov

Screenplay: Aleksei Balabanov and Stas Mokhnachev

Cinematography: Evgeny Privin

Art Design: Pavel Parkhomenko

Sound: Mikhail Nikolaev

Producer: Sergei Sel´ianov

Production Company: STV Film Company

Cast: Dmitry Diuzhev (Simon), Aleksei Panin (Sergei),
Nikita Mikhalkov (Sergei Mikhalych),
Renata Litvinova (waitress/secretary Katia),
Aleksei Serebriakov (Doctor), Grigory Sivatwinda
(Eggplant), Viktor Sukhorukov (Stepan)

Exorcising the Soviet

Aleksei Balabanov (1959–2013) is the most important filmmaker of his generation, perhaps the key figure in desovietizing Russian cinematic language after the collapse of the Soviet film industry in the late 1980s through early 1990s. Many critics compare Balabanov with Quentin Tarantino because both filmmakers aestheticize violence, mix it with black humor, favor disjointed narratives, use racial and gender slurs for shock effect, reference music and popular culture of the 1970s and 80s, and use comic strip aesthetics in their live-action films. Balabanov initially gained acclaim as an auteur

filmmaker. His first arthouse feature, *Happy Days* (*Schastlivye dni*, 1991), won the best film award at Moscow's Debut Festival in 1992. Later, he turned to commercial film genres and became popular with broad audiences. Arguably, his films brought Russian viewers back to the newly built multiplexes in the late 1990s after the near-death of the film industry following the collapse of the Soviet Union. In 1997, his gangster neo-noir film *Brother* (*Brat*) became the biggest box office success of the year and received the Grand Prix at the Open Russian Film Festival (Kinotavr), the nation's largest film festival, held annually in Sochi.

Balabanov grew up in Sverdlovsk (now Yekaterinburg) and received his first university degree from the Translation Department of Gorky Pedagogical Institute in Nizhny Novgorod. After graduation he served in the army as officer-translator and traveled to Africa and Asia, including Afghanistan. After his discharge from the military, Balabanov worked as a director's assistant at the Sverdlovsk Film Studio for four years. In 1987, he enrolled in The Graduate Courses for Screenwriters and Directors, where he studied filmmaking in the Auteur Cinema (Avtorskoe kino) Workshop led by Lev Nikolaev and Boris Galanter. He graduated in 1990 and moved to Leningrad, where he became associated with the Studio of First and Experimental Films, an independent film studio that emerged on the grounds of Soviet-era Lenfilm Studio in the late 1980s. Founded by the creative team of Aleksei German and Svetlana Karmalita, the studio nurtured emerging talent of the new generation of Russian filmmakers, including Lidiia Bobrova, Vitaly Mansky, Sergei Ovcharov and, of course, Balabanov. At the studio, he made his first feature *Happy Days*, a tale inspired by Samuel Beckett's short stories about a patient released from the hospital, wandering the city's empty streets in a futile search for shelter. The protagonist finds the shelter, along with human contact at a cemetery. Balabanov based his second film *Castle* (*Zamok*,1994) on Franz Kafka's unfinished novel. In these auteurist works Balabanov experiments with many key motifs, which later became part of his signature style, including a disoriented little man; the city as modernity's setting, which Nancy Condee defines as "the articulation of human's primal drives, dominant among them, the

death drive"[1]; the key role of music in the narrative; and portraying urban space as modernity's battlefield, in which people exchange their humanity for survival skills.

In 1992, Balabanov, Sergei Sel'ianov, and Viktor Sergeev co-founded STV Film Company, which has become one of the most successful film businesses in Russia. In 1995, the company produced a portmanteau film *Arrival of a Train* (*Pribytie poezda*) to commemorate the centenary of the Lumière brothers' pioneering film event at the 14 Boulevard des Capucines. Critics noted that Balabanov's short *Trofim* was the best of four films comprising *The Arrival* and foreshadowed the plot and the success of his action feature *Brother,* a departure from his early auteurist experiments in favor of genre cinema.

Brother is a vigilante neo-noir film about a Chechen war veteran, Danila Bagrov, seeking justice in post-socialist St. Petersburg. The film combines expert knowledge of the Hollywood gangster film tradition and a neo-noir treatment of genre conventions with motifs borrowed from the Petersburg literary tradition, above all the vision of the city as the dystopian locale of Russia's modernity. *Brother* became a major success with moviegoers, sold 400,000 legal video copies during the first five months of its release,[2] and triggered an even more successful sequel *Brother 2 (Brat 2,* 2000), in which the Russian gangster protagonist takes a trip to the US, not surprisingly, to Chicago, to avenge the death of his friend.

Rimgaila Salys notes that between the two "brothers" Balabanov "released his auteur film *Of Freaks and Men* (*Pro urodov i liudei,* 1998), which he views as his best film."[3] It is indeed the filmmaker's visual

[1] Nancy Condee, 223, in Further Reading.

[2] The number of legal copies sold is notable because the majority of video copies sold in the 1990s were pirated. For further discussion, see Jonathan Romney, "Brat-Pack," *New Statesman,* April 10, 2000, accessed March 13, 2018, https://www.newstatesman.com/node/151101.

[3] Rimgaila Salys, "*Brother,*" in *The Russian Cinema Reader. Volume Two. The Thaw to the Present,* ed. Rimgaila Salys (Boston, MA: Academic Studies Press, 2013), 258.

essay on the nature of cinematic gaze, which, according to Balabanov, has not changed much since its inception, no matter what narratives try to muffle cinema's visual appeal. A film about early twentieth-century photography and the pornography business, *Of Freaks and Men* examines the mobile gaze indulging in public voyeurism—cinema that displays rather than narrates. According to the director, in a good film unconscious drives and visual excess sooner or later overwhelm any reason-driven narrative impulse.

The distinction between the arthouse and commercial genre cinema provides a partial insight into Balabanov's creative output. Perhaps a better approach would be to say that Balabanov fused arthouse and global film genres, and above all crime film, in order to confront the dominant Other—the Hollywood cinema—and to engage with filmmaking as a mode of thinking. As a Russian artist, Balabanov asks age-old questions: how does Russian culture deal with Soviet and imperial legacies; what role did modernity play in Russian history; what is the place of the individual and intellectual in culture? In 2005–7 he released several auteur-genre fusion films: his gangster black comedy *Dead Man's Bluff* (2005); a self-reflexive exercise in the melodrama genre, *It Doesn't Hurt* (*Mne ne bol'no*, 2006); and a look at the late Soviet era from the point of view of the horror film *Cargo 200* (*Gruz 200*, 2007). *Morphine* (*Morfii*), his 2008 film adaptation of Mikhail Bulgakov's *Notes of a Young Doctor* (1925–26), is yet another genre hybrid, a combination of auteur film in dialogue with the conventions of the addiction film: the story of a young doctor's gradual transformation into a lying junkie, set against the backdrop of the Russian revolution. His last two films, *Stoker* (*Kochegar*, 2010) and *Me Too* (*Ia tozhe khochu*, 2012), are personal experimental films combining neo-noir aesthetics with the filmmaker's reflections on the process of creation itself. Vlad Strukov would call those last two films the cinema of "posthumous subjectivity continuing life after death and articulating non-knowledge," a condition of narrative rupture.[4]

[4] Vlad Strukov, *Contemporary Russian Cinema: Symbols of a New Era* (Edinburgh: Edinburgh University Press, 2017), 40.

The Gangster as Comic Hero

Dead Man's Bluff is the only film branded as comedy in Balabanov's filmography. His friend and producer Sel'ianov notes that they imagined the film as a comic flashback to the "roaring" 1990s—the era of nascent capitalism in Russia. The filmmaker produced his vision of Russia's gangster wars of the nineties in the style of a black humor parody of gangster film conventions. The title *Dead Man's Bluff* (*Zhmurki* in Russian) is a word play invoking the game blind-man's-bluff (*zhmurki*) as well as the colloquial word for a corpse or stiff (*zhmur*). By referring to the game in which the blind (the dead) are looking for those who can see (those who are alive), the director provides a metaphor for gangster wars in post-Soviet Russia and emphasizes the role of chance and luck in them—a far cry from a meritocracy or any other socially legitimate mode of upward mobility. Not unlike Jean Luc Godard's dedicating his *A Bout de Souffle* to Monogram Pictures, Balabanov playfully reinforces his title with a dedication: "To those who survived the nineties," that is, the lucky ones who won the game of death.

Balabanov considered his comedy an exercise in filmmaking that adapts the style of comic-book representation to Russian material.[5] As he notes in his interview to Dmitry Savel'ev, he made a film for younger viewers who comprised the new generation of moviegoers buying tickets in post-Soviet multiplexes.[6] In order to meet these viewers' expectations, he produced a film which consciously parodied the narrative style familiar to them: that of Quentin Tarantino's *Kill Bill: Vols. 1&2* (2003–4), especially his ability to combine comic strip aesthetics with live-action filmmaking.[7] Balabanov's two main heroes, Sergei and Simon, are two-dimensional gangsters, who over the course of the film enact a caricature

[5] Mariia Kuvshinova,134, in Further Reading.

[6] Dmitry Savel'ev, "Mne delat' kino dlia burzhuev kak-to ne ochen'," *Izvestiia*, May 25, 2005.

[7] Florian Weinhold, 115, in Further Reading.

of a centuries-old dispute between Slavophiles and Westernizers about Russia's historical path and the benefits of western influences on it. Sergei is a serial killer with strong Orthodox beliefs, who crosses himself before the next hit and promises to build a church when he gets rich. Simon is a mass murderer who loves everything Western. He reads comic books in order to learn English, his restaurant of choice is McDonald's, and his musical preferences are Stray Cats and Electric Light Orchestra, whose soundtracks he uses while torturing his victims. Simon is somewhat more consistent in his values than patriotic Sergei: the westernized mobster expands his criminal activities globally (he is heading out on a business trip to Burkina Faso), while the god-fearing Sergei never builds his church. In Putin-era Russia, where xenophobia-flavored patriotism became an indispensable part of the official ideology, Balabanov makes a special point of undermining Sergei's hypocritical pledge via Simon's comment that the church will never become a reality. In short, two mafia foot soldiers collaborate to form a productive team of cold-blooded murderers, who disagree on the path of Russian civilization. Will it be a lawless orgy of endless torture and butchery in the name of Orthodox values or one inspired by western pop culture? (Fig. 1).

The film opens with a lecture set in the present: a university professor explains to business school students how every capitalist

Fig. 1. Not so bright but deadly: heroin delivered.

venture begins with an initial investment of start-up capital. The question is how to acquire this capital. The rest of the film provides an illustration to the professor's question in the genre of black comedy about Russian gangsters. The introductory scene also establishes the temporal structure of the film: two episodes set in the present bookend the events set in the 1990s. The filmmaker seems to promise the viewer a trip back to the previous decade in the main narrative of the film with a safe return at film's end to the same classroom, where students study the history of the early tumultuous days of Russian capitalism and its progress to the enlightened stage of a market economy.

Balabanov, of course, cheats the naive viewer's expectations. In the main narrative of the film we follow the adventures of Sergei, Simon, and their criminal boss Sergei Mikhalych (played by the top dog of the Russian Filmmakers' Union, Nikita Mikhalkov). They make a living by the illegal drug trade (the post-classical substitute for classical-era illegal alcohol), drive a Russian gangster car—a black BMW—and kill anybody who stands in their way. When the viewers get back to the present at film's end, instead of the peaceful atmosphere of a university lecture hall, we end up in the office of a member of the Duma (the Russian parliament), with a view on the Kremlin towers. The member of parliament is Sergei, his top aide is Simon, while their former boss, Sergei Mikhalych, now works as their receptionist. No temple was erected but there is plenty of earthly power on display. While they are dressed in expensive suits and the interior design of their office has improved, they act like good old mobsters and discuss the same heroin transactions as in the 1990s. Nothing has changed, apart from an absurdist switch of mobsters in the pecking order within the gang. The older Sergei has been replaced with the younger Sergei.

As in his black comedy, in interviews Balabanov questions the very possibility of progress and historical development: "There is no development of humankind at all . . . and never has been."[8] Made in 2005 amidst the Putin-era "economic miracle," the film challenges

8 Condee, in Further Reading, 223.

the government media's claims that the new president changed the country and brought the rule of law and stability to Russia after the chaos and turmoil of the 1990s. The filmmaker noticed only one enlightening change in the way Russian capitalism operates: the gangsters moved from a provincial Russian city to a Moscow office with a view of the Kremlin.

At film's end Balabanov mocks his naive viewers by making them the object of his dark and satirical laughter. In his discussion of Balabanov's comedy, Florian Weinhold notes: "*Dead Man's Bluff*'s black comedy is funny only if we accept that comedy is simply tragedy happening to somebody else, that is, in this case, the Russian people. . . . For by turning [the] gangster genre on its head, *Dead Man's Bluff*'s story of the 1990s makes Russian audiences . . . the butt of its humor."[9] Weinhold argues that at film's end black comedy turns into satire, which holds up a mirror to a society that has not evolved. This point Balabanov will reiterate even more graphically in his 2007 film *Cargo 200*, a social horror-style commentary on Putin-era nostalgia for the Soviet past.

Balabanov's comedy is a scathing comment on the nature of Russia's new economic and political order. In his discussion of Hollywood gangster films, Fran Mason notes that "the gangster creates an alternative economy of excess in which modernity's separation of work and desire (in the Fordist mode of production where the worker does not do what he desires but works for others' desires) is obliterated by the gangster."[10] The mobster short-circuits the logic of capitalism driven by protestant ethics and works only toward advancing his own limitless desires. Classical Hollywood gangster films usually restored legitimate capitalism's order by eliminating the gangster as the character challenging the status quo. In his postmodern spoof of the gangster story, Balabanov subverts a well-established narrative convention. The filmmaker depicts Russia as a territory where gang-style capitalism has no alternative

[9] Weinhold, 120–21, in Further Reading.

[10] Fran Mason, *American Gangster Cinema: From Little Caesar to Pulp Fiction* (New York: Palgrave Macmillan, 2002),16.

economic model that can compete with its violent practices. There is nobody to enforce the rule of law in this wonderland of infinite wish fulfillment. The only government officer is the crooked cop Stepan, played by Viktor Sukhorukov, who is murdered in the middle of the narrative. His death seems not to add any more lawlessness to the world of the film because he himself used to be the head of one of the criminal gangs. If in the classical Hollywood gangster narrative, mafia economy exists as a perversion of protestant capitalism, in Balabanov's comedy there is only gangster economy driven by the mobsters' collective identity, no superego whatsoever being able to control it.

Balabanov also trolls another key convention of the gangster film: the juxtaposition of the protagonist's biological family and the surrogate family of the criminal gang. In the classical narrative the former stood for heteronormative hierarchy and a clear distinction between good and evil. The latter community represented mobility, rapid social change, excess, and the chaos of modernity. Moreover, at the center of the gang was usually a male pair of gangsters who spend more time with each other than with women. Mason notes that such a pair generates a strong homoerotic subtext.[11] Balabanov collapses the opposition between the heteronormative family and homosocial gang. In the diegetic world of the film, the only household is that of the criminal boss Mikhalych. Sergei and Simon are his foot soldiers and adopted children, and his criminal gang is the only community possible in the film. While examining Tarantino's *Pulp Fiction* (1994), Mason notes: "The film enacts a society where the semiotic codes of the gangster do not just exist on screen, but have become the norms of everyday behavior so that the gangster is no longer aberrant, but typical."[12] Every word of Mason's analysis applies to Balabanov's postmodern spoof of the gangster film, his dark vision of communities comprising present-day Russia.

[11] Mason, *American Gangster Cinema*, 10.

[12] Ibid., 161.

In contrast to Russian crime films released in the early 2000s that mythologized the figure of the gangster, Balabanov de-romanticizes the mobster as modernity's superhero. In his discussion of the nature of modern comic discourse Henri Bergson notes that "the attitudes, gestures and movements of the human body are laughable in the exact proportion as that body reminds us of a mere machine."[13] Balabanov's gangsters are precisely these killing machines, ridiculous in their lack of self-reflexivity. Explaining the origins of Balabanov's dark comedy, Weinhold contends that Balabanov "intervened in a post-Soviet cinematic debate that deployed the gangster genre to represent Russia's ruthless transition to a market society in the 1990s."[14] He observes that *Dead Man's Bluff* critiques the ideological stance of such gangster films as Yegor Konchalovsky's *Antikiller* (2002), a film that uses the gangster genre "to present a pro-establishment, restoration-nostalgic voice supportive of the contemporary Russian regime."[15] Konchalovsky introduces a perfect hero for the country run by former KGB officer Vladimir Putin: "the ex-KGB major with a metaphoric name Korenev (*koren'* meaning "root")."[16] Korenev fights mafia clans that emerged with the rise of capitalism. If for Konchalovsky his protagonist is a melodramatic superhero with strong connections to his Soviet past, and above all the KGB as an institution of integrity and honor, for Balabanov his gangster is a machine-like comic strip character without any past.

While some Russians saw the new gangster films (such as *Antikiller*) in theaters, almost every Russian watched gangster television sagas of the 2000s, such as *Brigade* (*Brigada,* directed by Aleksei Sidorov, 2002) and *Gangster Petersburg* (*Banditskii Peterburg,*

[13] Henri Bergson, *An Essay on the Meaning of the Comic,* translated by Fred Rothwell, a public domain book Kindle edition, location 235, accessed March 13, 2018, https://www.amazon.com/Laughter-Essay-Meaning-Henri-Bergson-ebook/dp/B0082YHCBG/ref=sr_1_12?ie=UTF8&qid=1520613810&sr=8-12&keywords=Bergson%2C+Essay+Meaning.

[14] Weinhold, 116, in Further Reading.

[15] Ibid., 121–22.

[16] Ibid., 116.

directed by Vladimir Bortko 2000–2007), in which the gangster is romanticized as a cultural hero of the 1990s and the Soviet past is whitewashed. The protagonists of these serials are teenagers whose Soviet past is morally pure and politically stable. Only the social turmoil of the sudden fall of good old socialism and the rise of evil capitalism turns them into outlaws who at times have to cut legal corners, but remain Romantic heroes transcending the profane world of capitalism. Balabanov's film provides a strong antidote to these narratives of nostalgia for a lost Soviet paradise. His casting is especially strategic in this respect. For the role of one of his ruthless killing machines, Simon, he invites Dmitry Diuzhev, who gained national popularity as Kosmos, the noble gangster and member of the Brigada gang who never betrays his male friends in the cult mini-series, *Brigada*.

In contrast to gangster films and television sagas of the early Putin era, Balabanov's black comedy is unforgiving in its depiction of mobsters, ridiculous in their one-dimensionality, mindlessness, and lack of humanity. Sergei and Simon and their competitors butcher each other without good cause and often for no practical reason. For example, when the filmmaker transports viewers from the lecture hall of 2005 Russia back to the 1990s, they end up in

Fig. 2. Mob Boss with USSR tattoo: nostalgia for the Soviet past mocked.

a morgue already brimming with corpses. It is not clear how one will even dispose of the new corpses that Sergei and Simon will generate in the course of the film. The excess of death is the main source of uneasy laughter in *Dead Man's Bluff*. The gangster-hero turns into a cog in the unrelenting mechanism of urban modernity. His machine-like performance in Balabanov's film produces a dark comic effect and by no means any sense of sympathy or viewers' identification with its heroes. Most importantly, in contrast to Konchalovsky's or Sidorov's works, in which the viewer could identify with the characters' Soviet past, Balabanov's killers have no past that can redeem or explain their absurd present. This is masculinity run amok (Fig. 2).

Balabanov contrasts the irrational world of toxic masculinity with the world of animals. His gangsters plan their heist in a zoo's reptile house, where the camera cuts between mafia men barely controlling their desire to attack each other and reptiles calmly dwelling in their glass containers. While the mobsters aggressively argue and insult each other, two visitors, father and son, offer food to a caiman that had already satisfied its appetite. In contrast to the mobsters who cannot control their greed and aggression, the reasonable reptile rejects food that exceeds its dietary needs.

Dead Man's Bluff represents the world of triumphant violent patriarchy where there is hardly any room for women. Katia (played by Renata Litvinova) is the only female character who appears in more than one scene in the film. Litvinova's hyper-sexualized speech and body language create a caricature of traditional gender roles assigned to women in the violent male-controlled world. Katia's career echoes the absurd upward mobility of her gangster buddies: the small-town waitress becomes a Duma deputy's secretary and moves to Moscow with Sergei and Simon. At film's end, Simon gives her a good-natured swat on the rear, thus confirming what, according to Balabanov, social change and upward mobility mean in the new and stable Russia. The only place where there is an abundance of female bodies in the film is the morgue seen at the beginning of the film. In view of this important detail, I have to clarify my earlier statement: the morgue does not brim with corpses,

it brims with naked female bodies—an important condition for the patriarchy to run smoothly.

Being a descendant of the formerly dominant and respected Soviet intelligentsia himself, Balabanov returns to the theme of the intelligentsia and its role in Russian culture in many of his films. His intelligentsia characters are usually hypocrites and incompetent cowards who serve as triggers of destruction and social horror in the narrative. (See, for example, Artem Kazakov, the professor of atheism from Leningrad in *Cargo 200*.) In *Dead Man's Bluff* the filmmaker is faithful to his vision of the intelligentsia's role in Russian culture. Out of the three intelligentsia characters appearing in the film, two are dead by film's end: a chemist in charge of heroin production in the city and an architect who builds a smoking fireplace in Mikhalych's mansion and gets snuffed out himself. Only the professor of economics from the film's opening scene survives and continues to poison students' minds about Russia's progress from the chaos of the 1990s to the economic stability of the 2000s.

Many film critics on both sides of the Atlantic were outraged by the xenophobic one-liners pronounced by Balabanov's characters and by the director himself in his provocative responses to journalists. In an interview with Roger Clarke, for example, Balabanov simply states that he "is against all things foreign."[17] Condee notes that Balabanov's stubborn political incorrectness has to do with his precarious position, first, as the director representing a Russian cinematic tradition currently colonized by Hollywood and, second, as the director representing the imperial center of the former Soviet film empire. "These internal contradictions in Balabanov's performative style—in global cinema, Russia's radical emancipation from Hollywood's rule; in the domestic arena, Russia's retrograde superiority over other subjects—must not be resolved."[18] Balabanov's films thus simultaneously challenge Hollywood conventions and speak a tongue-in-cheek hyperbolized version of Russo-Soviet imperialist discourse.

[17] Cited in Condee, 233, in Further Reading.

[18] Ibid., 235.

But there is yet another way to interpret the film's treatment of race: as a simultaneous reaction to gangster film conventions and Soviet-style multiculturalism. In *Dead Man's Bluff*, Balabanov parodies the conventions of the gangster film narrative, which traditionally revolves around the protagonist who lacks opportunities because of his immigrant status and compensates this lack with excess of violence and murder, the ultimate spectacle of triumphant virility. Balabanov trolls the rise and fall of the ethnic gangster story by making most of his gangsters Russian. The director includes in one of the gangs an African-Russian mobster who is the direct opposite of the empowered ethnic gangster: he is the weakest link, the butt of everyone's racist jokes.

In addition to parodying gangster film conventions, Balabanov pokes fun at traditional Soviet cinema's claim of inclusivity—representing Russia and formerly the Soviet Union as the land of opportunity for all nations and races. The story is familiar to many from such socialist realist classics as Grigory Aleksandrov's *Circus* (1936), in which an African American baby, little Jimmy, escapes the racist United States and becomes a proud African-Soviet. Balabanov's film inverts the familiar narrative of inclusion and takes the absurdist path of dark comedy. No matter how often the Afro-Russian gangster replies to racist nicknames by stating "I'm Russian," his gangster buddies deny him his Russianness while giving him the most nonsensical explanations. His friend Bala, for example, tells him that he cannot be Russian because he smokes two packs of cigarettes every day. Eventually, Simon resolves the identity dilemma in the least inclusive way. When the Afro-Russian mobster tells him that he is Russian, Simon shoots him dead. In Balabanov's film, no Russian misses an opportunity for using a racist slur at the expense of the lonely African mobster, whose name we never learn and only know his racist nicknames, "Eggplant" (Baklazhan) and "Ethiopian" (Efiop), given to him by his "tolerant" Russian mob buddies.[19]

[19] Weinhold notes that "Baklazhan's African roots (the Russian actor's father was Zambian) and his mates' incessantly racist jokes create a critical distance from

Critics point out the central role of music in Balabanov's films.[20] Condee, for example, notes that "Balabanov's soundtrack is a multidimensional, evolving project. . . . After *Brother*, which had tended to promote its musical choices, Balabanov's work turned to an intricate game of commentary on the visual landscape. In *Cargo 200* and . . . in *Stoker*, the music mocks the image and is suddenly mocked in turn by the circumstances of the plot."[21] In *Dead Man's Bluff*, for the first time in Balabanov's films, a number of English-language songs are used—but only to accompany the long and graphic torture scenes—key moments in the film. Kuvshinova contends that the director chose his favorite songs: "Reinforcements" by Sparks, "Ubangi Stomps" by Stray Cats, and "Look at me now" by Electric Light Orchestra.[22] The soundtrack also includes the road theme composed by Viacheslav Butusov. Butusov and his group Nautilus Pompilius were Balabanov's lifelong friends, and their music appears in several of Balabanov's films, including the famous *Brother.*

Sarcastic counterpoint of sound and image is Balabanov's signature device. *Dead Man's Bluff* ends with Zhanna Aguzarova's 1987 song "Wonderland," which plays while Sergei and Simon look at the postcard view of the Kremlin and St. Basil's Cathedral. After the heaps of corpses, endless torture scenes, and fifty liters of fake blood spilled, according to the promotional materials for the film, the song's key line—"You will not find a better country"—

what the film represents as the ambiguous nature of Russian ethno-chauvinist intolerance. Its inherent irony is directed at Russia's national infatuation with a person whom the national cultural canon of the country's aesthetic regime describes as the country's "greatest" poet: Aleksandr Sergeevich Pushkin. Baklazhan is continually ridiculed as an Ethiopian (Efiop) and a cannibal. They call him *liudoed* (cannibal), which may be a pun, one degree removed, on Pushkin's Ethiopian great-grandfather's name, Gannibal" (Weinhold, 131, in Further Reading).

20 See Birgit Beumers, *"Brother,"* in *The Russian Cinema Reader. Volume 2*, 265–66; Weinhold, *Path of Blood*, 126–27.

21 Nancy Condee, *"Stoker (Kochegar, 2010),"* *Kinokultura* 32 (2011), accessed December 15, 2017, http://www.kinokultura.com/2011/32r-kochegar.shtml#1.

22 Kuvshinova, 135, in Further Reading.

comments sarcastically on the beauty of the famous cathedral and the piety it presumably represents. It is fitting, of course, that St. Basil's was commissioned by Ivan the Terrible to commemorate the taking of Kazan´ and the expansion of his empire after considerable bloodshed (Fig. 3).

Fig. 3. From Gangsters to Public Servants: *plus ça change, plus c'est la même chose.*

Weinhold points out that Aguzarova's perestroika-era song also "serves to highlight intertextual ties between *Dead Man's Bluff* and *Assa*," a late Soviet-era crime punk film by Sergei Solov´ev (1987).[23] The film's love triangle turns into a bloody conflict between the mafia boss Krymov (played by the Soviet-generation filmmaker Stanislav Govorukhin) and a young rock musician, Bananan (played by the 1980s rock star Sergei Bugaev). The romantic rebel perishes in the confrontation with the leader of the criminal status quo. Because of its soundtrack, which included the leading musicians of the decade, *Assa* became a cult film of Gorbachev perestroika, one of the symbols of new values and social change. Appearing seventeen years later in a dark comedy, "Wonderland" serves not only as a sardonic aural comment on the horrors depicted previously in the film, but also as a statement on the nation's inability to change.

Aleksandr Prokhorov

[23] Weinhold, 127, in Further Reading.

Further Reading

Artamonov, A., and V. Stepanov, eds. *Balabanov. Perekrestki. Po materialam pervykh Balabanovskikh chtenii*. St. Petersburg: Seans, 2017.

Balabanov, Aleksei. *Gruz 200 i drugie kinostsenarii*. St. Petersburg: Seans-Amfora, 2007.

Condee, Nancy. *The Imperial Trace: Recent Russian Cinema*. Oxford: Oxford University Press, 2009. See in particular pp. 217–36.

Dolin, Anton. "Zhmurki kak gipertekst." In *Balabanov. Perekrestki. Po materialam pervykh Balabanovskikh chtenii*, edited by A. Artamonov and V. Stepanov, 23–36. St. Petersburg: Seans, 2017.

Kuvshinova, Mariia. *Balabanov*. St. Petersburg: Masterskaia "Seans," 2015.

Seckler, Dawn. "Dead Man's Bluff (*Zhmurki*, 2005)." *Kinokultura* 10 (2005). Accessed December 23, 2017. http://www.kinokultura.com/october05.html.

Weinhold, Florian. *Path of Blood. The Post-Soviet Gangster, His Mistress and Their Others in Aleksei Balabanov's Genre Films. Seattle, WA:* CreateSpace Independent Publishing Platform, 2013. See in particular pp. 115–38.

THE SUN

Solntse

2005

106 minutes

Director and Cinematography: Aleksandr Sokurov

Screenplay: Yury Arabov;

English dialogue: Jeremy Noble

Music: Andrei Sigle

Art Design: Elena Zhukova, Yury Kuper

Sound: Vladimir Persov

Production Companies: Nikola-Film, Proline Film, Downtown
 Pictures, Mast Productions, Riforma Films, Rai Cinema, Lenfilm

Cast: Issei Ogata (Emperor Hirohito), Robert Dawson
 (General MacArthur), Kaori Momoi (Empress Nagako),
 Georgy Pitskhelauri (translator), Shirō Sano
 (Majordomo)

With more than sixty movies to date, Aleksandr Sokurov is among the most prolific and provocative film directors of the past forty years and one of few living Russian filmmakers acknowledged by the rarefied world of the European art cinema as an *auteur*. Due to his intricate aesthetics and original worldview, Sokurov is often referred to as the heir of the great Soviet director Andrei Tarkovsky, a view Tarkovsky shared in one of his last interviews before his untimely death in 1986 while in self-imposed exile in Paris.[1]

[1] Anna Lawton, *Kinoglasnost: Soviet Cinema in Our Time* (Cambridge: Cambridge

Tarkovsky's work clearly influenced the stylistics of Sokurov's early films, a debt Sokurov acknowledged in his 1988 tribute to his mentor, *Moscow Elegy* (*Moskovskaia elegiia*), a documentary that was poorly received by the Soviet cinema establishment, even though the glasnost' era was well underway.[2]

Sokurov's *oeuvre* is, however, much more "difficult" for viewers (and critics) than Tarkovsky's and defiantly so. Sokurov seeks to destabilize all cinematic conventions, and he delights in confounding audiences, whose aesthetic values (including a marked fondness for stories with emotional resonance) he holds in open contempt.[3] As an artist, he does not condescend to "speak" to the people through his films and is thus possibly the most profoundly anti-Soviet of all Russian directors who made movies in the Soviet period. The challenge of this essay is, therefore, to try in relatively few pages to shed light on a director and an opus that resist simple explanations.[4] To do so, I have selected what I consider to be his most accessible film, *The Sun* (*Solntse*, 2005), a characteristically confounding portrait of the Shōwa Emperor Hirohito at the end of World War II, which is a somewhat familiar historical subject. *The Sun* is much

University Press, 1992), 132. This seminal book has been reprinted as *Before the Fall: Soviet Cinema in the Gorbachev Years* (Washington, DC: New Academia Publishing, 2004). Birgit Beumers also refers to Sokurov (and Andrei Zviagintsev) as "heirs to Tarkovsky" in her *History of Russian Cinema* (New York: Berg, 2009), 250.

2 Lawton, *Kinoglasnost*, 132–33. Sokurov argued that other Russian directors envied Tarkovsky's greater talent, a sentiment that did not endear Sokurov to his peers.

3 I witnessed this firsthand in 1989 at the Cleveland Cinematheque, where Sokurov had been invited to present his baffling rendition of Gustav Flaubert's *Madame Bovary* (*Save and Protect / Spasi i sokhrani*, 1989) as part of a glasnost' film festival and conference co-sponsored by John Carroll University. Within the first thirty minutes, local audience members began fleeing, and by the time the film was over, only conference participants remained. Sokurov launched into an attack on American "philistinism" so blistering (and obscene) that his interpreter did not translate much of it.

4 There is little Sokurov scholarship in English, mostly directed to a highly specialized academic readership; see titles in Further Reading.

easier for the non-specialist viewer to follow than most of Sokurov's other films, yet its dominant motifs are quite representative of the director's long-standing emphasis on individual isolation, the ephemeral nature and fragility of power, and the deconstruction of historical truisms.

Who is Aleksandr Sokurov?

Before turning to an explication of *The Sun*, however, it is important to discuss briefly Sokurov's biography and career. He is in many ways the most personal of Russian directors, but because he refuses to explain himself and his work, his motivations for the kinds of films he makes have been the subject of much speculation. Regardless of the genre he chooses—historical, literary adaptation, post-apocalyptic, documentary, fictional drama—Sokurov is obsessed with depicting individuals who seem merely to exist (passive, alienated, and isolated) in a world of desolate, depopulated landscapes and dark, blank interiors. What clues to this bleak worldview may be found in his own life?

Sokurov was born in 1951 in a village near Irkutsk, Siberia.[5] Given his preoccupation with featureless spaces, it seems a cosmic irony that this village, Podorvikha, no longer exists, lost to a massive irrigation project.[6] He attended university, however, in the historic Volga River town of Nizhny Novgorod, made vivid in the writings of Maxim Gorky, its most famous native son, who is sometimes considered the father of Socialist Realism.[7] Might Sokurov have been rebelling against Gorky's legacy as his own artistic worldview was forming?

[5] Unless otherwise noted, biographical information on Sokurov is drawn from Peter Rollberg, "Sokurov, Aleksandr Nikolaevich," *Historical Dictionary of Russian and Soviet Cinema* (Lanham, MD: Scarecrow Press, 2009), 651–56.

[6] Jeremi Szaniawski, 1, in Further Reading.

[7] The city was renamed "Gorky" in honor of the writer in 1932; it reverted to its original name in 1990.

In any event, Sokurov majored in history, a heavily politicized subject in the USSR, especially as it concerned the nineteenth and the twentieth centuries. A central premise of this essay is that Sokurov's continued self-identification as an historian, coupled with his desire to write a new kind of history on film, has influenced many of his movies. Although he worked in television while earning his undergraduate diploma, he decided to take up film almost immediately after his graduation in 1974, and headed for Moscow where he studied at VGIK, the Soviet film institute in Moscow, successfully completing the director's program in 1978.

It became immediately clear that Sokurov's uncompromising personality and acute originality could not thrive in the Soviet system. His early work, mainly documentaries, was considered too downbeat, too contrary to be released. However, his first feature film, *A Man's Lonely Voice* (*Odinoky golos cheloveka*, 1978, released 1987), loosely based on the story *Potudan River* by Andrei Platonov, was shown privately to other directors, most notably Tarkovsky, who admired it considerably. This meant that even though Sokurov's films were not being screened publically, his reputation as a rising artist was nevertheless growing.[8]

One might expect that with Mikhail Gorbachev's ascension to power in 1985 and the introduction of glasnost' the following year, Sokurov's problems with persistent rejection would end. After all, glasnost' was supposed to encourage both creative freedom and freedom to question the status quo. To be sure, Sokurov's early shelved films were approved for release in 1987, yet a new picture, *Mournful Indifference* (*Skorbnoe beschuvstvie*, 1987), inspired by George Bernard Shaw's World War I play *Heartbreak House,* was briefly banned for its end-of-the-world negativism. When *Mournful Indifference* was released, Sokurov was forced for the first time to confront the unpleasant fact that it was not just the censors who did not like his work. The film played to largely empty theaters.[9] Of

8 Lawton, *Kinoglasnost,* 133–34.

9 Ibid., 227–28.

his last Soviet films, *Days of Eclipse* (*Dni zatmeniia*, 1988) fared best with critics, but like *Mournful Indifference,* it failed to find a paying audience. This became a recurring pattern that certainly deepened the director's penchant for ignoring the tastes of moviegoers.

Sokurov's story to this point is a sad, but familiar one in Soviet cultural history: a talented young man from the provinces, rejected for years by the arts establishment, learns after artistic and political "freedom" is finally at hand that his genius is appreciated by the tiniest of minorities, and therefore disdains public opinion and develops a cinematic fixation with outsiders and misfits.[10] It hardly seemed likely that he would survive the "apocalypse" to come: the end of the Soviet Union on December 25, 1991, which ushered in the full privatization of the Russian film industry and the collapse of a storied cinematic empire.[11] Directors now had to scramble for funds, and films needed to turn a profit if Russian cinema were to continue. A director like Sokurov, who disdained everything "popular" or "commercial," seemed doomed to disappear (like many other talented Soviet artists) in the horrifying new world of gangster capitalism in the 1990s—except that he thrived.

Sokurov proved himself adept at cobbling together funds from disparate multinational sources; over the years he acquired enough admirers in West European arts circles with money or access to money to keep him in business. It helped, of course, that Sokurov was the master of the shoestring budget due to his aesthetic of minimalist sets, streamlined crews, and rejection of costly, big name actors. He continued to shoot documentaries in the 1990s and early

[10] There is another interpretation. It has long been rumored that Sokurov is homosexual, which he flatly denies. Some Western critics, most persistently Jeremi Szaniawski, argue that Sokurov's work can only be correctly understood though the lens of the director's alleged closeted homosexuality and that queer theory is, therefore, the most appropriate analytical tool for evaluating the films. For a demonstration, see Further Reading.

[11] The best account of Russian cinema in the chaotic 1990s can be found in Nancy Condee, *The Imperial Trace: Recent Russian Cinema* (Oxford: Oxford University Press, 2009), chap. 2. Condee also provides an interesting overview of Sokurov's films in chapter 6.

2000s, but also managed to direct fiction feature films with some regularity, notably on family themes: *The Second Circle* (Krug vtoroi, 1990), *Mother and Son* (Mat' i syn, 1997), and *Father and Son* (Otets i syn, 2003). These films screened regularly at international film festivals and occasionally won minor prizes, but distribution was generally limited to the European art house circuit.

Sokurov's Historical Turn[12]

Sokurov's "historical turn" is usually dated to 1999, with the release of *Moloch* (*Molokh*), the first film in his self-styled "tetralogy of power." This is somewhat misleading, given that his documentary films frequently dealt with the past and his fiction films sometimes employed newsreel footage or attempted to enhance historical verisimilitude through the use of non-professional actors.[13] Nevertheless, over the next five years, Sokurov focused on "history" with an intensity unusual even for him, completing three more major historical films: *Taurus* (*Telets*, 2001), *The Russian Ark* (*Russkii kovcheg*, 2002), and *The Sun* (*Solntse*, 2005). After a long and frustrating hiatus, *Faust*, his retelling of Johann Wolfgang von Goethe's tragedy, finally appeared in 2011, completing the "power" series that began with *Moloch*.

 The Russian Ark, which is not part of Sokurov's ambitious tetralogy, is the best known of these films in the US and the only one to play the national art film circuit (as opposed to just being screened in New York and Los Angeles). Its relative popularity (for a Sokurov film) stemmed largely from the technical virtuosity of its single take as well as from its sumptuous location, St. Petersburg's

12 Some of the ideas in this section were first developed in my article, "A Day in the Life: Historical Representation in Sokurov's 'Power' Tetralogy," in Birgit Beumers and Nancy Condee, 123–37, in Further Reading. See also Stephen Hutchings, "History, Alienation and the (Failed) Cinema of Embodiment: Sokurov's Tetralogy," in Beumers and Condee, 138–52, in Further Reading for a literary scholar's interpretation of the same films.

13 Lawton, *Kinoglasnost*, 134–35.

stunning Hermitage Museum, formerly the imperial Winter Palace.[14] Sokurov's singular interpretation of Russian history from Peter the Great to the eve of the Revolution deserves more attention from historians than it has received to date, but given the film's lush beauty, in such sharp contrast to Sokurov's other films, it is quite understandable that the *Russian Ark*'s rich imagery received so many accolades.

The other four films — *Moloch*, *Taurus*, *The Sun*, and *Faust* — are more "Sokurovian" in the ways they confound viewers' expectations for the historical film genre. The first three films, which Peter Rollberg terms "anti-biopics,"[15] take the twentieth-century autocrats Adolf Hitler, Vladimir Lenin, and Emperor Hirohito and display them not as powerful leaders, but as pathetic and vulnerable little men. For example, Hitler is portrayed as a sickly neurotic mocked by his vapid mistress, Eva Braun; Lenin, probably after his second, disabling stroke, when he is fairly, although not totally, helpless; Hirohito, alone with his trembling servants to face the mockery of the invading Americans at the end of the war. The final film in the tetralogy, *Faust*, is especially vexing because, like the other films, if it is meant to be an "anti-biopic," here the central character is a *fictional* scientist deranged by his lust for knowledge. This film is only "historical" in the sense that it is set in an exceptionally dark and grimy "pre-enlightened" eighteenth century. (Sokurov apparently rejects the acquisition of scientific knowledge as a step on the road to enlightenment.)

Whatever Sokurov's aspirations were for *Faust* as the culmination and universalization of his message about the futility (and dangers) of seeking power, in my opinion they were not achieved. His message is too obvious and trite to bear the weight of four long productions. The first three films, however, form a coherent *trilogy* that represents a unique and largely successful experiment in historical filmmaking. In *Moloch*, *Taurus*, and *The*

[14] For a detailed analysis of the film's aesthetics and reception, see Birgit Beumers, *Alexander Sokurov: Russian Ark* (Bristol: Intellect, 2016).

[15] Rollberg, "Sokurov," 654.

Sun, we see Sokurov attempting to create fully "postmodern" historical films that break with previous conventions of historical moviemaking in order to comment on their validity.

By way of definition, the "modern" (mid-twentieth century) historical filmmaker either consciously or subconsciously *presents* "real" people and events in a coherent narrative that generally aims for factual accuracy, while still allowing for some degree of "artistic license," such as deviations from the historical record that usually include inventing characters and compressing time to heighten drama. In sharp contrast, the postmodern historical filmmaker believes that "history" cannot be revealed through painstaking research. Rather, history is a cultural construct that is *represented*, not a "truth" that is *presented*. According to the theories of Hayden White, a prominent philosopher of literature and history, postmodern history "de-fetishizes" historical events and people by acknowledging that "realistic" presentation of them is, in the end, impossible and therefore a fiction.[16] White argues, therefore, that imagination does and should play an important role in historical discourse.

Not surprisingly, few academic historians (who mainly write books and tend to believe in facts) have fully embraced White's ideas about postmodern history. However, White's historical postmodernism *has* been practiced in film, whether filmmakers knew it or not (and I am certainly not suggesting that Sokurov has ever heard of White). The scholar who has written the most about the application of this theory to cinema is Robert Rosenstone, a historian who has also served as historical consultant on Hollywood films, notably Warren Beatty's *Reds* (1981). Rosenstone has articulated eleven characteristics of the postmodern historical movie, seven of

[16] This is an extreme simplification of some very complicated ideas. See Hayden White, "Historiography and Historiophoty," *American Historical Review* 93, no. 5 (1988): 1193–99 and White, "The Modernist Event," in Vivian Sobchack, ed., *The Persistence of History: Cinema, Television, and the Modern Event* (New York: Routledge, 1996), 17–38. Although White employs the terms "modernist" and "postmodern" interchangeably, I prefer the latter to avoid confusion between "modernist" and "modern."

which are found in Sokurov's films. The Rosenstonian postmodern markers that abound in Sokurov's "anti-biopics" include: rejection of narrative and "normal story development"; foregrounding of "irreverent attitudes" about the past; the deliberate insertion of contradictions; obvious "partialism [and] partisanship"; refusal to "focus or sum up the meaning of past events"; liberal use of alteration and invention; and an emphasis on the fragmentary and poetic.[17] To offer a few examples from the anti-biopics, in *Moloch*, *Taurus*, and *The Sun*, Sokurov ignores key historical events or relegates them to the background while foregrounding trivialities; undermines the putative "greatness" of his protagonists; muddies chronology; willfully invents and alters chronology when it is completely unnecessary to do so; deliberately renders events less dramatic than they actually were (or vice versa), and so on. Sokurov is quite intentional in his engagement with these postmodern markers. This is not because Sokurov does not know any better. In each film, it is clear through his inclusion of esoteric details that he *has* conducted extensive historical research but deliberately chose to jettison most of it. In none of the three films is the postmodern historical method displayed more extravagantly than in *The Sun*, to which we turn at last.

The Sun[18]

The Sun is set in Tokyo in the waning months of Emperor Hirohito's "divinity," from Japan's surrender on August 15, 1945, to Hirohito's meeting with General Douglas MacArthur on September 27, 1945, to the Emperor's renunciation of his divinity on January 1, 1946. In Sokurov's rendering, these nearly five months are condensed

[17] This list is paraphrased from Robert Rosenstone, "The Future of the Past: Film and the Beginnings of Postmodern History," in Sobchack, *The Persistence of History*, 206.

[18] According to Japanese mythology, the imperial dynasty descended from the sun goddess. For a very different analysis of *The Sun* as "iconoclastic humanism," see Szaniawski, chap. 13, in Further Reading.

into what seems to be a two or three day period, with Hirohito deciding to renounce godhood immediately after having dinner with MacArthur. Events that other historians consider central to this story mainly go unmentioned, although Sokurov does hint at the devastation in Tokyo caused by Allied "carpet bombing" of the city, which Hirohito sees (apparently for the first time) as he is being driven to meet MacArthur.

Unlike *Moloch* and *Taurus*, which display their protagonists muddling through a single uneventful day, *The Sun* offers viewers the solace of a simple narrative. Hirohito listens impatiently to his cabinet ministers' dire prognostications about the war; he meets twice with MacArthur; he decides to bend to the will of the victorious foe by "resigning" as a god. None of this seems to faze Sokurov's Hirohito much, which is a key to unlocking the director's messages.

The "real" Hirohito (by that I mean the person reflected in the historical record) was quite cosmopolitan for a Japanese emperor: he had traveled to the West, he liked to dress in Western clothes, and he knew Western languages, including English.[19] He took an active role in Japanese political life in the 1930s, albeit behind the scenes. Sokurov's Hirohito is depicted quite differently: as a fragile, isolated man-child, entombed in the bunker beneath his laboratory, and separated from his wife and children who have been evacuated away from the capital. In his "war room" (Fig. 1), this Hirohito is an outsider to whom no one speaks the truth about the calamity (although there is a squabble about the cowardice and technological backwardness of the Japanese navy). Sokurov's Hirohito is much more concerned about his amateur scientific work as a marine biologist and his avocation as a poet, the latter in the tradition of his grandfather, the Meiji Emperor.

[19] Much has been written about the "real" Hirohito. For biographical details, I have relied on Stephen Large, *Emperor Hirohito and Showa Japan: A Political Biography* (London: Routledge, 1992) and Herbert P. Bix, *Hirohito and the Making of Modern Japan* (New York: HarperCollins, 2000).

Fig. 1. Hirohito as Supreme Commander in his bunker war room.

Sokurov has done his homework. Hirohito *was* a serious student of marine life, with a few discoveries to his name; he also wrote haiku. Sokurov has, however, chosen to focus quite selectively and partially on the "good" emperor as a passive intellectual, ignoring the evidence of the Hirohito who was actively engaged in his country's political and military life. The only hint we receive of that other Hirohito is that Sokurov's camera lingers on the bust of Napoleon that actually was on the emperor's desk, before showing Sokurov's Hirohito furtively hiding it in a drawer, fearing it would make a bad impression on the Americans.[20]

Sokurov's view of Hirohito is that being emperor has enfeebled, not empowered, him. The emperor has been robbed of individual agency by a cruel, cosmic accident, his birth order in the Japanese

[20]　Hirohito was also known to keep busts of Charles Darwin and Abraham Lincoln, which Sokurov shows us. Historian Stephen Large sees the three busts as reflecting the emperor's longstanding interest in science and history (Large, *Emperor Hirohito*, 19), but there is debate about *when* Lincoln joined Darwin and Napoleon on Hirohito's desk. If it was only after American victory was assured, then it could be construed as a political ploy, not as an expression of genuine interest in the president's democratic ideals.

imperial dynasty. This assessment is reinforced by the film's glacial pace, particularly in the first half. Hirohito moves so slowly, regardless of whether he is examining his dissecting tools or turning the pages of a photo album, that he seems frozen in time. How could such a man possibly be held responsible for the deaths of thirty million Chinese in the war?

Sokurov also takes great pains to emphasize the unnaturalness of the emperor's relations with other human beings. Hirohito, whose mouth expressions resemble a fish struggling for air, is more comfortable with marine creatures like his (dead) hermit crab than with people. His servants tremble in his divine presence, particularly the old man who dresses him in the morning. The distinguished scientist brought to the laboratory to answer Hirohito's question about whether the Northern Lights can be observed in Japan is terrified by its very absurdity, especially since the assertion came first from Hirohito's even more sacred grandfather, the Meiji Emperor. Hirohito does, however, have the sense to be concerned that the professor might be shaking because he is hungry—so he orders a servant to bring the poor man a Hershey chocolate bar from a stash that American soldiers have delivered.

Hirohito expects this deference, however, and is visibly shocked if he does not receive it. When he travels to the American Embassy to meet MacArthur, he is taken aback at the lack of interest the American soldiers pay him. He has to open a door himself, and for a few painful seconds, the viewer wonders if he even knows how to perform this simple act. When Hirohito tries to be obliging to Allied photographers who want to take his picture beside his rosebushes and cranes, he looks so ridiculous in his top hat, striped pants, and fake smile that they dub him Charlie Chaplin, which seems to please him. (We have seen him earlier studying a portrait of Chaplin in his photo album.) However, the most awkward interaction of all occurs near the end of the film when he is reunited with his wife. Their strained smiles and stiff embrace serve as a vivid testament to the artificiality of their relationship. The empress is not sure what to do when he lays his head on her shoulder.

Hirohito's two meetings with MacArthur, supreme commander of the allied forces in Japan, constitute the political and psychological

core of *The Sun*. Sokurov's MacArthur is in appearance and manner very like the "real" man: an exemplar of US military might, imposing in stature (at least next to the diminutive Hirohito), forceful in presence, blunt in language. This is not to say that Sokurov does not take liberties with the historical record, in this case MacArthur's own account of his reaction to Hirohito, which the general reported to be favorable. In the film, Sokurov's MacArthur is annoyed by everything related to Hirohito: his small stature, soft voice, ridiculous attire, *femininity*. For the victorious general, this slight, timid person is not a worthy foe and cannot *represent* a worthy foe. In this case, Sokurov's version is much more believable than MacArthur's in the context of everything we know about the general; every good historian understands the unreliability of eye-witness reports and the importance of skepticism when evaluating them.

At the initial meeting, MacArthur reveals his contempt of Hirohito more through his bemused facial expressions and sarcastic tone of voice than his actual words. His bizarre personal questions to Hirohito upset the Japanese-American GI interpreter Okumura Katsuzo so much that he stops translating them. ("Why aren't you wearing a kimono?" "How are the emperor's children?" "What have you done recently?")[21] Hirohito gamely tries to answer in English, which upsets Katsuzo even more, leading him to dare to instruct the emperor to speak Japanese only in order to preserve his imperial dignity—and the dignity of the entire Japanese nation.

At their next meeting, which may be "that evening" or the evening of the next day (Sokurov deliberately obscures the time frame), MacArthur's hostility is on open display. The two leaders are dining *à deux* in an elegant room in the embassy. MacArthur offers Hirohito a Havana cigar, which he initially refuses because he does not smoke. MacArthur's smirk at Hirohito's response (of course this person has no manly habits) provokes the emperor into changing his mind, with predictable results, although Hirohito gamely controls his coughing when he inhales the unfamiliar smoke.

[21] Of course, a more benign interpretation is that these questions represent MacArthur's awkward efforts at conversational "ice-breakers."

Fig. 2. Hirohito, again isolated, at the dining table at the American Embassy.

The conversation quickly becomes political, with MacArthur grilling Hirohito on his rationale for allying with the emperor's "best friend" Hitler. Hirohito sidesteps maladroitly by explaining that they were not friends and that he never even met Hitler, which causes MacArthur to explode in angry disbelief that Hirohito would ally himself with a man he did not know. Hirohito makes another major verbal misstep when he explains to MacArthur that his family has been moved to safety far from Tokyo to protect them from "atrocities." When MacArthur demands that Hirohito explain what he means, the emperor whispers, "Hiroshima." MacArthur, who cannot let Hirohito imply that dropping an atomic bomb on Hiroshima was unjust, reminds the emperor about Japan's unprovoked attack on the US naval base at Pearl Harbor. Sokurov's Hirohito quickly denies that he knew anything about it, which is almost certainly not true.

Throughout these tense verbal exchanges, MacArthur makes plain his mastery over the emperor through his domination of the space. The general walks freely through the room as the emperor sits meekly at the table (Fig. 2), and then abruptly leaves "on an urgent matter," interrupting the emperor in mid-sentence. Then, in a particularly interesting development, MacArthur can be seen

spying on Hirohito through a half-open door. What will the little man do in MacArthur's absence? At first, nothing—then Hirohito wanders around inspecting objects, doing a little dance, before finally snuffing out the candles that light the room, rather obvious symbolism for the "snuffing out" of any hopes of real dialogue between two men who represent cultures that could hardly have less in common.

On MacArthur's return, he pointedly takes a seat *behind* the emperor; who has turned his back on whom? Here MacArthur launches into the real reason for the dinner invitation: the Americans want Hirohito to "come out" as an ordinary human, to renounce the myth of divinity that supported the Chrysanthemum Throne for more than two millennia. Sokurov, speaking through MacArthur, frames this very interestingly as a "betrayal": "If you betray your country, I won't make you do anything. I won't insist on anything." (The choice of words here is surprising; why "betrayal"?) Sokurov's Hirohito makes the decision to do so very quickly, although the real Hirohito agonized for some months, until January 1, 1946.

The Sun's Hirohito keeps his qualms to himself. We do not hear the words of this historic radio address, but meet up with the emperor again after the announcement has been taped. He seems almost giddy as he informs the startled empress. As the film ends, and Hirohito and his wife enter human history, he turns to his majordomo to ask if it is true that the young man who recorded the address committed ritual suicide.[22] When informed that it is true, Hirohito sternly asks the servant if he tried to prevent the suicide; the answer is a quick, confident "no," the implication obviously being "how could you ask such a stupid question?" Hirohito looks solemn for a fleeting moment, as if pondering the meaning of this seemingly unnecessary death, but when the empress tugs at him, he scampers off, leaving the question of his responsibility for this tragedy, like millions of other wartime deaths, behind him. Sokurov obviously wants audiences to understand this escape from

[22] I could not confirm whether this actually happened. The subtitles to the Artificial Eye DVD of *The Sun* translate the act as *hara-kiri.*

responsibility as Hirohito's victory as a human being, but surely, there are other, darker conclusions to be drawn.

Throughout *The Sun*, Sokurov studiously ignores the violence and terror of the war in the Pacific against civilians, whether Japanese citizens or those peoples oppressed by the Japanese. As noted above, there are fleeting shots of the destruction of *buildings* in Tokyo, and even more fleeting shots of desperate survivors rummaging in the rubble. The emperor also has a phantasmagoric nightmare about the incessant nighttime bombing of the city; however, there is not a hint about the savagery of the empire Hirohito ruled, in which millions of Asian civilians died in the most brutal circumstances— *not a single hint.* Sokurov's failure to mention the cruelty of Hitler's and Lenin's regimes is a hallmark of *Moloch* and *Taurus* as well. The clear implication is that we are to see these men as pitiful and ineffectual. They were not.

Indeed, Sokurov takes pains to present Hirohito's transgressions as almost comical, as those of the poor little rich kid who cannot reasonably be expected to empathize with others. As noted above, when Hirohito suspects that the professor may be about to faint from hunger, he offers him a Hershey bar. How ridiculous. A different interpretation that removes the onus of a "let them eat cake" attitude from the emperor could be that these empty calories are a *gift from MacArthur*, which means that the Americans—not Hirohito—are the ones failing to feed the starving Japanese people properly. Likewise, when Hirohito sees the devastation of his capital city from the comfortable interior of the American limousine escorting him to the American Embassy, it is as though he is watching a movie that has no connection to him at all; he presses his face to the window in wonderment. This is little different from his curious expression as he examines a reproduction of Albrecht Dürer's 1498 woodcut "Four Horsemen of the Apocalypse" earlier in the film.[23] (Sokurov sees the connection, of course, but does the emperor?) And when Hirohito learns that the sound engineer who recorded his historic radio address has committed suicide from shame, any feeling that

[23] The horsemen represent Death, Famine, War, and Conquest; *Revelation* 6:1–8.

the emperor can summon for his unfortunate compatriot is as ephemeral as the winter snows and spring cherry blossoms (*sakura*) that Hirohito compared in his haiku. Is there any reason to believe that such a man can ever become "human"?

The Anti-Biopics as History

By making Hirohito childlike, Sokurov tries to remold a remote and complicated historical personage into a sympathetic character to whom we can relate, an effort that I find objectionable on historical and moral grounds. Here I am straying into dangerous territory for the historian, if not for the filmmaker. In the Rankean tradition of "objective" history that dominated Western historiography from the late nineteenth to late twentieth centuries, historians attempt as scrupulously as possible to research the historical record thoroughly, present representative (not selective) evidence, and avoid even the insinuation of value judgment. According to this method, it is not necessary to announce that Hitler (or Stalin) is a "monster"; the weight of the atrocities undertaken in his name and with his knowledge make this kind of labeling completely unnecessary.

While postmodern historians agree that moralizing is antithetical to the historical project, they disagree that historical objectivity is necessary or even possible. Therefore, the partiality that Sokurov demonstrates toward Hirohito (Fig. 3), and his omission of all details that might cause a viewer to disagree with his view of the emperor as a powerless actor in World War II, is accepted as a legitimate, even *preferable*, way to represent the past. It is preferable because Sokurov openly reveals his pro-Hirohito biases rather than disguising them in a cloud of false "objectivity." For a postmodern historian, there are no sins of omission and selectivity because no matter how diligent the researcher, no one can claim to present all of the evidence. As a result, there are multiple historical "truths," not a dominant Truth, and Sokurov has shown one possibly legitimate version of this pivotal period in Japanese history in *The Sun*. That most academic historians (at least in the West) do not agree that Hirohito was a naïve and passive observer of the terrible events in East Asia in the 1930s is irrelevant to this perspective.

Fig. 3. This poster for *The Sun* demonstrates Sokurov's pro-Hirohito bias brilliantly.

Whether or not the real Hirohito actually reclaimed the humanity his position denied him by renouncing his putative divinity is also beside the point as far as Sokurov is concerned. In each of the anti-biopics, he seeks to take a major twentieth-century figure and "de-fetishize" him. After receiving the Sokurov treatment in *Moloch* and *Taurus*, Hitler and Lenin can no longer inspire anyone to anything—good or evil. They are too pathetic. Hirohito is different because he was never a leader in the same public sense as Hitler and Lenin; he never stood on a stage exhorting the masses to take action on behalf of an ideology or cause. Never truly wielding power (at least according to Sokurov), Hirohito only symbolized it. Given that Sokurov believes power is a false (and flimsy) god, the emperor's renunciation of the divinity he never actually possessed was the best, and perhaps only, gift he could bestow upon his people.

Sokurov's most significant goal as a postmodern historian is to challenge what traditional historians find "important." These three men are not "important," the films seem to argue, nor are their ideas or deeds. Their coteries are likewise composed of nonentities. In *Moloch*, at least Eva Braun, Josef and Magda Goebbels, and Martin Bormann are recognizable; the same goes for Nadezhda Krupskaya (Lenin's wife) and Stalin in *Taurus*. In *The Sun*, however, Hirohito's

entourage is totally anonymous, taking Sokurov's disdain for the historian's love of specificity to new extremes. What about their opponents? Sokurov's Hitler has none; his Lenin, only a shadowy Stalin. In *The Sun*, the director allows his protagonist a foil, but what does MacArthur actually *do* besides bully a man almost half his size?

Sokurov also takes issue with historians' obsession with dates and chronology, an obsession that he mocks by populating his sets with loudly ticking clocks. In *Moloch*, the Führer and his entourage watch a newsreel about the German victory at Voronezh, which dates the scene to July 1942 (but the viewer must know the battle history of the Eastern Front to figure this out). Sokurov has more fun muddling the chronology in *Taurus*, showing Lenin, still speaking and walking, at his dacha in Gorky,[24] to which he was not actually moved until May 1923 when he was essentially incapacitated. The chronological disruption in *The Sun* is also uncomfortably compressed, as already mentioned: at one moment, the emperor and his cabinet are discussing possible surrender, then the war is over, MacArthur arrives, and Hirohito tapes his radio address. Sokurov can afford to reject the chronology and dates so loved by historians because he is completely uninterested in the concept of historical causation. Given the director's worldview, his disinterest makes perfect sense: if "big events" hold no importance, then why do we need to understand what caused them?

Through his anti-biopics, Sokurov creates a deliberately defined position for himself as a historian-provocateur. The value to this approach comes not from "evidence" or "analysis"; Sokurov's views on Hitler, Lenin, and Hirohito are as superficial as they are supercilious. What matters in the end are the myriad ways he shakes up viewer expectations not just about genre or history, but also about cinema as an art. Sokurov does not court passive moviegoers for good reason.

[24] This village near Moscow should not be confused with Nizhny Novgorod, which was called Gorky when Sokurov was studying at the university there.

Is Sokurov "Tarkovsky's Heir"?—or, Sokurov's Place in Cinema

Sokurov is emphatically *not* Tarkovsky's heir, superficial similarities in their Soviet-era creative biographies and their cinematic style notwithstanding.[25] Tarkovsky was a humanist in the great tradition of the Russian *intelligentsia* and Russian literary realism, even though he eschewed stylistic realism after *Andrei Rublev*. Revealing the director's profound knowledge of Russian and European arts and ideas, Tarkovsky's deeply spiritual films engage the human condition head on, critically but empathetically. Sokurov, in sharp contrast, is a nihilist and contrarian, the perennially disgruntled outsider from the provinces. Although he was born only fourteen years after Tarkovsky in the middle of the twentieth century, Sokurov is best understood as a *twenty-first-century* prophet who completely rejects the possibility of human progress. For Sokurov, the past, present, and future are equally bleak, as illustrated by his protagonists, who lead lives so devoid of meaning that they cannot even be dignified as "anti-heroes."

Nowhere is Sokurov's dispiriting worldview clearer than in his historical films. For four decades, Sokurov has told us through his films that universal truths are an illusion, a sop for lesser mortals who cannot face the black void of human existence. His *oeuvre* also strongly suggests that belief in knowledge and valuing its pursuit are likewise illusions for the weak-minded. Therefore, Sokurov's highly selective and distorted version of Hirohito in *The Sun* is, in his view, as valid (and valuable) as anybody else's—probably better, because at least Sokurov does not pretend that facts matter or that truth is something to aspire to. Sokurov, whose films stand as a monument to human futility, is truly a director uniquely suited to reflect our troubled times.

Denise J. Youngblood

[25] Szaniawski agrees, see Szaniawski, 5, in Further Reading.

Further Reading

Beumers, Birgit, and Nancy Condee, eds. *The Cinema of Alexander Sokurov.* London: I. B. Tauris, 2011.

Szaniawski, Jeremi. *The Cinema of Alexander Sokurov: Figures of Paradox.* London: Wallflower Press, 2014.

CARGO 200

Gruz 200

2007

89 minutes

Director: Aleksei Balabanov

Screenplay: Aleksei Balabanov

Cinematography: Aleksandr Simonov

Art Design: Pavel Parkhomenko

Sound: Mikhail Nikolaev

Producer: Sergei Sel´ianov

Production Company: STV Film Company

Cast: Agniia Kuznetsova (Angelika), Aleksei Poluian (Zhurov),
 Leonid Gromov (Artem Kazakov), Aleksei Serebriakov (Aleksei),
 Leonid Bichevin (Valera), Natal´ia Akimova (Antonina),
 Iury Stepanov (Mikhail Kazakov), Valentina Andriukova
 (Zhurov's mother), Mikhail Skriabin (Sun´ka), Aleksandr Bashirov
 (the drunk)

If not the best Russian film of 2007, Balabanov's *Cargo 200* was
certainly its most controversial.[1] At its first public screening at
the 2007 Kinotavr Film Festival in Sochi, critics were split, in

[1] After they read the script, well-known actors Yevgeny Mironov and Sergei
 Makovitsky refused to appear in the film. Yury Loza announced publicly that
 if he had known what kind of film Balabanov was making, he would have
 refused the rights to his song "My Raft." (Oleg Sul'kin, in Further Reading).
 See Alexander Prokhorov's introduction to *Dead Man's Bluff* in this volume for
 information on Balabanov and his other films.

the words of Seth Graham, "over the question of whether it was a mature virtuoso's masterpiece or an irresponsible act of celluloid hooliganism."[2] Theater owners were reluctant to book it and for many viewers the psychological tension, graphic sexual torture, and increasing sense of madness, claustrophobia, and hopelessness make the film almost impossible to watch to the end. Still, for those who could stomach its violence, perversity, and pathologies, *Cargo 200* is probably Balabanov's most significant achievement: a visually striking and emotionally powerful film that speaks to the Soviet past as well as to post-Soviet reality. Although Russian cinema of the late 1980s and 1990s reveled in depicting the horrors of Soviet and post-Soviet life, such films had become exceedingly rare in following decades. Perhaps not since Aleksei German's *Khrustalev, My Car!* (*Khrustalev, mashinu!*, 1998) has a Russian movie depicted the social squalor, criminality, and sexual and psychological torture of everyday life in the Soviet Union as darkly and as powerfully. Building on this tradition of so-called *chernukha* films,[3] Balabanov created a kind of Soviet Gothic, a shocking and shattering look at Soviet life guaranteed to horrify all but the most jaded film viewers. The film represents Soviet society circa 1984 as the poisonous wreck of an industrial civilization tottering on the verge of collapse from the sum of its vices: a pointless foreign war, a terrorized and infantilized populace, a corrupt police force, rampant alcohol abuse, a geriatric and out of touch government, a dismal and hypocritical popular culture, an arrogant and cynical intelligentsia,

[2] Nevertheless, the film received an award from the Guild of Russian Film Critics at Kinotavr and was screened at numerous international film festivals, including Venice, Rotterdam, and Hong Kong. See Seth Graham, "Fade to Black," in Further Reading.

[3] Defined by Seth Graham as literary or cinematic works "that emphasize the darkest, bleakest aspects of human life," *chernukha* implies an extreme naturalism, focusing on poverty, ugliness, physical and sexual violence, alcohol abuse, and the like. See Seth Graham, "Chernukha and Russian Film," in Further Reading. As a film genre, it was initiated by Vasily Pichul's 1988 *Little Vera*, which, despite its unremitting bleak treatment of contemporary Soviet life, had the highest gross of any Soviet film at the box office that year.

a nihilistic younger generation, and the soul-crushing hopelessness of everyday life for the masses.[4]

During the almost twenty-year rule of Communist Party Secretary Leonid Brezhnev (1964–82), with which the term "stagnation" is most closely associated, the Soviet Union experienced decreasing economic growth while becoming increasingly weighed down by bloated bureaucracies and pervasive corruption. Soviet individuals needed to hide their loss of faith in a better future as Soviet society lost all semblance of energy, dynamism, and optimism. When Brezhnev's immediate successor, Yury Andropov, the long-term chairman of the KGB who became Party Secretary in 1982 with a mandate to reform the Soviet economy, died suddenly in February 1984, he was replaced by an aging, ailing, and colorless Party bureaucrat, Konstantin Chernenko, who promptly abandoned all attempts at reform. For Balabanov, the Chernenko period represented the final stage of Brezhnev's "stagnation," as the political establishment seemed unable even to recognize, much less address, the multiple and festering dysfunctions of Soviet society. By the time Chernenko died in March 1985, barely thirteen months into his administration, the need for reform was so pressing that the Politburo chose the "radical" young reformer Mikhail Gorbachev as Party Secretary. Within months, Gorbachev launched a policy of glasnost' and perestroika (transparency and restructuring) that, after an initial period of optimism, would lead to social and political crises that culminated in the dissolution of the Soviet Union in 1991.

Beginning with a title announcing that the film is based on a true story,[5] *Cargo 200* depicts the intersecting fates of several families in provincial Russia in the late summer of 1984, during the brief and

4 The connections between individual sadism, sexual violence, and national pathology in connection with the Nazi legacy have been explored in films like Liliana Cavani's *The Night Porter* (Italy, 1974), Pier-Paolo Pasolini's *Salo, or the 120 Days of Sodom* (Italy, 1975), and Agusti Villaronga's *In a Glass Cage* (Spain, 1987). In the Soviet-Russian context, the most relevant movies are Aleksandr Rogozhkin's 1992 *Chekist* and Aleksei German's 1998 *Khrustalev, My Car!*

5 As we will see, this is not precisely true.

ill-starred Chernenko period. As the film opens, Artem Kazakov,[6] a professor of scientific atheism at Leningrad University, is traveling to visit his mother in the city of Leninsk.[7] On the way, he complains to his brother Misha, an army colonel in charge of the local recruitment center, that his college-age son Slavik spends his time partying (*vse tusuetsia*) and despises his parents. Slavik's alienation from his parents, it soon becomes apparent, is symptomatic of a larger breakdown of Soviet values in the 1980s. After being introduced to his niece's friend Valera, another representative of a younger generation that has rejected traditional Soviet values for a life of selfish hedonism, the professor continues his trip, but his car breaks down on the road. Forced to seek help at the only farmhouse in the vicinity, he comes across Aleksei, an illegal moonshiner,[8] his long-suffering wife Antonina, their Vietnamese hired hand Sun´ka, and the corrupt and sinister militia captain, Zhurov. As Sun´ka repairs the car, the professor and the moonshiner eat mushroom soup, drink vodka, and discuss the eternal questions: the existence of God and the soul, the relationship between matter and consciousness, Darwin's theory of evolution, the morality of the Communist Party, and the possibility of building a utopia in Russia. More than simply a peddler of illegal vodka, Aleksei is a fanatical opponent of Soviet-Marxist materialism, a well-read autodidact who not only knows Tommaso Campanella's 1602 utopian *City of the Sun* but is committed to making a utopia in his own little world. A competent debater, Aleksei is more than a match for the professor whose "arguments" never rise above familiar Marxist clichés.

[6] Although he refused to appear in the film, veteran actor Sergei Makovetsky voiced the character played by Leonid Gromov.

[7] Leninsk is actually Cherepovets, an industrial city located about 600 kilometers due east of St. Petersburg, where Russia's largest metallurgy factory and important chemical plants are still located.

[8] Short-lived anti-alcohol programs of the 1980s introduced by Andropov and Gorbachev resulted in increased prices, less alcoholic vodka, decreased hours for State liquor stores, and an increase in illegal vodka distilling by individuals.

His car repaired, an inebriated Artem slowly drives away as Valera and Angelika, the daughter of the local party secretary, drive up to Aleksei's home looking to buy vodka. But when Valera drinks himself under the table, Angelika is stranded overnight at the farmhouse, alone and defenseless. Although Antonina hides her and Sun´ka tries to protect her, the silent and watchful Zhurov finds her hiding in the bathhouse, kills Sun´ka and rapes Angelika with an empty vodka bottle.[9] The next morning, with Angelika handcuffed to the sidecar of his motorcycle (Fig. 1), the pair return to his squalid

Fig. 1. Zhurov and Angelika leave the scene of the crime.

apartment in Leninsk, which he shares with his unhinged alcoholic mother. Having watched the captain drive away with Angelika, Valera abandons her to her fate and disappears. With a simple anonymous call to the police, Zhurov instigates Aleksei's arrest for

9 Gregory Freidin sees here a reference to Svidrigailov's comments in Book 4 of Dostoevsky's *Crime and Punishment* that "eternity is nothing but a peasant bathhouse with cockroaches in every corner." See Gregory Freidin, in Further Reading.

Sun'ka's murder. After Artem refuses Antonina's request to testify in Aleksei's defense—the potential scandal could affect his party membership and university position—Aleksei is quickly tried, convicted, and executed for the murder committed by Zhurov. In the meantime, Zhurov announces to his inebriated mother that the girl now handcuffed to his bed is his wife.

The characterization of Zhurov is, typically for Balabanov, both horrifying and funny. More than simply a psychopathic corrupt cop who murders and rapes without compunction or emotion, Zhurov is also a dutiful son, would-be lover, and family man. Sincerely believing that the abused and captive Angelika is his wife, he tries in shocking and sick ways to make her happy and is genuinely pained by his failure to do so. Apparently impotent, Zhurov brings a drunk home from jail to have sex with Angelika while he watches. Her only response to the unimaginable horror is to drink herself into unconsciousness. Meanwhile, Zhurov's mother, drunk, oblivious and glued to a TV tuned to the worst kind of Soviet musical variety shows (*estrada*) and political speeches, periodically tries to befriend her new "daughter-in- law." Her willful blindness to the compulsion, violence, hypocrisy, and perversion that surround her corresponds to the blindness of many, then and now, to the horrors of life in the USSR.

Astonishingly, Zhurov is assigned the case of the party secretary's missing daughter and simultaneously asked to arrange for the burial of her fiancé, Sergeant Major Gorbunov, a local boy killed in Afghanistan. (His coffin is the "Cargo 200" referenced in the title.) At the local airport, Zhurov and his men take possession of the "cargo" offloaded from a military transport plane, while a squad of soldiers march into the hold of the same transport that will take them to Afghanistan and a war that we know will end in abject failure. As the inevitable paperwork is being completed and the plane taxies down the runway, a "demob" song (*dembel'skaia*), celebrating a soldier's discharge from the army, plays on the soundtrack. Going beyond a simple parody of the soldier's return home from war, Balabanov opts for grotesque horror as Zhurov's police officers dump Gorbunov's rotting corpse in Angelika's bed. Although Zhurov will eventually be punished, at the movie's end

Angelica will remain handcuffed to the bed, surrounded by the corpses of the men who "loved" her. In an epilogue of sorts, the film moves to Leningrad, where the professor of scientific atheism seems to have repented his cowardly refusal to help Aleksei and seeks to be baptized by a local parish priest. Also in Leningrad, Valera meets Slava, the professor's ne'er-do-well son, at a rock concert, and they make plans to go into business together trading vodka for furs from Siberia, as the screen goes dark and a title announces: "These events took place in the second half of 1984."

The characters of *Cargo 200* represent, in the words of Gregory Freidin, "eternal Russian types" who are organized into a symbolic portrait of the Russian people in the 1980s. For example, Artem and his brother Misha, the "fathers," embody a familiar type of late Soviet privileged conformist: corrupt, hypocritical, and intellectually quite limited, yet devoted to their families. The "sons" (Valera and Slava), on the other hand, represent the worst of a selfish and self-centered generation that lacks both personal courage and a moral or ethical compass. Lacking the agency of the male characters, the women of *Cargo 200* are victims of the brutality and corruption of late Soviet life: the innocent and naïve Angelika, the privileged daughter of the regional Party Secretary subjected to sexual slavery; Antonina, the

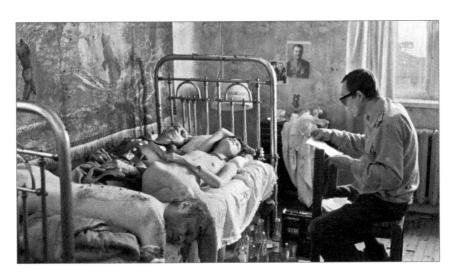

Fig. 2. Horror in Zhurov's bedroom.

embittered and powerless wife of Aleksei, who can neither combat the evildoers, nor protect the innocent; and Zhurov's demented mother, whose mind has been eroded by a steady diet of vodka and Soviet television. Both Aleksei and Zhurov, fanatical individualists who have gone far beyond the limits of acceptable behavior to create their own personal utopias, are characters straight out of a novel by Dostoevsky. Both share the "broad Russian nature" capable of the best and worst of which humans are capable. As Dmitry Karamazov puts it: "I can't endure the thought that a man of lofty mind and heart begins with the ideal of the Madonna and ends with the ideal of Sodom. What's still more awful is that a man with the ideal of Sodom in his soul does not renounce the ideal of the Madonna, and his heart may be on fire with that ideal, genuinely on fire, just as in his days of youth and innocence. Yes, man is broad, too broad."[10] What is true of them as individuals is equally true of Soviet society and history: the rotting corpse of Sergeant Gorbunov in Angelika's bed refers directly to the connection between the dream and the horror of the Soviet project (Fig. 2).

In addition to its brilliant visual reconstruction of provincial Russia in the last years of Soviet power, *Cargo 200* is remarkable for its tight plot construction, intense thematic focus, brilliant soundtrack, and the way Balabanov invests apparently ordinary objects, places, characters, and conversations with larger social and symbolic significance. In other words, everything seen on the screen or heard on the soundtrack contributes either to the film's plot or its themes. The clogged spark plugs of the underpowered *Zaporozhets* that Artem drives, the run-down and poorly furnished Soviet apartment where Zhurov lives with his mother, the dingy provincial youth club housed in a former church where Valera picks up Angelika, the clothing, hair styles, music and television broadcasts, and the giant chemical factory that blights the urban landscape—all recognizable aspects of Soviet reality of the 1980s— combine to form a symbolic image of a decrepit, morally empty, and hypocritical culture and

[10] Fyodor Dostoevsky, *The Brothers Karamazov*, translated by Constance Garnett (New York: The Lowell Press, 2009), 115.

Fig. 3. Artem explains to Antonina.

society on the verge of collapse. Even place names point to the historical context for the horrors of late Soviet life. For instance, the village where the crime wave begins, Kaliaevo, is named for the Socialist-Revolutionary poet-terrorist, Ivan Kaliaev, the assassin of Grand Duke Sergei Aleksandrovich, while Artem's mother and the Zhurovs live in the hellish industrial city of Leninsk. Indeed, nothing in the world of *Cargo 200* is random: ordinary conversations foreshadow future plot developments, apparently unrelated actions provide an ironic commentary on characters' moral dilemmas, and chance meetings determine characters' fates. Artem's automotive breakdown and religious conversion are foreshadowed in his first conversation with his brother; as Artem explains to Antonina that he cannot testify in court because of the possible scandal, a troop of young pioneers march past a poster proclaiming "Glory to the KPSS" (Fig. 3),[11] while a chance glance at a snapshot at the beginning of the film sets up the fateful meeting of Valera and Slava in the epilogue.

Like Andrei Tarkovsky, Aleksei German, and Andrei Zviagintsev, Balabanov builds his movies from the subtle and complex

[11] KPSS is the abbreviation for the Communist Party of the Soviet Union.

counterpoint between speech, image, action, and sound, using music to illuminate his heroes' inner lives and to locate the action in a specific historical moment. His earlier film *Brother*, for example, is inconceivable without the music of Viacheslav Butusov and Nautilus Pompilius. In addition to providing an important rhythmical accompaniment to the editing (for example, Danila Bagrov wandering through a rainy and grey Leningrad, or improvising weapons), their music also expresses Danila's vague desire for a kind of transcendence that he will never attain (e.g., *Kryl'ia / Wings*). Yet, the music for *Cargo 200* rises to a level of complexity not previously seen in Balabanov's films. The complex counterpoint between action and song in *Cargo 200* increases tension, deepens emotions, comments on characters' decisions and dilemmas, illuminates themes, and even foreshadows social developments. By associating pop songs with specific characters, Balabanov clarifies their individual choices and dilemmas, allowing the audience to understand them at a deeper level. On the most basic level, music in *Cargo 200* illuminates the distance between Soviet rhetoric and reality: after watching Angelika and Valera dance to a song about a cosmonaut looking back to earth and imagining the "green, green grass of home," we cannot help but notice how lofty dreams of conquering the universe and sentimental nostalgia about "home" are both deflated by the squalid reality of a dirty and dingy youth club built in the remains of a crumbling church. The song to which they dance, "The Grass of home" (*Trava u doma*) by the Earthlings (Zemliane), supposedly written to commemorate Cosmonauts Day in 1982, was regularly played as cosmonauts prepared to board the Soviet Space Shuttle and is still one of the most popular songs in Russia, having been used repeatedly in films, commercials, and an episode of a famous Soviet television animated children's show (*Just you wait!* [*Nu, pogodi!*]).[12]

[12] "The Green Grass of Home" was the official hymn of the Russian Space Program in 2009. See Zemliane's blog, accessed February 28, 2018, http:// zemlyane-group.livejournal.com/643.html.

Another popular song of the period sheds a harsh light on a character's moral cowardice: whenever the professor drives his car, we hear the song "In the Land of Magnolias" (*V kraiu magnolii*), a nostalgic pop song about the idyllic world of childhood, performed by the group Ariel. Hardly a carefree jaunt down memory lane, the professor's trip home has become a nightmare of violence, drunkenness, rape, and murder. In the context of his failure to share with the authorities his knowledge of Sun'ka's murder and Angelika's abduction, the song's lines about "the sweet voice of a bass guitar that troubles my memory" ("I sladkii golos bas-gitary / Trevozhit pamiat' moiu, nu i pust', nu i pust'") suggest the bad conscience that will eventually lead him to the church in search of forgiveness. Finally, the song's final words, "and we can speak freely / about life and love" ("I mozhno govorit' svobodno, svobodno / Pro zhizn' i pro liubov'), underscore the pervasive secrecy and lack of open and free communication in the lives of the film's characters. Indeed, among the movie's central concerns are the myriad ways that communication is impeded, ignored, and denied in Soviet life. In addition to the usual lies, rationalizations, and euphemisms that people everywhere use to obscure unpleasant truths, Balabanov shows a world where young and old, urban and rural, educated and uneducated, men and women, and superiors and subordinates neither understand nor communicate with each other. Yet the familiar Chekhovian theme of the failure to communicate rises to a metaphysical plane in the terrifying figure of Zhurov, whose unnerving silences reflect an absolute lack of empathy for others. Like a character in a play by Samuel Beckett,[13] Zhurov's language has been reduced to an absolute minimum: he repeatedly substitutes wordless gestures or actions for words, responding to the professor's query with a simple hand gesture and to Sun'ka's plea by shooting him. When he does speak, he does so with either simple commands ("Drink." "Sit down." "Record it as an escape." "Do the paperwork for the cemetery."), or warnings ("Open your trap and we'll beat

[13] Balabanov's career as a filmmaker began with an adaptation of Beckett's play *Happy Days*.

him to death."). His longest "speech" in the movie is when he reads Sergeant Gorbunov's last letter to the sobbing Angelika, handcuffed to the bed (Fig. 2). The only time he speaks "from the heart" is when he sadly informs his mother that, despite his efforts to make Angelika happy, she does not love him: significantly, his mother is not listening and does not respond.

Balabanov uses another popular sentimental ballad, Yury Loza's "My Raft" (*Moi plot*), in even more complex and interesting ways. Heard for the first time as Zhurov drives Angelika in his motorcycle's sidecar through the gray and dreary streets of a Soviet industrial wasteland, a gentle song about a poet sailing on a little raft "made of songs and words" ("svityi iz pesen i slov") through the "tempests, rains, and storms" ("buri, dozhd' i grozy") of "monotonous everyday life" ("iz monotonnykh buden"), hoping to find "a world of happiness and peace" ("mir schastiia i pokoia") is utterly transformed. As Gregory Freidin has pointed out,[14] this scene transposes the central image of *Easy Rider* (Dennis Hopper, 1969), in which the heroes cruising on motorcycles through the American landscape to songs by Steppenwolf, The Byrds, and Jimi Hendrix symbolizes the freedom and, indeed, the moral superiority of the counter-culture. Like the heroes of *Easy Rider* and of Loza's song, Zhurov is also an individualist and a dreamer, albeit one who seeks his "world of happiness and peace" in rape, sexual slavery, and murder. By quoting from a quintessential American movie of the 1960s, Balabanov reveals a dark side of Russian history, suggesting how easily utopian dreams of liberating the individual can turn into nightmares of violence, degradations, and perversion.[15]

[14] Freidin, in Further Reading.

[15] Interestingly, later in the film Balabanov uses the same song for a very different purpose. As Antonina prepares to exact revenge on Zhurov for causing the death of her husband, we hear Loza's song again. But in this context, the song highlights the heroic, perhaps tragic willingness of a lonely woman to struggle and fight ("even if my path will be difficult, if idleness and sadness, the weight of past mistakes pull me to the bottom") for what is right despite knowing that her actions will be misunderstood by others ("they can't know, what suddenly happened to me, what's called me into the distance, what will soothe me").

Finally, in a coda that echoes the famous ending of one of the best-known films of the Gorbachev period, Sergei Solov'ev's *Assa* (1988), *Cargo 200* ends with a performance by Viktor Tsoi and Kino, the most significant and socially conscious rock band of the perestroika period. A comparison of the two films' endings reveals another dimension of the complex intertextuality of Balabanov's film. By ending *Assa* with Tsoi and Kino performing "We expect changes" (*My zhdem peremen*), Solov'ev unambiguously endorsed the younger generation's demand for political freedom denied them in the Soviet period and allowed the audience to believe that change for the better was imminent. But from Balabanov's vantage point in 2007, Solov'ev's confidence in a better future has proven illusory. *Cargo 200* ends with Tsoi and Kino performing "Got plenty of time but no money" (*Vremia est', a deneg net*) at a dance party in Leningrad, where Valera meets Slava, Artem's son. As Tsoi sings "I want to drink, I want to eat, I just want to take a load off my feet" (*Ia khochu pit', ia khochu est', / Ia khochu prosto gde-nibud' sest'*), Valera explains his get-rich scheme to trade alcohol (*spirt*) to the indigenous Siberians for furs which they can sell at a profit in Leningrad. If "We expect changes" represents society's highest aspirations for freedom and a new life, "Got plenty of time but no money" brings those utopian dreams down to reality with a thud! Zhurov, Aleksei, and Valera all dream of the freedom to do as they please, liberated from all ethical or moral restrains, and it is this dream, the movie suggests, that has given birth to contemporary Russia. Balabanov sees a paradoxical continuity between the dreams of freedom of the Gorbachev age and the nightmare of the post-Soviet years of rampant criminality, when unscrupulous individuals amassed gigantic fortunes while the general population experienced violence, deprivation, marginalization, and poverty. In post-Soviet Russia freedom is for the wealthy and powerful; arbitrary and unencumbered by the usual ethical or moral restraints, it is closer to *proizvol* than *svoboda*.[16]

16 Russian distinguishes between freedom as a positive concept that can be either social (*svoboda*) or personal (*volia*), and a negative association with arbitrariness, whim, and even violence (*proizvol*).

Cargo 200 imagines the Soviet Union in 1984 as a society in crisis and on the eve of a revolution. Its central elements—a profound generation gap, intense disagreements about the existence of God and the soul, the symbolic confrontation between the materialist beliefs of the atheistic intelligentsia and the quasi-religious utopian and nationalistic faith of the common people, violent criminal acts that result in religious conversion, family drama symptomatic of larger social and psychological pathology—all connect Balabanov's film to the themes and obsessions of the classic Russian novel of the nineteenth century, and particularly to Dostoevsky's metaphysical murder mysteries. As Dostoevsky did in *Crime and Punishment, The Devils*, and *The Brothers Karamazov*, Balabanov transforms scandalous crime stories into a symbolic portrait of a civilization in crisis, a world where "all is permitted." Yet, paradoxically (and despite the director's insistence that *Cargo 200* is based on real events in Soviet life of the 1980s), Balabanov lifted its plot and cast of characters from the pages of William Faulkner's scandalous novel *Sanctuary*.[17] First published in 1931, *Sanctuary* is a lurid tale of rape, sexual slavery, alcoholism, and the miscarriage of justice, played out in the American South by moonshiners, murderers, rapists, ineffectual intellectuals, and innocent female victims. In fact, Balabanov's greatest achievement may be his seamless translation of unmistakably American characters, situations, and milieu into an equally convincing view of Soviet life of the 1980s. As Frederick White has argued, by combining the plot of *Sanctuary* with Dostoevsky's philosophical and theological concerns, Balabanov was exploring "the realities of a Godless, morally corrupt Soviet society in which anything and everything was permitted," thus "challenging the official nostalgia" for the recent Soviet past.[18] Even if one is not convinced that Balabanov shared Dostoevsky's faith that Russia's salvation was to be found in Orthodox Christianity, what is beyond question is the director's seriousness, ambition, and

[17] For a longer discussion of the relation between Faulkner and Balabanov, see Frederick White, in Further Reading.

[18] Ibid., 95.

desire to contribute to a national debate about the Soviet past and the post-Soviet present.

Plagued by rampant corruption, bureaucratic ineptitude, an ineffectual military, a brutal and corrupt police force, a hypocritical and cowardly intelligentsia, a brutalized populace, and a cynically hedonistic younger generation, Soviet society in the 1980s could not long survive. Still, *Cargo 200* aspires to more than providing a lurid cinematic portrait of the last days of the Soviet world. Presenting an unsparing and brutal vision of Soviet society and culture on its last legs, Balabanov suggests an essential continuity with the post-Soviet present: once the best representatives of the younger generation had been sacrificed to vain and doomed imperial ambitions in Afghanistan, the country's future was hijacked, and power came to rest in the hands of amoral black-marketeers (*fartsovshchiki*), the predictable products of a soulless, cynical, and materialistic culture. As we will see in Balabanov's 2005 *Dead Man's Bluff* (*Zhmurki*), young people like Valera and Slava will go on to become the criminal elite of the 1990s, and the business elite in the Putin years. Those who remember the Soviet Union in the 1980s will agree that Balabanov has captured some of the bleakness, hopelessness, and brutality of the period. And yet, many will feel that Balabanov overdoes it and that the film's picture of Soviet life is exaggerated and one-sided to the point of caricature. By focusing so relentlessly and exclusively on degeneration, squalor, and depravity among the last generation of Soviet citizens, Balabanov shocks the audience but at the risk of simplifying history. As a result, the film's warning of the dangers of idealizing the Soviet past is weakened. This is too bad because, in a period of resurgent nationalism and imperial nostalgia, Russians needs an accurate understanding of the true complexities of the Soviet past more than ever.

Anthony Anemone

Further Reading

Freidin, Gregory. "Russia's Grey Underbelly: Aleksei Balabanov's Thriller Reveals Soviet Corruption." *Film Watch* (Telluride Film Festival), August 2007, 72–74.

Graham, Seth. "Chernukha and Russian Film." *Studies in Slavic Cultures* 1 (2000): 9-27.

———. "Fade to Black: Remembering Controversial Director Aleksei Balabanov." *The Calvert Journal*, May 23, 2013. Accessed February 18, 2018. http://www.calvertjournal.com/opinion/show/991/alexei-balabanov-obituary-cargo-200.

Plakhov, Andrei. "Nevynosimyi gruz." *Prochtenie*. Accessed February 18, 2018. http://prochtenie.ru/passage/23837.

Sul′kin, Oleg. "Interview with Aleksei Balabanov." *Mignews.com*. Accessed February 10, 2018. http://mignews.com/news/interview/world/150109_135750_19568.html.

White, Frederick. "*Cargo 200*: a bricolage of cultural references." *Studies in Russian and Soviet Cinema* 9, no. 2 (2015): 94–109.

MERMAID

Rusalka

2007

114 minutes

Director: Anna Melikian

Screenplay: Anna Melikian and Natal´ia Nazarova

Cinematography: Oleg Kirichenko

Art Design: Ul´iana Riabova

Composer: Igor´ Vdovin

Sound: Dmitry Smirnov

Production Company: Magnum, commissioned by Central Partnership, with assistance from the Federal Agency for Culture and Cinema

Cast: Mariia Shalaeva (Alisa), Evgeny Tsyganov (Sasha), Mariia Sokova (Alisa's mother), Nastia Dontsova (Alisa as child), Irina Skrinichenko (Rita), Albina Evtushevskaia (Alisa's grandmother)

Mermaid, the second full-length feature film of Armenian-Russian director/producer and screenwriter Anna Melikian (b. 1976 in Baku), received generally positive reviews and several significant awards. These included the FIPRESCI prize in Berlin and the Sundance Film Festival Directing Award in 2008—somewhat surprisingly, for the year 2007 witnessed the release of such weighty Russian cinematic fare as Andrei Zviagintsev's *Banishment* (*Izgnanie*), Aleksandr Sokurov's *Aleksandra*, Aleksei Balabanov's *Cargo 200* (*Gruz 200*), Sergei Bodrov's *Mongol*, Andrei Konchalovsky's *Gloss* (*Glianets*), and Vera Storozheva's *Traveling with Pets* (*Puteshestvie s domashnimi zhivotnymi*). Touted by some critics as a breath of fresh air, Melikian's film contrasted with all these sober, tragedy-

laden offerings by virtue of its humorous lightheartedness, which would mark her subsequent works and attract audiences as well as recognition from juries at international film festivals. Unexpectedly, *Mermaid* was Russia's 2008 official submission for Hollywood's Academy Awards in the category of Foreign Film.[1]

Andersen's and Melikian's Mermaids

Inspiration for *Mermaid* sprang from Melikian's avowedly favorite Hans Christian Andersen's fairy tale, "The Little Mermaid" (1837), which earlier had been transferred to the screen by Soviet directors Ivan Aksenchuk (1968) and Vasily Bychkov (1976), Japan's popular animé specialist Tomoharu Katsumata (1975), and, most influentially, Walt Disney (1989). Predictably, Disney's musical fantasy generated a host of lucrative products that held children around the world in thrall and possibly drew viewers to Melikian's film. The automatic association of fairy tales with children doubtless accounts for most directors' preference for animated adaptations, with Bychkov and Melikian the rare exceptions. Bychkov's film, however, opted for a melodramatic scenario preoccupied with the lamentable fate of individualism within Soviet society, whereas Melikian infused her film's narrative with comic characters, situations, dialogue, and commentary. As in her other works, *Mermaid*'s major concern is female love in today's Russia, loosely linked to Andersen's popular fairy tale and evocative of the Russian folkloric *rusalka*, a pagan water spirit incarnating a young woman who perishes by watery suicide when betrayed in love.[2]

Since its publication, Andersen's world-renowned tale has inspired numerous translations, illustrations, films, stage plays, musical genres, products ranging from jewelry to shampoos, and

[1] For its nominations and other awards, see *Rusalka,* accessed July 1, 2018, http://www.imdb.com/title/tt0995747/awards.

[2] On both personae, see Helena Goscilo, "Watery Maidens: Rusalki as Sirens and Slippery Signs," in *Poetics, Self, Place: Essays in Honor of Anna Lisa Crone* (Bloomington, IN: Slavica, 2007), 50–70.

seemingly boundless enthusiasm for the mysteries of the sea world.[3] His tale narrates the lachrymose fate of a mermaid whose yearning for a soul intensifies when she falls in love with a prince whom she rescues from drowning when his ship capsizes during a storm. Learning that she can become fully human if he reciprocates her love in marriage, she makes a pact with a witch, forever sacrificing her seductive voice, fishtail, family, and the underwater realm to remain at his side in human form. Though affectionate toward her, however, the prince perceives her merely as a mute, appealing child, and upon his marriage to a princess, she prefers to drown herself than exercise the option offered by the witch to kill her beloved. She thereby earns the possibility of ascending to heaven after three hundred years as a spirit whose trials may be shortened by her charitable acts and children's good behavior.[4] In short, not only love, but also spirituality and moral values in action compose the cornerstone of Andersen's narrative.

Melikian's *Mermaid* borrows selectively from Andersen's tale, limning a contemporary heroine driven by love, dreams, and aspirations that her environment cannot accommodate. Parallels with Andersen's tale include the sea, the protagonist's alienation from her surroundings, her unreciprocated love for a "socially superior" male whom she rescues from death, a female rival with whom she forges amicable relations, and a preordained death, followed by an anomalous form of afterlife for the "otherworldly" heroine. These commonalities notwithstanding, both plot and tone deviate markedly from Andersen's melancholy narrative, which completely lacks the humor that pervades Melikian's film.

As in many tales by Andersen, immoderate faith, masochistic self-sacrifice, and preternatural patience constitute his protagonist's

[3] Thanks to Disney's adaptation, an online store called *The Mermaid Cove* sells such improbable items as mermaid lamps, mermaid bookends, mermaid bottle openers, and the like. See *The Mermaid Cove*, accessed July 6, 2018, http://mermaidcoveonline.com/.

[4] Hans Christian Andersen, *The Little Mermaid*, translated by H. B. Paull (Lexington, KY: Hythloday Press), 2014.

traits, rendering her a typical Andersen heroine while also converging with the stereotyped ideal of Russian womanhood that persisted throughout the Soviet era (see, for instance, such films as Aleksandr Stolper's *Wait for Me* [*Zhdi menia*, 1943] and Mikhail Kalatozov's *The Cranes Are Flying* [*Letiat zhuravli*, 1960]). Though endowed with a measure of agency, Melikian's heroine, Alisa,[5] directs all her energy to "winning" the unremarkable man she loves, serves, and rescues. No wonder an astute Slavic scholar analyzing Melikian's film noted Alisa's "compliance with traditional gender values."[6] One might argue that Shalaeva's plain face differentiates her from the typical romantic heroine for whom beauty is a *sine qua non*, but her persistent, self-abnegating pursuit of a worthless male outweighs the factor of her nondescript looks.[7] One could even argue that her unprepossessing physical appearance explains her lack of appeal for Sasha, who already has an incomparably more attractive woman in tow, a long-legged model named Rita. Even Rita follows the established pattern of women in a profoundly misogynistic culture by attempting to please "her man" by cooking his favorite food—quite improbably, the fried potatoes that Alisa obligingly peels to preserve Rita's killer artificial nails.

In Melikian's scenario, Alisa Titova (clearly named after Lewis Carroll's *Alice's Adventures in Wonderland* [1865] to emphasize her ubiquitous alienation) results from a single sexual encounter between her mammoth-sized mother and a transient sailor relaxing on the beach. Residing in a shack beside the sea with her ever-sedentary, ice cream-obsessed grandmother and raucous mother, six-year-old Alisa yearns to meet her father and to dance ballet. Thwarted in both desires and outraged at her mother's bout of sexual gratification with a chance naval officer, she sets fire to their dwelling and withdraws into steadfast silence. Her recalcitrance

[5] Shalaeva received the Kinotavr award in the best female role for 2007.

[6] Lena Doubivko, in Further Reading.

[7] Melikian wrote the film script specifically for Shalaeva, who also stars in the first of three narratives composing Melikian's fourth film, *About Love*.

leads to her placement in a special school for handicapped children, where she wordlessly bonds with a fellow inmate suffering from Down syndrome and demonstrates her magical abilities (willing apples to drop from a tree), subsequently summoned to provoke a hurricane that destroys the family home and forces the trio to relocate to Moscow. Once there, Alisa obtains a series of menial jobs (toilet cleaner, assembly-line cog, envelope-stuffer, ambulatory cell phone), saves the life of Sasha, an alcoholic, suicidal swindler selling plots on the moon, instantly falls in myopic love with him, recovers speech, and becomes his housemaid, stalker, and salvation. She befriends his current amour, again saves him—this time from a fatal plane crash—and finally dies when knocked down by a car.

Such a structure, in which at the last moment humor yields to melodrama, is Melikian's directorial signature, already evident in her debut film, *Mars* (2004), and in the later *Star* (*Zvezda*, 2014), though not in the more conventional *About Love* (*Pro liubov'*, 2015).[8] *Mars* follows the unlikely adventures of a boxer fleeing from the mob who comes upon a provincial town seemingly called Mars because the "k" has dropped out of "Marks" (Marx) in its train station sign. The poverty-stricken population of this extraterrestrial milieu produces and exchanges gigantic stuffed toys as payment for life's necessities, while its women passionately yearn for love— a motivation that propels the film's events and ultimately leads to a major character's suicide in the film's second half. Death likewise hangs over *Star*, which interweaves two parallel plotlines: the hyperbolic efforts in Moscow of the provincial Masha to become a famous actress and the sophisticated Rita's banishment by her hypochondriac tycoon/lover, after she is diagnosed with a terminal disease and feels free to insult him. Linking the two women is the tycoon's young son, Kostia, smitten with Masha and employed in a nightclub where she appears as a mermaid in a tank of water. Rita befriends Masha, who, in a predicable twist, is suddenly revealed as

[8] For a smart review of *Mars*, see Elena Prokhorova, "Anna Melikian, *Mars* (2004)," *KinoKultura* (2005), accessed July 7, 2018, http://www.kinokultura. com/reviews/R7-05mars.html.

the one terminally ill, whereas Rita returns to her lover and becomes pregnant. Just as in *Mermaid,* superficiality and appearance rule Moscow. Such by now familiar elements also pepper *About Love,* Melikian's portmanteau outing, which juxtaposes three different narratives about heterosexual relations, embedded in a frame showing a psychologist (Renata Litvinova) who lectures to a crowd about the nature of love.

All too obviously, the rather tired theme of star-crossed love runs throughout Melikian's oeuvre, as does death. Likewise typical of her individual repertoire of features are the female protagonist's unworldliness yet dogged persistence, camaraderie between ostensible rivals, and an uneasy blend of humor and melodrama, culminating in the sudden reversal of viewers' expectations at film's conclusion, all of which are especially prominent in her first three films. In short, Melikian developed a directorial formula early in her career that so far has proved successful with audiences and festival organizers.

Appropriations, Intertexts, and Death

While indebted to Andersen's tale for its plotline and major personae, *Mermaid* evinces the influence of Tom Tykwer's thriller, *Run Lola Run (Lola rennt,* 1998), in its turn inspired by Krzysztof Kieślowski's *Blind Chance (Przypadek,* 1981).[9] Tykwer borrowed from *Blind Chance* the central device of three storylines that chart alternatives in the protagonist's life (and death). In both films, the trajectory of that life depends upon how quickly the hero and heroine can run: in the case of Kieślowski's Witek, to catch a train; and in that of Tykwer's Lola, to find an individual who can save her boyfriend's life. Notably, one of the three storylines in both films culminates in the protagonist's death. Melikian's most obvious appropriations from Tykwer are the motif of running and the inclusion of three different life scenarios. Tracking a rapidly moving body, of course, imparts

[9] For a list of possible other intertexts, see Stanislav Rostotskii, "Bremia zhelanii," *Iskusstvo kino* 8 (2007): 35–38.

dynamism and a sense of narrative drive to a film, both of which are critical to Melikian's tale of relentless pursuit and to her fondness for accelerated action and editing.

During her childhood, the constantly disgruntled Alisa repeatedly races onto the dock of the Black Sea and around the dilapidated provincial coastal town. As a seventeen-year-old in the capital, she similarly speeds along streets, enabling Melikian to feature, with an economy of means, not only sundry individuals and groups going about their business, but also the numerous advertisements and posters she passes on route. And at film's conclusion, Alisa runs toward her own death, killed by a car as she crosses a street without paying attention to two-way traffic. Dissatisfaction and impatience, translated into headlong speed, rule her life.

Though *Mermaid* resembles *Run Lola Run* in the heroine's efforts to save her beloved's life, only to die herself while he survives, Melikian intriguingly complicates the issue of death as an unacknowledged bond between Alisa and Sasha that *Mermaid* reinforces at several junctures. Shortly before leaping into the Moscow River to save Sasha from drowning, Alisa readies to commit suicide herself by jumping into the water. Since that rescue, which constitutes their first meeting, takes place at night without witnesses, it emanates an aura of spurious intimacy. Later, after she prevents him from boarding the plane that crashes, killing everyone on board, she perishes by sheer chance as she hurries in search of him. If in the first instance he is her surrogate for suicide, in the second occurrence she becomes his surrogate in a public death after they have attained what vaguely resembles an authentic incipient symbiosis.

Sasha's fish humorously symbolizes the potential for a genuine relationship between them. Evoking Andersen's tale and Alisa's fabled biological origins (Alisa's voiceover informs the audience, "Mama said that first I was a fish"), it prompts an exchange that reveals both his proprietorial attachment to the fish and Alisa's concern that it swim in conditions optimal for leading a full life — precisely what she herself seeks. Fish, as she tells him, also have feelings. Rita's jealous elimination of the goldfish in a fit of pique

Fig. 1. Posthumous fame of Alisa as the Moon Girl in a Moscow overrun by ads.

prefigures Alisa's death, and just as the fish is an alien entity in Sasha's maximally technologized apartment, replete with every conceivable gadget, so the seaside town and especially Moscow constitute foreign environments for the displaced Alisa—a status linking the film to Andersen's tale.

Melikian's parallel to the three life-scenarios of *Run Lola Run* comprises three contrasting stages in Alisa's life in Moscow: the first entails her silent, solitary work at various demeaning jobs that erase her individualism and even her visibility when she walks back and forth on the city's pavement inside a cell phone to advertise a media company's services. The second stage entails her social ascent in the world upon becoming Sasha's cleaning woman, enabling her to meet people in his professional and social milieu. Her final stage literally and figuratively elevates her further as she posthumously becomes the image of the Moon Girl on billboards suspended on walls throughout Moscow, hailing residents and visitors to the capital (Fig. 1). Thus Melikian retains the connection with death in one of the three scenarios depicted by both Kieślowski and Tykwer, but, not unlike Andersen in his original fairy tale, vouchsafes her protagonist an idiosyncratically "happy" afterlife. And the motif of

three, of course, connects the film to one of the constituent features of the fairy-tale genre, which invariably incorporates trebling in characters, plots, and structure.

Devices and Desires

Essentially centering *Mermaid* on a banal love plot, Melikian partially redeems its triteness by several devices that her subsequent screen offerings would both modify and elaborate. The infusion of humor, abetted by Alisa's naïveté and narration, as well as her voluminous mother's indiscriminate sexual drive, sets the tone early. Even as the credits roll, Igor' Vdovin's catchy, frivolous "pom-pom-pom-pom" music, plus the sound of gurgling water and the cartoonish images of fish seemingly swimming underwater, signals a comic take on what ensues. And once the camera zooms out, the establishing shot playfully exposes the impression of live fish as an illusion, for we see instead the back of a huge female form in motion, showcasing swaying buttocks clad in a garish dress imprinted with precisely those cartoonish fish. That fishy bulk turns out to be Alisa's appetite-driven mother, the revelation launching the theme of illusion and misperception critical to the film. Melikian sustains this image of Alisa's mother (never named, hence presented purely as fulfilling the maternal function) throughout, from her naked frolics in the water, which attract an unsuspecting sailor, to her sexual avidity for a passing naval officer and later, for the butcher at the Moscow store where she finds employment (Fig. 2). Garrulous coyness and bellowing laughter accentuate the comic nature of her persona, contrasted to her thin daughter's inwardness, silence, and mulish naïveté. Whereas Alisa is emotions and fantasies, her mother's essence may be crudely defined as meat—a trait emphasized by her passion for physical gratification and a butcher. Comedy, however, ultimately cannot disguise the fact that Alisa lacks a mother as a source of nurture and wise counsel, for the woman's self-involvement leaves scant room for maternal care, perhaps best visualized when she tactlessly presents the flat-chested Alisa with a large, colorful brassiere on her birthday, brayingly noting that she will grow into it. From the outset, Alisa and her mother utterly fail

Fig. 2. Coquettish introduction by Alisa's mother of her resistant offspring to the meaty object of her desire.

to communicate, though the latter on several occasions smilingly refers to Alisa as "mine." While the contrast between the two echoes the typical polarized duo of comedy (Laurel and Hardy, The Bowery Boys, etc.), such episodes as Alisa's birthday "celebration" verge on sadism, more painful than comic.

Humor also derives from Alisa's voiceover, which blends purely matter-of-fact exposition with pearls of pseudo-wisdom and information to which she could not possibly be privy. For instance, she relates the circumstances of her own birth, comments on such phenomena as the employment situation in Moscow solely on the basis of her own degrading experience, and waxes eloquent about her own death, in a posthumous observation that such incidents as her demise by a speeding car frequently occur in a city: "2,000 people die in street accidents annually in Moscow." The discrepancy between the generalizations and data she dispenses so freely and her circumscribed perspective tends to be humorous. Though some commentators have accepted her voiceover as authoritative up to that point,[10] it sooner functions to signal her limitations and

[10] Chip Crane, in Further Reading.

evoke laughter. In general, no persona in Melikian's films carries narrative or philosophical authority, for the director subjects everything and everyone to the ironic perspective that frames the diegesis of her works. Indisputably, Alisa's interpretation of events cannot be trusted, especially because her persona borrows from the age-old Russian phenomenon of the *iurodivye*—holy fools whose simplicity and unconventional behavior border on idiocy (Sasha, in fact, calls her *dura* [fool]), which render them one of God's elect but ill-equipped for society and for reliable assessment of everyday life. Melikian's concept of her female protagonist blends features from paganism (the folkloric *rusalka* endowed with supernatural powers) and Russian Orthodoxy (the *iurodivaia*, who is "not of this world"). Neither can assimilate into a conventional environment.

Dynamic camerawork and rigorous editing similarly rescue the film to some degree from the pitfalls of a hackneyed plot. With considerable experience in TV and music productions, Melikian skillfully tracks Alisa's speedy movements and rapidly shifts from one sequence to another, alternating long and medium shots with closeups in a visual rhythm that never allows the film to sag. Stop motion for the Titovs' introduction to Moscow via its most famous venues; point of view shots from Alisa's angle (when she discovers Sasha and Rita enjoying vigorous sex); overhead shots (when her corpse lies sprawled on the street, surrounded by curious passersby); distorting close-ups (when Alisa's mother wakes her on her birthday); and in the first part of the film, recurrent reliance on visual synecdoche, whereby the camera targets people's feet instead of the entire body—these convey respectively Moscow's frenetic pace, the protagonist's subjectivity, a "divine" point of view, implicit judgment, and the director's tongue-in-cheek attitude toward her materials.

Moreover, though Alisa's viewpoint dominates and vividly determines the presentation of certain developments, other shots objectify her, as when she smokes and chats with Rita in companionable relaxation in Sasha's apartment and when she auditions for the job of Moon Girl. Elsewhere, however, Melikian relies on original filming devices to underscore Alisa's role of

narrator. For instance, when she rescues Sasha from his second suicide attempt as he staggers between traffic lanes on a highway, Melikian has Alisa use her hands and eyes to restrict the shot of the inebriated fool as a two-dimensional cinematic frame, extracting him to safety from the certainty of death by vehicle. That shot reiterates and anticipates identical earlier and later ones, when she "frames" a ship, likewise an object of her desire for her maritime father's presence, and also a passenger boat on the Moscow River with the slogan "All will be fine."[11]

In a sense, Alisa appears to save Sasha by photographing him as a cinematographer would, in a metafilmic moment that accords with another effective device that Melikian interpolates here and in her later films, especially *About Love*. On several occasions, she translates Alisa's desires into a superimposition onto the screen of atemporal, ideal scenarios resembling comics or cartoons. For instance, she casts Alisa's childhood desires as a "fake" screen scenario in which her father in diving gear suddenly finds her standing outfitted as a little ballerina on the beach, projected against a huge, operatic, bone-white ship. Later Melikian situates Alisa and Sasha gazing at each other in profile, to the left and the right of the screen, once more superimposed upon the backdrop of a beach, both of them smiling and presumably sharing emotional intimacy while a sunny, tranquil sea reflects Alisa's notion of their perfect relationship (Fig. 3). These deep-focus sequences constitute stylized enactments of Alisa's romantic fantasies and wish-fulfillment dreams, belied by the "real" incidents captured on screen, which confirm that her father will never arrive and unmistakably demonstrate Sasha's indifference and unceremonious treatment of her.[12] As if taking her

[11] The slogan belongs to the host of advertisements repeatedly spotlighted by Melikian, but also could refer to a 1995 film with that title by Dmitry Astrakhan, which also addressed the issue of wealth and the influx of Western phenomena into post-Soviet Russia, encompassing Madison Avenue tactics.

[12] Melikian's enthusiasm for this stratagem leads to an error in judgment when the final frame of the film captures a smiling Alisa projected against the same water and sand, even though by then she is dead, so cannot possibly be dreaming.

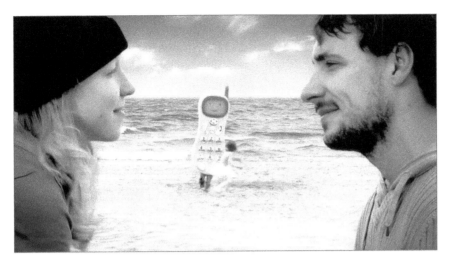

Fig. 3. Alisa's fantasy of intimate bonding with Sasha.

cue from early or experimental cinema, Melikian fruitfully explores the screen's capacity to absorb superimposed print and images, to divide into a split screen (when Alisa and Rita occupy space divided by a thick wall in Sasha's apartment), and to synthesize the cinematic frame with other media (such as the video recording of a fire that melts the phone encasing Alisa). These devices multiply more productively and meaningfully in *Star* and *About Love*.

Selling the Moon and Dreams

Melikian's preoccupation with desire and its frustration lies at the heart of the film, illustrated by Alisa's dreams of meeting her father, becoming a ballerina, and having Sasha reciprocate her love; by her mother's endless search for a male partner in brief sexual encounters; by Sasha's efforts to find oblivion in alcohol or death; by Rita's wish to become at least as important to Sasha as his goldfish; and by contemporary Russians' absurd purchase of plots on the moon, presumably in irrational expectation of exoticism or a better life. This last, an expansion of the dream-theme's range, gains promising traction once the family moves to Moscow — after the first fifth of the film. It is adumbrated, however, by Alisa's claim in the early section that intense wishes result in attainment of

one's goal, which coincides with the first instance of a slogan about fulfilling one's dream, suspended in front of the school for "retarded children," as she phrases it. Shown three times, the sign quotes and depicts Karlsson, the fat protagonist in three of the Swedish Astrid Lindgren's children's books, "We guarantee to make all dreams come true."[13] De-semanticized advertisements, in other words, are not the exclusive province of the country's capital.

Pursuit of a communal goal, which fueled Soviet ideology, did not disappear with the demise of the USSR, but during the post-Soviet era merely transformed into a chase for individual acquisition of money, prestige, or romance. Here the protagonist's objective is to gain Sasha's love; in *Star*, to become a media celebrity; and in the three narratives composing *About Love*, to "snag" a supposedly desirable male. Melikian invariably genders these "humble" quests female. They could hardly be more remote from such noble mythological quests as that of the Holy Grail in the West and a Radiant Future in the Soviet Union, with men as the heroic seekers and pioneers. Average young women with more hopes than brains, her protagonists are willing to undergo all conceivable trials to realize their wishes. And their narratives retain elements of the Soviet past, including provincials' perception of urban centers, and especially Moscow, as the Promised Land to which they flocked. Alisa's cluelessness may be gauged by her comment that when people have nowhere to go, they move to Moscow, whereas the capital, on the contrary, long reigned as the fabled ideal for most Russians, and remains so to this day.[14]

[13] Christine Goelz, "A Modern Fairy Tale," *ARTMargins*, April 29, 2009, accessed July 6, 2018, http://www.artmargins.com/index.php/christine-goelz-a-modern-fairy-tale. These books enjoyed enormous popularity in the Soviet Union and were adapted into two vastly popular animated films as well as a play.

[14] Indeed, as Vladimir Men'shov's Oscar-winning crowd-pleaser, *Moscow Does Not Believe in Tears* (*Moskva slezam ne verit*, 1979) illustrates, provincials were willing to undertake any jobs in Moscow simply to earn a residence permit. The phenomenon was sufficiently widespread for the conferral of the standard label *limitchiki* upon these optimists.

Whereas during the tsarist era Orthodox Russians typically reserved a corner of their dwelling (*krasnyi ugolok*) for an icon, during the officially atheistic Soviet period families replaced these religious images with strategically located portraits of their secular counterparts: political leaders. Both were supposed to safeguard the citizenry's well-being. Aleksandr Laktionov's famous painting of *A New Apartment* (*Novaia kvartira*, 1952) shows a smiling four-member family joyfully examining its living space, which already contains a Ficus houseplant, poster, balalaika, books, and, in the hands of the Pioneer younger son, the obligatory portrait of Stalin, which obligatorily occupied pride of place on one of the walls. Melikian similarly relies on visual shorthand to suggest, not the reassuring oversight of Putin, but the possibilities for women in an urban locale. She does so through a famous painting hung by Alisa's mother on the wall: Ivan Kramskoi's historically controversial *Unknown Woman* (*Neizvestnaia*, 1883), which portrays a young, richly dressed woman in a carriage gazing self-assuredly down at the viewer. Initially seen in the mother's bedroom in the family's coastal shack, rather unobtrusively contrasting with the obese woman's appearance as she compulsively changes outfits and dances in front of a mirror, when transferred to the Moscow apartment it becomes an object of the camera's sustained attention. When Kramskoi first unveiled the portrait, it created a scandal because her clothing, unabashed demeanor, and lack of escort (not to mention the title of the painting) caused even supposedly sophisticated viewers to presuppose that the anonymous woman was a prostitute working the streets of St. Petersburg. With time, however, that opinion changed, and for today's viewers she embodies chic aplomb. Melikian capitalizes on the ambiguity with which women in the "big city" are identified: they may sell themselves, but they also may achieve success, wealth, and all that the latter can buy through effort and self-confidence. After all, Alisa, who confides to Sasha that she is "nothing," starts out cleaning toilets but ends up as the poetic Moon Girl presiding over the city streets and inspiring its inhabitants "to reach for the moon." The "only" cost of that social promotion is her life. By replacing leaders' portraits with that of a well-to-do young woman, Melikian embeds the shift in priorities during the post-Soviet era.

Media as Lunar Lure

As attested by numerous literary (such as Shakespeare's *Romeo and Juliet*, 1597, Aleksandr Pushkin's *Eugene Onegin*, 1832, Mikhail Bulgakov's *Master and Margarita*, written 1940, published 1967), visual (such as Norman Jewison's film *Moonstruck*, 1987), and musical works (such as Ludwig van Beethoven's *Moonlight Sonata*, 1801, Petr Tchaikovsky's opera *Eugene Onegin*, 1878, Antonin Dvořák's opera *Rusalka*, 1901), the moon carries abundant associations with dreams, imagination, yearning, creativity, and madness. Hence the term "lunatic," from Latin *luna* (moon). The very idioms "reaching for the moon" or "baying at the moon" convey the sense of craving the impossible. And as a director attuned to the dynamics of contemporary life, Melikian understandably weds that impulse to the power of media.

Indeed, one of the most thought-provoking aspects of *Mermaid*, though subordinated to the love plot, is Melikian's mode of depicting the influence of media on quotidian life (and on her own film). Once Alisa and her family settle in Moscow, the incalculable impact of media gains prominence and unifies the lives of the major characters. Telephones, television, video, and graphics rule people's existence. To advertise a company headed by a crook, Alisa not only functions as a mobile telephone and foaming beer mug (in perpetual though circumscribed motion), but also relies on the telephone to save Sasha's life the second time, preventing him from boarding the fatal flight that kills all on board (hence Lera Masskva's clichéd song "One phone call" [*Odin telefonnyi zvonok*] that accompanies Alisa's final movements along the street).[15] Seeing Milla Jovovich's orange

[15] Lera Masskva is the pseudonym of Valeriia Gureeva, a pop singer who won a Russian MTV award in 2006. The lyrics of the song in *Mermaid* make little sense, but point to the role of the telephone and love in the plot: "Odin telefonnyi zvonok, / I ty uzhe ne odinok. / Moi telefon stoit tysiachu evro ,/ No ia ne khochu zvonit' tebe pervoi, ...Nashi telefonnye trubki / Meshaiut nam delat' postupki..." [A single phone call / And you're no longer alone. / My telephone costs a thousand euros, / But I don't want to call you first… Our phones prevent us from undertaking [certain] actions...] The banal

hair in a TV broadcast of Luc Besson's blockbuster sci-fi film *The Fifth Element* (1997) induces Alisa to dye hers mermaid-green. Rita, who as a model patently relies on images (including her own) circulated by various media, watches TV even in the bathroom. Sasha's sales job entails disseminating advertisements via TV and billboards for the company he manages that inundate the urban space. Screaming mothers flock to a TV studio with their reluctant little sons as competitors for the role of Moon poster boy. How this formidable glut of ads overwhelms Moscow residents may be deduced from an advertisement for the Evolution brand, trumpeting, "It's good to be home," which covers not only the window of the Titov family's new apartment, but the entire wall and all the windows of the multi-storied building in which they reside, essentially immuring those within by severing their connection with the outside world. When Alisa cuts out the section pasted over their window and opens the latter, she appears in the right eye of the sleek woman at the center of the ad. This moment visually equates the various slogans with Alisa and perception, the significant irony being that she perpetually misperceives reality and never feels at home either in the coastal shack or in Moscow. She *becomes* an ad, first in life as a telephone and mug of foamy beer, and finally after death—the precondition for her integration into the cityscape.

The superabundance of ads festooning buildings in the capital convey messages that leave no doubt about Russia's adoption of capitalist strategies for financial gain.[16] Just as Alice's Wonderland at every turn parades illogicality and irresponsible egotism (note the Queen of Heart's pronouncement, "Sentence first—verdict afterwards!"), Moscow is a virtual Wonderland—of hyperbolic, ludicrous slogans targeting emotions. It appears as a money-obsessed, surreal world where selling property on the moon proves a highly lucrative occupation, humans serve as objects, and obtrusive

lyrics proceed from a female point of view, chiming with the perspective of Melikian's film, which privileges female subjectivity.

[16] Mihaela Mihailova's fine article addresses in some detail this aspect of the film. See Mihaela Mihailova, in Further Reading.

placards and posters relentlessly assail everyone, proclaiming, "We guarantee to make all your dreams come true," "Don't be afraid of your desires," "Everything is in your hands," "Progress depends on you," "Class!," "The winner takes all!," "Follow your star!," and similar formulas all too familiar from Western and particularly American marketing strategies.

Almost a half-century ago John Berger's milestone study titled *Ways of Seeing*,[17] based on his award-winning BBC series, contended that ads sell not merchandise, but seductive images of a future self. That proposition finds comprehensive corroboration in *Mermaid*, where ads function as signs without a referent. Though these commercial clichés have no basis in the empirical Moscow depicted onscreen, they chime with the protagonist's fantasies about the capacity of passionate desires to forge reality, and appear as an implicit approval of her actions. After all, her determination to enter an institute in the city leads to success, even though she originally fails the entrance exam, for her passionate desire magically causes someone accepted into the program to die in a car crash, allowing her to move into the vacated slot. Immediately after that episode, "The winner takes all!" appears on the screen, as if cheering Alisa's "victory." In short, Alisa is the living embodiment of the advertisements overrunning Moscow, which seem to speak to her, goading her to persist in her endeavors. Small wonder, then, that her "otherworldly" self assumes the form of an outsized advertisement as the Moon Girl paralleling the Evolution ad—an identity that, ironically, is predicated upon her death (Fig. 4). Such printed bromides have their oral counterpart in the techniques used by Sasha and his coworker, Kostia, who appeal to gullible Muscovites' snobbery by nonsensically pointing out that a "prestigious" and picturesque plot on the moon borders the properties of Ronald Reagan and Mike Tyson. Name-dropping (the Prince of Monaco, Russell Crowe) and assurances that since 1980 the agency has sold over a million lunar lots, as well as 500,000 on Mars and Venus, apparently persuade their social-climber clients to invest in these

[17] John Berger, *Ways of Seeing* (London: Penguin Books, 1972).

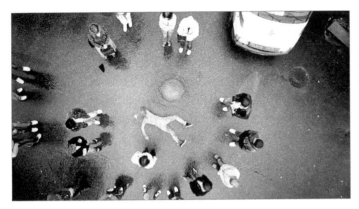

Fig. 4. Neatly orchestrated commonplace death by traffic accident.

"properties," whose receptivity to such primitive techniques is primed by the flood of ads they encounter on a daily basis. Yet, as one sugar daddy sarcastically asks the young woman whose favors he obviously has bought and whom he intends to placate by purchasing moon space, "What, do you intend to live there?", thereby pointing to the senselessness of such pseudo-glamorous investments.

The Film's Reception and Its Problems

While Melikian's light treatment of her scenario might strike some viewers as incompatible with a serious appraisal of the film's implications, it is well worth noting what conclusions such an assessment encourages or intimates. Sundry responses to the film as well as its profits provide a viable entry point. Though the film, which cost approximately $1,700,000, garnered awards and met with largely positive reviews, its box office receipts were strikingly modest: the equivalent of $1,364,720 in Russia and $1,431,983 worldwide.[18] Moreover, a number of critics, scholars, and viewers expressed reservations about various aspects of the film. Several accusations of pilfering from the French director Jean-Pierre Jeunet's popular comedy *Amélie* (2001) impugned the originality of

[18] Lindon Kamusov, "Fil'm Rusalka, retsenziia, 2007," *yakinolub*, March 15, 2015, accessed July 6, 2018, http://yakinolub.ru/rusalka.html.

Mermaid. In like vein, some pointed out that Andrei Konchalovsky's *Gloss* (*Glianets*, 2007) and Elena Nikolaeva's *Pops* (*Popsa*, 2005) already had lambasted Moscow's enslavement to surface glitter in a kindred narrative about a provincial do-gooder young woman in search of fame and fortune in the capital.[19] Others, such as Natascha Drubek-Meyer, faulted the mothballed representation of gender and the protagonist's unlikability, maintaining, "the film misses a great opportunity to rethink the gender stereotypes present in its 19th century precursor," unexpected in an ambitious female director.[20] Still others found Melikian's treatment of her protagonist inconsistent.

While the charge of "stealing" from previous films through citations or parallels rather injudiciously ignores the legitimate, constant dialogue of films with their predecessors, the last three objections merit closer scrutiny. Notably, after almost a half-century of feminism in the West, in Russia its principles remain the conceptual enclave of a miniscule minority of scholars. That lamentable fact notwithstanding, surely Alisa as a protagonist must raise more than a few hackles even among feminism's detractors.[21] To feature a heroine rendered almost witless by a clamorous, obdurate love for an unresponsive drunk betrays all too eloquently not only the lack of a reality compass on her part, but also the director's inability to embrace contemporary Western values. Instead, the film parades Russia's retrograde attachment to its feudal past, which entails atavistic assumptions about gender. Men come off badly in *Mermaid*: they are dishonest and greedy (Sasha and the

[19] See, for instance, Bettina Lange, "Glamour Discourse," *ARTmargins*, April, 30, 2009), accessed July 7, 2018, http://www.artmargins.com/index.php/bettina-lange-glamor-discourse.

[20] Natascha Drubek-Meyer, "A Little Mermaid in the World of Russian Advertising," *ARTmargins*, February 5, 2009), accessed July 6, 2018, http://www.artmargins.com/index.php/natascha-drubek-meyer-a-little-mermaid-in-the-world-of-russian-advertising.

[21] For Western audiences familiar with such feminist ripostes to Andersen's tale as Joanna Russ's ironically deconstructive "Russalka, or the Seacoast of Bohemia" (1979), Melikian's film seems particularly retrogressive.

media boss who takes Alisa's passport); betray an incapacity for love and commitment (Sasha and Alisa's father); live off women and seem interested exclusively in casual sex (the sailors copulating with Alisa's mother). Yet the film shows women apparently unable to live without them, for all three major female personae—Alisa, her mother, and Rita—devote their time and energy to nabbing a man at all costs.

Furthermore, Alisa's failure to charm some viewers originates in the director's uneven and erratic, even capricious characterization of her protagonist. Though Alisa initially appears innocent and vulnerable, if overly willful, in Moscow she emerges as a selfish killer, so eager to enter an institute that she seemingly causes a more successful applicant's death by uttering the "magic formula" of her profound desire. Yet once his death gains her admission to the institution, she apparently never attends it, for romance supersedes her alleged educational aspirations immediately after she encounters Sasha. Is Alisa unforgivably frivolous or is her director careless? In any event, Alisa manifests a nasty readiness to sacrifice others to her cause, however nugatory, and more than once: she wishes dead anyone failing to conform to her plans, starting with her mother when the latter has sexual intercourse with a naval officer and concluding with Sasha when he engages in the same activity with Rita. In both cases she shouts, "Traitor! May you croak!," yet with no result.[22] Thus the key question is: does Alisa possess the power to transform her desires into reality, thereby dooming those who thwart her intentions while also magically saving her beloved? What we see on screen yields a negative answer to that question, one that suggests the director's indecisiveness and confusion.

The strongest argument against Alisa's supernatural gift is her failure to win Sasha's love, particularly because that objective tops her hierarchy of goals. Similarly, her death in a random traffic accident surely contravenes her desires. As a number of

[22] One might note parenthetically that the motivation behind Alisa's apparently sole sexual experience (with the verbose Iura) is punitive—childish revenge for the intercourse she witnesses between Sasha and Rita.

commentators have maintained, the various instances of her ostensible exercise of magical powers may be interpreted as strange coincidences: hurricanes occur, cars kill people, and planes explode. Yet apple trees do not shed all their apples in a single moment, and if all the incidents Alisa confidently credits to her magical gifts are, indeed, coincidences, then the film's surfeit of manufactured coincidences elicits skepticism. Logic leads to the conclusion that Melikian either changes horses midstream or simply abandons all consistency in order to make her point. What that point is, however, remains unclear, unless she wishes to underscore the impossibility of happy love in today's world, a notion implied by the absence of true intimacy other than sex between Rita and Sasha[23] and by the arguing couple beside a sleek red sports car,[24] on whom Alisa focuses instead of photographing the Japanese tourists who pose with her as an ambulatory telephone. Love may be a major drive, but it never leads to happiness or fulfillment.

[23] In this regard Henrike Schmidt's reading of the film strikes me as wishful thinking. She claims, "*Rusalka* does have a happy ending that re-unites two representatives of the new media elite and Russian glamour society, Sasha and Rita, who—with the help of an outsider (Alisa)—discover their real emotions and are given a chance to abandon their shallow life style for a better future in wealth, prosperity, and love." When Sasha unexpectedly meets Rita at film's end the first thing he does is lie to her, saying that he was searching for her. Nothing whatever indicates that the two will change their relationship or abandon their "shallow life style," whatever the "chance" offered them. In fact, the idea that the two will abandon their lucrative careers is not only unfounded, but downright grotesque. Melikian ends her film inconclusively probably because she had no idea how to provide it with convincing closure. See Henrike Schmidt, "Happy End," *ARTmargins*, April 30, 2009, accessed July 6, 2018, http://www.artmargins.com/index.php/henrike-schmidt-happy-end.

[24] The red car returns at film's end, when Alisa, by staring at it again while in the middle of the road, neglects to check the other direction, from which the speeding car that kills her emerges. As throughout her life, she misjudges the appropriate object of her attention and its significance. In the earlier scene the striking sartorial incongruity of the squabbling couple—the soignée woman chicly dressed, and the man in nondescript undershirt and worn jeans— mirror the incompatibility of Sasha and Alisa, were she observant enough to perceive the parallel.

Genre

The film's lack of clarity partly explains critics' and viewers' uncertainty and unsubstantiated assumptions regarding its genre. Matthias Meindl and Svetlana Sirotinina refer to it as "a film designed [intended?] as a popular comedy."[25] By contrast, according to Bettina Lange, the film draws upon "the biography, the melodrama and the fairy tale,"[26] while a Russian reviewer refers to it somewhat fuzzily as "a romantic comedy in symbiosis with elements of an adult fairy tale."[27] In a sardonically negative review Aleksandra Dobrianskaia delegates it to the genre of melodrama.[28] And, perhaps most contentiously, Drubek-Meyer declares that the film "was meant to be a 'tragical comedy,'" and lambasts it for failing "to cope with the challenge of its genre," but omits any explanation of her reason for presupposing that *Mermaid* instances that genre.[29] No director need shoulder responsibility for the speculations and suppositions of critics and reviewers, but surely the divergence of opinions about the generic nature of *Mermaid* to some extent stems from Melikian's wavering control of the film's orientation, which suffers from a potpourri of conventions calculated to produce ambiguity and assure *Mermaid* popularity, but instead causes the plot to sicken. Manifestly synthetic in its generic affiliations, the film is a stew of diverse, occasionally clashing ingredients assembled around a protagonist stimulating contradictory reactions. Tragedy plays no role in the film, but elements of comedy and melodrama

[25] See Matthias Meindl and Svetlana Sirotinina, "Theodor Adorno, Fairy Tales, and *Rusalka*," *ARTmargins* April 29 2009, accessed July 3, 2018, http://www.artmargins.com/index.php/matthias-meindl-and-svetlana-sirotinina-theodor-adorno-fairy-tales-and-qrusalkaq.

[26] Lange, "Glamor Discourse."

[27] Kamusov, "Fil'm Rusalka."

[28] Aleksandra Dobrianskaia, "Devushka iz vody (Fil'm Anny Melikian *Rusalka*)," *geometriia*, accessed July 7, 2018, http://geometria.by/blogs/culture/27226.

[29] Drubek-Meyer, "A Little Mermaid."

alternate and intermittently fuse, while fairy tale motifs tend to take a back seat or function perfunctorily.

Whatever the film's unevenness, Melikian clearly strives for a coherent structure by iterating and interweaving plot, visual, and audial motifs throughout: fish, sea, ads, ballet, triples, running, red car, sex, Alisa's "idiocy," statements such as "You're lucky" (uttered by Iura and Sasha), and so forth. For instance, Alisa's love of ballet generates two episodes of her unfortunately belated arrival for auditions in two different locations; her repeated appearance as a child ballerina in her dreams; a shot of a young man posting an ad for a ballet school that she intermittently peruses on the metro; and the final image, from her horizontal perspective when dead in the street, of an ideal little girl in a white tutu. Interspersal of this sort aids in creating an impression of continuity, if not cohesion. Yet the multitude of mixed responses to the film suggests that particularly its abrupt death ex machina at the conclusion proves problematic for viewers, even those appreciative of Melikian's spirited efforts to bring humor to a tale of unrequited love typically associated with sentimentalism and a reception of teary-eyed sympathy. In her next film, *Star*, Melikian resorted to analogous devices, but with a firmer control over structure and somewhat more convincing results.

Helena Goscilo

Further Reading

Crane, Chip. "Anna Melikian: *Mermaid* (*Rusalka*, 2007). *KinoKultura* 20 (2008). Accessed July 3, 2018. http://www.kinokultura.com/2008/20r-rusalka.shtml.

Doubivko, Lena. "No nailing fins to the floor: ambivalent femininities in Anna Melikian's *The Mermaid*." *Studies in Russian and Soviet Cinema* 5, no. 2 (2011): 255–76.

Goscilo, Helena. "The Danish Little Mermaid vs. the Russian Rusalka: Screen Choices." In *Hans Christian Andersen and Russia*, edited by Marina Balina and Mads Sohl Jessen. Odense: University Press of Southern Denmark, 2018.

Mihailova, Mihaela. "'I am Empty Space:' A Mermaid in Hyperreal Moscow." *KinoKultura* 34 (2011). Accessed July 7, 2018. http://www.kinokultura.com/2011/34-mihailova.shtml.

HIPSTERS*

Stiliagi

2008

136 minutes (director's cut), 125 minutes (American release)

Director: Valery Todorovsky

Screenplay: Iury Korotkov and Valery Todorovsky

Cinematography: Roman Vas´ianov

Art Design: Vladimir Gudilin

Composer: Konstantin Meladze

Reworked Lyrics: Ol´ga Tsipeniuk

Choreography: Oleg Glushkov and Leonid Timtsunik

Costumes: Aleksandr Osipov

Sound: Sergei Chuprov

Producers: Leonid Lebedev, Leonid Iarmol´nik, Vadim Goriainov, Valery Todorovsky

Production Company: Red Arrow Cinema Company (Kinokompaniia Krasnaia Strela), Television Channel Russia (Telekanal Rossiia)

Cast: Anton Shagin (Mels), Oksana Akin'shina (Pol'za), Evgeniia Brik (Katia), Maksim Matveev (Fred), Ekaterina Vilkova (Betsi), Igor´ Voinarovsky (Bob), Konstantin Balakirev (Dryn), Sergei Garmash (Mels's father), Oleg Iankovsky (Fred's father), Irina Rozanova (Pol´za's mother), Leonid Iarmol´nik (Bob's father), Aleksei Gorbunov (old jazzman)

* Part of this essay was published in *Kinokultura* 50 (2015).

Career

Valery Todorovsky (b. 1962), the son of director Petr Todorovsky, is a leading figure of the current middle generation of Russian filmmakers. Todorovsky graduated from the scriptwriting department of the All Union State Film Institute (VGIK) in 1984. He had initially applied to the more prestigious directing department and was rejected, but in retrospect felt that his training had taught him to "think dramaturgically," to learn how to develop a narrative effectively, whether through plot dynamics, editing or music.[1] Since 1990, he has made nine feature films, discovered stars such as Yevgeny Mironov, Chulpan Khamatova, and Vladimir Mashkov, and has produced film and TV hits, such as *Kamenskaia* (1999–2005), *Brigada* (2002), *The Idiot* (an adaptation of the Dostoevsky novel, 2003), *Hunting the Piranha* (*Okhota na Piran'iu*, 2006), *Hipsters* (2008), *Kandahar* (*Kandagar*, 2010), *The Geographer Drank His Globe Away* (*Geograf globus propil*, 2013), *The Thaw* (*Ottepel'*, 2013), *Poddubnyi* (2014), *The Optimists* (*Optimisty*, 2017), and *Bol'shoi* (2017). His early films had little resonance in Russia because of the collapse of the distribution system in the 1990s, but they have since been widely recognized.

Todorovsky has always sought a middle path between arthouse and commercial film, making idea dramas that are stylistically accessible to broad audiences:

> There are people who supposedly film art with the words "we're not interested in the viewer." This turns out to be arthouse. Films of genius, perhaps, but no one watches them. There is commercial film about which people say, "We're doing this for the viewer, to entertain him." Often this fails. Sometimes it hits the mark. But more often it's very weak cinema, from the perspective of artistry. [. . .] Everything that's in between, in the middle—that is genuine

[1] "Valerii Todorovskii. O 'Stiliagakh' i o mnogom drugom," interview by Sergei El'kin, October 25, 2009, accessed January 29, 2017, http://sergeyelkin.blogspot.ru/2009/10/blog-post_25.html.

film. But there's no demand for it. It's not entertaining enough to become commercial. It's not complicated enough to become arthouse. However, if we look at the Americans for example—we're going to involuntarily correlate with them somehow—during the past year it's precisely these films that are in the middle that amazingly racked up Oscars, on the one hand, and made money on the other. Take the film *Black Swan* or the Coen brothers' *True Grit*, or *The Fighter*. All of these prize-winning films are very audience-oriented. I would say it this way: this is the cinema I love, cinema shot by talented people expressing what really pains them, in a language that is understandable to everyone. [. . .] All my life I've tried to go in this direction. It's difficult here because it's considered unpromising. [. . .] I like films with good dramaturgy, good acting, strong stories, not made for idiots, but such that they are widely seen, that's all.[2]

It was this conviction that eventually led to *Hipsters* and then *The Thaw*, Todorovsky's turning to television.

Through the early 2000s, Todorovsky made psychological dramas taking place in circumscribed spaces, typically interiors, and with one or more marginal characters set against "normal" individuals from mainstream Russian society. In his first film, *The Catafalque* (*Katafalk*, 1990) all three central characters—the widow of a high party official who has withdrawn from life, her mentally impaired but attractive daughter, and a young vagabond—are misfits who, for various reasons, are alienated from conventional Soviet society. To allay her fears about her daughter's future, the widow persuades the young man to marry the girl, but he abandons her after the ceremony, departing in his true love object, the widow's large automobile. The film evokes the late Soviet era—a decrepit

[2] Valerii Todorovskii, "Obsuzhdenie: Stenogramma programmy "Stop-kadr," interview by Roman Olenev, May 26, 2015, accessed January 29, 2017, http://newlit.ru/forum/index.php?topic=5022.0. See also "Valerii Todorovskii. Interv'iu bral M. Vereshchagin," no date, accessed January 29, 2017, http://m-voice.ru/portfolio-item/1022.

ruling elite, the rise of the trickster-conman, and the hoodwinking of helpless citizens.

In *Love* (*Liubov'*, 1991) the naïve Russian hero falls in love with a Jewish girl and discovers an entire marginalized and persecuted group to which he was previously oblivious. In *Katia Izmailova* (1994) the heroine's sexual obsession with a handsome local carpenter sunders her from her normal (read hypocritical) husband and mother-in-law. In *The Land of the Deaf* (*Strana glukhikh*, 1998) the conventional heroine, Rita, bonds with the deaf stripper Iaia, ultimately escaping into deafness from the quotidian, normalized violence of Russian society. In *The Lover* (*Liubovnik*, 2002) the successful, complacent husband and the self-marginalized lover of a dead woman duke it out à deux (mostly verbally) until their fraught bond is severed by departure and death. In *My Stepbrother Frankenstein* (*Moi svodnyi brat Frankenshtein*, 2004), which polemicizes with Aleksei Balabanov's *Brother*, the outsider is a mentally and physically damaged soldier-survivor of the second Chechen war who upends the life of an ordinary Moscow family; however, except for the young daughter, family members prove to be just as capable of violence as the deranged Pavlik. The military drumbeat at the beginning and end of the film insists on a war not only there, in Chechnia, but also at home.

Up to this point, Todorovsky had directed intimate psychological dramas, while experimenting on the way with elements of different genres and modes: *Catafalque* as grotesque melodrama and adaptation, *Love* as romantic melodrama, *Katia Izmailova* as noir and modern adaptation, *Land of the Deaf* as women's and gangster drama, *The Lover* as psychological dialogue-drama, and *My Stepbrother Frankenstein* as psychological drama and thriller. At that point Todorovsky felt the need for a change: "Speaking of form, I shot *The Lover* and *My Stepbrother Frankenstein*, and at a certain moment understood that I was getting onto a fairly narrow path: two people in one set sorting things out between them. [. . .] It was wonderful. I did this with great pleasure, and this is normal. It's not pandering to the public; in *The Vise* (*Tiski*) I began to want streets, alleys, yards, clubs, discotheques, sultry nights, sex . . . I wanted to burst into that

life, and live and breathe it. In *Boogie* [the original title of *Hipsters*] I wanted spectacle."[3]

In *The Vise* (2007), the young hero living a normal life is caught between two marginals: a police officer–former drug addict obsessed with eradicating dealers in his town and his enemy, the local druglord, both of whom trap him into working for them. In the musical *Hipsters* the upstanding Komsomol member Mels, motivated by unexpected love, joins the enemy marginals, the *stiliagi*. With *The Thaw*, the controversial TV series about his father's generation of film workers, Todorovsky returned to the psychological drama in which, as he has explained, one can tell about people quietly and in detail.[4] The gifted but troubled cameraman, Vitia Khrustalev, is a complicated marginal, a Thaw era superfluous man, constantly at odds with the more conventional people close to him (his ex-wife, his current girlfriend, his father, his co-workers), as well as the powers that be (the studio head and a retrograde prosecutor who accuses him of murder). Another marginal, the gay costume designer Sansha, is beaten and outed by a straight actor friend who has him arrested but he is saved by another marginal of the Thaw era, a *female* camera operator. *Bol'shoi* (2017) is a melodrama about another outsider, Iuliia Ol'shanskaia, from the provincial town of Shakhtinskoe, who gains a chance to become a principal dancer at the Bol'shoi Theatre after various peripaties. The film is most interesting for its portrayal of the competitive world of Russian ballet and for Alisa Freindlich's brilliant performance as Iuliia's crusty teacher-mentor grudgingly slipping into senility.

3 Valery Todorovsky, "The bitter truth was hard to accept at all times," interview by Svitlana Agrest-Korotkova, August 6, 2013, accessed February 9, 2017, https://day.kyiv.ua/en/article/culture/valery-todorovsky-bitter-truth-was-hard-accept-all-times; Andrei Zakhar'ev, "Kto luchshe vsekh tantsuet tvist i rok-n-roll . . . ,"June 1, 2007, accessed January 29, 2017, http://www.film.ru/articles/kto-luchshe-vseh-tancuet-tvist-i-rok-n-roll.

4 "Valerii Todorovskii and Evgeniia Brik: about the daughter, collaboration and cinema," 2013, accessed January 29, 2017, http://direct-beauty.ru/stars/interview/1184-valeriy-todorovskiy-and-evgeniya-brik-about-the-daughter-collaboration-and-cinema.

Hipsters and the Historical *Stiliagi*

Hipsters was among the top grossing Russian films of 2008, with $16, 810, 383 in ticket sales and almost three million viewers in Russia and Ukraine. The film's budget was fifteen million dollars, highlighting the difficulty of making a substantial profit on non-blockbuster Russian films.[5] *Hipsters* has been influential in three areas of Russian cinematic culture: genre revival in the film industry, the arguments about the Soviet past, and the viability of a social message with contemporary reverberations. Set in 1955–56, the slippery time loosely framed by the death of Stalin and Khrushchev's secret speech at the Twentieth Party Congress, the film deals with a group of jazz-loving dandies, led by Fred (Fedia), the son of a Soviet diplomat, who imitate what they suppose to be an American phenomenon, and are persecuted by the Komsomol and the KGB. *Komsomolets* Mels (named for Marx, Engels, Lenin, and Stalin), literally falls for a *stiliaga* girl, Polly (Polina) or Pol'za[6] when she pushes him into a lake. Mels transforms into the *stiliaga* Mel and eventually marries Pol'za, who gives birth to a mulatto baby and becomes an ordinary Soviet mother, straining the relationship. Nevertheless, Mel and Pol'za are ultimately reunited in a traditional ending for the musical, as *Hipsters* extends its message of inclusivity from the couple to the outside world of a fantasy present.

To date, *Hipsters* is the only post-Soviet musical film—a bold attempt to return a mainstream genre to cinematic mass culture. In a landscape dominated by patriotic blockbusters and simplistic comedies featuring media personalities, Todorovsky put forth his

5 "*Stiliagi* boks-ofis," accessed August 11, 2015, http://www.kino-teatr.ru/kino/movie/ros/661/annot/. The comedy *Liubov'-morkov'* 2 surpassed *Hipsters* with $17, 846,362 in sales. To attract more viewers, *Hipsters* was marketed as a "fil'm-prazdnik" (holiday film), suitable for New Year's entertainment. The film won *Nika*, *Zolotoi orel*, and *Belyi slon* prizes, as well as awards at other minor international festivals.

6 *Pol'za* denotes "use" or "benefit," her initial function in converting *komsomolets* Mels, but her name is also an acronym for *Pomni leninskie zavety* ("Remember Lenin's precepts"), an ironic reversal for a *stiliaga* girl.

musical as the conscious choice of a third way: "Every director must, at least once in his life, make a film accessible to everyone without exception."[7] As a visual and auditory surface phenomenon (colorful clothes, jazz song and dance music), the *stiliagi* were, in fact, perfect subjects for a musical film.

The historical *stiliagi* were a youth subculture that emerged after World War II and existed up to the early 1960s, gradually spreading from Soviet urban centers to the provinces.[8] They formed the first openly non-conformist group, but had no ideology or political agenda and cannot be considered dissidents. The *stiliagi* espoused aspects of American and western European culture in dress, music, dance, and speech, adopting the name *shtatniki*, from "United States," in a later iteration of the movement. "*Stiliagi*," from *stil'* (style) or *stiliat'* (to play jazz in a borrowed style), was originally a propaganda label introduced during the campaign against "rootless cosmopolitans" by D. G. Beliaev in a March 10, 1949 article in the satirical magazine *Krokodil*. Famous one-time *stiliagi* included filmmaker Andrei Tarkovsky, writer Vasily Aksenov, and director and actor Mikhail Kozakov. During the Soviet era the *stiliagi* were consistently depicted as criminals in such films as *The Case of the "Motley" Gang* (*Delo "pestrykh,"* 1958).

Postwar shifts in Soviet society facilitated the appearance of *stiliagi* culture, as increasing international contacts during and after World War II destroyed prewar isolation. Soldiers brought back western clothing and music from Germany, more diplomatic families and industrial specialists were sent abroad after the war, Western radio broadcasts, such as the Voice of America, penetrated the Iron

7 Valerii Todorovskii, "Nuzhna smelost' nadet' zelenye noski!," interview by Ian Levchenko, February 25, 2009, accessed August 12, 2015, http://www.peoples.ru/art/cinema/producer/valeriy_todorovskiy/interview7.html.

8 "My Mom remembers how during her youth *druzhinniki* (civilian public order volunteers) walked around, ripping open *dudochki* (narrow trousers), cutting *kanadki* and *koki* (*stiliaga* hairstyles). . . . And this wasn't in Moscow, but in the very proletarian Donbass, in the town of Gorlovka! So the *stiliagi* were everywhere." Bartalomeo, "Stiliagi, retsenziia," January 8, 2009, accessed February 9, 2017, http://bartalomeo.livejournal.com/28034.html.

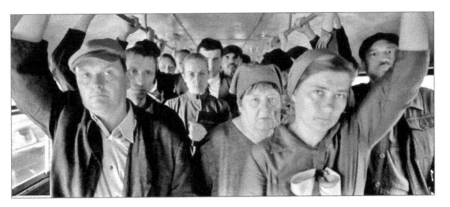

Fig. 1. Ordinary Soviet people.

Curtain with jazz music, and trophy films released in the USSR modelled a glamorous lifestyle that contrasted with the extreme poverty of postwar existence. As eager consumers of material goods, viewed in ideological terms as an anti-Soviet activity, the *stiliagi* opposed themselves to the industrial production economy. Both their consumerism and alternative lifestyle were a protest against Soviet collectivity which imposed physical, intellectual, and moral uniformity on the population (Fig. 1). In some sense, the more superficial freedom espoused by the *stiliagi* was a harbinger of the inner freedom and individualism of Thaw culture.

The first wave of *stiliagi* shocked the general population by their appearance (Fig. 2). The men favored longer hair brushed back and brilliantined into a pompadour or *kok* à la James Dean

Fig. 2. Cinematic stiliagi.

and Elvis Presley. Their clothing consisted of narrow trousers, a long jacket with wide shoulders, a very narrow *seledka* (herring) tie or a brightly colored one called *pozhar v dzhungliakh* ("fire in the jungle"), and shoes with a thick white rubber sole (*mannaia kasha*, "cream of wheat"). In winter they wore sweaters with reindeer figures (borrowed from films such as *Sun Valley Serenade),* while in summer they wore colorful Hawaiian shirts. Female dress was less specific: heavier makeup than the norm, complicated hairdos, narrow or very full skirts, and stockings with black seams (often drawn on bare skin because a deficit item). Fred, the leader of the *stiliagi* in the film, who dyes his English bulldog red and then green, is based on the *stiliaga* Iulian Semenov. According to Todorovsky, "This is a real story. And it wasn't just for no particular reason. He painted the dog in order to go out on the street, to show the crowd that even my dog is colorful, while you are grey."[9] In larger cities, the *stiliagi* created public spaces for themselves on the *Brod* (Broadway) or main street where they displayed themselves and examined other *stiliagi* during late evening strolls. In Moscow, the stiliagi occupied the left side of Tverskaia (then Gorky St.) from the Pushkin monument to the Manezh, while ordinary citizens walked on the right side.[10]

The *stiliagi* listened to American jazz ("Chattanooga Choo-choo" with its promise of travel-escape was an unofficial anthem), later moving into improvisation, and developed their own dance moves. Until the early 1960s, when tape recorders became widely available, they copied jazz music onto used x-ray film

[9] "Q and A with V[alery] Todorovsky about 'Hipsters,'" June 10, 2010, Seattle, accessed February 18, 2017, http://pol-video.ru/oJJRTY_sU1I/todorovskij_o_filme_stilyagi___todorovsky_about_hipsters.html.
 Volha Isakava suggests correctly that the English-language title "Teddy Boys," rather than "Hipsters" would have better conveyed the nature of the *stiliaga* rebellion. See Isakava, in Further Reading.

[10] Nina Dorda, "Menia perevospityvala ministr kul´tury," interview by Maia Mamedova, *Trud,* May 5, 2005, accessed February 9, 2017, http://www.trud.ru/article/05-05-2005/87272_nina_dorda_menja_perevospityvala_ministr_kultury/print/.

(a cheap source of plastic), as shown at the beginning of *Hipsters.* The original title of the film was *Bugi na kostiakh* ("Boogie on the Bones"), but the distributors objected that the reference would be incomprehensible to younger audiences.[11] The *stiliagi* also developed their own slang, some of it based on English words: *shuzy* (shoes), *maniushki* (money), *khetok* (hat). The derivation of *chuvak* (male *stiliaga*, dude) and *chuvikha* (female *stiliaga*, chick) remains unknown. Persecution of *stiliagi* subsided after the 1957 Moscow International Youth Festival, which allowed large numbers of foreign visitors and foreign styles into the country, and contributed to changing perceptions among the general population.

The Making of *Hipsters*, Structure and Meaning

For obvious reasons, during the Soviet era the State Film Institute did not train students to make commercial films. However, Todorovsky had admired the Fred Astaire-Ginger Rogers-Gene Kelly musicals since his student days and had long wanted to try his hand at the genre. The first version of the scenario for *Hipsters* was written circa 1999, but gathered dust until it became possible to think about obtaining the financing to make a musical film.[12] Together with his Red Arrow company, his co-producers, and with financial help from billionaire politician Mikhail Prokhorov, Todorovsky decided to risk a big budget musical production. Even so, he had to make *The Vise* in order to keep his cast employed during the peripeties of the financing process.

Todorovsky soon discovered that the practice of musical film had been completely lost in Russia:

> No one knows how it should be made. It broke off, in my view, back in the time of Mikhail Grigor'ev and Grigory Aleksandrov. [. . .] The absence of a tradition means that everything has to be invented from scratch. There was

[11] Valerii Todorovskii, "O Stiliagakh i o mnogom drugom."

[12] Valery Todorovsky, "The bitter truth was hard to accept at all times."

Aleksandrov who loved musicals and even studied the genre in Hollywood. But remember: when he was making his films, beside him was a person like Dunaevsky, a genius who was constantly coming up with melodies. He had a hit every two weeks. There was Liubov´ Orlova, a singing and dancing star. And that became the reason for the brief renaissance of the Soviet musical, because many different factors coincided.[13]

The composers Todorovsky contacted for *Hipsters* were enthusiastic, but ultimately unable to create original songs. He then thought of using archival recordings from the fifties, but it turned out that the *stiliagi* had listened primarily to foreign music, which would be impossible to replicate in a Russian-language musical.[14] Instead, Todorovsky had composer Konstantin Meladze arrange rock classics of the seventies and eighties (largely unfamiliar to young audiences), with a partial set of new, film-appropriate lyrics by Ol´ga Tsipeniuk. Todorovsky justified this less than ideal solution by pointing out that first wave rockers had demanded individual freedom and social change even more insistently than the apolitical *stiliagi*. They were essentially the children of the *stiliagi* generation and had similarly created their own counterculture.[15]

The songs and lyrics of *Hipsters* were, in fact, constructed ingeniously using three strategies. In the simplest cases, such as "Man and Cat" ("Chelovek i koshka") and "I'm What You Need" ("Ia to, chto nado"), the tempos were altered and the original lyrics

[13] Valerii Todorovskii, "*Stiliagi* (fil´m, 2008)—Istoriia sozdaniia," accessed August 11, 2015, http://4461.ru/t/stiliagi_film_2008_-_istoriya_sozdaniya. Mikhail Grigor´ev (Mikhail Gutgarts, 1925–79) worked as a theater director beginning in 1950, but became a television director of musical films and comedies in 1956; Valerii Todorovskii, "Ochen´ chestnye skazki," interview by Andrei Zakhar´ev, June 13, 2007, accessed February 26, 2017, http://viperson. ru/articles/ochen-chestnye-skazki.

[14] Valerii Todorovskii, interview by Sergei Nekrasov, *Kinobiznes segodnia* 170 (2008), accessed February 10, 2017, http://krasnayastrela.ru/?page_id=24.

[15] "Valerii Todorovskii o 'Stiliagakh', den´gakh, sekse i kinokritike," interview by Fearless, December 4, 2008, accessed February 26, 2017, http://fantlab.ru/ blogarticle1778. *Moulin Rouge* (Baz Luhrmann, 2001) also reworks several decades of popular songs.

left unchanged, but adapted to a different context. For example, the lyrics of "Man and Cat" (Fedor Chistiakov and the group "Nol'") actually refer to a user waiting for his drug dealer to arrive, while in *Hipsters* the song and dance number comments ironically on life in a communal apartment and Mels's father's family history. A second group of adaptations uses the original melody, adds completely new lyrics (as relevant to the film), but mediates meaning between the old and new versions.[16] Consequently, in the film the ideological "Fettered by the Same Chain" ("Skovannye odnoi tsep'iu") resonates with the protest against conformism of the Nautilus Pompilius original.[17] "Eighth Grade Girl" ("Vos'miklassnitsa"), which voices the love scene in *Hipsters*, completely replaces the lyrics of the Viktor Tsoi original, yet the latter is similarly affectionately sexual in Tsoi's rendition. Furthermore, the *Hipsters* version inserts the word *vos'miklassnitsa* at the very end of the song about Mel and Pol'za's love—not fully logical, but a baring of the device. In the third strategy, the lyrics of a song are partially altered to correspond to the filmic narrative, but in each case a striking refrain is preserved. "My Little Baby" ("Moia malen'kaia beiba") and "Let Everything Be as You Wish" ("Pust' vse budet tak, kak ty zakhochesh'") are examples. In "Shaliai-valiai" (translated in the American release as "Go on and play!") the original lyrics are preserved, as is the refrain, but one new stanza is added to sum up the *stiliaga* experience: "Ty znaesh', ved' vse neplokho, / Etot stil' pobezhdaet strakh. / Eta divnaia, zlaia, smeshnaia epokha / Nas s toboiu ne sterla v prakh. / Davai zapomnim eti litsa i plastinki ostryi krai, / I pust' khranit nas liubov'. / Shaliai-valiai!" ("You know, it's not all bad after all, / This style overcomes fear. / This wonderful, wicked, funny era / Hasn't ground you and me into dust. / Let's remember these faces

[16] For a list of the original songs recast for the film, see the soundtrack section of "*Stiliagi* (fil'm, 2008)" in Russian Wikipedia, accessed May 30, 2017, https://ru.wikipedia.org/wiki/.

[17] Commentators have noted the formal influence of Pink Floyd's "Another Brick in the Wall" from the film *The Wall* (Alan Parker, 1982), although in the latter the schoolchildren detest their condition, while the Komsomols of *Hipsters* ostensibly enjoy their collectivity.

and the record's sharp edge, / And may love keep us safe. / Go on and play!")

Choreographers Oleg Glushkov and Leonid Timtsunik had never worked in film; neither had the dancers hired for *Hipsters*, and both were unused to the boundaries of the film frame and shifting perspectives. After six months of rehearsals, half the dancers left the project and new performers had to be found. The director himself felt unsure when faced with filming a large crowd scene:

> When, for the first time in my life, I saw on the set a crowd of one thousand, dressed in fifties-style costumes, and then remembered that at the same time the computer guys were drawing in old Moscow, I was scared. I'm a responsible person and think that, when you spend a lot of money, you need to answer for it. Earlier I had only read about Hollywood directors who felt themselves much more inhibited with hundred million dollar budgets than with modest films. The less money, the more freedom."[18]

But in the end Todorovsky successfully staged a world cinema genre grounded in a localized, national subject. According to Rick Altman's subject typology, *Hipsters* is a variant of the show musical: the hero becomes a *stiliaga*-singer-saxophone player, and his transformation—the making of a star—parallels the making of the couple.[19] In a version of Richard Dyer's form-based scheme, numbers such as "I'm What You Need" or "Go On and Play" provide solutions to problems in the narrative (Pol'za's initial rejection of Mels; societal rejection of difference).[20] In contrast, "My Little Baby" and "Let Everything Be as You Wish" are performances

[18] "Todorovskii pro 'Stiliag,'" interview by Lelia Smolina and Vladimir Zakharov, *Empire*, November 18, 2008, accessed February 25, 2017, http://www.webcitation.org/5w9gGbq6R.

[19] Rick Altman, *The American Film Musical* (Bloomington, IN: Indiana University Press, 1989), 200.

[20] Richard Dyer, *Only Entertainment*, 2nd ed. (New York: Routledge, 2002), 28. Todorovsky does not try to integrate such numbers into the narrative by obvious song cues, but prefers to use editing cuts that do not disrupt the narrative.

in the cocktail club frequented by the *stiliagi*, keeping narrative and number formally separate. *Hipsters* is a true musical in which songs do not function simply as inserted musical interludes. Todorovsky was clear about the definition: "Films where the hero picks up a guitar and sings—this isn't a musical. In a musical both the plot and the relationships between heroes are decided through the music. In the film *All That Jazz* the great Bob Fosse showed the death of the hero through musical numbers!"[21] Together with their choreographed images, the songs in *Hipsters* further the narrative, as they convey the thoughts or feelings of the hero, while parallel images depict relevant events or actions undertaken by the hero. None of this, neither feelings nor actions, is repeated in dialogues.

"Man and Cat" is the most complex example of this method, in which at times lyrics even coincide with images. The musical set-piece tells the story of Mels's father in shots of his communal apartment and its inhabitants intercut with episodes from the father's past. The lyrics "Doktor edet, edet" ("The doctor is coming, coming") coincide with a shot of a man coughing in the communal apartment. "I toska proidet" ("And the anguish will pass") comments on the scene of the father's concussion during World War II bombing. "Poroshok tot primut" ("They'll swallow that powder") parallels a shot of the communal dwellers brushing their teeth with tooth powder ("zubnoi poroshok"), while a later repetition of the phrase alliterates with a primus being pumped ("primus" ↔ "primut"), as shown onscreen. The lyrics "Gde ty, belaia kareta? / V stenakh tualeta chelovek krichit" ("Where are you, white carriage?[22] In the bathroom a man screams [in pain]") accompany a flashback in which the father returns from the war, only to find his wife in bed with her lover. The concluding "I toska proidet" ("And the anguish will pass") overlays the two now grown sons

21 Valerii Kichin, "'Stiliagi' Todorovskogo," *Rossiiskaia gazeta*, federal'nyi vypusk 4814, December 17, 2008, accessed February 18, 2017, https://rg.ru/2008/12/17/stilyagi.html.

22 In the Russian song, "white carriage" refers to an ambulance.

saying a happy goodbye to the father as the three go off to work and school. The musical-visual registers of other production numbers, such as "I'm What You Need," "My Little Baby," "Let Everything Be as You Wish," and "He Doesn't Need an American Wife" ("Emu ne nuzhna amerikanskaia zhena") function on the same principle. The structure of "Song of the Old Jazzman" ("Pesnia starogo dzhazmena") and "Fettered by the Same Chain" is simpler. In the latter, the alliterating lyrics "Skovannye odnoi tsep'iu, / Sviazannye odnoi tsel'iu" ("Fettered by the same chain, / Bound by the same aim") are reinforced by rap rhythms and collective, synchronized movements (banging desks, bodies swaying side to side), as the lyrics describe Mels's censure at the Komsomol meeting.[23]

Todorovsky uses only two foreign jazz songs, but they occur at critical junctions in the film, in both instances when Mels absorbs the jazz spirit. (Mels's saxophone improvisations represent freedom from the rigidity of the Soviet system.) Marc Bolan and T. Rex's "I Love to Boogie," in a new arrangement, undergirds Bob's teaching Mels to dance like a *stiliaga*. The Charlie Parker rendition of Gershwin's "Summertime" helps Mels learn to play the saxophone by ear, first from a Voice of America broadcast, then from a black jazzman who appears magically in the doorway, improvises with him and, as the music possesses Mels, both are transported to 1940s New York. The melancholy "Summertime" also signals the demise of the *stiliagi*, playing on the soundtrack as Bob is arrested and Fred returns as a conformist who denies the existence of *stiliagi* in the US.[24] Impressive production numbers like "Man and Cat" and "Bound by the Same Chain," together with dynamic cinematography, full of rapid editing, shifting angles, crane, zoom, and tracking shots, gave the film the energy, high spirits, and humor that made it attractive to Russian audiences.

[23] The growing accusatory hysteria of the meeting is staged rhetorically, perhaps as reminiscent of the show trials.

[24] Todorovsky explained, "He lied. They existed. He simply stopped seeing them. He's already 'a man in a suit'." ("Q and A with V. Todorovsky about 'Hipsters'")

Todorovsky explained that, although the historical *stiliagi* were all about music, clothing, and sex, as a musical, the film was more of a "fantasy on our fifties" rather than realistic depiction.[25] "*Hipsters* doesn't recreate the past at all. I chose the fifties because there was a very sharp confrontation at that time. They simply didn't have time to get to the question of who feels or thinks what. Everything began from how someone looks."[26] In researching *stiliagi* dress, Todorovsky discovered that their clothes, though radically different from ordinary Soviet wear of the time, would seem totally conventional to modern audiences who would then not understand the scope of their rebellion. To underscore the sartorial abyss between ordinary citizens and the *stiliagi*, the film's costume designer resorted to much brighter, bolder, and more eccentric fashions for both male and female characters than existed historically (Fig. 2). As a "fantasy on our fifties," the playful retro atmosphere is reinforced by the use of handwritten inscriptions with arrows pointing to different locations, resembling a former *stiliaga*'s notations on old photographs: "Moscow 1955," "Broadway," "The pad, the keys to which Nolik gave to Mels," "Here John was born," "Mels's mother-in-law's place," and so on. These inscriptions on panoramic postcard views combine to create historical distance.

Nevertheless, *Hipsters* provoked heated discussions about this colorful chapter of the Soviet past. The website Kinoteatr. ru maintains online comments on the film that typify the range of viewer reactions.[27] These were divided between a focus on historical truth vs. the view that the film could only be evaluated as a musical, that is, within the context of its genre. In the first category viewers either saw the depiction of the era and the *stiliagi* as largely accurate, pointing to Tarkovsky and Aksenov's *stiliaga* phases, and describing pressures to conform. Others viewed the film as

25 "Valerii Todorovskii o 'Stiliagakh', den'gakh, sekse i kinokritike."

26 Valerii Todorovskii, "Nuzhna smelost' nadet' zelenye noski!"

27 As of February 25, 2017, there were 931 comments on the website.

exaggerated regarding lack of freedom of expression, and even a slander on the country.[28]

Along with Balabanov, Andrei Zviagintsev, Aleksei Fedorchenko, and Petr Lutsik, Todorovsky belongs to the generation born in the late fifties to mid-sixties that experienced the chaotic but also liberating 1990s as young professionals: "this was a fantastic, unique time for Russia—a time of extraordinary freedom. It was probably the most free country in the world. [. . .] The foundations for the very best things happening in Russia now [2009] were laid then."[29] In a climate of increasing imperialist ambitions reminiscent of the Soviet era and an eroding freedom of public discourse leading to anti-government protests in 2007–8, Todorovsky described his film as a "fairytale about our country, in which the most difficult thing was always not to resemble others and to be free." According to Todorovsky, "in the 1950s the *stiliagi* were simply the quintessence of freedom. In a closed country in which everything was known ahead of time—how to look, how to dress, what to think and what to say, people chose to become different, actually risking their lives."[30] Although *Hipsters* has no pretensions to documentary verisimilitude, both the 2008 musical (a western genre) and the *stiliagi* era it constructs share the same oppositional turning toward the West in the face of the 1950s Cold War mentality and the contemporary rise of the imperial Putin regime.

[28] One colorful comment: "I managed to be in time to catch the *stiliagi*. I didn't like them much, there was too much épatage. [. . .] But I remembered one *stiliaga* shirt my entire life—a bright green one with little pictures, a sax on the back. From the keys hung rope swings and on the swings were half-dressed girls—that made an impression! The dude (*chuvak*) was walking past the Central Committee of the Ukrainian Communist Party [building], which was also pretty provocative" (*Kinoteatr.ru*, accessed December 10, 2015, http://www.kino-teatr.ru/kino/movie/ros/661/forum).

[29] Valerii Todorovskii, "O 'Stiliagakh' i o mnogom drugom."

[30] "'Stiliagi' Todorovskogo v Rostove," December 17, 2008, accessed February 22, 2017, http://www.kalitva.ru/130105-stiljagi-todorovskogo-v-rostove.html; Valerii Todorovskii, "O 'Stiliagakh' i o mnogom drugom."

Hipsters against *Circus*

It is not at all surprising that in *Hipsters* Todorovsky quotes Grigory Aleksandrov's *Circus* (*Tsirk*, 1936) as the iconic Soviet urban show musical. In *Circus*, despite the film's ideological pronouncements, Marion Dixon initially decides to remain in the USSR because she has fallen in love with Martynov. In the same way, Mels becomes a *stiliaga* only because he has fallen for Pol'za. Using a different time frame referencing the fate of mixed-race "festival children," conceived during the 1957 Moscow international youth festival, Todorovsky readdresses the message of *Circus*, making a plea for individual and lifestyle—and not only racial—tolerance in post-Soviet society in the final unifying spectacle of *Hipsters*.[31] At the same time, he quotes several motifs from *Circus* in the film—and not all of them approvingly. Outside the maternity home ordinary Russian people (Mel's father and friends) welcome the mulatto baby, modelled on little Jimmy of *Circus*, as "ours." Unlike the more privileged urban party members and Komsomol students, Mel's father, a first generation worker from the countryside, wryly accepts his son's transformation as a normal rite of passage, thereby reconciling the peasantry with the *stiliagi*, if over the heads of urban *zhloby* (conformist squares): "I like it. In the village we also dressed up (*nariazhalis'*) to scare the girls." Later, however, there is a quotation of *Circus*'s lullaby episode, as the baby is passed around among grotesquely fawning *stiliagi* friends (Fig.3), until Pol'za angrily takes him away. By implication, the parodic episode, along with the mother's reaction, rejects the sentimental falseness of the *Circus* lullaby. Handing a startled baby around a crowd of admirers

[31] Iury Korotkov, author of the screenplay, underscored the right to individual freedom of expression as the message of the film: "This isn't a film about the *stiliagi* or the music; it's a film about the possibility of being free in conditions of non-freedom." ("Stiliagi (fil'm, 2008)," Russian Wikipedia). In the film the *stiliagi* come from all classes, from the children of the diplomatic elite (Fred) and the *nomenklatura* (Polly-Pol'za) to the offspring of professionals (Bob) and workers (Mel, Dryn). The need for individual self-expression thus crosses all class boundaries.

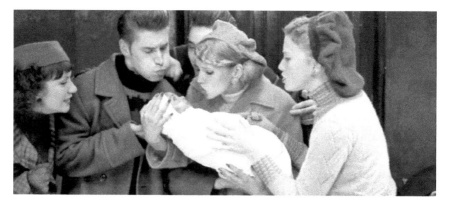

Fig. 3. The stiliagi welcome the baby.

may afford the latter gratification, or in the case of *Circus*, some politically kitsch emotions but, implies Todorovsky, the benefit is to the state, not the baby.

Earlier, at a secret *stiliaga* party, Mel and the pregnant Pol'za are attacked by Komsomol raiders. As they run to escape, they come face to face with a caged lion, a quick nod to Skameikin's duel with the trained lions of *Circus*. However, Todorovsky reverses the outcome of the episode from improbable comedic victory to a more bitter reality: Skameikin successfully fends off the lions with a bouquet of roses, while Mel is unable to save Pol'za from a punitive haircut.

In spite of its explicitly stated message of tolerance, *Circus* projects an underlying racist discourse in narrative, dialogue, and imagery.[32] Although Marion Dixon's affair with a black man occurs outside the *Circus* narrative and is not explicitly disparaged, the ideological message of the film is nonetheless that Marion's hypersexuality, as demonstrated by her desire for a black man, has been channeled into a proper and legitimate union with Martynov, the Stalinist New Man, who is white. In *Hipsters* the conception of Polly's child with a black man is framed very differently, as she explains to Mel:

[32] See Rimgaila Salys, *The Musical Comedy Films of Grigorii Aleksandrov: Laughing Matters* (Bristol: Intellect, 2009), 158–59.

—His name was Michael.

—One of ours?

—No, he was an American. He was walking along Sadovaia, trying to stop someone to find out where he was, and people kept running away from him.

—Did you love him?

—No, it was something completely different. Imagine, a person flew in from another planet only for a few hours. And there's so much to ask about them and so much to tell about us. But the minutes keep ticking away, and soon he must return to his rocket.

And we both know that we'll never see each other again.

Pol'za understands her meeting with the black American as an encounter with a visitor from another planet, as completely outside conventional moral boundaries, a supremely unique event, and therefore almost as a blessing. As a *stiliaga*, her contact with the foreign culture is then just as sincere as Mel's immersion in American jazz.[33]

Both *Circus* and *Hipsters* end with song and large crowd scenes. In *Circus* the disciplined, singing marchers move through Red Square, and Marion Dixon draws Raechka's attention to the unseen leader atop the mausoleum. In *Hipsters* a random crowd of punks, rastafarians, goths, emos, among others—some of the subcultures being attacked in Russia today, as were the *stiliagi* in the fifties—strolls along Tverskaia, along with twenty-somethings in jeans and even an occasional office worker, in the direction of the Kremlin (visible in the distance) singing the easygoing, carefree "Shaliai-valiai." Todorovsky thus concludes *Hipsters* with a pointedly inverted filmic quotation of *Circus*, including a reversal of Dunaevsky's "Song of the Motherland" ("Pesnia o rodine"), which ends the Aleksandrov film in military march tempo.

But *Hipsters* turns on two endings—one more realistically mundane, the other a fictional apotheosis. The first is a dramatic

[33] Todorovsky made an ironic comment after the release of the film: "Mel so much wanted to merge with this culture and this music. We gave this [the mulatto baby] as a gift to him." ("Q and A with V. Todorovsky about 'Hipsters'.")

epilogue that brings the optimism of the musical down to earth, foregrounds the coming-of-age motif introduced by the two fathers, and acknowledges difference as mutable. *Stiliaga* princess turned housewife Pol'za scolds Mel for the very saxophone playing that first brought her to him, and Fred, Mels's former mentor, explains to him that there are no *stiliagi* in the US. The Moscow *stiliagi* have dispersed—they have been drafted into the military, arrested, forced to leave the city, or turned to establishment careers and conventional social roles. Only Mel remains unchanged, as a necessary bridge to the second finale on contemporary Tverskaia, the "up" ending of classic musicals.[34] When this genre projects a concluding temporal shift, as in *Hipsters*, it also proposes a larger, symbolic message. In joining the *stiliagi* with contemporary subcultures in a fantasy present, the film validates and celebrates difference as essential to human freedom.

Outside the paradigm of the genre, it is possible to read the second ending, with its happy mix of non-conformist groups moving in the direction of the Kremlin, as an unwitting affirmation of greater tolerance under the current regime—possibly a reason for Channel One and NTV's enthusiastic advertising of the film. However, in 2008, Todorovsky was clearly taking aim at monolithic tendencies in Russian society: ". . . in general young people today, on the contrary, try to merge into one mass. They're sick of being different, now they want to be similar again. And what happens when all are similar? All sorts of *Nashi*[35] and the like." ". . .[T]his is our eternal theme: walk in formation with identical badges—or against everyone and in green socks."[36]

Rimgaila Salys

[34] Modern advertising on Tverskaia, the *stiliagi*'s "Brod," was purposely not erased in the ending scenes in order to underscore its contemporaneity.

[35] *Nashi* (2005–13) was a Russian right-wing Russian youth group modelled on the Komsomol and supported by the Kremlin. In 2007 it numbered approximately 120,000 members.

[36] "Valerii Todorovskii o 'Stiliagakh', den'gakh, sekse i kinokritike"; Todorovskii, "Nuzhna smelost' nadet' zelenye noski."

Further Reading

Beumers, Birgit. "*Hipsters*." In *Directory of World Cinema. Russia*, edited by Birgit Beumers, 143–45. Bristol and Chicago: Intellect, 2011.

Edele, Mark. "Strange Young Men in Stalin's Moscow: The Birth and Life of the Stiliagi, 1945–1953." *Jahrbücher für Geschichte Osteuropas*, Neue Folge 50, no. 1 (2002): 37–61.

Isakava, Volha. Review of *Hipsters* (*Stiliagi*, 2008). *KinoKultura* 25 (2009). Accessed June 1, 2018. www.kinokultura.com/2009/25r-stiliagi.shtml.

Kaganovsky, Lilya. "Russian Rock on Soviet Bones." In *Sound, Speech, Music in Soviet and Post-Soviet Cinema*, edited by Lilya Kaganovsky and Masha Salazkina, 252–72. Bloomington, IN: Indiana University Press, 2014.

Kozlov, Aleksei. *Kozel na sakse*. Expanded from the 1998 print edition. Accessed December 13, 2016. http://www.lib.ru/CULTURE/MUSIC/KOZLOV/kozel_na_saxe.txt. See in particular pp. 31–45.

Meerzon, Yana. "Dancing on the X-rays: On the Theatre of Memory, Counter-memory, and Postmemory in the Post-1989 East-European Context." *Modern Drama* 54, no. 4 (2011): 479–510.

Roberts, Graham H. "Revolt into Style: Consumption and its (Dis)Contents in Valery Todorovsky's Film *Stilyagi*." *Film, Fashion and Consumption* 2, no. 2 (2013): 187–200.

Starr, S. Frederick. *Red and Hot. The Fate of Jazz in the Soviet Union 1917–1991*. New York: Limelight Editions, 1994.

Stiliagi. Fil'm o fil'me (*Hipsters*. A film about the making of the film). Accessed February 20, 2017. youtube.com > watch?v=vo1YdjlDecw.

Stiliagi, film text in Russian. Accessed February 20, 2017. http://www.vvord.ru/tekst-filma/Stilyagi/.

SILENT SOULS

Ovsianki

2010

75 minutes

Director: Aleksei Fedorchenko

Screenplay: Denis Osokin

Cinematography: Mikhail Krichman

Art Design: Andrei Ponkratov

Production: Meri Nazari, Igor´ Mishin, AprilMigPictures,
 Mediamir Fund, 29 February

Cast: Iury Tsurilo (Miron), Igor´ Sergeev (Aist), Iuliia Aug (Tanya),
 Viktor Sukhorukov (Vesa, Aist's father)

IMAGINARY DOCUMENTS: INVENTING TRADITIONS IN ALEKSEI FEDORCHENKO'S CINEMA [*]

The document has always enjoyed a peculiar status in Russian cinema: rarely considered for its own importance, the cinematic document is often seen as a "weapon," as an expressive tool to fight an aesthetic battle. In Dziga Vertov's "unplayed" cinema (*neigrovaia fil'ma*), the emphasis on factography and the unmediated portrayal of life-caught-unawares was supposed to act as an antidote against the prosthetic psychologism and narrative straightjackets of the formulaic cinematic genres of the time.[1] The same distancing from dominant expressive canons and formats seems to be at stake in the current investment of Russian New Drama in the use of verbatim. The "uncombed" (and often violent) speech of teatr.doc has usefully expanded the scope of discursive ethnography of Russian society, providing a welcome alternative to highly stylized plots and strictly policed formats of glam-literature and film of the last decade.[2]

Aleksei Fedorchenko's films assume a special position in this newly inspired interest in the document. Since 2004, he has been producing a stream of films that deliberately blur the clear-cut distinction between the real and the imaginary, and between the documentary and the fictional. Of course, this approach is hardly new: real fictions (and fictitious realities) have become a major organizing framework for various performative projects. What makes Fedorchenko's engagement with the document interesting,

[*] A shorter version of this essay was published in *Kinokultura* 31 (2011).

[1] For details, see Elizabeth Astrid Papazian, *Manufacturing Truth: The Documentary Moment in Early Soviet Culture* (DeKalb, IL: Northern Illinois University Press, 2009) and Andrei Fomenko, *Montazh, faktografiia, epos: proizvodstvennoe dvizhenie i fotografiia* (St. Petersburg: Izdatel'stvo Sankt-Peterburgskogo gosudarstvennogo universiteta, 2007).

[2] Birgit Beumers and Mark Lipovetsky, *Performing Violence: Literary and Theoretical Experiments of New Russian Drama* (Chicago: Intellect and The University of Chicago Press, 2009).

though, is his profound investment in deploying conventions and features of documentary genres for creating worlds that never existed and situations that never occurred. While being deeply illusionistic and mimetic, his "documentary fairy-tales" (as he defines his films)[3] point to no original that they allegedly reproduce. All of his films are deeply embedded in history and/or ethnography, yet Fedorchenko always manages to turn history and ethnography into something else. From his very first film on early Soviet space programs, *First on the Moon* (*Pervye na lune*, 2005) to his latest film on the Soviet avant-garde, *Angels of Revolution* (*Angely revoliutsii*, 2014), Fedorchenko has mocked and undermined all the historical premises and ethnographic assumptions that made his films plausible in the first place.

Fedorchenko's cinematic biography began rather accidentally. An economist and engineer by training, he started his professional career in the late 1980s in a "closed" military plant in the Urals, computerizing its accounting system. Drastic economic changes in the country forced him to start his own business; for a while, he was a salesperson, selling everything from chocolate to processed cheeses. His first position at the Sverdlovsk Film Studio, a company with a long history of successful documentary films, was in the economics department: Fedorchenko was helping the new management to revive the studio that was looted and bankrupted during the privatization frenzy of the 1990s. Later, he supplemented his first-hand knowledge of cinematic processes by studying in the script-writing department (*stsenarnyi fakul'tet*) of VGIK, the leading cinema school in Russia.[4]

Fedorchenko's first full-length feature film, *First on the Moon*, was a 75-minute mockumentary about an "unknown," successful

[3] For more detail, see an interview with Aleksei Fedorchenko: Irina Semenova, "Real'nyi volshebnyi mir," *Iskusstvo kino* 10 (October 2010), accessed August 25, 2017, http://kinoart.ru/archive/2010/10/n10-article13.

[4] Ibid.; Natal'ia Bondarenko, "Moi fil'my—eto skazki dlia vzroslykh." *Ogonek* 34 (August 30, 2010): 43, accessed August 25, 2017, https://www.kommersant.ru/doc/1490171. See also the official site of Fedorchenko's film production company *29 February*, accessed August 25, 2017, http://29f.org/o-kompanii/managers/aleksei-fedorchenko.

voyage to the moon conducted by the first Soviet "cosmopilot" in 1938.[5] His second feature film, *Silent Souls* (*Ovsianki*, 2010) is also a mockumentary of sorts. Yet, unlike in his début, here Fedorchenko moves beyond the retrofitting of familiar plotlines and visual conventions (of the USSR's heroic history) with new content. Instead, he creates an ethnographic *trompe l'œil* by inventing a realistically detailed story about entirely invented customs of the actual Merya people. What is unsettled here is not a particular plot or myth, but rather the very desire to find ontological certainty and identificatory stability in a tradition carefully protected from the influence of the present. As *Silent Souls* suggests, traditions are indeed invented, made from scratch, and constantly woven into the fabric of the daily life. Rather than providing an emotional template, they mystify social relations. Instead of suggesting a clear direction in an uncommon situation, they obscure already available paths.

This skepticism about the value of history can, of course, be expected from a director who approaches the document as a source of artistic inspiration rather than evidence of authenticity. Yet Fedorchenko is no Sergei Kurekhin,[6] and *Silent Souls* is not a campy variation of the Lenin-was-a-mushroom genre. The point of Fedorchenko's *trompe l'œil* is not to defamiliarize the already known, but to imagine a counterfactual yet plausible past. To frame it differently: Fedorchenko does not just limit tradition to its deconstructive potential. Also, and perhaps more importantly, his emphasis on the fictitious, fabricated—and therefore changeable— nature of tradition helps move beyond the obsessive (and often parasitic) fascination with forms of the past by inventing new points of origin. As the director explained in an interview: "We invented

[5] See Alexander Prokhorov's review of the film in *KinoKultura* (2006), accessed August 25, 2017, http://www.kinokultura.com/2006/11r-firstmoon2.shtml,.

[6] Sergei Kurekhin (1954–96), musician, composer, actor, and scriptwriter, was known for his hoaxes and mystifications. His 1991 television broadcast "Lenin—grib," a satire on the Lenin myth (Lenin used hallucinogenic mushrooms and ultimately turned into a mushroom) and pseudo-scientific documentaries, went viral.

the mythology of the Merya people from scratch. We wanted to offer them a mythology that would not offend this people; the customs that could have existed."[7]

This reference to the Merya people could, however, be misleading. Taken for a ride by Fedorchenko's *trompe l'oeil*, *The Boston Globe* described *Silent Souls* as a "cinematic field guide to Merya traditions," as a restorative ethnographic project of sorts.[8] Restorative it is not: *Silent Souls* uses the fabricated "ethnic peculiarities of the disappeared people," as *The Boston Globe* puts it, to tell a basic existential fable about death and love. Taken together with such films as *The Lover* (*Liubovnik*, Valery Todorovsky, 2002), and *How I Ended This Summer* (*Kak ia provel etim letom*, Aleksei Popogrebsky, 2010), *Silent Souls* contributes to the emergence of a strange post-Soviet genre of the "pietà of our times," in which traditional gender roles are completely reversed.[9]

All three films use the death of a woman to initiate a story about two men sorting out their complicated relationship with each other. In *The Lover*, the widower becomes engaged in prolonged and painful exchanges with his wife's lover. In *How I Ended This Summer*, the sudden death of the protagonist's wife results in a convoluted psychological fight between the widower and his male intern. *Silent Souls* has nothing in common with the exalted emotional drama presented in *The Lover*, nor does it provide anything similar to the thrill of the psychological nightmare of *How I Ended This Summer*.

[7] Mariia Kuvshinova, "Rezhisser Fedorchenko sozdal v fil'me *Ovsianki* novuiu mifologiiu," *RIA Novosti*, September 4, 2010, accessed August 25, 2017, https://ria.ru/culture/20100904/272274687.html.

[8] Colleen Barry, "*Silent Souls* revives ancient Merja traditions," *The Boston Globe*, September 4, 2010, accessed August 25, 2017, http://www.boston.com/ae/movies/articles/2010/09/04/silent_souls_revives_ancient_merja_traditions.

[9] See reviews by Birgit Beumers (http://www.kinokultura.com/reviews/Rlover.html) and Mark Lipovetsky and Tatiana Mikhailova (http://www.kinokultura.com/2010/30r-leto.shtml), accessed August 25, 2017.

Yet, like these two films, it places the unlikely figure of the widower at the center of a story about coping and survival.[10]

This re-emergence of the trope of "men without women" is important. Unlike early Soviet variations of this theme, perceptively discussed by Eliot Borenstein,[11] the narrative disappearance of the woman in post-Soviet cinema is compensated neither by a rediscovery of the value of masculine camaraderie, nor by utopian visions of the global collective. Instead, the erasure of the woman is presented here as a menacing sign, as a symptom of the impending collapse of the man.

Silent Souls is based on a story published in the literary magazine *Oktiabr'* in 2008, in which Aist Sergeev describes a road trip with his boss, Miron.[12] The trip is a funeral ritual: Miron's wife suddenly died, and—as is common among the Merya people—her body should be cremated so that the ashes can be scattered in the river. Structured as a collection of non-dated diary entries, this allegedly autobiographic story is a thinly disguised mystification. The reader (and the film viewer) learns at the very end that the monologue is narrated by Aist from under water: after cremating the body of Miron's wife, the car with two men falls (accidentally?) from a bridge into the river. The story, in other words, turns into the message of a ghost, a post-mortem auto-obituary.[13]

[10] Sociologically, the emergence of this genre is puzzling: the figure of widower is anomalous, given the available data about life expectancy in Russia, where in 2011, life expectancy at birth was 64.0 years for Russian men and 75.6 years for Russian women. *Study on Global Ageing and Adult Health Wave 1. Russian Federation National Report*, December 2013, 9, accessed August 25, 2017, http://apps.who.int/healthinfo/systems/surveydata/index.php/catalog/68/download/2042.

[11] Eliot Borenstein. *Men without Women: Masculinity and Revolution in Russian Fiction, 1917–1929* (Durham: Duke University Press, 2001).

[12] Aist Sergeev (Denis Osokin), "Ovsianki," *Oktiabr'* 10 (2008), http://magazines.russ.ru/october/2008/10/se12.html.

[13] A similar narrative device was used earlier in yet another post-Soviet quasi-documentary. In his *Private Chronicles. Monologue* (1999), Vitaly Mansky created a (fictitious) postmortem biography of the last Soviet man by montaging endless cuts of disparate home videos, which were sent to the

Written by Denis Osokin, the story/screenplay provides a poetic backbone for Fedorchenko's inventive play with the ideas of unlocalizable authorship and fluid pasts. The term *ovsianki* (the Russian title of the film) refers to finches or buntings, small birds which Aist buys in the beginning of the film and takes with him (in a cage) on the journey (Fig. 1). The maiden name of Miron's wife was Ovsiankina; her nickname was "ovsianka." The viewer will

Fig. 1. Aist buying buntings.

never learn the exact importance of this parallel, but some scenes provide clues: the cremation ends with a shot of a couple of buntings suddenly appearing on a tree branch. And the fatal car accident on the way back home is also caused by the buntings: released from the cage by Aist, they "rushed to kiss the eyes" of Miron as he steers the car.

The instability of symbols, the consistent transformation of the mundane into the metaphoric and vice versa is hardly accidental. And Fedorchenko emphasizes this semantic liminality further by his choice of crucial images: every major scene begins or ends with a shot of a bridge or a road whose starting points and destinations

director by people from all over the former Soviet Union. For a discussion of this documentary, see my essay "Totality Decomposed: Objectalizing Late Socialism in Post-Soviet Biochronicles," *The Russian Review* 69 (October 2010): 638–69.

are rarely specified (Fig. 2). Epitomizing the key message of the film, these endless (and origin-less) roads and bridges stand as

Fig. 2. A bridge.

materialized metaphors of the importance of the process of linking, connecting, bringing together different parts of one's life and one's history. Traditions and rituals—cultural bridges of sorts—are indeed constructed, but the process of such construction is neither automatic, nor autonomous. It requires some vision; it needs some will; and it demands some perseverance. The film's biggest contribution is its convincing (and long-overdue) suggestion to make a paradigmatic shift—from laments about lost traditions to their creative invention.

Serguei Alex. Oushakine

THE SMOKE OF THE FATHERLAND: BODY AS TERRITORY, SEXUALITY AS IDENTITY IN *SILENT SOULS*[*]

The Yekaterinburg-based director Aleksei Fedorchenko, previously known as the author of the outstanding mockumentary *First on the Moon* (*Pervye na Lune*, 2005) and the documentary film *Shosho* (2006), caused a sensation in 2010 with his first feature film, *Buntings* (*Ovsianki*, released in the US as *Silent Souls*), based on the eponymous novella by Denis Osokin (aka Aist Sergeev), a young author from Kazan' and Fedorchenko's collaborator since *Shosho*. The film won several prizes at the 2010 Venice Film Festival: the Osella, FIPRESCI, and Ecumenical Jury Awards, as well as the Grand Prix at the "Black Pearl" festival in Dubai. As Fedorchenko told me in July 2011, various film festivals booked *Buntings* for years ahead after the Venice screening. For a rather sophisticated film, *Silent Souls* was a popular success, earning $410,988 in 2011 (meaning about 60,000 people watched it) and taking second place in earnings among Russian films of the last few years, yielding only to *How I Ended this Summer* (*Kak ia provel etim letom*, Aleksei Popogrebsky, 2010).

Silent Souls presents an inventive and original exploration of a cultural identity that seems to differ from, if not directly oppose, an imperial Russian identity. Osokin and Fedorchenko disclose the captivating mythology of the Merya, a Finno-Ugric tribe that occupied the territory of central and northern Russia, from the Volga to Moscow, but completely assimilated into Slavic tribes by the sixteenth century, leaving traces in the toponymy of this region and a substantial body of archeological artifacts. Western film critics were enchanted by the way the film envelops contemporary viewers in ancient Merya mythology and rituals.

[*] A shorter version of this essay was published in *Kinokultura* 36 (2012).

In their numerous interviews, both Osokin and Fedorchenko emphasize that, for them, Merya represents a certain aspect of Russianness. Fedorchenko argues that in contemporary Russians more than 50 percent of the genetic pool is of Finnish origin (a fact supported by recent research in evolutionary biology). He adds, however, that for him Merya embodies the secret, hidden sides of every Russian. In another interview, seemingly contradicting the previous statement, he adds that "Merya is more like a synonym of the intimate and sacred (*zavetnoe*) in everyone," not necessarily just Russians.

The exploration of the Merya identity relates to Fedorchenko's ongoing debate with the Russian nationalists begun in his early documentaries about a Jewish boy named David, Kazakh Germans, Russian Poles, Tartars, Chechens, Koreans, and Mari priests. In this context, the constructed mythology of the Merya appears as a daring attempt to undermine an imperial Russian identity by demonstrating the possibility of other, liberated identity models, imagined as the imperial self, yet supposedly free from the xenophobia, aggression, and the self-aggrandizing mania associated with imperialism.

Notably, a separate quest for a Finno-Ugric origin and identity can be seen in contemporary Russian culture. The relaxation of imperial Russo-centrism triggered this quest in the 1990s, along with a growing interest in Islamic cultures and Slavic paganism. The 1990s witnessed the emergence of such an imagined community as the "Finno-Ugric world"—a cooperative enterprise rooted in an attempt to construct a new identity across nation-state borders:

> The decade saw an accelerating emergence of that community, including not only some Russian Federation regions, but also Finland, Hungary, and Estonia. The Finno-Ugric world stapled together by shared culture, language, and history, has no common economic platform in modern times, but culture is being used as a way to political unity. In addition to purely cultural interaction (e.g., congregations of Finno-Ugric writers, song and dance festivals, exchanges of students and linguists, etc.) . . . [the Finno-Ugric world] is a gold mine for provincial authorities irrespective of whether they actually belong to that community, of their own nationality, of familiarity with language. Their goal is to transcend regional

limitations, circumvent state borders, and thus gain a degree of independence from Moscow.[1]

Furthermore, the Russian Internet contains communities of users that consider themselves Merya and watchfully register all references to this culture. These sites not only offer a wealth of material about Merya history, but also grant visitors a chance to "get enrolled" into the Merya.[2]

The Internet communities of Mari, another Finno-Ugric ethnic group, unlike the vanished Merya, has its own administrative body—the Mari Autonomous Republic—which is part of the Russian Federation, is even more pro-active, and it quite ardently discussed Fedorchenko's film *The Heavenly Wives of the Field Mari* (*Nebesnye zheny lugovykh Mari*, 2012). This film is also based on Osokin's script and sexualizes the national identity. While one group accused the film director of the distortion of the Mari traditions and rites, their opponents argued that the Mari should be grateful to the film director for at least making them visible to the world.

Those Western critics who place *Silent Souls* in the context of neo-anthropological cinematography concerning minorities and disappearing indigenous cultures are typically unaware of the fact that all the Merya rituals and beliefs showcased in the film are definitively *fakelore*. The Merya myths and rituals as depicted in *Silent Souls* were single-handedly designed by Osokin, the author of the script and a trained philologist with a deep interest in Finno-Ugric indigenous cultures. However, the film's creators present this pseudo-tradition both as authentic and alive today; indeed, as deeply interwoven with the daily fabric of the provincial lifestyle as, for example, the episode in which the film's protagonists, Aist and Miron, drive the corpse of Miron's wife Tanya to the river

[1] Viktor Kowalev, "Power and Ethnicity in the Finno-Ugric Republics of the Russian Federation," *International Journal of Political Economy* 30, no. 3 (2000), 92.

[2] See, for example: "Narod meria, meriane," http://komanda-k.ru/Россия/народ-меря-меряне; "Merianskoe nasledie Rossii," http: www.merjamaa.ru, both resources accessed September 3, 2017.

shore to cremate it there in accordance with alleged Merya ritual. The widower accompanies their journey by the so-called "dym" (smoke)—a conversation about the most intimate aspects of his relationship with the wife. Curiously, a policeman who stops their car is not in the least surprised by the dead body in the back seat and the men's intention to burn it. He is also a Merya, and he understands what they are supposed to do.

Among the most memorable of Osokin/Fedorchenko's inventions in the Merya "folk tradition" is a custom supposedly belonging both to wedding and death rites—the weaving of colored threads into a woman's pubic hair (Fig. 1). This ritual is somewhat

Fig. 1. Preparing the bride

similar to the Slavic Rusalia festival, when young women "would decorate the tree with ribbons and towels called the *rusalka*'s shirt, which the nymphs had requested."[3] *Silent Souls*, on the one hand, works to reveal the internal logic of these rituals by establishing a direct connection between the tree and the female body, fertility (tree, ribbons as solar symbols), and death (*rusalka*, water). On the other hand, the film and its literary source both radically invert this mythological motif. Rusalia rites "affirmed the solidarity of the feminine community [. . .] and asserted its own order over that

3 Joanne Hubbs, *Mother Russia. The Feminine Myth in Russian Culture* (Bloomington: Indiana University Press, 1993), 72.

of the prevailing social one."[4] This is why men were not typically allowed to participate in these rites.

Symptomatically, Osokin and Fedorchenko undermine the women's power as manifested by this ritual both by reducing a woman's symbolic body to her genitalia and by giving the men authority over the dead female body, something unthinkable in traditional culture. Thus, in *Silent Souls* the autonomy of the feminine order is violated by the men without the slightest recognition of the transgression—either by the protagonists, or by the film's authors.

The popularity of *Silent Souls* in Russia may be partially explained by how well it fits a pattern of popular films, exemplified by the work of such directors as Nikita Mikhalkov and Aleksei Balabanov. Susan Larsen explains that: "These models are all emphatically masculine, as are the conflicts and communities central to these films, each of which casts paternal and fraternal bonds as vital threads in the tattered post-Soviet fabric of Russian national identity. [. . .] The conflation of national identity with masculine authority is a key component of these films' appeal to Russian viewers in a decade in which it often seemed as if Russian film-makers had lost both their market share and their claim to the nation's imagination."[5]

Silent Souls focuses on two male characters. The first is Miron, the director of a small-town factory, whose young wife Tanya dies suddenly. The second is Aist, the plant's photographer, who not only helps Miron bury Tanya according to imagined Merya ritual, but also simultaneously recollects his father (a poet named Vesa Sergeev) and an analogous journey with his mother's corpse, during which his father shared stunning details of their conjugal life with fourteen-year-old Aist. Similarly, during their journey to the burial place, Miron tells Aist of his sexual conquest of Tanya. The connection between the woman, the woman's body and sexuality on

[4] Ibid.

[5] Susan Larsen, "National Identity, Cultural Authority and the Post-Soviet Blockbuster: Nikita Mikhalkov and Aleksei Balabanov," *Slavic Review* 62, no. 3 (2003), 493.

the one hand, and a (re)constructed anti-imperial national identity on the other, lies at the heart of the film's complexity, as well as its internal contradictions.

Silent Souls' representation of femininity is in sharp contrast with the typical Soviet and post-Soviet aggrandizing of the mother figure. The mother is an idiomatic symbol not just of Russia but of Russian imperial power and benevolence to its infantilized subjects, as is seen in a wide range of films from *She Defends the Motherland* (*Ona zashchishchaet rodinu,* directed by Fridrikh Ermler, 1943) to Aleksandr Sokurov's neo-imperialist *Alexandra* (2007). Tanya in *Silent Souls* is emphatically *not* a mother figure; on the contrary, she is openly sexualized. Furthermore, Miron's recollections of his sexual exploration and conquest of Tanya's body are projected onto images of the journey Miron and Aist take to the place of Tanya's burial—a typical central-Russian landscape with recurring rivers and bridges. Serguei Oushakine argued in his review of the film that "these endless (and origin-less) roads and bridges stand as materialized metaphors of the importance of the process of linking, connecting, bringing together parts of one's life and one's history."[6] However, as other critics writing about either Osokin's novella or Fedorchenko's film have noted, all interpersonal connections in *Silent Souls* are inevitably sexualized. Therefore, when the film pairs graphic representations of Tanya's body and sexuality with images of rivers and bridges, the latter begin to represent the former, and vice versa. This connection is also reinforced by a traditional mythological connection between women and water. This is seen in the film's finale when Aist says that "women's living bodies are also rivers carrying away our [men's] sorrow," when Miron dreams of joining Tanya, whose ashes he has thrown into the river, and when after a night with cheerful female strangers, the car carrying Miron and Aist falls into the river—the viewer understands that *Silent Souls* offers a typical symbolization of the motherland as a feminine character, predominantly through imagery of the female body and sexual relations with it. Nicola Kuchta is absolutely correct in

[6] See the preceding Oushakine essay in this volume.

arguing that "although Miron and Aist are cast as the keepers of Merya culture, it is Tanya's body (and that of Aist's mother) that provides the rationale for the men to come together and reenact cultural identity through ritual, be it in marriage or death."[7]

In *Silent Souls* the sexualization of stereotypical imagery associated with the native land produces conflicting interpretations. On the one hand, an attempt to undermine the imperial hierarchy is obviously made as a dominating and authoritative mother is replaced in *Silent Souls* by a passive and submissive, yet cheerful and sexually adventurous sexual partner—no matter whether a wife or a complete stranger. On the other hand, both Osokin's novella and the Fedorchenko's film emphasize the pre-Christian trope of woman as the manifestation of natural forces. We read in Osokin's text:

> I asked Tanyusha to stop cutting her hair, and by the New Year she turned into our best-kept secret. Modest, young, beautiful in beautiful clothes—and underneath the beautiful clothes these bouquets between white skin, islands of grass into which I delved like a duckling. I delved into Tanya's depths, hiding my face in the grassy islands under her armpits...[8]

Fedorchenko preserves this symbolism through several scenes: in the depiction of the ritualistic tying of multicolored strings onto a woman's pubic hair, and the scene in which a public performance of a song composed by Aist's father, consisting of long list of various herbs' names, provokes in Miron a strong sexual desire for Tanya.

Despite their ostensible links to pre-Christian traditions, these images and motifs surprisingly lack a major element of analogous mythological constructions—the theme of fertility and the circle of life, inevitably associated with motherhood. Since the pagan mythology of the Great Mother has been absorbed by an imperial mythology of the Motherland, the authors of *Silent Souls* eradicate

[7] Nicola Kuchta, in Further Reading.

[8] Aist Sergeev [Denis Osokin], "Ovsianki," *Oktiabr'* 10 (2008), accessed August 29, 2017, http://magazines.russ.ru/october/2008/10/se12.html.

motherhood from their mythology—at the cost of removing the center of feminine power in traditional cultures. It is noteworthy that both Tanya and Miron have no children, and Aist's mother dies while giving birth to his stillborn sister. No less characteristically, Miron does not tell Tanya's mother about her daughter's death when she calls him and asks about Tanya. The mother's role here is dramatically diminished in comparison to the husband's authority.

All these details testify to the fact that the representation of female sexuality in the film in no way manifests the woman's power over the forces of life. Instead, it signifies only male desire and sexual dominance. This is particularly noticeable in the scene in which Miron shows Aist video recordings of him copulating with Tanya, inviting Aist to share his pleasure. One of the most sexually explicit scenes of the film, when Miron washes the naked Tanya with vodka, obviously combines the two main, stereotypical Russian male pleasures: sex and alcohol. In Osokin's novella, this episode deepened the pornographic objectivization of Tanya through the description of an encounter bordering on rape:

> Two bottles (of vodka) on the body. The third for the head.
> And a fourth bottle we drank afterwards. Tanyusha had a bite
> after the drink—you can guess what? She took a bite of me.
> She drank the glass, and I put it out straight into her mouth.
> And then fed her a spoonful of salad.[9]

Thus, the authors' attempt to distance the trope of the native land/woman's body from imperial connotations is paradoxically paired with the reinforcement of male power over the woman's body. In *Silent Souls*, the effort to present an alternative to imperial power appears to be founded on a parochial split into masculine narration and the reduction of the woman to a powerless female body serving as spectacle.[10] This distribution between the power-charged male

9 Ibid.

10 As Laura Mulvey explains: "the split between spectacle and narrative supports
 the man's role as the active one of advancing the story, making things happen.
 The man controls the film fantasy and also emerges as the representative of

narrative and powerless female body spectacle is evident in the fact that Tanya, the central female character in *Silent Souls*, is completely deprived of any discourse and agency: she can only moan or nod, expressing her complete agreement with the man's (her husband's) sexual or sexualized desires. The other female characters also speak only when they want to offer themselves to men: "Boys, do you want us?"

Only a few moments in the film suggest—however vaguely—that, perhaps, Tanya is not such a passive receptacle of Miron's sexual powers. At one point, Aist mentions that the entire town knew not only about Miron's passion for his wife but also about Tanya's not loving her husband, "but Miron was silent about this." Elsewhere Aist says that he and Tanya liked each other and that there was once a spark between them, but soon everything was gone. Aist's tender gaze at Tanya through the glass of her office and the bracelet on her dead arm (a gift from Aist) are the only visual markers of Tanya's possible resistance to Miron's despotic love. If this is indeed the case, Tanya's mysterious and premature death acquires a different meaning: Miron could have killed her, which coincides with what Miron says in the film's finale: "I should have let her go" ("Nado bylo otpustit' ee").

Notably, almost immediately after this admission of guilt, the birds—the buntings who were locked in the cage inside the car during the entire journey—suddenly break free and "start kissing [Miron's] eyes." As a result, the car falls from the bridge and both Miron and Aist drown. Earlier in the film, Miron establishes the symbolic relation between the buntings (*ovsianki*) and Tanya, neé Ovsiankina. Considering the fact that drowning in the Volga river, according to Aist, is the most desirable death for a Merya, this sequence of events can be read as the sign of Tanya's posthumous forgiveness of her abuser and probably even murderer.

power in a further sense . . . so that the power of the male protagonist as he controls events coincides with the active power of the erotic look both giving a satisfying sense of omnipotence." (Laura Mulvey, "Visual Pleasure and Narrative Cinema," in *Feminist Film Theory: A Reader*, ed. Sue Thornham, [Edinburgh: Edinburgh University Press, 1999], 63–64.)

However, the film's authors prefer not to emphasize this reading, offering instead a pagan/sexual utopia, in Mikhail Trofimenkov's words.[11] But the critic fails to mention that this is definitely a utopia of male power presented as a "natural" and "ingenious" state of affairs. No wonder then that the male characters in the film control not only the gaze (Aist is a photographer), but also the narrative (his father is a poet), and administrative power (Miron is the director of the paper mill and offers jobs at his factory to accidental lovers). Their control over female bodies is represented as an educational, or even colonizing process: Miron is much older than Tanya and he brags of "uncorking" all three of Tanya's holes and making them work for his pleasure after their marriage, despite her being quite unmoved. No wonder that sex in *Silent Souls* appears to be institutionalized as a form of training: in the director's cut of the movie, after having sex with two women, Miron offers to hire them. Sex appears as part of the job description, but this is matter-of-factly stated in the film as the most normal thing in the world.

The scene of post-funeral sex between the protagonists and the two young women they meet on a bridge is especially telling for the meaning of sexuality in the film. (Notably, in the original director's cut of the film, this scene was placed out of the plot sequence, at the very end.) The women's faces beam with pleasure while their bodies move mechanically, as though by themselves (Fig. 2). The men are emphatically outside of the frame, suggesting a distant, controlling gaze. The scene invites the male spectator to share the gaze, thus sharing pleasure with the protagonists. This performance of communality constructed through the sharing of a female body serves as the film's emotional and symbolic coda. Here a shared, objectified female body is a medium for a performative act of identity construction.

The systematic objectification of the female subject and body in the film reveals a deeply imperial structure, underpinning *Silent Souls'* ostensible attempt to construct a different model of identity. In a traditional imperial narrative, as Anne McClintock notes:

[11] Mikhail Trofimenkov, in Further Reading.

Fig. 2. The pleasure of the shared gaze

"women were not seen as inhabiting history proper but existing, like colonized peoples, in a permanently anterior time within the modern nation."[12] In *Silent Souls* this silent assumption serves as the foundation for the male protagonists' quest: the "anterior— in other words, mythic—time within the modern nation." This ultimate goal is achieved by the men through the use of a woman, or rather her body, as a channel connecting them with a myth-based identity. However, the identity—national or cultural—that is constructed here through a woman's body, is built without her consent or participation. The woman is emphatically deprived of agency, which belongs entirely to the men. In this respect, the "anti-imperial" *Silent Souls* is hardly different from Mikhalkov's *Burnt by the Sun* (*Utomlennye solntsem*, 1994) or *The Barber of Siberia* (*Sibirisky tsiriulnik*, 1998), as well as Balabanov's *Brother* (*Brat*, 1997) or *War* (*Voina*, 2002).

Having said this, I would like, however, to emphasize that the film's authors are, at the least, intuitively aware of the contradictions

[12] Anne McClintock, *Imperial Leather: Race, Gender, and Sexuality in the Colonial Contest* (New York: Routledge, 1995), 359.

inherent in their work. It is not by accident that *Silent Souls* resonates deeply with those recent Russian films where male characters are brought into conflict by a dead or absent woman, as in Valery Todorovsky's *The Lover* (*Liubovnik*, 2002) or Aleksei Popogrebsky's *How I Ended this Summer* (*Kak ia provel etim letom*, 2010). Like these films, *Silent Souls* not only mourns the death of the woman as a mediator—in Fedorchenko's case the woman connects with a non-hierarchical cultural tradition, but also indirectly requires a woman's death for the males' self-realization through conflict and eventual bonding. Intentionally or not, these films demonstrate the flipside of their own semiotics.

In *Silent Souls* the structure of male domination subtly creeps into a seemingly non-imperial identity construction, thus betraying the unconscious imperialism of the gender models presented by the film not as cultural constructs, but as natural logic justified by Merya ancient mythology. Tanya's death, in this context, acquires a new—self-referential—meaning: her erasure, her transformation into a pile of ashes, is the inevitable price for the erection of this new mythology of identity. As such, the film's sole alternative to imperial identity seems founded upon the female body and conveyed through its objectification.

Tatiana Mikhailova

FURTHER READING:

Abdullaeva, Zara. "Tiazhest' i nezhnost'." *Iskusstvo kino* 10 (2010). Accessed September 3, 2017. http://kinoart.ru/archive/2010/10/n10-article12.

Bondarenko, Natal'ia. "Aleksei Fedorchenko: 'Moi fil'my—eto skazki dlia vzroslykh.'" *Ogonek* 34 (August 30, 2010). Accessed September 3, 2017. https://www.kommersant.ru/doc/1490171.

Kuchta, Nicola. *"Silent Souls."* Accessed August 29, 2017. http://www.rusfilm.pitt.edu/2011/silentsouls.html.

Strukov, Vlad. *Contemporary Russian Cinema: Symbols of a New Era.* Edinburgh: Edinburgh University Press, 2016. See in particular pp. 199-216.

Timasheva, Marina. "Rezhisser Fedorchenko—o svoem fil'me *Ovsianki.*" *Radio Svoboda.* Accessed September 3, 2017. https://www.svoboda.org/a/25670725.

Trofimenkov, Mikhail. "Meria, pobedivshie smert'." *Kommersant,* October 22, 2010. Accessed September 3, 2017. https://www.kommersant.ru/doc/1521501.

MY JOY

Schast´e moe

2010

127 minutes

Director: Sergei Loznitsa

Screenplay: Sergei Loznitsa

Cinematography: Oleg Mutu

Sound: Vladimir Golovnitsky

Art Direction: Kirill Shuvalov

Editor: Danielius Kokanauskis

Producers: Heino Deckert, Oleg Kohan

Production Companies: a.ja.de.filmproduktion (Germany), Sota
 Cinema Group (Ukraine), Hubert Bals Fund (Netherlands)

Cast: Viktor Nemets (Georgy), Vladimir Golovin (old man),
 Olga Shuvalova (young prostitute), Vlad Ivanov (major from
 Moscow), Maria Varsami (Maria), Aleksei Vertkov (young
 lieutenant), Dmitry Gotsdiner (commander), Boris Kamorzin
 (truck driver)

My Joy is the feature film debut of Ukrainian director Sergei
Loznitsa. The film won several awards on the international circuit
in 2010, including grand prizes at the Tallinn and Minsk Interna-
tional Film Festivals and was a selection for the main competition
at Cannes. In Russia, *My Joy* has proven to be one of the most
controversial films of the new millennium. Praised by many critics
and intellectuals as an uncompromising and original portrait of
society, it provoked indignation from others who saw in it the
"Russophobic" gaze of an outsider. Karen Shakhnazarov, head of

Mosfilm Studios, described *My Joy* as an "openly anti-Russian film, implying that anyone born in Russia should be shot," while another critic called it "a crime against national pride and morality."[1] Despite its controversial content, it won a number of prestigious awards at Russian film festivals, including Best Director and the Critics' Award at the Kinotavr Film Festival and Best Debut from the Guild of Russian Film Critics. Indeed, *My Joy* struck a nerve in the post-Soviet world and its reception reveals much about the highly polarized discourse surrounding artistic production in Russia in recent years.

Loznitsa was born in Baranavichy, Belarus in 1964, and moved the following year with his family to Kiev, Ukraine, where he lived until 1991. Following in the footsteps of his mathematician parents, he studied at the Kiev Polytechnic University and later worked as a researcher in artificial intelligence. From 1991–97 he studied in Moscow at the Gerasimov Institute of Cinematography (VGIK) and began his career as a documentary filmmaker. In 2001, Loznitsa emigrated from Russia to Hamburg, Germany, but continued to make documentaries set in the villages and provinces of western Russia, an interest that has carried over to his feature films. By the release of *My Joy* in 2010, he had made a dozen documentary films and was one of the most acclaimed documentarians in the Russian-speaking world, winning awards at Cannes for *The Portrait* (*Portret*, 2001) and a Russian Nika for Best Documentary for *The Siege* (*Blokada*, 2006). Since the breakout success of *My Joy*, Loznitsa's most notable work includes the feature films *In the Fog* (*V tumane*, 2012), *Gentle Creature* (*Krotkaia*, 2017), and the political documentaries *Maidan* (2015) and *Donbass* (2018), all of which received accolades and sharply divided audiences.

My Joy tells the story of truck driver Georgy as he delivers a shipment of flour across the Russian hinterland, somewhere in the

[1] Elena Iampol'skaia, "Chuzhoe schast'e," *Izvestiia*, March 30, 2011, accessed October 6, 2017, https://iz.ru/news/373039; and Vladimir Liashchenko, "Schast'e moe, ia tvoi khaos," *Gazeta.ru*, March 29, 2011, accessed October 6, 2017, https://www.gazeta.ru/culture/2011/03/29/a_3568857.shtml.

Smolensk region. We follow as Georgy drives through abandoned truck stops, police checkpoints, forests, and villages. A throwback to another era, the simple protagonist—reminiscent of the many positive heroes of Soviet cinema—takes in the surrounding provinces with bright-eyed curiosity. He picks up a teenage prostitute, attempting to help her rather than use her services (Fig. 1). He gives a ride to a nameless former Red Army soldier

Fig. 1. Georgy attempts to help a teenage prostitute in a small village.

who tells his tragic story from the Great Patriotic War. However, in contrast to the mythologies and "varnished reality"[2] of Soviet cinema and post-Soviet blockbusters, the good-natured hero is universally met with hostility and violence. The teenage prostitute rebuffs his offer of help, throwing the money back in his face. Villagers threaten and run him off when he comes to them, freezing in the winter. A band of wandering thieves invites him to join them by the fireside, only to knock him unconscious with a log to steal

2 "Varnished reality" (*lakirovannaia real'nost'*), a term coined under Khrushchev in 1956, refers to the overly positive and utopian portrayals of society in Soviet art.

his freight, leaving him brain-damaged for life. Adding to the film's bitterly ironic intonation, the title alludes to the famous Soviet ballad "My Joy" of 1939 by Georgy Vinogradov, the words of which are familiar to older viewers: "My joy, look, our youth is blooming / So much love and merriment all around."[3] Thus, *My Joy* invokes tropes of Soviet art and discourse—such as happiness and collective community—to draw stark contrasts with Loznitsa's vision of post-Soviet society. Loznitsa's film is part of a broader tendency in post-Soviet independent cinema, sometimes referred to as *neo-chernukha*,[4] along with films such as Aleksei Balabanov's *Cargo 200* (*Gruz 200*, 2007), Aleksei Mizgirev's *Tambourine, Drum* (*Buben, baraban*, 2009), Vasily Sigarev's *Living* (*Zhit'*, 2012), and Andrei Zviagintsev's *Leviathan* (*Leviafan*, 2014), which debunks the romantic/nostalgic images of mainstream cinema through unvarnished portraits of history and contemporary social conditions.

From Ethnographic Road Film to Dark Fairy Tale

One of *My Joy*'s most striking features is an innovative combination of documentary aesthetics with various genre conventions—particularly macabre elements and fairy tale motifs. Clearly reflecting Loznitsa's background as documentarian, the film's photography alternates between fixed long shots and a Dogme-style handheld camera, trailing the protagonist behind the nape of the neck and sporadically zooming in on objects like an unseen observer. With relatively few cuts and a total absence of non-diegetic music, the viewer accompanies characters on long walks, hearing only the crunching of snow underfoot, howling winds, the barking of dogs, and rumbling of Georgy's truck. The ambulatory

[3] *"Schast'e moe, posmotri, nasha iunost' tsvetet / Skol'ko liubvi i vesel'ia vokrug."* The word "happiness" appears several times in the film. One of the thieves remarks bitterly about "our damned happiness" (*schast'e nashe kurinoe*) and another truck driver at the film's end expounds at length his vision of happiness as staying out of others' business.

[4] For an in-depth discussion of *neo-chernukha* in recent Russian cinema, see Dusty Wilmes, in Further Reading.

pace of the editing reinforces the sense of journey and is conducive to reflection. As is typical of documentary film, there is a primacy of place over action, of sonic and visual texture over plot. Fixed point-of-view shots from the truck capture the surrounding landscape, recalling Aleksandr Medvedkin's *Film Train* (*Kinopoezd*) project of the 1920s, giving the impression of an ethnographic tour of the Russian villages and countryside. In one memorable documentary-style flourish, the camera pans for nearly two minutes across the faces in a crowded village square, accompanied by the murmuring of faint conversations. This is a direct citation of Loznitsa's earlier documentary *Landscape* (*Peizazh*, 2003), in which the camera pans villagers for an entire hour at a provincial bus stop and captures fragments of conversations. In *My Joy*, such footage and the film's loose, episodic structure impart an ethnographic feel and a heightened sense of realism, blurring the boundary between document and fiction. Loznitsa commented on his ethnographic interest in the Russian villages, saying, "Cinema is interested in objects that pass away. Ten years from now there will be no villages in the traditional form. The way of life is changing, even the appearance of the inhabitants of these villages is changing."[5] Although Loznitsa's penchant for documenting the Russian *narod* (folk) continues in this film, in contrast to his more neutral documentaries, *My Joy* is tinged throughout with elements of grotesque caricature, emphasizing the hardened, almost inhuman, expressions of those caught on camera.

Moving beyond mere docufiction, however, *My Joy* innovatively combines these elements with prominent motifs from fairy tales. The blending of documentary and dramatic conventions is a broader tendency in Russian and world cinema in recent years—arguably a reaction against a growing artificiality in blockbuster cinema and heavily influenced by the Dogme 95 movement of the 1990s—that some have called "post-documentalism."[6] What

[5] Anton Sidarenka, in Further Reading.

[6] For a discussion of Loznitsa's "post-documentary" aesthetic, see Zara Abdullaeva, 266–77, in Further Reading.

Fig. 2. One of Loznitsa's many crowd scenes, a train station during World War II.

begins as a road film, following the hero's journey and depicting the surrounding landscape, suddenly shifts to a macabre fairy tale. Indeed, many of the structural elements of the fairy tale, identified by folklorist Vladimir Propp,[7] are present in the story: the hero's departure from home, the warnings he receives not to veer from the main road, his disregard for these warnings, his encounter with villains in the forest, the villains' deception of the hero, and so on. However, stripped of any magic that would allow him to transcend his circumstances, Georgy is instead maimed and becomes trapped in a cursed realm (Fig. 3). It is as though, passing through the police checkpoint, Georgy has crossed the River Styx into an underworld filled with tormented and lost souls. Indeed, the checkpoint stands on an elevated surface and recalls the hut of Baba Yaga, a witch in Russian folklore who invariably tests travelers. Throughout *My Joy*, naturalistic depictions combine with supernatural elements: the nameless old soldier magically appears and disappears; the teenage prostitute advises Georgy against the "cursed" road he is taking;

[7] Vladimir Propp was a Soviet scholar who published seminal work on the structural analysis of folklore.

Fig. 3. Brain damaged after an assault, the protagonist is stuck in a remote village.

Georgy comes upon a log blocking the road on a bridge, a common folkloric device warning the traveler not to enter; the army major sees the ghost of a hanged man near the film's end. Fairy tale motifs impart an archetypal, timeless quality to the narrative and are combined with bleak realities of post-Soviet life, recalling writer Liudmila Petrushevskaya's dark fairy tales, such as "The New Robinson Crusoes" and "The Father."

After Georgy's injury, the linear progression of the ethnographic road film is thwarted and shifts to a tale of violence and stagnation. While most critics focused on the film's social commentary and fairy tale elements, for others the sense of cyclicality in the narrative evoked the absurdist works of Franz Kafka and Samuel Beckett. After his accident, Georgy's life in the provinces is not unlike that of the protagonists in Beckett's *Waiting for Godot*, who sit waiting for someone who never arrives and indeed forget what they are waiting for.[8] While lacking the humor of those works, the sense of futility and inescapability from patterns of violence creates a mood of tragic absurdity.

[8] Igor' Vishnevetskii, in Further Reading.

Cycles of Violence, Trauma, and the Buried Past

As the director frequently remarked, *My Joy*'s script was meticulously planned and structured, interweaving a large number of episodes and characters (around thirty-eight in total), which echo one another and are interconnected.[9] The narrative shifts temporally between the present of Georgy's journey and flashbacks from the Great Patriotic War. After leaving the checkpoint where traffic cops extort bribes from passing drivers, the nameless veteran tells Georgy a parallel tale of extortion from the period of the war. In this flashback, a Red Army commander threatens the soldier with imprisonment in order to steal the gifts that he is bringing home to his bride. The soldier hands over the prized gifts, but avenges the theft by shooting the commander as his train pulls away. This tragic turn of events, however, prevents him from ever returning to his former life. Soon thereafter the protagonist Georgy, like the old man, loses everything—his name, memory, and identity—when he is assaulted by the three thieves in the forest. In a third parallel, one of the three vagrants who assault Georgy is in fact his double, a mute who is similarly brain damaged from an earlier act of treachery. From subtle clues in the narrative—one of his fellow thieves remarks by the fireside, "They say they killed his father"—we learn that this mute thief was formerly the little boy in a subsequent flashback. In this scene, two Red Army soldiers are given shelter in the country home of a schoolteacher and his son, only to kill the father and loot the house the following morning as the son looks on. This child grows up to become the very same mute who assaults Georgy with the roaming band of thieves. In this way, the structure of the narrative creates a circularity and continuity between the villainy of the past and present, and debunks any possible nostalgia, even for the sacrosanct period of the Great Patriotic War. Loznitsa continues

[9] "Q & A: Sergei Loznitsa," *The Hollywood Reporter* (May 15, 2010), accessed October 6, 2017, http://www.hollywoodreporter.com/news/qampa-sergei-loznitsa-23743.

to problematize simplistic patriotic narratives about the war in his subsequent film *In the Fog*.

In *My Joy*, Russia's past is unequivocally traumatic and has left its people damaged. The elderly former Red Army soldier lives out the rest of his days in obscurity, nameless and isolated. Georgy is a walking zombie, unable to speak or recall his former life. In stark contrast to recent Russian blockbusters, which revive various patriotic myths and construct a usable past—such as *Brest Fortress* (*Brestskaia krepost'*, Alexander Kott, 2010), *Stalingrad* (Fedor Bondarchuk, 2013), and *Panfilov's 28 Men* (*Dvadtsat' vosem' panfilovtsev*, Kim Druzhinin, 2016)—the film portrays Russia's past as "a total, nullifying negative experience" from which no meaning can be recovered.[10] This pessimistic view of Russian cultural tradition is encapsulated by the conversation between Georgy and the thieves:

> —Where does this road lead?
> —It's not a road, it's a direction.
> —Well, where does this direction lead?
> —It's a dead end. A dead end of evil power.[11]

In *My Joy*, the traumatic past manifests itself in cycles of violence that will continue indefinitely into the future. Fittingly, the film ends where it begins. Georgy returns to the police checkpoint and shoots the agents of official power, turning the violence of the authoritarian system on itself. However, denying the viewer a cathartic sense of justice, Georgy shoots the corrupt police and innocent bystanders alike, with the same gun used decades earlier to shoot the Red Army commander, before walking off into the darkness as the credits roll. Thus, the narrative shatters any hope of escaping the

10 Evgenii Gusiatinskii, in Further Reading.

11 "—Kuda vedet eta doroga?—Eto ne doroga, eto napravlenie.—Nu, kuda zhe vedet eto napravlenie?—Eto tupik. Tupik nechistoi sily." This is yet another reference to the supernatural, which conflates the fate of the Russian nation with the influences of evil forces.

cycles of violence and trauma from which contemporary Russian culture continues to suffer.

The prevalence of dead bodies and burial in the film suggests a link between social decay and psychological repression. The film opens with the churning of a cement mixer, accompanied by the sound of sloshing cement, before it is poured on top of a dead body. This scene, which has no direct connection to the plot, serves as poetic epigraph, presaging *My Joy*'s message and mood. Later in the film, the theme of burial and repression is engaged more explicitly. In this scene, another veteran of the Great Patriotic War, clearly deranged, wanders along the side of the road muttering an extraordinary monologue:

> We put them all down, to the very last one, in one mass grave. Not one of those bastards got out, not one escaped my righteous bullet. Comrade General! For the Fatherland! For peace around the world! [. . .] The task is complete! Bastards will lie in the ground, children will smile, and the stars will shine! Comrade General [. . .] Traces, traces, but I killed those traces and they disappeared into the air. Comrade General, we added the murdered traces to the mass grave, the mass grave of murdered traces, Comrade General! Our victory has wiped away all the traces.[12]

Several more subtle allusions to violence and unprocessed trauma appear throughout the film. At the beginning of Georgy's journey, the well-known song of 1989, "We Are Leaving" ("My ukhodim") comes on the radio, lamenting the Soviet-Afghan War: "We are leaving, leaving, leaving / Farewell mountains, to you it's clearer / What our pain and our glory was for / How will you, Afghanistan,

[12] "Vsekh vylozhil, vsekh do odnogo. V odnu bratskuiu mogilu. Ni odin suka ne ushel. Ni odin ne uliznul ot spravedlivoi puli! Tovarishch general! Za otechestvo, za mir vo vsem mire! [. . .] Zadanie vypolneno. Suki budut lezhat' v zemle, deti budut ulybat'sia, a zvezdy budut siiat'! Tovarishch general [. . .] Sledy, sledy, a ia ubil eti sledy i oni rastvorilis' v vozdukhe. Tovarishch general, v bratskie mogily dobavleny ubitye sledy, bratskaia mogila ubitykh sledov, tovarishch general! Nasha pobeda sterla vse sledy."

redeem mothers' tears?"[13] Echoing the motif of traumatic and questionable wars, near the film's conclusion soldiers drive around in circles through this remote region with a body lying in a zinc coffin—a likely reference to the Second Chechen War. Rather than ensuring a proper burial and mourning the fallen soldier, his compatriots search for someone to forge a signature and dispose of the body, echoing the opening scene.[14] The film's stark portrayal of the ghosts and "buried skeletons" of Stalinism suggests a potential dialogue with Tengiz Abuladze's groundbreaking perestroika-era film *Repentance* (*Pokaianie*, 1984). In *Repentance*, the body of a fictional Stalin-esque leader, Varlam Aravidze, is buried and repeatedly exhumed by Keti Barateli, the daughter of one of his victims, to remind the town about the painful truth of his crimes. While in *Repentance* it is the murderer who is buried and exhumed, in *My Joy*, on the contrary, the bodies of the victims are repeatedly disposed of and forgotten. In both films, however, ultimately the victims and perpetrator remain buried, leading to a return of the repressed. In Freudian and Lacanian psychoanalysis, repression and foreclosure lead respectively to neuroses and psychoses, which abound in Loznitsa's provincial dystopia

My Joy's various allusions to a repressed or unacknowledged past are part of a broader liberal critique in Russia of post-Soviet nationhood discourse. Celebrated postmodernist writer Vladimir Sorokin, in a widely publicized 2014 article titled "Let the Past Collapse on Time!," asserts that Russia failed to come to terms with the crimes of Stalinism and other traumas, arguing that attempts in the Putin era to construct patriotic narratives about Soviet history

[13] "Proshchaite, gory, vam vidnei / V chem nasha bol´ i nasha slava. / Chem ty, zemlia Afganistana, / Iskupish´ slezy materei?" Given his age and interest in this song, viewers might infer that Georgy himself is a veteran of the Afghan war.

[14] The trope of zinc coffins (*tsinkovye groby*)—a reference to the clandestine return of dead soldiers from Russia's wars in Afghanistan and Chechnya— is prominent in artistic production since perestroika. It is featured in Aleksei Balabanov's *Cargo 200* (2007) and in Svetlana Aleksievich's work of documentary prose *Zinky Boys* (1989).

have led to a sort of discursive schizophrenia.[15] Consequently, there has been a resurgence in the popularity and legacy of Joseph Stalin (a leader who, by most historical accounts, was responsible for the deaths of over fifteen million of his own people) and persistent nostalgia for the Soviet Union.[16] As one critic points out, from this "amnesic" view of history comes a common trope in Russian cinema of the last decade, the concussed hero, of which Georgy is the latest example.[17] Stricken with brain damage, amnesia, or shell-shocked from wartime trauma, the damaged protagonists in other recent independent films such as *Shultes* (Bakuradze, 2008), *The Edge* (*Krai*, Uchitel', 2010), *The Stoker* (*Kochegar*, Balabanov, 2010) and *The Convoy* (*Konvoi*, Mizgirev, 2013), symbolize a nation traumatized and unable or unwilling to confront its past. In a similar vein, cultural historian Alexander Etkind articulates a theory of "post-Soviet hauntology," or a prevalence of grotesque and macabre imagery in recent Russian artistic productions. He asserts: "Haunted by the unburied past, post-Soviet culture has produced perverse memorial practices."[18] Indeed, the well-meaning hero Georgy finds himself in a haunted space full of dehumanized and mad inhabitants, dead bodies, and ghosts. Near the film's finale, the army commander, while attempting to dispose of the zinc coffin, suddenly sees the specter of a hanged man and loses his mind.

[15] Vladimir Sorokin, in Further Reading.

[16] Sociological surveys reveal a major resurgence of Stalin's popularity among the Russian public. While in 1994, only 27 percent of Russians viewed Stalin positively, that number has steadily increased. In 2017, a Pew Research poll found that 58 percent of Russians saw Stalin's role as "very" or "mostly" positive. David Masci, "In Russia, nostalgia for Soviet Union and positive feelings about Stalin," *Pew Research Center* (June 29, 2017), accessed October 6, 2017, http://www.pewresearch.org/fact-tank/2017/06/29/in-russia-nostalgia-for-soviet-union-and-positive-feelings-about-stalin/; and Samuel Rachlin, "Stalin's Long Shadow," *The New York Times*, March 4, 2013, accessed October 6, 2017, http://www.nytimes.com/2013/03/05/opinion/global/stalins-long-shadow.html.

[17] Aleksei Gusev, in Further Reading.

[18] Alexander Etkind, 182, in Further Reading.

My Joy traces the roots of Russia's culture of violence not only to manifestations of a buried and unacknowledged past, but to broader tendencies in Russian cultural history. One scene in the film is key to understanding Loznitsa's diagnosis. When the rural schoolteacher and his small son welcome two partisans into their home during the war, the soldiers learn of the teacher's sympathies for the Germans. This is their justification to murder the man in his sleep and loot the home the following morning. Drawing particular attention to this scene in interviews, Loznitsa describes it as an illustration of a "culture of intolerance" and a pervasive division of community between selves and others (*svoi* and *chuzhie*). For the Russian partisans, the teacher's admiration of German orderliness and religion—and notably not for the Nazi regime—was sufficient to identify him as Other, after which "he ceases to exist as a person. . .[he becomes] an object."[19] The dehumanization of the Other underpins the assault of Georgy for a meager cargo of flour; his assault by bandits at the market, concerned about him encroaching on their territory; the murder of the school teacher in front of his son; and the unceremonious dumping of a dead body in the opening scene into a pit, and covering it in cement. Loznitsa's critique of everyday violence and pervasive divisions of society into self and Other recalls writer Tatyana Tolstaya's description of a "Little Terror" in Russian culture, or the everyday spite and violence, an "ocean from which the huge wave of a Great Terror periodically rises."[20] The emotionally provocative scene of the

[19] Loznitsa remarked: "[Intolerance is absolutely at the root of everything.] It is a cause in our history which we still have not understood. One of the most important reasons behind what is happening is a readiness to kill another for an idea, to do this parenthetically, in passing. The division into 'one's own' and 'Other.' When you see someone as 'Other,' he ceases to exist for you as a person: he is already a hindrance that needs to be disposed of. And after that any amoral thing is permitted. . . . It is transferred into a different category. In other words, he becomes an object. That is what is awful—and it is what ultimately has destroyed society." (See Shakina, in Further Reading).

[20] Tatyana Tolstaya, *Pushkin's Children: Writings on Russia and Russians* (Boston, MA: Houghton Mifflin Harcourt, 2003), 17. Cultural historians Mark Lipovetsky and Birgit Beumers examine in considerable depth a "discourse

murdered schoolteacher, moreover, divides the narrative structure into two halves: the first half of the film taking place in the span of a single day, and the second half spread out over a much longer period of time and shifting dramatically in tone.

The legacy of violent totalitarian culture continues to manifest in the film's present as menacing police rule the highways, bandits run the markets, and thieves roam the fields and forests. Signs of cultural decay are ubiquitous. The once-vibrant country home of the schoolteacher transforms into a dilapidated hut, inhabited by the Roma woman who morbidly uses the damaged Georgy for sex. Georgy's cargo of flour, the symbolic "lifebread" of the nation, is sold off piecemeal and carted away by stone-faced villagers. Significantly, the film's critique extends beyond the totalitarian past, implicating present-day citizens in its perpetuation through ethical compromise and a lack of social responsibility, encapsulated by the pithy phrase "Don't meddle!" (*Ne lez'!*). Near the film's conclusion, the truck driver who picks up Georgy expounds this worldview at great length: "Don't meddle! [. . .] You know, it's a real talent to know how not to get involved! [. . .] If you steal, go ahead and steal! Just don't meddle in others' business!"[21] In the final scene, the menacing traffic cops assault a police major from Moscow and attempt to frame him by forcing Georgy and the truck driver to sign false testimony against him. As if to rebut the truck driver's philosophy of self-preservation, the major pleads with them: "Don't do it! If they do this to me, what do you think will happen to you?"[22] In short, *My Joy* presents a far-reaching and uncompromising critique of Russian culture, tracing a history of violence and intolerance through manifestations in Stalinism, imperialist wars, and present-day passivity and self-interest. Interweaving episodes from the

of communal violence" in their monograph *Performing Violence: Literary and Theatrical Experiments of New Russian Drama* (Bristol, UK: Intellect, 2009), 49–70.

21 "Ne lez'! [. . .] Ty znaesh', chto talant nado imet' nikuda ne lezt'! Esli voruesh', to vorui! Tol'ko ne lez'!"

22 "Muzhiki, ne delaite etogo, esli so mnoi tak, chto s vami budet?"

Soviet period and the present, *My Joy* constructs a composite picture of Russian society in which lessons of history have gone unlearned and amnesia leads to a reproduction of the same.

The Problem of "Reality": Critical Realism and *Chernukha*

As if to state the director's goal from the outset, *My Joy*'s original script began with an epigraph from Nikolai Gogol's remarks about his novel *Dead Souls*: "There are times when it is not possible to turn society, or even one generation, towards the beautiful, so long as it is not shown the depths of its present abasement."[23] Deciding that the epigraph was too didactic, Loznitsa replaced it with the opening scene of a body being buried in cement, transposing, as it were, the epigraph into filmic language. Loznitsa consciously engages Russia's longstanding tradition of critical realism—including writers such as Mikhail Lermontov, Nikolai Gogol, Fyodor Dostoevsky, Andrei Platonov, and Varlam Shalamov—which played an influential role in civic and spiritual life and often held up a sobering "mirror" to society. Loznitsa's remarks in interviews reflect such a belief in the role of art to inspire social change:

> The artist reforms the main thing on which a world constructed by totalitarianism depends. What does an artist offer? Vision. If it is a vision of the order of things—a real, essential one—it has the ability to change the general view and, consequently, the order itself. Much like [Hans Christian] Anderson's "The Emperor's New Clothes."[24]

Praise of the film by Russian critics and intellectuals reflected a similar orientation toward critical realism and the civic function of

23 Nikolai Gogol, *Selected Passages from Correspondence with Friends*, translated by Jesse Zeldin (Richmond, VA: Vanderbilt University Press, 1969), 109.

24 Larisa Maliukova, "Kak soprotivliat′sia vlasti: Interv′iu Sergeia Loznitsy," *Novaia gazeta*, May 31, 2017, accessed October 6, 2017, https://www.novayagazeta.ru/articles/2017/05/29/72622-sergey-loznitsa-istoriya-ne-podchinyaetsya-silnoy-ruke.

art: "Yes, anti-Russian *chernukha* I suppose. Just as was *Dead Souls*, *The Golovlyov Family*, and *The Foundation Pit*. Or like *Cargo 200*, only *My Joy* is more radical, more timely, more truthful, and therefore more hopeless than Balabanov's grotesque cine-fresco."[25]

Nevertheless, amidst the highly divided discursive and political climate of Russia today, films such as *My Joy* are rejected by a large portion of the populace as politically inflected and part of a revitalization of the aesthetics of *chernukha*. *Chernukha*, an artistic tendency that has its roots in the exposés and bleak depictions of society during perestroika, typically constructs narratives that debunk "whitewashed" or idealized depictions of history and contemporary realities, leaving viewers with little positive identification or catharsis. The increased globalization of film markets and festivals in recent years has intensified and further politicized debates around films such as *My Joy*. Accusations of "tarnishing Russia's image" and "pandering to western conceptions" are increasingly common. Given *My Joy*'s overwhelmingly despondent mood and arguably grotesque portrayal of the Russian people, such arguments are also worth examining.

Here, the film's production history and the cultural positioning of its filmmakers raise interesting questions. Originally planned as a German-Russian co-production, *My Joy* was later denied funding by the Russian Ministry of Culture, which has increasingly used financing as a mechanism for ideological control in recent years. Consequently, the filmmakers appealed to alternative funding sources and *My Joy* became a Ukrainian-Dutch-German co-production. Originally planned to be shot in the Novgorod region of Russia, filming ultimately took place in northeastern Ukraine on the Russian border in order to comply with funding requirements from the Ukrainian Ministry of Culture. Loznitsa's liminal position — Belarussian-born, raised in Soviet Ukraine, Russian-speaking and having lived for many years in Russia — problematizes the issue of

[25] Anton Dolin, "Drugie russkie: Dnevnik Kannskogo kinofestivalia," *Gazeta.ru*, May 19, 2010, accessed October 6, 2017, https://www.gazeta.ru/culture/2010/05/19/a_3370110.shtml.

national and political point of view. Not unlike Belarussian writer and 2015 Nobel laureate Svetlana Alexievich, whose work turns a critical gaze to Russian society and has been similarly accused of pandering to western audiences, Loznitsa's positioning as an East European, former subject of empire, likely informs his view of a persistent Soviet legacy of authoritarianism and imperialism.

My Joy's international crew consisted of, among others, Ukrainian director Loznitsa, Russian producer Kirill Shuvalov, Romanian cinematographer Oleg Mutu, Belarussian sound editor Vladimir Golovnitsky, a German technical staff, and Lithuanian editor Danielius Kokanauskis. This arguably contributes to a "European gaze" through which the film examines Russian life. The success of *My Joy* is in large part the result of Loznitsa's felicitous collaboration with the outstanding cinematographer Mutu, one of the central figures of the Romanian New Wave, as well as talented sound editor Golovnitsky. Mutu's remarkable sense of photographic composition—color scheme, texture, lighting, *faktura* of actor and costume—lends a certain aesthetic elegance to Loznitsa's gloomy spectacle and aligns Loznitsa's films more closely to visual trends in European art cinema than those of his Russian contemporaries. Loznitsa's work in fiction film, then, exemplifies a broader movement of East European artists formerly under Soviet domination, whose works critique the vestiges of Soviet totalitarian culture and aspire to Western European humanism.

Although basing his script on stories accumulated during extensive travel around the Russian provinces, it is not surprising that Loznitsa's *My Joy* is perceived by many as an anti-Russian caricature.[26] However, the director has repeatedly insisted that his films are not only about Russia, but construct a composite post-Soviet space that is applicable to all parts of the region where

[26] Loznitsa has often stated that many of the episodes in the film came from stories he was told during his travels and documentary work in Russia. For example, he heard a story of a man who was hit over the head and ended up stuck in a remote village, as well as a story from a former soldier in World War II, whose gifts for his fiancée were stolen by a corrupt commander on his return from the front. See Ol'ga Shakina, in Further Reading

totalitarian tendencies persist.[27] Put another way, his critique is ideological rather than nationalistic, anti-Stalinist rather than anti-Russian. Moreover, objections to Loznitsa's Russophobia are less compelling when considering an array of recent films made by Russian-born directors—such as Zviagintsev's *Leviathan* and *Loveless* (*Neliubov'*, 2017), Balabanov's *Cargo 200*, Mizgirev's *Tambourine Drum* and *The Convoy,* and Sigarev's *Wolfie* (*Volchok*, 2009) and *Living* (*Zhit'*)—which present similarly stark critiques of society and face accusations of *chernukha* and pandering to the West. In this sense, Loznitsa's feature films share the critical and alienated intonation of the post-Soviet generation of Russian auteurs who came of age in the wake of the collapsed Soviet Union and the troubled period of the 1990s.

Justin Wilmes

[27] "The film is not about Russia, the film is about the context of all post-Soviet countries." See "Sergei Loznitsa: *Krotkaia*—Film ne pro p'ianstvo!" *Youtube* (May 27, 2017), accessed October 6, 2017, https://www.youtube.com/watch?v=vDG7P9foqvg.

Further Reading

Abdullaeva, Zara. *Postdok: Igrovoe/neigrovoe*. Moscow: NLO, 2011.

Andreescu, Florentina. "Doleo, ergo sum: the masochistic aesthetic of Sergei Loznitsa's *My Joy* (2010)." *Studies in Russian and Soviet Cinema* 9, no. 3 (2015): 200–15.

Etkind, Alexander. "Post-Soviet Hauntology: Cultural Memory of the Soviet Terror." *Constellations* 16 (2009): 182–99.

Gusev, Aleksei. "Schastlivye vmeste." *SeansBlog*, March 31, 2011. Accessed October 6, 2017. http://seance.ru/blog/my-joy.

Gusiatinskii, Evgenii. "Proshche, chem krov´. *Schast'e moe*, rezhisser Sergei Loznitsa." *Iskusstvo kino* 7 (2010). Accessed October 6, 2017. http://kinoart.ru/archive/2010/07/n7-article5.

Hames, Peter. "Sergei Loznitsa: *My Joy* (*Schast'e moe*, 2010)." *KinoKultura* 30 (2010). Accessed October 6, 2017. http://www.kinokultura.com/2010/30r-schaste.shtml.

Shakina, Ol´ga. "Sergei Loznitsa: 'Ni cherta ne srastetsia.'" *OpenSpace.ru* (August 25, 2010). Accessed October 6, 2017. http://www.openspace.ru/#/cinema/events/details/17550/.

Sidarenka, Anton. "Sergei Loznitsa: Conversations on Cinema: 'A Master of Time,'" *KinoKultura* 25 (2009). Accessed October 6, 2017. http://www.kinokultura.com/2009/25-sidarenka.shtml.

Sorokin, Vladimir. "Let the Past Collapse on Time!" *The New York Review of Books*. May 8, 2014. Accessed October 6, 2017. http://www.nybooks.com/articles/2014/05/08/let-the-past-collapse-on-time.

Vishnevetskii, Igor´. "Schast'e moe i nashe obshchee." *Chastnyi korrespondent*, June 21, 2010. Accessed October 6, 2017. http://www.chaskor.ru/article/schaste_moe_i_nashe_obshchee_18064.

Wilmes, Dusty. "National Identity (De)Construction in Recent Independent Cinema: Kirill Serebrennikov's *Yuri's Day* and Sergei Loznitsa's *My Joy*." *Studies in Russian and Soviet Cinema* 8, no. 3 (2014): 218–32.

ELENA

2011

109 minutes

Director: Andrei Zviagintsev

Screenplay: Oleg Negin, Andrei Zviagintsev

Cinematography: Mikhail Krichman

Art Design: Andrei Ponkratov

Costume Design: Anna Bartuli

Music: Philip Glass

Producers: Aleksandr Rodniansky, Sergei Mel'kumov

Production Company: Non-Stop Prodakshn

Cast: Nadezhda Markina (Elena), Andrei Smirnov (Vladimir), Elena Liadova (Katia, Vladimir's daughter), Aleksei Rozin (Sergei, Elena's son), Evgeniia Konushkina (Tania, Sergei's wife), Igor' Ogurtsov (Sasha, Elena's grandson)

THE FILMS OF ANDREI ZVIAGINTSEV: AN UNBLINKING CHRONICLE OF FAMILY CRISIS AND HUMAN FRAILTY

Andrei Zviagintsev was born on February 6, 1964 in Novosibirsk. After graduating from the acting faculty of the Novosibirsk Theatre Academy in 1984, he joined the Novosibirsk TIuZ (Theatre of the Young Viewer) as an actor, but conscription into the army led to work as a Master of Ceremonies in the Novosibirsk Military Ensemble. In 1986, he left Novosibirsk for Moscow where he enrolled in the acting faculty at GITIS (the State Institute of Theatre Art), graduating in 1990.[1]

During the 1990s, Zviagintsev wrote a number of short stories and spent much time watching the classics of world cinema at the Moscow Cinema Museum. He shot commercials, did some theatrical acting, and worked as a cinema extra. But in 2000, the producer Dmitry Lesnevsky invited him to make three short novellas—*Busido*, *Obscure*, and *The Choice* (*Vybor*)—for the REN-TV film almanac *The Black Room* (*Chernaia komnata*) which had the subtitle "Amazing and Terrifying Stories."[2] In making these films, Zviagintsev had to conform to the demands of the genre: they each last less than half an hour, have a cast of two or three characters, and are limited to a very small number of sets and a short timescale. It is nevertheless remarkable how many of the concerns and approaches of Zviagintsev's mature style are already on display here. The plots of all three films address questions of trust and betrayal, real or imagined. In all of the films the central character is representative of a type of brutal masculinity and all of them include violent deaths

[1] Details of Zviagintsev's biography are available on his personal website, at http://www.az-film.com/. This site is also an invaluable source for materials about his films, in both Russian and English.

[2] These three films are available, in Russian, on Zviagintsev's website.

(real and imagined).[3] In both *Obscure* and *The Choice* this violence erupts within a broken family unit, while in *Busido*, an older man chooses to interpret his relationship with his bodyguard as akin to that of brothers. In both *Obscure* and *The Choice* the wives are more mysterious than the husbands and their motivation is more difficult to understand, a factor which will mark all Zviagintsev's feature films from *The Banishment* (*Izgnanie*, 2007) onward. All three films are explicitly concerned with questions of observation and representation: in *Busido* a photograph on the wall conceals a spy hole, while all the events of *Obscure* are filmed by a video camera, and in *The Choice* a husband secretly observes a conversation between his wife and her posited lover.[4] This gives all the films a strong element of ambiguity, offering the characters moral tests and leaving the viewer to ponder ethical questions. (*The Choice* explicitly deploys the trope of alternative endings.) All three films are shot by Mikhail Krichman, who has remained Zviagintsev's cinematographer on all his feature films to date. Even small details of the mise-en-scène, the constantly playing televisions in *Busido* and *Obscure* continue to play a key role in Zviagintsev's mature work. Lesnevsky, who was also General Director of REN-TV, was so impressed by what he saw that he commissioned a feature film, the film that would become *The Return* (*Vozvrashchenie*, 2003).

The Return tells the story of an unnamed man returning to his family after a long absence and taking his two sons on a trip through Russia's far north.[5] Much about the man remains satisfyingly and productively mysterious. Why has he been away so long? What is in the box that he digs up on a northern island? Who is he continually phoning? Why is his treatment of his sons so demanding? This enigmatic quality encourages the film's viewers to interpret the film

[3] All five of Zviagintsev's feature films so far are about family in crisis and include the trope of violent death.

[4] The plot of *The Choice*, which concerns a husband's reaction to his wife's story of infidelity, closely prefigures that of *The Banishment*.

[5] The tense, rivalrous, and ultimately violent car journey of the three central characters had already been used in *The Choice*.

as parable. For some, the man's absence coincides with the period since the demise of the Soviet Union, making him Soviet man bereft and adrift.[6] For others, an early scene in which he lies resting on a bed in an obvious recreation of Andrea Mantegna's painting *The Lamentation of Christ* suggests interpreting the film as religious allegory.[7] This religious element, absent in the early shorts, will recur in all of Zviagintsev's later films.[8] The interest in family and its trials, confined to the relationships of husbands and wives in the early films, is here extended to address the intense and potentially violent relationships of parents and children, another concern present in all Zviagintsev's later films. The sons are frequently seen observing their father and the trope of the family photograph, used sparingly in the early films, now comes to play a central role in the elaboration of the film's meaning. On the man's unexpected return, the boys rush to check an old photograph hidden in a Bible to assure themselves that he is who he says he is, while the film's coda consists of another twenty-five photographs, the majority of them ostensibly taken by the boys during their trip, the others

[6] The break-up of the Soviet Union has frequently been said to have been a more difficult experience for men than for women, in both ideological and economic terms, leading to a "crisis of masculinity," which is reflected in many Russian films of the early twenty-first century, for example in Boris Khlebnikov and Aleksei Popogrebsky's *Koktebel'*, released the same year as *The Return*. For revealing readings of the crisis of masculinity, see Helena Goscilo and Yana Hashamova, eds. *Cinepaternity. Fathers and Sons in Soviet and Post-Soviet Film* (Bloomington IN: Indiana University Press, 2010).

[7] On the biblical allusions in the film, see Vlad Strukov, "The Return of Gods: Andrei Zviagintsev's *Vozvrashchenie (The Return),*" *Slavic and East European Journal* 51, no. 2 (2007): 331–56.

[8] There are several biblical allusions in *The Banishment*, in which children work on a jigsaw puzzle of Leonardo da Vinci's "Annunciation" and are read at bedtime a passage from St Paul's First Letter to the Corinthians concerning the consequences of the lack of charity; in *Elena* the heroine quotes the parable of the laborers in the vineyard in an attempt to persuade her husband to generosity; while in *Leviathan* the hero's experiences are explicitly modeled on the Book of Job.

taken earlier in the family's history.[9] At the 2003 Venice Film Festival, *The Return* won not only the prize for best debut feature but also the Golden Lion itself, a rare accolade for a first feature.

Zviagintsev's second feature film, *The Banishment,* is also concerned with family, with masculinity in crisis and with the home as a place of trial, but its setting is the most abstract of all of his films (the film was shot in Belgium, northern France, and Moldova) and the names of the characters (Alex, Vera, Mark, and Robert) are such that they could belong to most European nationalities. The sense of abstraction extends to the time, which is not specified, and to the film's story. This is the first of Zviagintsev's co-operations with Oleg Negin, who will be the scriptwriter on all his later films. It tells the story of a woman who lies to her husband that the child she is expecting is not his, and of his devastated and violent reaction. The woman's motives are not revealed until after her death but the work with Negin marks a new turn in Zviagintsev's films. In this film and the following two films it is the central female figure, a woman conflicted over her husband's perceived indifference, who is capable of the deepest emotions and who displays the greatest moral complexity. Nevertheless, the decision not to allow the living Vera to articulate her feelings and an unease with the film's abstraction led many viewers to be dissatisfied with *The Banishment* and it attracted far less critical attention than *The Return.* For some time it was widely considered a failure, leading Zviagintsev, in several later interviews, to describe it as his favorite among his films, the "child" needing most love and encouragement. It was only later, after the release of *Leviathan* (*Leviafan,* 2014), which in some respects it prefigures, that its role in Zviagintsev's artistic development was better understood.

[9] For a suggestive interpretation of the role of these photographs, see Philip Cavendish, "The Return of the Prodigal Photograph: Time, Memory, and the Genre of the Photo-Film in Andrei Zviagintsev's *Vozvrashchenie* (*The Return,* 2003)," *Slavonic and East European Review* 91, no. 3 (2013): 465–510. Family photographs will play a role in defining the relationships between the central characters in all Zviagintsev's later films.

In 2008, Zviagintsev made the short film *Apocrypha*, a contribution to the film almanac *New York, I Love You*, eventually removed from the film's cinema release. A father lends his son a video camera. When he asks the young man how his mother is we assume that this is another of Zviagintsev's families in crisis. The young man films from a bridge, and when he reviews his material we see that he has captured the anguished parting of a young couple. Rushing back to the spot, he finds a photo of them in a forgotten book, but it blows away in the wind. This enigmatic short film, which is framed by allusions to the work of Joseph Brodsky, reworks the key Zviagintsev trope of the tragic sundering of erotic and family relationships. Once again, as in *Obscure*, a relationship in crisis is captured by a video camera, while a photograph suggests happier times, and once again the act of observation is itself observed, by director and viewer. Once more Zviagintsev uses a short film as an experiment, as a means of discovering new ways to express his concerns.

In his third feature film, *Elena* (2011), Zviagintsev continues to probe the inner world of a complex woman (Elena is both wife and mother, both nurse and murderess) and the film retains the broad symbolism and intellectual rigor of the early features. But by setting his film in two contrasting flats in contemporary Moscow, and by invading the space both visually and aurally with constantly jabbering television sets, he adds a new social specificity to his work.

In the same year, Zviagintsev made the short film *The Secret* (*Taina*), a contribution to the almanac *Eksperiment 5ive*, in which all the films open with a shot of a photograph that holds the key to the unfolding story. Like all his shorts, *The Secret* experiments with the themes Zviagintsev addresses in his feature films. The story is one of suspected marital infidelity, already treated in *The Choice* and *The Banishment*. But whereas there it was the husband who had to respond to the suspicion of betrayal, in this case it is a wronged wife who hires a private detective, but eventually takes his advice to remain in ignorance. As the detective puts it, in explicit articulation of a recurring Zviagintsev concern: "A person is a mystery [. . .]. We all hide something from each other."

The social concern that subtly pervades *Elena* comes to the forefront in *Leviathan*, an epic film, set, once again, in the Russian far north, in which an ordinary car mechanic finds himself assailed simultaneously by dire fate and the petty demons of contemporary Russia. Though it shares many of the concerns of Zviagintsev's earlier films, it brings a new directness and civic anger to their examination. *Leviathan* was greeted with controversy in Russia and with acclaim around the world.

Both formally (it opens, as does *Elena*, with forlorn trees and cawing birds) and narratively (it shows a family in crisis and the characters leaving home), Zviagintsev's fifth feature film, *Loveless* (*Neliubov'*, 2017) confirms the suspicion that, like that of several great directors (for example Antonioni and Tarkovsky), Zviagintsev's genius lies in composing virtuosic variations on a single theme. As in *The Banishment*, *Elena* and *Leviathan*, a married couple are in crisis—and this time they have already both embarked upon new relationships, which, by the film's end, are cruelly exposed as just as arid as the marriage that they have fled. As in *The Return* and *Leviathan*, a young boy is at odds with his father and attempts to escape from his control, but this time his disappearance is permanent and the viewer is left to surmise whether the boy has been killed. In its skewering of a Moscow family, *Loveless* is both darker and more conventional than the earlier features.

At this stage in his career, Andrei Zviagintsev has made five feature films that have combined formal rigor and ambition with the unflinching examination of universal existential issues of human motivation, character, and relationships. His work has won prizes and acclaim around the world and made him into the most important Russian director of his generation.

Julian Graffy

CRIME WITHOUT PUNISHMENT?
ANDREI ZVIAGINTSEV'S *ELENA* BETWEEN ART CINEMA
AND SOCIAL DRAMA

Andrei Zviagintsev is the most internationally acclaimed Russian filmmaker to emerge in the twenty-first century. With a host of awards and nominations at such prestigious venues as the Venice, London, Shanghai, and Cannes Film Festivals under his belt, he simultaneously managed to capture the imagination of the more commercially oriented juries, such as France's César, the Golden Globe, and the American Academy Awards. In this bridging of art house and social problem cinema *Elena* constitutes a watershed of sorts: it is more socially specific than Zviagintsev's previous two films, with many recognizable markers of Putin-era Russia. Yet the script of *Elena* was originally commissioned by a British producer, Oliver Dungey, for a four-part international series of films on the theme of Apocalypse. The plan was to film in English, with the setting in Britain or the US. Because the project was slow to materialize, Zviagintsev and his writer Oleg Negin decided to pull out and to convert the script into a freestanding film set in contemporary Russia. Meanwhile, the screenplay was awarded a prize for "script potential" at the Sundance Film Festival even before the film went into production—a sign that the story transcended national borders.

Like all of Zviagintsev's films to date, *Elena* zooms in on the problems of family and parenthood. Unlike his other films, it focuses on a woman, a mother, a grandmother, and a wife. The title of the film is the protagonist's name and thus a deviation from Zviagintsev's tendency to name his films in a more abstract and symbolic way: *The Return, Banishment, Leviathan,* or *Loveless.* The title character, Elena, is a former nurse who lives with her wealthy aging husband Vladimir in a luxury apartment in an élite area of downtown Moscow. (Think of Manhattan's Upper East Side.) The husband and wife are united by a pragmatic arrangement: she

Elena Prokhorova

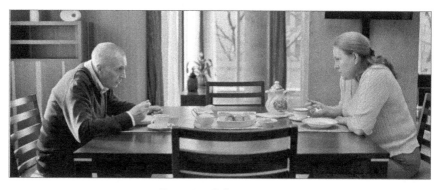

Fig. 1. Family happiness?

enjoys the comforts of an upper middle class lifestyle in exchange for cooking, cleaning, nursing and, if needed, sharing Vladimir's bed. As the couple sits down to have breakfast it instantly becomes clear that their orderly family routine is only superficial; beneath it simmers an old argument about two eternal things: family and money (Fig. 1). Both Elena's son and Vladimir's daughter first emerge in that conversation, and the looks that Elena and Vladimir exchange betray mutual frustration. As with Zviagintsev's other films, this opening scene already contains all the questions (and perhaps the answers) that lie at the core of the narrative: who exactly counts as "family"? What, if any, obligations do we have toward those "others" whom we do not consider "us"? And how do we expect to be treated by those we reject? Add in money and we are dealing with an archetypal plot that is as archaic as it is modern, as transnational as it is nationally specific. Money, of course, has always been a factor in human relations. But after the fall of communism *a lot of money* became a factor *very quickly*.

For the next ten minutes of the film we accompany Elena as she goes to visit her son: via a bank, where she gets her pension, to give all of it to the son's family; a shuttle van (*marshrutka*) and a suburban train (*elektrichka*) to the outskirts of the city; a long walk through a barren industrial landscape; a stop at the grocery store; and finally the pre-fab "projects." While Elena is taking the elevator, the camera leaves her and frames her son, Sergei, on the balcony of his apartment. It is a long take, typical of Zviagintsev, which allows us to examine him in detail: the discarded packs of Marlboros, the

Fig. 2. Blood is thicker than water.

beer belly, the spitting, the slouch. He looks like someone who spends a lot of time on this balcony, smoking and spitting and staring at nothing in particular. Finally, we witness Elena with Sergei's family, and she smiles for the first time in the film as she hugs her toddler grandson. It is clear that, while Elena respects and perhaps even loves Vladimir, her heart is with her son and his family (Fig. 2). For this family she is ready to murder—and will do so.

There are at least two ways to approach *Elena*. First, it is a critique of Putin-era Russia, with its abysmal economic inequality between the haves and have-nots, and the resulting "natural" resentment and social envy. This conflict also points to the co-existence in contemporary Russia of a traditional collectivist mentality with a new individualistic (Western) mindset. Second, one can see in *Elena* a universal parable of human instincts and passions, transcending its particular setting—the kind that all of Zviagintsev's films favor. This examination of the human condition foregrounds the artist's unique vision of the world, his "signature style."[10] These approaches

[10] David Bordwell argues that, in contrast to classical narrative cinema, art cinema underplays and loosens the cause-and-effect logic. In its stead, it deploys realism and authorial expressivity as narrative motivations, conveyed via certain devices that form the filmmaker's "signature style." Where genre cinema tends to resolve all conflicts and strives for maximum clarity, art cinema prefers ambiguity, such as open-endedness and withholding of the authorial position. David Bordwell, "The Art Cinema as a Mode of Film Practice," *Film Criticism* 4, no. 1 (Fall 1979): 56–64.

are not mutually exclusive, of course, but looking at the film through each frame separately often reveals interesting patterns.

In *Elena*'s mise-en-scène we see unmistakable signs of contemporary Russia: the bribe that Sergei needs to pay to get his son admitted to college and save him from being drafted—a scary prospect for young men in Russia because of brutal hazing and the possibility of being sent to a war zone; a suburban train with sellers peddling all manner of knick-knacks; migrant workers from Central Asia crossing the street; and ubiquitous and loud television sets. Apart from the final scene in which Elena's family settles in to watch television in their new pad, we only *hear* television. But the drone of lifestyle programs (for Elena), sports broadcasts (for Vladimir), and dating shows (for Sergei and his family) is a comment on the contemporary culture of mind-numbing entertainment. Television is also the one item that is present in both households, otherwise quite different. In the absence of civil society in Russia, television provides a sense of community to the fragmented empire that never became a nation state.

Visually, a series of images organizes a transparent contrast: a spacious, Western-furnished condo against a cramped Soviet-style apartment, filled with furniture and people; an Audi and an élite health club vs. cheap beer and smokestacks for a landscape; home delivery of groceries vs. a convenience store where the saleslady does not know how to run a credit card. The contrasting mise-en-scène also works as scaffolding for social characterization: Vladimir's belief that Sergei must take care of his own family vs. Sergei's expectation that Vladimir must share his wealth; Katia's ironic but firm refusal to have children because of the family's "rotten seed" vs. Sergei's ever-multiplying clan. The title character moves between and, up to a point, tries to bridge the two worlds, crossing not only the sprawling space of Moscow and the socioeconomic stratification of post-Soviet Russia, but also the historical legacy of the Soviet past, still quite visible. Elena's journey from Vladimir's apartment to Sergei's prefab house in the outskirts of Moscow is also a trip back in time.

The film's unsentimental dissection of life and relationships in contemporary society is sobering and, for Russia, quite

revolutionary. With few exceptions (for instance, *Little Vera* [*Malen'kaia Vera*, Vasily Pichul, 1988] or *Kokoko* [Dunia Smirnova, 2012]) neither Soviet nor post-Soviet cinema was willing to engage with such issues as social class, or family and money, and other such "distasteful" and "mercantile" topics. But in *Elena* the contrast is perhaps a little too neat and obvious and thus a bit of a red herring. Despite the rich social context that the film provides, there are some crucial omissions. For example, we do not know the source of Vladimir's considerable wealth. While the kneejerk reaction is to think that he is a retired businessman, the people who assemble at his funeral point to his belonging to the so-called *silovye struktury* (security agencies, that is, the FSB, the army, etc.), who took over Russia and its resources. This does not change Elena's crime or the conflict between the "haves" and "have-nots," but it undermines the legitimacy of Vladimir's sermons to Elena about the value of hard work. Likewise, many Russian and Western critics call Elena's son a "ne'er-do-well," but describe Katia, Vladimir's offspring, in a more flattering way as sophisticated, modern, and cosmopolitan. Yet the film does not show either Sergei or Katia working; as far as we can tell, they both live mooching off their respective parents. Zviagintsev first planned to make Katia a translator and even shot a scene, in which she and her boyfriend were watching a documentary on the Internet about the Marxist philosopher Slavoj Žižek—a prominent figure of Western cultural theory. By leaving such details out of the final cut, Zviagintsev elevates the plot to a symbolic level. The film's unhurried pace, sparse dialogue, the characters drawn with razor-sharp precision, and a basic, archetypal conflict invite us to project our own life philosophy onto the visual field of the story world.

A good example of the director's "signature style" is the opening shot of the film; it will be repeated with variations at the film's end. It is an extremely long take lasting a minute and twenty seconds, when almost nothing happens in the shot in the conventional sense. It is early dawn, and we look at the balcony of an apartment, out of focus, obstructed by tree branches. The color palette is typical for Zviagintsev—bluish, cold, washed out, a child of northern light. Eventually, the rising sun lights up the room, and one minute into

the shot a crow lands on a tree brunch and caws. Such a shot at the film's opening signals an invitation to learn about the characters, but in accordance with the filmmaker's individual agenda. For example, in *Citizen Kane* (1941), from the sign "No Trespassing," Orson Welles takes us through a series of dissolves to the lit window of Xanadu, and we hear "Rosebud," the last word of the dying man. The film sets us on a road of inquiry into its meaning. Alfred Hitchcock's *Psycho* (1960)—a film about dark secrets and voyeurism—begins with the bird's eye panning shot of Phoenix, eventually focusing on a hotel and inviting us to follow the camera through a black opening in window shades. The shades' horizontal bars replicate the design of the credits sequence; both anticipate the theme of cutting, central to this horror film. Likewise, *Elena*'s opening and the following series of static shots inside the apartment symbolically introduce *Elena*'s major themes: a family tree; a tree of life; nature (blood ties) vs. culture (Christian ethics). The opening also establishes a mode that the film will sustain: that of an anthropological study of humans in their physical environment.

As viewers, we are given full freedom to make sense of what we see. At the level of plot there is no mystery: we witness Vladimir's heart attack in the swimming pool, his drafting of the will, and his categorical refusal to give money to Elena's family—with a didactic lecture to boot; finally we follow Elena's murder plan step by step. Mikhail Krichman's camera in fact is keen on making us privy to the details of Elena's actions: we are there when she mixes Viagra pills with the health drink that she prepares for Vladimir, when she sits alone in her room waiting for the pills to do their job, when she finds him dead, and when she burns the draft of the will. As film critic Jay Hoberman notes, "none of the characters in *Elena* is particularly likeable—and only Elena seems capable of disinterested action. That her selflessness is also a heinous crime gives the movie its Hitchcockian aspect: Whom do we spectators root for? What is it that we want to happen?"[11] While the crime

[11] Jay Hoberman, "With *Elena*, Andrey Zvyagintsev Vividly Exposes the Moscow of Today," *Blouinartinfo*, May 16, 2012, accessed November 10,

and its beneficiaries are clear, Elena's psychological portrait is left for the viewer to construe. Was she always resentful of Vladimir's "stinginess" and his brushing off of her family? Was the plan to kill Vladimir a spur-of-the-moment decision, triggered by his heart attack and the drawing of the will? Or had it always been at the back of her mind, as a possibility? Is she an awe-inspiring matriarch defending her young or an evil fairytale stepmother, who gets rid of her husband (with a modern substitute of Viagra for a poisonous apple) and cheats her stepdaughter out of a fortune? Katia certainly knows that she is no match for Elena or what Elena is capable of; hence her question, "So, how are we going carve up Dad's place?," hiding her pain and perhaps even fear behind the façade of cynicism.

The most shocking aspect of Elena's crime, perhaps, is that there is no marked change in her behavior, no break in narration. The murder sequence is anti-climactic and understated. The decision to take a human life comes to her as inevitability: she has only half a day to act before Vladimir signs the will; she has to help Sergei and his family at any cost because blood is thicker than water. In depicting Elena's transformation from a wife to a murderer, the film does not attempt to draw us *into* its story world; instead we remain observers, suspended between the film's surface and our own understanding of the world. Film scholar Naum Kleiman argues that Zviagintsev's visual style conveys an ethical stance. For example, Zviagintsev's film *Return* brings to the screen the horizon line, which divides space and separates heaven and earth. In *Elena,* the camera follows the female protagonist in such a way that our heart sinks even before we know that she has decided to kill her husband. The camera is neither subjective—hand-held and jittery— nor is it detached. It rather hints at the mysterious presence of a higher power, witnessing the events.[12]

2017, http://www.blouinartinfo.com/news/story/804706/hoberman-with-%E2%80%9Celena%E2%80%9D-andrei-zvyagintsev-vividly-exposes-the-moscow-of-today.

[12] Naum Kleiman, "Algebra i metafizika: O kinematografe Andreia

Vlad Strukov quotes Zviagintsev's diary, in which the director notes that, in depicting "Elena's 'personal apocalypse,' he gives preference to the use of the camera—what he calls 'special optics'—rather than actors and extras."[13] There are, in other words, images in Zviagintsev's film that form motifs and provide insights into characters. One such motif is reflective surfaces: mirrors, windows, and glass frames. For example, there is a repeated shot of Elena in front of the mirror with three panels, which splits her image in two, suggesting that underneath an ordinary woman there is another person. When the image first appears at the beginning of the film, the film racks focus from Elena to her two reflections, attracting attention to the split but not giving any clues. The second reflection occurs right after Vladimir's announcement of his will. Elena gives him the paper he requests, goes to her room, and calls Sergei to tell him that Vladimir refused to give money for the bribe. While she tries to calm down her son who is spitting profanities at the "tightwad," it is her uncanny reflections that tell us that she *will* kill: in the left edge of the mirror, out of focus and facing left (which is associated with the Devil in Russian folklore), is a faceless third reflection of Elena (Fig. 3). Finally, on the morning after the murder, the mirror repeats the first shot, except now we notice a picture of Sasha attached to the mirror—the one for whom she has killed.

Family photographs play an important role in Zviagintsev's films and *Elena* is no exception. These pictures are signs of the past in the present and are often keys to an enigma. We see the photograph of Katia as a little girl on the desk at the film's beginning. It appears before we are introduced to any of the characters and is easy to miss amidst the static shots of the apartment. But by placing the photograph as the *first* human image in the film, immediately preceding our introduction to Elena, the director hints at the as yet

Zviagintseva." In *Dykhanie kamnia: Mir fil'mov Andreia Zviagintseva* (Moscow: Novoe literaturnoe obozrenie, 2014), 438–45. See in particular p. 440.

13 Vlad Strukov, 98, in Further Reading.

Fig. 3. At the crossroads: Elena and her reflections.

unseen conflict, the two versions of "family." In contrast, Elena's family pictures on the wall of her room are as numerous as her clan. Even though we have seen Elena's room several times before, the first time we notice the pictures is when Elena sits on her bed, waiting for the deadly pill mix to work, and looks at the opposite wall. There are photos of her son as he grows up, gets married, has children. There are no pictures of her husband. The pictures suddenly illuminate the previously invisible mental landscape: this is what has been on Elena's mind day in and day out. But then the camera zooms in on the photograph in the middle: of Elena herself when she was younger; she is smiling in that picture, taken in a park. We see this picture from Elena's point of view, until she lowers her eyes. The contrast between the person in the picture and the one who is murdering her husband either does not exist or does not deter her. In his numerous interviews, Zviagintsev claims that the way Elena commits her crime makes the story not a drama, where the protagonist has doubts and a degree of self-reflection, but a tragedy: her action equals her fate and the call of blood justifies everything. Zviagintsev also refers to Katia as Cordelia, King Lear's true daughter. In the hospital scene after Vladimir's heart attack she tells him the truth about the convenient lie he is living, pretending that his business arrangement with Elena involves real love and care—the delusion that Elena sustains and even shares herself, until she has to choose. In this sense, by making Vladimir realize his

profound love for his daughter, Katia inspires him to write his will and thus sets the tragedy in motion.[14]

Elena also comments on the role of the Orthodox Church in contemporary Russia. The influence of the church has been steadily rising in the two decades of Putin's presidency, which uses its authority to strengthen the state's legitimacy. Elena, whom one might take for a believer, turns to religion opportunistically, to spite the stingy Vladimir, or "just in case." In the church where she goes after Vladimir's heart attack she is clearly a stranger: she does not cover her head and does not know to which saint she should light a candle to pray for her husband's health. The camera suggests as much when Elena sees her own face reflected in the glass covering the icon. Her one true faith and her one iconostasis is the wall covered with pictures of her family. The crucial conversation between Elena and Vladimir about his will is also filled with Biblical quotes. Vladimir mocks Elena's invocation of Jesus's words: "And the last shall be first and the first last," calling the parable a "fairy tale for the poor." This kind of language to talk about religion was typical of the Soviet era, known for its anti-religious propaganda. But apart from this instance, Vladimir is as far removed from Soviet behavior as possible. He is an individualist and (seemingly) a self-made man: brotherly love, whether socialist or Christian, is completely alien to him.

Unlike religion proper, the ethical dimension of the film—as an exploration of the human soul and the social fabric—manifests itself in the film's mise-en-scène, camera work and the soundtrack. Although the filmmakers pulled out of the "Apocalypse" project, *Elena* retained some echoes of the original idea. Only now it is an "Apocalypse for one." For example, the fragment from Philip Glass's Third Symphony first appears, mixed with urban sounds, during Elena's first trip to visit her son. The music conveys an as yet unexplained sense of anxiety to the viewer, pointing to the moral abyss, which Elena does not notice. When Elena lights a candle in

[14] See Kseniia Golubovich, "Zerkalo," Zviagintsev's website, February 16, 2012, accessed July 5, 2018, http://az-film.com/ru/Publications/123-Zerkalo.html.

the church she is framed against a fresco depicting a scene from the Last Judgment. The Apocalyptic motif is also present in the image of the white horse by the side of the train, which Elena sees on her way to her family with the money stolen from Vladimir's safe after his murder. The most striking sign is the unexpected blackout that occurs in Sergei's apartment building while Elena and Sergei's family are celebrating their newly acquired wealth. When the kitchen suddenly goes pitch-black, we hear Sergei say "What's wrong, mom? You are gonna break my hand," as Elena squeezes his hand—a gesture signifying her terror. Zviagintsev noted that the horse and the power outage are signals of Elena's personal hell; they are also the only gleams of the irrational, the mystical in the otherwise very rational(ist) story.[15]

Meanwhile, Sergei goes to the staircase landing to check the fuse, and we hear his exchange with a neighbor. To the question whether the light is gone in the entire building, the neighbor jokingly answers "in the entire world" (*na vsem svete*). The next five minutes of the film are shot in the dark. The camera, which kept its distance from the events and was often static, is unchained in the scene of the violent and senseless fight between Sasha's pack and another neighborhood gang. We do not need this scene to realize that the beneficiary of Elena's horrendous crime is a mindless thug. We are simply in hell. When the light returns, Sergei's family has moved into Vladimir's apartment, settling in front of the television (now we get the screen as well as the sound) and discussing remodeling. Nothing is out of the ordinary. The stronger species has won and is procreating:[16] the "God's eye view shot" frames

[15] Roman Volobuev, "I ia ne znaiu, chto s etim delat'." Interview with Andrei Zviagintsev, *Afisha*, September 28, 2011, accessed February 2, 2018, http://az-film.com/ru/Publications/57-I-ja-ne-znaju-chto-s-jetim-delat.html.

[16] One of the draft scenes depicted Vladimir in the hospital, after his meeting with Katia, watching a film about a plague of locusts on television. The scene suggests a foreboding of disaster: the coming of new barbarians. Zviagintsev, however, decided to eliminate it from the film's final cut, because the author's voice became too clear. See Irina Liubarskaia, "Vne KANNkurentsii." Interview with Andrei Zviagintsev, *Itogi* (May 23, 2011), accessed October 13, 2017, http://www.itogi.ru/teatr/2011/21 /165516/html.

Sergei's toddler son, who awakens and sits up on the bed where Vladimir was murdered. Glass's musical motif reappears, playing over the last few scenes, which cut from the baby to the long shot of the family in the living room, and finally, with a slight re-framing, return to the original shot, with the tree in focus. On the one hand, the repetition of the visual and the musical motifs closes the frame opened at the beginning of the film. On the other hand, the music engenders anxiety in viewers that is never resolved. The familiar trope of celebrating a new generation and a renewal of life acquires an ominous meaning, setting biological, blood ties and an almost primordial sense of kinship *against* fragile social norms, Christian commandments, or humanistic values. The film leaves the viewer with a profound sense of anxiety, but without a definitive authorial judgment.

Elena Prokhorova

FURTHER READING

Graffy, Julian. "Andrei Zviagintsev: *Elena* (2011)." *KinoKultura* 35 (2012). Accessed March 12, 2018. http://www.kinokultura.com/2012/35r-elena.shtml.

Kondratov, Mariia. "Andrei Zviagintsev: *Elena* (2011)." *KinoKultura* 39 (2013). Accessed March 12, 2018. http://www.kinokultura.com/2013/39rr-elena.shtml.

Mohney, Gillian. "Russian Blues: Andrei Zvyagintsev on *Elena*." *Interview*, May 17, 2012. Accessed March 12, 2018. http://www.interviewmagazine.com/film/russian-blues-andrei-zvyagintsev-on-elena.

Strukov, Vlad. *Contemporary Russian Cinema: Symbols of a New Era.* Edinburgh: Edinburgh University Press, 2016. See pp. 99–108 on *Elena*.

THE TARGET*

Mishen´

2011

160 minutes

Director: Aleksandr Zel´dovich

Screenplay: Vladimir Sorokin and Aleksandr Zel´dovich

Cinematography: Aleksandr Il´khovsky

Art Design: Vladimir Rodimov

Music: Leonid Desiatnikov

Producer: Dmitry Lesnevsky

Cast: Maksim Sukhanov (Viktor), Justine Waddell (Zoia), Vitaly
 Kishchenko (Nikolai), Danila Kozlovsky (Mitia), Danijela Stojanovic
 (Anna), Nina Loshchinina (Taia)

This article is focused on the film idiom(s) elaborated by Vladimir
Sorokin and Aleksandr Zel´dovich in the 2000s to 2010s. A writer,
playwright, screenwriter, opera librettist, and artist, Sorokin
(b. 1955) is one of the most important figures of late-Soviet and post-
Soviet culture. His novels and short stories have been translated
into twenty-seven languages, and in Russia he has been awarded
important independent literary prizes. His works skillfully
combine the features of the radical avant-garde and mainstream
fiction.

* This article is a shortened version of Ilya Kukulin, "From History as Language
to the Language of History: Notes on *The Target*," in *Vladimir Sorokin's
Languages*, Slavica Bergencia, eds. Tine Roesen and Dirk Uffelmann (Bergen:
University of Bergen, 2013), 314–44.

Sorokin graduated from the Gubkin Institute of Oil and Gas Industry in Moscow. He was employed by a popular journal for youngsters, *The Shift* (*Smena*), but was fired after refusing to join the Young Communists' League (Komsomol), and then worked as an artist designing book covers and illustrating books. In the late 1970s, he began to write shocking short stories deconstructing the clichés of Soviet literature and demonstrating, in their plots, the potential for psychological and physical violence hidden beneath the surface of legally acknowledged literary discourses. His works could not be published, and circulated only in unofficial and underground culture. Early, Sorokin participated in Moscow Conceptualism, an unofficial postmodernist cultural movement that included such authors as Dmitry A. Prigov, Vsevolod Nekrasov, Ilya Kabakov, Lev Rubinstein, and Andrei Monastyrsky. In 1985, Sorokin's novel *The Queue* (*Ochered'*) was published in Paris. During the 1990s–2010s, Sorokin published a number of books and his plays are widely staged in Russia and especially abroad. Beginning in 2001, he has often been attacked by conservative, state-backed public activists for the "immorality" of his works.

In 2000, the director Zel'dovich released the film *Moscow* (*Moskva*), based on the script coauthored by him with Sorokin in 1995. (He was unable to find financial backers for five years.) Sorokin then scripted three more films: *One Kopeck* (*Kopeika* [*A Penny*], Ivan Dykhovichny, 2002), *4* (Ilya Khrzhanovsky, 2004), and *The Target* (*Mishen'*, Zel'dovich, 2011). Three additional films based on scripts by Sorokin are currently being shot or in postproduction, as reported in the media.

Among critics, Zel'dovich has acquired a reputation as a director-intellectual. He graduated from the Department of Psychology at Moscow State University and later, the Advanced Courses for Scriptwriters and Film Directors, which provided him a second graduate education in cinema. His first film, *The Decline* (*Zakat*), based on the 1928 play by the Russian-Jewish author Isaak Babel', was released in 1990. *Moscow*, released ten years later in 2000, was based on a Sorokin script and became Zel'dovich's second film. *The Target* premiered eleven years later and became one of the first sci-fi films shot in Russia during the 2000s-2010s. Meanwhile, Zel'dovich,

in collaboration with the radical postmodernist artistic group AES+F, staged two theater performances in Moscow: Shakespeare's *Othello* (2003) and Sarah Kane's *4.48 Psychosis* (2016). In Zel′dovich's *Othello*, the action was transferred to today's Moscow.

In his early texts, Sorokin presented an imaginary world of brutal violence and embodied metaphors, demonstrating, like other Moscow Conceptualists, the discursive subconscious of Soviet society. The images of this subconscious revealed the fears and tensions of Russia's society and demonstrated the authoritarian ambitions and potential of "infinite looping" hidden within *any* social discourse and *any* kind of literary imagination, not only of official literature, but also of dissidents' works. This "war of discourses" appeared endless and ahistorical. In the post-Soviet period, Sorokin shifted his method to an artistic study of contemporaneity. He presents different images of a society based on embodiment of discourses "impregnating" the Russian public sphere, such as the political idioms of power and today's reconsiderations of the classic works of Russian literature, transforming and mixing these idioms in grotesque ways. Sorokin's works throughout the decades have been full of fantastic, surreal images, but his most recent novels and short stories are now focused on how contemporary Russian society, afflicted with fear, aggression, and xenophobia, is being inscribed into the international context of a changing world.

The Target: A Historico-Political Comment on Russia in the 2010s

The American philosopher and literary theorist Fredric Jameson once described Utopia as a radical form of historicization of the present.[1] This interpretation is obviously relevant for any Utopia or anti-utopia, but it has a special significance when discussing *The Target*. The film problematizes the very historicization which serves as a basis for both Utopian and anti-utopian imagination.

[1] F. Jameson, "Progress versus Utopia; Or, Can We Imagine the Future?" *Science Fiction Studies* 9, no. 2, *Utopia and Anti-Utopia* (July 1982): 147–58.

The Target was given a limited release in Moscow in September 2011. Before that, it was presented at international film festivals in Berlin and Moscow and won several prizes.[2] But the response to the film in Russian newspapers, electronic media, and blogs was far from positive. The new film did not trigger any substantial analysis in the media: in rather superficial reviews, it was either heavily criticized or—more rarely—praised, but in overly generalized terms, as if the reviewers were too embarrassed to be positive.

Another telling point in the reception of the film was the almost demonstrative refusal by the critics to discuss its political connotations, although it is clearly a satirical depiction of contemporary Russia's "upper class." According to Sorokin, the society represented in the film is a kind of visualized dream of Russia's political elites. *The Target* portrays Russian society in the imminent future, such as in the year 2020, or, more exactly, contemporary society slightly masked as a future one. The depicted society is radically alienated from the historical process. The film's protagonists, unaware of their situation, try to break out of this unhistorical state, but have no psychological resources to acquire historical agency. In such a society, the historical process has nothing to which to return, there is no psychological and social room for it. The semantic focus of the film, which brings to the fore the motif of the impossible return of history, is the image of the Target itself.

The Plot of the Film and Its Social and Political Parallels in the Present

The action in the film takes place in the 2020s and the protagonists are well established, rich, and well respected. Viktor, Russia's minister of natural resources, sees himself as a brilliant example of a high-flyer; at the very beginning of the film he is interviewed by

[2] The Russian *Bely Slon* award, which is conferred by the Russian Guild of Film Critics, in the nominations "best cameraman" (Aleksandr Il'khovsky), "best production design" (Iury Kharikov and Vladimir Rodimov), and "best soundtrack" (Leonid Desiatnikov).

Fig. 1. The Glasses of Good and Evil.

a journalist, a representative of the media of the new superpower, China, who wishes to write Viktor's biography. Viktor eats only healthy food, always looks after himself, and uses fantastical technical devices—for example, the special glasses which can show the precise correlation between good and evil in each focalized object (a thing or a human being, Fig. 1). However, Viktor's wife, Zoia, as well-groomed as her husband, considers her life pointless, despite the family's wealth.

The spouses learn that far away, in the Altai mountains, there is a "Target"—a scientific and technical facility built in the Soviet era to collect elementary cosmic particles. A person who spends only one night inside the Target will attain eternal or, at least, long-lasting youth, and will regain meaning in his or her life. The spouses decide to make for the Target. They are accompanied by Nikolai, a customs officer and amateur sportsman, whose acquaintance Zoia first makes at the hippodrome, and by Mitia, Zoia's brother, a cheeky television host, who comments on the races in which Nikolai competes as a jockey (Fig. 2).

After a long and difficult journey (by plane, helicopter, and minibus), they all reach a half-deserted village located near the Target. The village's inhabitants make a fortune out of this

Fig. 2. At the Hippodrome.

profitable neighborhood: both the accommodation and meals cost an outrageous amount of money. In the only canteen in the village, they are waited on by Taia, a woman who looks to be twenty-years-old, although she claims that she is fifty-two; she spent a night in the Target when she was nineteen. They also meet another tourist from Moscow, Anna, an anchorwoman who provides the voice for a Chinese-language radio course. She has come there for the same purpose, and Mitia confesses that he fell in love with her voice long ago.

The Target is a huge—some one hundred meters to one kilometer across—disk, covered with small metal plates; it is embedded in the soil of a mountain hollow. There is an aperture in the center, which one must enter in order to experience rebirth. Here, the protagonists find a bottomless well surrounded by a concrete cell in which they spend one night. The sight of them leaning on one another, their frightened and irritated moods, the twilight, the atmosphere of mystery and unpredictability—all of this has obvious associations with Andrei Tarkovsky's *Stalker* (1979), particularly in the scene at the threshold of the room where dreams are fulfilled.

In the morning, the protagonists resurface, and on their way back to Moscow they pick up Taia. They build strange relationships with her—not just adopting the "barbarian" girl, casting themselves

as a collective Professor Doolittle (the protagonist of G.B. Shaw's play *Pygmalion*), but also taking her with them as a talisman, evidence of the effectiveness of the Target. Soon it becomes clear that the Target has influenced the protagonists much more significantly than they had expected. They stop feeling shy—or, at least, they are no longer able to suppress their hatred of the social conventions that they have come to find loathsome.

The protagonists of *The Target* are oppressed not only by the social conventions of everyday life, but also by the necessity of taking part in the cynical rituals of staged and mediatized public activity. For example, Mitia moderates a political-cooking TV show, where a supporter of the welfare state faces off against a conservative proponent of "ecological democracy." The participants do not really argue but simply perform their political roles: answering Mitia's question of what freedom means for them, they unanimously proclaim, "Freedom is the consciousness of necessity . . . of what the state wants!" According to Jean Baudrillard and Pierre Bourdieu, such a transformation of worldviews in *simulacra* is specific to contemporary media representations of public policy in general,[3] but the plot of Sorokin and Zel'dovich's film directly associates the imitating of "public policy" with the situation in contemporary Russia. This can be seen in the fact that Danila Kozlovsky, who plays Mitia, gave an obvious parody of Andrei Malakhov, one of the most popular television hosts in present-day Russia; and Zel'dovich has said in one of his interviews that Kozlovsky did this in accordance with the director's instructions. In his show, with a skittish intonation, Mitia quotes Nadezhda Mandel'shtam's *Hope against Hope*: "Why do you think you must be happy?"—as if ignoring the dark meaning of the quoted words. I agree with the implicit assumption of the authors of *The Target:* the degree of *imitativeness* of the public sphere in Russian television representations is generally higher than in programs broadcast in Western European countries.[4] All the scenes

3 Jean Baudrillard, *La Guerre du Golfe n'a pas eu lieu* (Paris: Galilée, 1991); Pierre Bourdieu, *Sur la télévision* (Montréal: Liber Editions, 1996).

4 See, for example, Vera Zvereva, *"Nastoiashchaia zhizn'" v televizore: issledovaniia*

from everyday life inserted into the plot of *The Target*—meetings at work, public presentations, or family holidays—are shown as more or less formal or hypocritical (with few significant exceptions).

Total corruption is another important element of the social context. The customs officer Nikolai is regularly bribed by Chinese truckers crossing European Russia on the ultra-modern Guangzhou-Paris highway (Fig. 3, this fictional highway is also

Fig. 3. The Guangzhou-Paris Highway.

mentioned in Sorokin's novel *Day of the Oprichnik*, 2006), and he arrests illegal Chinese migrant workers, whose masters then have to buy them from Nikolai. In the scene depicting the "migrant hunting," Russian officers tear across the steppe on motorbikes and throw nets shot from special handguns over the running men, as if they were wild animals. The music accompanying this scene was written by Leonid Desiatnikov and refers to Richard Wagner's *Walkürenritt (Ride of the Valkyries*, 1851/1854–56). The music, as well

sovremennoi mediakul' tury (Moscow: RGGU, 2012); Peter Pomerantsev, *Nothing Is True and Everything Is Possible: The Surreal Heart of the New Russia* (New York: PublicAffairs, 2015).

as the ethnic divergence of the characters—Europeans catch people with an Asian appearance—makes this scene an extended allusion to the "neo-colonialist" episode of the American helicopter attack on a Vietnamese village in Francis F. Coppola's film *Apocalypse Now* (1979), a scene also accompanied by *Walkürenritt*.

During a visit to the Bol'shoi Theatre, Taia tells the group that, thirty years before (in 1990), she had promised her boyfriend, who had also gone through the Target, to leave him for thirty years and meet him again in Moscow near the Bol'shoi Theatre. They separated "in order to become estranged from one another" and to recover their mutual attraction. She meets her boyfriend at the promised time and place and disappears with him, vanishing from the rest of the story.

Upon their return, the protagonists begin to rebel against their seemingly unproblematic social status. Zoia and Nikolai become involved in a love affair, in what is the first of numerous allusions to the plot of Tolstoy's *Anna Karenina* (1873–77/78) in which Anna, the wife of a high-ranking official, falls in love with an officer competing in the races. Unlike Tolstoy's protagonists, however, Zoia and Nikolai date almost openly. During the recording of his cooking program, Mitia produces a monstrous performance: after their call "for new blood in Russian politics," he invites his guests to taste his blood from huge goblets (a brutal materialization of metaphor—one of Sorokin's most characteristic devices).[5] This causes the television authorities to expel Mitia from Moscow with a few hours' notice—and after asking his beloved Anna to wait for him for two decades and to meet him in front of the Bol'shoi Theatre, Mitia too vanishes.

While opening his ministry's stand at an international exhibition, Viktor delivers a speech with a strange beginning and a politically dangerous continuation. He first suggests that only mineral products that contain (moral) good and truth should be

[5] Mark Lipovetsky, "Fleshing/Flashing Discourse: Sorokin's Master Trope," in *Vladimir Sorokin's Languages,* Slavica Bergencia, eds. Tine Roesen and Dirk Uffelmann (Bergen: University of Bergen, 2013), 25–47.

recovered—evidently, as seen through his electronic glasses—and then, in answering a baffled journalist's question about the meaning of "good mineral resources," he goes on to expose the corrupt chains in his "own" sphere. This scene refers to a problem which is very painful for contemporary Russia—corruption in oil and gas mining and transportation. Later, Nikolai is insulted by a young but powerful Chinese mafioso (possibly the son of a high-ranking bureaucrat or a gangster boss) and kills him. After this Nikolai has to leave Russia in a truck heading to the West.

Viktor organizes a party for beggars who are invited to his villa from the whole neighborhood. At this party a group of homeless men rape Zoia, and after that, the government officer who is sent to stop this strange "breach of order," deals Viktor a fatal blow with a piece of metal pipe. Viktor dies in his wife's arms—reconciled with the world and spiritually enlightened. Despite its baroque artistic splendor, the "beggars' ball" scene seemed absurd to some critics, who considered it to be unjustified. I could not find any mention in the reviews that the events in this scene were very precisely prefigured at the beginning of the film: the sexually unsatisfied wife Zoia tells Viktor a dream in which she is raped by several men. After having sex with her, Viktor says that he would be happy if she fell in love with him if he were a beggar, and could have died peacefully. But the protagonists do not remember these predictions when they become reality.

After Viktor's death Zoia commits suicide, throwing herself from a bridge under a train, the final allusion to *Anna Karenina*. The film ends with an episode where a calm Anna is looking at the Target from the mountain: she has replaced Taia in her job in the village canteen. She is probably hiding from Mitia's enemies and waiting for him in the same way Taia had been waiting for her boyfriend. In this film, as the only person who ends up safe, Anna becomes the surprising counterpart of Tolstoy's Levin.

In *The Target*, Sorokin and Zel'dovich showed the revolt of political and media elites—the event that was predicted repeatedly during the political discussions following the wave of protests of educated urban citizens in late 2011–early 2012 against the cynical public "exchange" of power positions between Vladimir Putin (then

the Prime Minister) and Dmitry Medvedev (then the President of Russia), and subsequent mass falsifications in the elections of 2011. Such a revolt is presented as ending in *failure* and unaware of its political implications. After the protests that began in December 2011, Sorokin and Zel'dovich would perhaps have depicted such a revolt of elites in another way, but the reasons that seemed important to them in 2005, when the script of this film was written, are worth further study.

The protagonists do not know exactly for which concrete purposes they are rebelling against social conventions. The Target has obviously inspired in them a yearning for a new experience of life and for fulfilment "here and now," but has not helped them to clarify the meaning of their existence. Why does this clarification remain impossible for all of them? Zel'dovich answered this question in one of his interviews when he said that the slogan of the film could be the phrase "God is not a supermarket!"[6] The protagonists make use of a miracle as if it were an expensive medical service. The film begins with a telling allusion: Viktor is going to work by car and performing a long soliloquy about what he is doing to preserve his health: for example, he does not drink any stimulant beverages, not even green tea—only warm and filtered water. This scene is an unfolding allusion to the famous beginning of Mary Harron's film version of Bret Easton Ellis' *American Psycho* (2000), where the main protagonist, who is later recognized as a cold serial killer, is attending to his morning toilette and speaking at the same time about his preferences in men's cosmetics.

Yet the interpretation provided by Zel'dovich in his interview remains insufficient: we still do not know why an object built in the Soviet era—an era which has been constantly criticized by Sorokin in previous interviews—now becomes a place of rebirth for the protagonists. In the following analysis of the film's cultural

[6] Valerii Kichin, 2009, "Kogda vremia techet vspiat': Aleksandr Zel'dovich i Vladimir Sorokin zakanchivaiut fantasticheskii fil'm," *Rossiiskaia Gazeta*, July 15, 2009, accessed January 27, 2013, http://www.rg.ru/2009/07/15/zeldovitch.html.

traditions and contexts, I consider it to be of great importance that this place of rebirth was built in the Soviet era, and that there is a considerable chronological distance between the construction of the object and the action in the film.

Allocontexts: The Target at the Intersection of Historical and Cultural Traditions

The image of the Target in Sorokin and Zel'dovich's film can be analyzed in the context of three important trends in contemporary Russian culture. As it turns out, the image enters into a polemical relationship with each of these trends.

The Target is the result of Soviet research and development, and obviously a secret one. In contemporary mass culture, secret research from the Soviet period is associated with a secret knowledge which is both demonic and beneficial. Soviet science is represented in this mass culture as a kind of magical practice. The most direct representation of this association can be found in the Russian blockbuster *Chernaia Molniia* (*Black Lightning*, Aleksandr Voitinsky and Dmitry Kiselev, 2009). The protagonist of this film — a young man — has a Volga brand car, which has been refined in a secret Soviet laboratory and turned into a retro version of James Bond's car. With the aid of this marvelous device, he punishes villains and saves a whole Moscow district from their crafty designs. But in Sorokin and Zel'dovich's script, the miracles performed by the Target do not make people happy.

The Target is an archaic facility (from the protagonists' point of view), situated in a remote place and connecting a person with the universe. In this description, the Target has much in common with Arkaim — the ruins of an ancient settlement, built approximately in 1800–1700 BCE and circular (!) in plain view. The excavation in Arkaim began in 1987, that is, at the very end of the Soviet period. This settlement is situated in the steppe zone of the South Urals in the Cheliabinsk region, and particularly attracts followers of some (but not all) Russian versions of New Age religions. These people consider Arkaim to be a place where cosmic energy can easily be felt. In the 2000s, this settlement became a popular place for an

esoteric tourism which very much resembles the pilgrimage of *The Target's* protagonists, but the former is much more popular. Sorokin and Zel'dovich's film establishes a polemical relation to the Arkaim mythology: the Target in the film has no connection with ancient cults (as pilgrims believe Arkaim to have); it is a very secular construction, although it has a miraculous effect on people.

In *The Target*, the transformation of human corporeality takes place in an abandoned empty space. The nearest equivalent of such a space, as mentioned earlier, is the Zone room in Tarkovsky's *Stalker*. This room is a mysterious area that allows human beings to fulfil all their desires. The parallels between *The Target* and *Stalker* have been discussed many times by critics since *The Target's* first festival release in Berlin. But in comparison to Tarkovsky's work, *The Target* actually has one important novelty: as an object, the Target has not only a transcendental but also an historical nature. The function of the Target in the film can be defined as a quasi-sacral space or a secular model of a sacred space. The most productive way to interpret the Target's function in the film is to use the conception of "image-paradigm" introduced by the art historian Aleksei Lidov. The "image-paradigm" is visible and recognizable as a resemblance between various pictures, buildings, or performance scenes, suggests Lidov, although this resemblance is not formalized as a figurative scheme and cannot be reduced to an illustration of one or other statement. From this point of view the image-paradigm is similar to a metaphor which loses its meaning when separated into its parts.[7]

Originally, Lidov suggested his model for the analysis of "hierotopies." According to his definition, this term means 1) the process of the creation of sacred spaces that plays an important part in the ritual and architectural practices of the world's religions: Christianity, Judaism, Islam, Buddhism, etc.; 2) the academic study of such spaces. The visual and spatial traditions represented in the

[7] A. M. Lidov, *Ierotopiia: prostranstvennye ikony i obrazy-paradigmy v vizantiiskoi kul'ture* (Moscow: Feoriia, 2009), 293.

image of the Target, however, are not connected to any specific religious practices, but to their transformation in the history of secularization. These are the image-paradigms of ruins and of "bewitched place." Sorokin and Zel'dovich bring them together without making a direct connection with their primary traditions, and identify them with the image of a womb.

The pre-Romantic cult of ruins has been thoroughly studied in cultural history. It is well-known that images of ruins functioned in the art of the late eighteenth and early nineteenth centuries as a material reflection of the destructive march of time. Andreas Schönle points out that a ruin expresses a presence and an absence at the same time; it is the trace of a whole, the sliver of a lost entity.[8] The Target functions in accordance with this interpretation: it is a technogenic ruin testifying to the presence of the past in the present. As is typical for a Romantic ruin, the Target is associated with irrational forces. In the Western European and Russian traditions, as mentioned above, such forces have been identified with the eroding effect of time and the unavoidability of death. In the film they are identified with the soul- and body-transforming effect of cosmic radiation.

The image-paradigm of the bewitched place has been studied less than the image-paradigm of ruins. The most vivid example of the former can be found in Nikolai Gogol''s story "The Bewitched Place" from the collection *Evenings on a Farm near Dikanka*, 1831–32. While looking for the devils' hoard of gold, the protagonist sees frightening visions, and the seeds sown there bring nothing good: "They may sow it properly, but there's no saying what it is that

[8] "A ruin carries a double message: it provokes a paradoxical thought about the loss and the preservation of the past at the same time." Andreas Schönle, "Apologiia ruiny v filosofii istorii: providentsializm i ego raspad," *Novoe literaturnoe obozrenie* 95 (2009): 24–38; see especially p. 24. On the pre-Romantic and Romantic cult of ruins see also: Mikhail Iampol'skii, *O blizkom* (Moscow: Novoe Literaturnoe Obozrenie, 2001), 124–46; Andreas Schönle, "Mezhdu 'drevnei' i 'novoi' Rossii: ruiny u rannego Karamzina kak mesto modernity," *Novoe literaturnoe obozrenie* 59 (2003): 125–41; Tatiana Smoliarova, *Derzhavin: zrimaia lirika*, Moscow: Novoe Literaturnoe Obozrenie, 2011), 520–31.

comes up: not a melon—not a pumpkin—not a cucumber, the devil only knows what to make of it."[9] The Target is also a demonic and "mutagenous" place: it has an effect on the psyche and the body.

In one of the periods of cultural history that followed Romanticism, we find an image-paradigm which is very important for the interpretation of the image of the Target: it is a secular model of the space of hierophany (in Aleksei Lidov's terms), that is, a manifestation of divine action in the world. The image-paradigm of "hierophanic space" is represented in culturally constitutive texts, for example, in the scene of Moses's meeting with the burning bush (Exodus 3:2). But in the twentieth century this image-paradigm reappeared in sci-fi literature and cinema, which are secular in spirit. It is precisely sci-fi where the specific, marked, and aesthetically shaped space of human beings meets with forces that are transcendental to human reason; it has become a permanent image-paradigm. This force may be represented, for example, in the figures of extra-terrestrials, in the unpredictably changing world of nature, or in reviving traumatic remembrances, which cannot be controlled by consciousness. Their reanimation, however, is also usually a result of extra-terrestrial activity. This kind of plot is developed in Stanisław Lem's novel *Solaris* (1961), in which the thinking ocean of the planet Solaris acquires the features of a quasi-sacral space.

Variations on this image-paradigm can also be found in Arkady and Boris Strugatsky's novels *The Snail on the Slope* (1965)—the image of the forest—and *Roadside Picnic* (1972)—the image of the Zone—as well as in Tarkovsky's *Stalker*. The latter is based on a script by the Strugatsky brothers and a free adaptation of *Roadside Picnic*. The zone is represented as a post-apocalyptic and post-historical space.

[9] Nikolai Gogol, "A Bewitched Place," *The Complete Tales*, trans. C. Garnett, ed. L J. Kent (Chicago: Chicago University Press, 1985), 198–206; see especially p. 206.

In all these cases the quasi-sacral spaces—like the bewitched places, but unlike the ruins—have one quality in common, which Lidov attributes to the sacred ("hierotopic") spaces: endless mutability.[10] But unlike traditional sacral spaces, the changeability of the quasi-sacral spaces is chaotic for human perception: there is no comprehensible plan, in fact, no conceivable plan at all. The Target is depicted as totally unchangeable, and this is underlined by the final scene of the film.[11] But it is important that this object contains a very deep well—a kind of rudiment of the changeability and unpredictability specific to image-paradigms of meeting with a secular *other*.

One more type of quasi-sacral space which has obviously had a strong impact on shaping the image of the Target can be found in the "zones" of the Moscow Conceptualists' performances, with their prescription to perceive the events' participants as strange and unpredictable creatures. Conceptualists worked with two types of *loci*: forest glades and "places of power" in the Soviet ideology, most often represented by the Exhibition of Achievements of the National Economy (VDNKh) in Moscow. The forest glades were used for numerous ritual-like performances by the group "Collective Actions"; very soon after, these one-off events evolved into the performance art cycle *Trips to the Countryside,* mostly conducted

[10] "The hierotopical projects presumed space to be permanently moving and changing." A. M. Lidov, "Vrashchaiushchiisia khram: ikonicheskoe kak performativnoe v prostranstvennykh ikonakh Vizantii," *Prostranstvennye ikony: performativnoe v Vizantii i Drevnii Rusi,* ed. A.M. Lidov (Moscow: Indrik, 211). 27–51; see especially p. 27.

[11] After an extremely long shot with a tiny Anna on the horizon, the screen goes white and the word *mishen'* ("Target") appears once again—just as in the opening credits. But at the beginning of the film, this word seems to expand letter by letter out of a strange hieroglyph resembling a Chinese word, and in the end, it again forms the initial hieroglyph. That symmetry, and the distance shot with a motionless object, accentuates the "extratemporality" and invariability of the film's central image.

in 1976–89.[12] Sorokin was well aware of these events and took part in some of them.

Sorokin's Target is located in the mountains (that is, far away from any town) and has a Soviet origin and ambitious original purpose. It combines the characteristics of the two types of Conceptualists' spaces described above. The Target is thus an instrument of historicization. (Compare the experience of contemplating the ruins.) This historicization is implemented as a kind of magic quasi-ritual practice (like the romantic bewitched place or conceptualists' spaces of performances), and imitates passage through the birth canal (as in rites of initiation).

"The Birth Trauma" of Post-Soviet Elites

The protagonists of *The Target* seldom mention the Soviet era. They are all (except Taia) between twenty-five and forty-fve years old. If the action takes place in 2020, we can infer that they were born in the last years of the Soviet era or soon after it had finished. For them, the Target turns out to be an instrument of historicization and rebirth, but neither the object itself, nor any other circumstances evoke any remembrances of the past. For example, Taia separated with her boyfriend in 1990; it is no accident that Sorokin, who is very attentive to such details, mentions a thirty-year term for his heroine's solitude. It is probable that the Soviet era has disappeared from the consciousness of the protagonists, even though they are historically connected with it, just as, in the doctrines of the psychoanalysts Otto Rank and his follower Stanislav Grof, the birth trauma is usually displaced from human consciousness.[13]

12 See the documentation and interpretation of their events and art performances: Andrei Monastyrskii et al., *Poezdki za gorod* (Moscow: Poligraf-kniga, 1998); Andrei Monastyrskii et al., *Poezdki za gorod* (Vologda: German Titov, 2009), vols. 6–11 (in one book).

13 Rank considers the separation from the mother's body the most painful event in human life, while Grof highlights the moment when you pass through the birth canal. See Otto Rank, *Das Trauma der Geburt und seine Bedeutung für*

The promise of eternal youth is an important but still secondary aspect of the film's plot. More important, although less evident, is the grotesque depiction of the essential socio-psychological trait of the political and media elites of post-Soviet Russia, caused by their refusal to scrutinize elements of the "Soviet" in their own consciousness and to apprehend the historicity of their social genesis. This leads to their inability to transform their consciousness, to insert it into changing history. The film's protagonists belong to these elites, and, due to their exclusion from history, they become incapable of orientating themselves, even if, like Viktor, they possess a device that makes it possible to distinguish between good and evil in quantitative terms.

The Target may suggest that the most catastrophic event in Russia's transition from Soviet to post-Soviet was members of the elites (those whose words and actions impact many people) not recalling their "birth trauma,"—in other words, the death of the Soviet dehistoricized, mythological space-time and emergence of the new state intended to be more historical and less "eternal." This "forgetfulness of the elites" is especially dangerous, and their irresponsibility may explain why the dénouement of the plot is much happier for Anna and former villager Taia, who do not occupy a high position in the social hierarchy.

The concept of human historicity developed in the film may, moreover, have been influenced by the ideas of the famous Georgian-Russian philosopher Merab Mamardashvili (1930–90). He has discussed the phenomenology of autobiographical and historical reflection in detail in two cycles of lectures about Marcel Proust and in many other talks.[14] In an interview with *Rossiiskaia Gazeta*, Zel'dovich said that, during his work on the script of

die *Psychoanalyse* (Gießen: Psychosozial-Verlag, 2007); Stanislav Grof, *Beyond the Brain: Birth, Death and Transcendence in Psychotherapy*, (Albany, NY: State University of New York Press, 1985).

[14] Merab Mamardashvili, *Lektsii o Pruste* (Moscow: Ad Marginem, 1995); Merab Mamardashvili, *Psikhologicheskaia topologiia puti* (St. Petersburg: Izdatel'stvo Russkogo Khristianskogo Gumanitarnogo Instituta).

The Target, he reread his own synopsis of Mamardashvili's lectures, which he had attended while studying at the Psychological Faculty of Moscow State University.[15]

Mamardashvili often returned to the idea that introspection, the base of the construction of the self, is an ethical duty for every person. This duty emerges because the self is too separated from previous states of consciousness, both from its own and those of others, to become aware of him- or herself as an actor in the present; it is therefore necessary to reconstruct a critical understanding of the link between these states. As Mamardashvili acknowledged, this idea was important for him under the conditions of the unreasonable oblivion of the Great Terror, which was supported by Soviet censorship.

The "Chinese" Cycle

The script of *The Target* is part of Sorokin's futurologist cycle; the main feature of the works that belong to this cycle is the depiction of a Sinocentric world. In this imagined reality, China is the international leader, with influence comparable to that of the US in the second half of the twentieth century. There are numerous acquisitions from Chinese in Sorokin's Russian language, like the borrowings from English in contemporary Russian. Sorokin's China is the place where technological trends, culinary fashion, and communicative styles originate.

In Sorokin's novel *Day of the Oprichnik* (2006), Russia is portrayed as an economic dependent of China; it is a transport adjunct of its eastern neighbor, and Russian members of the *siloviki* (the military and the law-enforcement agencies) are constantly demanding bribes from Chinese businessmen. There is also a hint of the repressive nature of the Chinese political regime: the narrator of *Day of the Oprichnik*, the oprichnik Komiaga, mentions that in China

[15] Valerii Kichin, "Sekrety ikh molodosti: Na Moskovskom festivale proshla gala-prem'era fil'ma *Mishen'*," *Rossiiskaia Gazeta*, June 27, 2011, accessed December 14, 2013, http://www.rg.ru/2011/06/23/mishen-site.html.

he would be sentenced to death for practicing "fish injections" (the bites of particular tiny fishes), which have a narcotic effect. This shift could easily be explained as a move from representation of one media myth to another. In the late 1990s, economists and political analysts from different countries predicted that China would be the superpower of the twenty-first century.[16] In the 2000s, Russian opposition media developed the idea that, by exporting oil to China, Russia would become its raw material adjunct and, moreover, Russia would become dependent on its neighbor. In other words, China in Sorokin's works of the 2000s resembles not an imaginary future, but contemporary scenarios that have not yet come true to the extent that Sorokin predicts.

The script of *The Target* was written in 2005, before *Day of the Oprichnik*, but the film itself was released after the novel's publication. In the film, the image of China is even more controversial: China is still a leader in technology (some episodes of the most fantastic urban views were shot in Shanghai), but it is at the same time a country which is connected to Russia through transnational crime and serves as a provider of illegal migrant workers. So, for Russia, it could be described as a functional equivalent of contemporary Tadzhikistan. The elites represented in the film are dependent on China, but their consciousness is both colonialist and disdainful toward any "plebeians." In the episode of "hunting for illegal immigrants," Nikolai allows Zoia to shoot a handgun that throws a net over the people who are running away. She shoots with pleasure and then immediately wants to have sex with Nikolai; they

[16] Conservative Russian analysts and journalists argued that this would be possible because China had started to reform its socialist system in the "right" way, that is, without ideological change. They implied that in the USSR Mikhail Gorbachev had attempted to implement ideological reform which had had negative consequences. Had he not chosen that way but instead reformed only the Soviet economy, the USSR could have been where China is today. Conservatives persistently "forget," however, that the oil dependence of the Soviet/Russian economy, which fundamentally distinguishes it from the Chinese situation, did not begin in the post-Soviet period but during the Soviet epoch itself—after the worldwide rise in oil prices in 1973. See Archie Brown, *The Rise and Fall of Communism* (New York: HarperCollins, 2009), 415.

copulate in the tractor trailer that transports bound immigrants, without feeling any unease, as if surrounded by animals. Just before this hunting episode, there is a scene in which Viktor opens a secret underground factory which uses milled Runius—a rare and very expensive imaginary metal. When he is shown three tiny bars of Runius, he snatches them and responds ironically to a question from the astonished laboratory supervisor: "But how will I account for that?" "You have already accounted for it to me!" The protagonists treat people around them both as colonizers (toward the conquered population) and as serf-owners (toward their own peasants as well as to those belonging to someone else, such as the Chinese illegals).

Conclusion: From Leo Tolstoy's Plot to Contemporary Russian Society

As mentioned above, Sorokin's film is full of references to Tolstoy's *Anna Karenina*. One of that novel's most important aims was to show that its protagonists are incapable of dealing with their lives because they cannot establish control over their current passions in the contemporary world. The specific characteristic of this world is the pace with which towns and regions that were previously unaware of each other become strongly connected. The most essential images in the novel are trains and railways. Directly after the description of Anna's suicide, a scene follows where Koznyshev and Vronsky meet in the train to go to the Russian-Turkish War (1877–78) as volunteers. Levin does not agree with them, since he believes that even a religious, "sacred" war is contrary to human nature. He is one of the few protagonists in the novel who almost never travels by train and, consequently, is only loosely bound to the newer, faster world. He is basically the only character in the novel who permanently comprehends the principles of good in a world of high speeds.

The scriptwriters Sorokin and Zel'dovich live in a world characterized by liberal (not Tolstoyan) attitudes to sexuality, by high-speed and immediate connections. Thus, it is characteristic that Zoia throws herself under the train *after having left the car.*

The central image of the film—the Target—is not ultramodern, like the train in Tolstoy's novel, but demonstratively anachronistic.

Political scientists, sociologists, and bloggers have often noticed that the present Russian regime and Russian society as a whole have a very narrow and permanently diminishing horizon of the future. The protagonists of *The Target* demonstrate the consequences of such a "narrowing of the horizon": the characters cannot establish control over their passions because they cannot find themselves in history. Planning to live peacefully in the future, they imagine it as similar to the present or the recent past. One of the scenes in the film demonstrates their self-assuredness and blindness with the clarity of a parable. After having left her husband for Nikolai, Zoia encounters his incomprehension and coldness, and says melancholically: "What will happen in fifty years? In eighty years?" And Nikolai, tiredly waving her aside, replies: "What eighty years? Wait for me, I'll be back soon..."—and departs for his meeting with the Chinese businessman/mafioso, that is, forever. Sorokin and Zel′dovich point out that the basis of this narrow-minded planning is not only a fear of the future, but also a displaced trauma which blocks historical self-consciousness. Within the logic of the film, even if one were to become free from authoritarian pressure, this would not bring "healing."

Ilya Kukulin

Further Reading

DeBlasio, Alyssa. "'Nothing in Life but Death': Aleksandr Zel′dovich's *Target* in Conversation with Lev Tolstoy's Philosophy of the Value of Death." *Russian Review* 73, no. 3 (July 2014): 427–46.

Dobrenko, Evgenii, Il′ia Kalinin and Mark Lipovetskii, eds. *"Eto prosto bukvy na bumage. . ." Vladimir Sorokin: posle literatury*. Moscow: Novoe literaturnoe obozrenie, 2018.

Strukov, Vlad. *Contemporary Russian Cinema: Symbols of a New Era*. Edinburgh: Edinburgh University Press, 2016. See pp. 236–57.

Wurm, Barbara. "Aleksandr Zel′dovich: *The Target* (*Mishen′*, 2011)." *KinoKultura* 32 (2011). Accessed September 12, 2017. http://www.kinokultura.com/2011/32r-mishen.shtml.

THE HORDE

Orda

2012

127 minutes

Director: Andrei Proshkin

Screenplay: Iury Arabov

Cinematography: Iury Raisky

Music: Aleksei Aigi

Producers: Sergei Kravets, Natal´ia Gostiushina

Production Company: Pravoslavnaia Entsiklopediia

Cast: Maksim Sukhanov (Metropolitan Aleksy), Roza Khairullina
(Taidula Khatun), Andrei Panin (Khan Tinibek), Innokenty Dakaiarov
(Khan Dzhanibek), Moge Oorzhak (Khan Berdibek), Aleksandr
Iatsenko (Fed´ka), Vitaly Khaev (Prince Ivan the Fair)

Like other directors of his generation, the career path of Andrei
Proshkin (b. 1969) is very much in the "family line": he is the
son of acclaimed director Aleksandr Proshkin, and shares his
interest in historical subject matter. Proshkin studied journalism
at Moscow State University, then completed the Higher Courses
for Screenwriters and Directors, where he worked with Thaw-era
luminary Marlen Khutsiev. In addition to his formal training, he
served as second director for his father and Karen Shakhnazarov
from 1994 to 2000. After working in Russian television in the late
1990s, Proshkin's first film, *Spartacus and Kalashnikov* (*Spartak
i Kalashnikov*, 2002), garnered prizes at Kinotavr and the Moscow
Film Festival, as well as the "Golden Eagle" award of Russia's

National Academy of Motion Pictures Arts and Sciences for best directorial debut. He has since worked consistently in film and television, collaborating with director and screenwriter Aleksandr Mindadze, and the celebrated screenwriter Iury Arabov. Proshkin has also joined with other prominent Russian directors to establish the Union of Cinematographers and Professional Cinematographic Organizations and Associations, or Kino-Soiuz, which elected him as the union's first chairman in 2011.

Proshkin's films balance suspenseful plots with a meditative visual style to explore philosophical issues, while sustaining indeterminacy of meaning. *The Horde* (*Orda*, 2012), based on a screenplay by Arabov, exemplifies this technique, framing political and historical commentary in the guise of the blockbuster epic. The film is a fictionalized account of a legendary episode from the Mongol occupation of medieval Russia, when the Russian Orthodox Metropolitan Aleksy was called from Moscow in 1357 to cure the blindness of Taidula Khatun, the mother of Khan Dzhanibek of the Golden Horde.[1] The historical Aleksy (c. 1296–1378) reportedly succeeded in his commission; he was canonized in the fifteenth century, and is celebrated as a wonderworker in the Russian Orthodox Church. While *The Horde* depicts Aleksy in heroic terms, Proshkin's portrait of the saint withstands easy appropriation by the Russian church and state—despite the metropolitan's role, according to historical accounts, in substantiating the authority of both institutions.

In assessing Aleksy's character, and the overall content of the film, it is important to underscore the participation of Arabov, as *The Horde* reflects his unique approach to historical narrative. Arabov studied screenwriting at the State Film Institute (VGIK), and is best known for his decades-long collaboration with Aleksandr

[1] The Golden Horde was the Mongol khanate established in the thirteenth century in the northwest territory of the greater Mongol Empire, including the occupied Russian lands. The khanate persisted in this form into the mid-fifteenth century, and was gradually Turkicized through the absorption of Central Asian Tatars.

Sokurov, dating to the director's "shelved" debut, *The Solitary Voice of Man* (*Odinokii golos cheloveka*, 1978/1987). Arabov's projects with Sokurov and other directors are typically less concerned with strict historical veracity than the location of cultural mythology within history, as well as how myths in turn shape historical representation. His screenplays emphasize the humanity of historical figures, often challenging conventional interpretations, and exposing ideological constructs. Arabov's postmodern, "deconstructive" approach is foundational to the historical films in Sokurov's "power tetralogy," in the representation of Hitler, in *Moloch* (1999); Lenin, in *Taurus* (*Telets*, 2001); and Hirohito, in *The Sun* (*Solntse*, 2004). Similar techniques are evident in his screenplay for Aleksandr Proshkin's *Miracle* (*Chudo*, 2009), which displays narrative and thematic similarities to *The Horde*. In addition to their collaboration on the latter film, Arabov worked with Andrei Proshkin on a second project, the fantastical comedy *Orlean* (2015), which draws on the Russian literary tradition of Nikolai Gogol and Mikhail Bulgakov. Proshkin's interest in Russian Orthodoxy is also evident in his screenplay for Nikolai Dostal's recent *The Monk and the Demon* (*Monakh i bes*, 2016), which likewise engages with the Russian literary canon to explore life in a nineteenth-century Orthodox monastery.

The Horde presents the Mongol khanate amidst dynastic competition and violence, loosely adapting a series of historical events from the mid-fourteenth century. In the opening sequence, Khan Tinibek is murdered by his brother Dzhanibek. The audience to Dzhanibek's crime immediately accepts his accession to the throne, and Taidula blesses her son as khan, though she criticizes Dzhanibek's decline as a warrior and his preference for life in the capital of Sarai-Batu. Shortly after, Taidula is suddenly stricken with blindness, as she and Dzhanibek oversee an arriving transport of Russian slaves. When attempts to cure Taidula's blindness fail, Dzhanibek summons the "magician" (*koldun*) Aleksy, warning that the metropolitan's failure will result in the destruction of Moscow. When he first treats Taidula, by way of Orthodox ritual, Aleksy does fail; he is consequently expelled from the city, and wanders the steppe before voluntarily submitting to Mongol enslavement as a willful act of penance (Fig. 1). Finally, it is revealed that Taidula's

Fig. 1. Metropolitan Aleksy in Mongol captivity.

vision is restored, and the feat is attributed to Aleksy. While the metropolitan returns to Moscow, having saved the fledgling capital from destruction, Dzhanibek is poisoned by his son Berdibek, who assumes control of the khanate. Before the credits roll, a voiceover explains how the ongoing dynastic conflict within the Golden Horde led to its decline and absorption by an ascendant Russia in subsequent years.

The struggle over succession was indeed critical to the Horde's collapse: Berdibek himself fell victim to a coup in 1359, and dozens of leaders held the throne for brief periods in the next twenty years. But other factors certainly contributed to the khanate's decline, including the devastation of the bubonic plague, which traveled west with the Mongols along the Silk Road trade route; and the rise of neighboring states, including the consolidation of power by the Muscovite princes, who would eventually unite the Russian territory under tsarist rule.[2] *The Horde* assumes many liberties in historical representation and explanation. And while it is beyond the scope of discussion to thoroughly assess the film's historical

[2] For general discussion of the Golden Horde in the context of Russian historical development, see Charles J. Halperin, *Russia and the Golden Horde: The Mongol Impact on Medieval Russian History* (Bloomington, IN: Indiana University Press, 1985); Janet Martin, *Medieval Russia, 980–1584* (Cambridge: Cambridge University Press, 2011), 149–260; and David Morgan, *The Mongols* (Oxford: Blackwell, 2007), 120–28.

accuracy, the following analysis will address particular distortions to explicate how Proshkin employs historical fiction to construct a discourse on the place of the "Mongol Yoke" in the Russian cultural imagination, and its influence on Russian historical identity more broadly. To be sure, *The Horde* lends itself to diverse interpretations, and I begin by summarizing some competing responses to the film. As I proceed to argue, Arabov and Proshkin offer a subversive take on a canonical figure, presenting Aleksy as a model of radical religious faith and humility. While his character embodies Orthodox spiritual values, these tenets are personalized as an internal project that unites Aleksy with the common Russian people, yet exceeds the jurisdiction of the medieval church and state—and thereby challenges the appropriation of the saint's legacy by the contemporary Russian church and state. Though elaborating a negative correlation between Mongol and Russian political authority, the film also proposes forms of spiritual experience that transcend cultural difference, allowing for meaningful intercultural exchange, albeit in primarily Russian terms. Ultimately, *The Horde* strikes an uneasy balance between essentializing and nuanced forms of ethnic representation; between an embracing of cultural pluralism, and the structuring of multi-ethnic space in predominantly Christian terms.

Creating Myth, Deconstructing History

Work on *The Horde* began in 2009, and filming proceeded in the second half of 2010 across multiple shooting locations. The interior of the Dormition Cathedral in the Moscow Kremlin was reconstructed in the studios of Mosfilm, while the exterior scenes of fourteenth-century Moscow were staged near the Kliazma River in the Vladimir region. More impressive still, a set was built to replicate Sarai-Batu in Russia's southern region of Astrakhan´ near Selitrennoe, the former site of the Golden Horde's legendary capital. In addition to the elaborate set design, over 1,000 costumes were reportedly created for the diverse cast, which included Buriats, Iakuts, Kalmyks, Kazakhs, Kirgiz, Russians, Tatars, and Tuvins; many of the principle Mongol roles were played by Iakut actors, while

Roza Khairullina, the female lead, is Tatar. While the film's Russian actors were mostly relegated to the roles of Russian characters, Andrei Panin appears briefly in "yellowface" as Khan Tinibek—a questionable casting decision, to say the least, presumably intended to capitalize on Panin's stardom.

The Russian Orthodox Church played its own prominent role in the production of *The Horde*, funding the project under the aegis of the publishing house Orthodox Encyclopedia (*Pravoslavnaia Entsiklopediia*), a film and television company founded by the Moscow Patriarchate in 1996 to bolster the church's presence in Russian civil society.[3] Orthodox Encyclopedia contributed the considerable sum of $12 million to the production, with the organization's director, Sergei Kravets, attached as general producer. When it premiered at the Moscow Film Festival in June 2012, *The Horde* was greeted with enthusiasm: the festival jury awarded Proshkin the prize for best director, and Roza Khairullina the prize for best actress, while the Network for the Promotion of Asian Cinema (NETPAC) recognized the film for its contribution to Asian cinema, and its artistic conceptualization of Mongol history. The film also performed well at other festivals, including Russia's Nika and Golden Eagle competitions, and enjoyed wide domestic distribution, playing on 539 screens across Russia upon its general release in September 2012.[4]

Still, not all responses to *The Horde* were so positive. Russian nationalists decried the unflattering image of Moscow, seen to exaggerate the primitive nature of the Russian state at this time, especially by comparison with the presentation of Sarai-Batu. Conversely, the film was perceived as orientalizing and offensive by Russia's Tatars, who are commonly identified as the modern

[3] Information on Orthodox Encyclopedia, including the organization's history, is available at http://www.pravenc.ru/, accessed July 6, 2017.

[4] Notably, the film failed to recoup its production costs at the box office. Distribution and revenue information cited in *KinoBook 2012: The Russian Film Industry Review* 13, accessed July 26, 2017, http://research.nevafilm.ru/public/research/KINOBOOK/2012/kinobook_2012_eng.pdf.

descendants of the Golden Horde.[5] While the film's representation of the Golden Horde is problematic in its own right, it simultaneously downplays the Mongol-Tatar influence on Russia's historical development and cultural identity. In fact, as Maureen Petrie has insightfully observed, the suggestion of mutual hostility and distrust between the Mongols and Russians in *The Horde* can even be interpreted as anti-Eurasionist, stridently rejecting any notion of a "symbiotic relationship" between the two cultures.[6]

Proshkin claims that his production team conducted extensive historical research for the film, consulting literary documents, museum collections, and archaeological fragments. Simultaneously, he has also downplayed its historical aspect, even identifying *The Horde* as a work of "myth-creation" (*mifotvorchestvo*).[7] Vadim Rudakov, a specialist on the Golden Horde who was hired as a consultant in the first stages of production, claimed that much of his input was ignored in the development of the final script.[8] Indeed, *The Horde* reconfigures basic features of the khanate's history and culture. For example, the film portrays the rapid succession of Tinibek, Dzhanibek, and Berdibek, suggesting that the two coups

[5] Today, nearly 6 million Tatars live in the Russian Federation, with the majority residing in the republic of Tatarstan.

[6] See Maureen Petrie, in Further Reading. Eurasianism is a school of cultural and political theory, which conceives of Eurasia as an independent sphere of civilizational development, distinct from Europe and Asia. While the movement originated in Russian émigré circles of the 1920s, a resurgent Eurasianism, affiliated with right-wing extremism, has surfaced in Russia's contemporary political landscape. On this neo-Eurasianist movement, see Edith W. Clowes, "Postmodernist Empire Meets Holy Rus': How Aleksandr Dugin Tried to Change the Eurasian Periphery into the Sacred Center of the World," in *Russia on the Edge: Imagined Geographies and Post-Soviet Identity* (Ithaca, NY: Cornell University Press, 2011), 43–67. On the development of Russian Eurasianism in the early Soviet period, see Sergey Glebov, *From Empire to Eurasia: Politics, Scholarship, and Ideology in Russian Eurasianism, 1920s–1930s.* (Dekalb, IL: Northern Illinois University Press, 2017), 9–110.

[7] Svetlana Khokhriakova, in Further Reading.

[8] As Rudakov points out, the filmmakers took considerable liberties designing architecture and costumes, as well as in the presentation of Mongol customs. See Daisy Sindelar and Rimma Bikmukhametova, in Further Reading.

represented in the film transpired only months apart. In reality, Dzhanibek retained the Mongol throne from 1342 to 1357, when Berdibek mounted his own successful coup against his father. In collapsing events separated by fifteen years into the diegetic time frame of mere months, the film exaggerates the dynastic instability of the Golden Horde, at least in the 1350s. In addition, *The Horde* only makes passing allusions to the Muslim faith of the Mongol leaders of the period. In reality, Khan Uzbek (reigned 1313–41), the husband of Taidula, and father of Tinibek and Dzhanibek, converted the Golden Horde to Islam decades earlier. The film's occasional references to Allah contribute to a composite image of religious syncretism, combining Muslim and pagan tendencies, while the Mongols themselves are presented as alternately superstitious and cynical. When Taidula is stricken with blindness, she is treated unsuccessfully by several religious figures, including a shaman, a Hindu Brahmin, a witch doctor, and finally the Russian Orthodox metropolitan. The Mongols lack faith, the film suggests, and measure religion by its utility. Dzhanibek, when later assessing Aleksy's own faith, even concedes this: "There must be some use in God. If God's not beneficial to me, then what do I need Him for?" Additionally, Russian Orthodoxy was hardly novel to the Golden Horde by this time, as the church had developed direct relations with the Mongols as early as 1242, more than a century earlier, under the leadership of Metropolitan Kirill, and even established an Orthodox bishopric at Sarai-Batu in 1261. Russian Orthodoxy was not, therefore, the exotic religion of the oppressed "other," but rather a recognizable feature of the khanate's multi-ethnic cultural landscape.

While there are various ways to account for the historical distortions in *The Horde*, those outlined here are particularly ironic in the context of Russia's own history. As noted, the Golden Horde did succumb to political instability in the late fourteenth century, but it also controlled the Rus' principalities for nearly 250 years. Dynastic struggle was likewise a familiar problem for Russia's Riurikid princes: it already plagued the political culture of late Kievan Rus', weakening the state in advance of the Mongol Invasion of 1237; and competition among the Riurikid lines continued throughout the appanage period, arguably enabling the rise of the Daniilovichi

princes in Moscow. In fact, the violent overthrow of Russian leaders occurred with alarming frequency, figuring in nearly every period of Russia's political history into the twentieth century. Meanwhile, religious syncretism was hardly unique to Mongol culture of the period, and the phenomenon of *dvoeverie* ("double-faith"), though disputed in some historiography, is often identified as a feature of medieval Russian popular Christianity.[9]

If *The Horde* critiques the Mongol attitude toward religion as pragmatic, even transactional, we find similar tendencies in several of the film's Russian characters, as well. Aleksy's servant Fed´ka, who accompanies the metropolitan on his commission to the Mongols, conceives of Russian Orthodoxy in primarily ritual terms, and as a site of ethno-national identity: he dramatically declares "Farewell, Orthodox people!" as they depart for Sarai-Batu, and later shows disdain for the cultural conventions of the Golden Horde. As they travel with the khan's couriers, Fed´ka ponders what luxury items he might request in exchange for the curing of Taidula, and approaches her treatment as merely formulaic incantation. Later in the film, after falling into Mongol slavery, Fed´ka combines Muslim and Orthodox formulations in a desperate prayer for salvation, performing prostrations presumably intended to curry favor with his captors. In a more literal parallel with the Mongol leadership, the grand prince of Moscow, Ivan the Fair, implores Aleksy to provide the requested miracle, and thereby spare Moscow from destruction. In pleading with Aleksy, he even compares the Christian God to Russia's former pagan deities, facetiously contemplating to whom he should direct his prayers. The prince clearly conceives of the mission in solely political terms, relative to the survival and prosperity of the state. Like his suzerain Khan Dzhanibek, Prince Ivan shows little regard for matters of religious faith in the film,

[9] On this aspect of Russian popular religion, see Eve Levin, "*Dvoeverie* and Popular Religion," in *Seeking God: The Recovery of Religious Identity in Orthodox Russia, Ukraine, and Georgia*, ed. Stephen K. Batalden (Dekalb, IL: Northern Illinois University Press, 1993), 31–52; and Eve Levin, *Dvoeverie i narodnaia religiia v istorii Rossii*, translated by A. L. Toporkov and Z. N. Isidorova (Moskva: Indrik, 2004).

approaching Russian Orthodoxy as a form of political expediency. Notably, Ivan receives the Mongol envoys in Moscow while eating nuts, which correlates the prince with Dzhanibek's gluttony at the Mongol court; both rulers model an image of casual affluence, even amidst suggestions that their subjects face possible starvation in the coming winter months.

Blindness and Insight: Dual Models of Cultural Identity

While *The Horde* provides Mongol and Russian models of a superficial attitude toward religion, these examples are sharply juxtaposed with the faith of Aleksy, whose spiritual journey comprises the central narrative of the film. Proshkin emphasizes the metropolitan's humility from his first appearance, when the khan's envoys arrive in Moscow, and find him leading the liturgy in Dormition Cathedral. In broad strokes, the film subsequently parallels Aleksy's experience with the Gospel accounts of the Passion of Christ. Following the mass, Prince Ivan is directed to the church garden to find Aleksy, reminiscent of Christ's praying in the Garden of Gethsemane. The metropolitan is also quick to give the footbath prepared for him by Fed'ka to the prince, invoking Christ's washing of the disciples' feet at the Last Supper. With these Gospel allusions, both situated in the hours immediately before Christ's arrest, trial, and execution in the Passion narrative, the film's Moscow sequence foreshadows the torture that Aleksy will undergo in the coming journey for the sake of the Russian people. The metropolitan's departure from Moscow emphasizes his underlying concern for the common people, whom Proshkin foregrounds in the scene's cinematography. After his initial failure to cure Taidula, meanwhile, Aleksy's harrowing experience corresponds to the Orthodox tradition of *kenosis*, a pietistic practice of self-abasement (literally, "self-emptying") that aspires to imitate Christ's deliberate embrace of suffering to secure the redemption of humanity. In the film, Aleksy subjects himself to torments enacted by the natural elements, the Mongols, and even his fellow Russians; he denies himself comfort and nourishment, and eventually renounces his very identity, claiming he no longer possesses a name. His behavior is thus sharply juxtaposed with

characters who project power through forms of accumulation and consumption, whether actual (Dzhanibek, Ivan) or desired (Fed'ka). Aleksy pursues his *kenotic* project as a form of personal penance, undertaken of his own free will, while the precedent of Christ's Passion suggests that his actions be interpreted as a form of self-sacrifice. Aleksy thereby balances spiritual humility with a collective concern for the Russian people; he fulfills the prince's request, but hardly in the manner Ivan expected, or even deliberately. In an instance of improbable narrative irony, the metropolitan's imitation of Christ's *kenotic* example is accurately interpreted only by one of Dzhanibek's own men.

Miraculous intervention does follow in the curing of Taidula, though it is significant that the event occurs off-screen, and is only revealed to Aleksy at the same time as to the viewer. Moreover, the miracle is correlated with the metropolitan's attempt to sacrifice himself, through self-immolation, for the sake of the other Russian slaves, after Dzhanibek decrees that they be killed gradually in front of the metropolitan, so long as he survives. The episode brings Aleksy's "passion" to culmination, though it stops short of claiming his life. While the khan and his men are quick to attribute the restoration of Taidula's vision to Aleksy, the film does not confirm its provenance, and Aleksy declines to take credit for the miracle, asserting that he "did nothing." His humility echoes the earlier conversation with Prince Ivan, when he stresses that God produces miracles, not man. However, Aleksy's wonder-working capacity is strongly implied earlier in *The Horde*. During the journey from Moscow to Sarai-Batu, one of the khan's couriers stabs his horse, and proceeds to consume a cup of its blood, reenacting a stereotypical legend of the ferocity of the Mongol horseman; in response, Aleksy places his hand over the wound, which seems to stem the flow of blood from the horse. Thus, Aleksy's ability to work miracles is only ambiguously demonstrated in this brief, tangential episode, notably subverting a classic trope of Mongolian warrior identity.

Ultimately, while *The Horde* implies that Aleksy has the power to produce miracles for the benefit of the Russian people, this ability is secondary to his willingness to embrace suffering.

In this, the character advances a solitary and inscrutable model of religious experience, which the film clearly endorses. This constitutes the subversive discourse of Proshkin's project, which rejects religious sacramentalism, as well as the triumphalist vision of Russian Orthodoxy affiliated with secular power—whether in historical context, or in the contemporary setting of Putin's Russia. The patriarchate's financial backing of Proshkin's film was construed as a sign of government endorsement, in light of the close ties between church and state, and the specific relationship between Putin and the current head of the church, Patriarch Kirill. As details of the project emerged, and production moved forward in 2010, Russia's liberal media was justifiably wary of a nationalist epic underwritten by Kremlin ideology, which has rarely been averse to historical revisionism for political purposes. However, in considering such suspicions it is important to situate the production in the context of the Putin-era Russian film industry. Stephen Norris has demonstrated how the rise of Russian patriotism in the 2000s coalesced with the recovery of the nation's popular cinema to produce the phenomenon of "blockbuster history," as Russian cinema adapted Hollywood techniques to articulate patriotic images of Russian and Soviet history, in turn shaping forms of collective identity and memory.[10] Despite the church's support of the project, and the film's seeming aspiration to blockbuster status, *The Horde* hardly provides the palatable "kvas patriotism" that Norris identifies in many recent Russian films. As Russian critic Lidiia Maslova observes, *The Horde* displays features of the conventional historical blockbuster, but is in essence a mystical film, which she correlates with Arabov's participation in the project.[11] Orthodox Encyclopedia's Kravets, the general producer, has made similar comments about the film, emphasizing Aleksy's individual relationship to God as a model of radical belief and acceptance—in

[10] Stephen M. Norris, *Blockbuster History in the New Russia: Movies, Memory, and Patriotism* (Bloomington, IN: Indiana University Press, 2012), 5–6.

[11] Lidiia Maslova, in Further Reading.

opposition, he notes, to contemporary religious attitudes within the Russian Orthodox community.[12]

To some extent, this representation of the saint contradicts the activity of the historical Aleksy, who went to considerable effort to ensure the autonomy of the Russian Orthodox Church, relative to Byzantine ecclesiastic power; and to substantiate the political authority of Moscow, especially in his regency of the young Dmitry Donskoi, the son and successor of Ivan the Fair. While *The Horde* brings little attention to these conventional, institutional aspects of the saint's biography, it is nonetheless difficult to maintain, as Kravets has asserted, that the film bears no relation to contemporary political and social issues. On the contrary, it arguably advances a religious worldview and model of piety that can be traced to the Muscovite period, which continue to be relevant in Russian culture. As Nancy Condee has argued, in the fifteenth century Russian Orthodoxy assimilated strategies of passive acquiescence, contradiction, and inversion, constructing a mystical, disembodied notion of "Holy Russia" in opposition to the theocratic ambitions of the tsarist state, pursued under the auspices of the Russian church. Evident in practices ranging from communal monasticism to "holy foolishness" (*iurodstvo*), this "Russian Idea" rejects the institutional realization of the divine order; simultaneously, Condee suggests, it engages in an ongoing "internal cultural dialogue" with "its conjoined twin and interlocutor," the concept of Moscow as the "Third Rome," which aims to instantiate this order in Russia's political and religious institutions.[13] In Proshkin's film, needless to say, Aleksy's faith and willing self-abasement correspond to this mystical typology of "Holy Russia." Thus, while his heroic spiritual odyssey may

12 Oksana Golovko and Sergei Kravets, "*Orda*: fil'm ob otnosheniiakh cheloveka i Boga." *Pravoslavie i mir*, September 20, 2012, accessed June 20, 2017, http://www.pravmir.ru/orda-film-ob-otnosheniyax-cheloveka-i-boga/.

13 Nancy Condee, "No Glory, No Majesty, or Honour: The Russian Idea and Inverse Value," in *Russia on Reels: The Russian Idea in Post-Soviet Cinema*, ed. Birgit Beumers (London: I. B. Tauris, 1999), 25–33.

Fig. 2. Russian Orthodox procession, including icons of the Virgin Hodegetria (left)
and the Mandylion image (right), marking Aleksy's departure
from Moscow.

seem to represent a form of "bare life," independent of church and state, the representation of Aleksy's experience in *The Horde* engages a longstanding discourse in Russian culture, which locates an alternative site of power in claims to an inscrutable, invisible divine order, which only the elect may discern or intuit.

Of course, this poses interesting challenges for Proshkin's project, in attempting to give visual expression to a conceptual order that in essence eludes representation. In a literal sense, the viewer can only witness Aleksy's behavior and statements, as opposed to directly accessing his perspective. However, *The Horde* employs auxiliary strategies to enhance our understanding of his religious psychology. In the Moscow sequence, for example, Proshkin emphasizes Russian Orthodox visual culture, as shots pass over the frescoes of Dormition Cathedral, and the icons carried forth in the procession marking the metropolitan's departure for Sarai-Batu. In both settings, two of the most prominent images include the icon of the Virgin *Hodegetria*, and the *Mandylion* image of Christ (Fig. 2). Whether in visual symbolism or origin myth, both images underscore the triumphant aspect of Christ's death and resurrection, and are thus frequently associated with political authority, as a means of underwriting state power in the sphere of Eastern Christian

culture.[14] In this sense, the icons we see establish an ironic counterpoint to Aleksy's actual spiritual values, which would be better represented by other images, particularly the Virgin *Eleousa* (Russian: *Umilenie*), or Virgin of Tenderness. The latter image, which is especially prominent in Russian Orthodox culture, stresses Mary's maternal concern for the infant Christ; in place of spiritual triumph, it anticipates Christ's suffering in the Passion, and the pain the Virgin will endure through the loss of her child.

The images of Russian Orthodoxy on display in *The Horde*—which are not limited to art and architecture, but also include scenes of religious ritual, and Aleksy's behavioral model of penance and piety—demonstrate the coexistence of competing representational forms within a common tradition, as well as how such representation is essential to political and religious discourse. In foregrounding a single style of Orthodox self-representation in the Moscow scenes, one typically associated with the goals of the state, Proshkin offers the viewer something of a red herring; what he omits from representation, but arguably implies, is more relevant to Aleksy's experience of suffering in the film. As the metropolitan, the designated leader of the Russian Orthodox Church, exits the institutional space of the church itself, as well as the cultural space of Muscovy, his faith persists in ever starker contrast with his surroundings, which lack any markers of his religious identity, or any evidence of divine presence.

Appropriately, the motif of blindness is central to *The Horde*. In the film, blindness gives metaphorical expression to a model of faith, like Aleksy's, in the invisible and ineffable; conversely, it

[14] The *Hodegetria* (Russian: *Odigitriia*) icon derives its name from a Greek word, which translates as "she who shows the way"; the image portrays the Virgin Mary gesturing toward the infant Jesus, indicating the path to human salvation through Christ. The *Mandylion* icon, also known as the Image of Edessa, is an image of Christ's face, allegedly created when he pressed his face against a piece of cloth. This "first icon" is thereby attributed to a divine miracle, and is often identified by the Greek *Archeiropoietos* (in Russian, *Nerukotvornyi*): "not made by human hands." Both images are prevalent in the Russian Orthodox tradition.

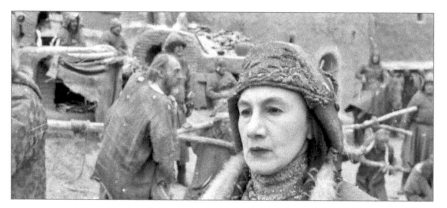

Fig. 3. Taidula registers her sudden loss of sight.

may also suggest a misguided faith in the "false gods" of power, glory, or material extravagance, as evident in many of Proshkin's characters. Of course, the sudden blindness of Taidula drives the plot, fostering a correlation with Aleksy that figures at many levels of the film. When the metropolitan first arrives to treat Taidula, she seems to recognize him by the feel and smell of his beard, an intimate moment that suggests an essential, even mystical connection between the two. Like Aleksy, she also provides a counterpoint to the secular ambitions of a political leader, her son Dzhanibek. In the film's initial sequences, Taidula simultaneously represents Mongol values, as the imperial matriarch, and violates the same norms, demonstrating the dual tendencies of her conflicted identity. While furious with Dzhanibek for his murder of Tinibek, she defers her anger and mourning to bless Dzhanibek's accession to the Mongol throne; later, she punishes herself by cutting off a finger, and throwing it in the fire—prefiguring Aleksy's kenotic odyssey, and the burning of his own flesh in attempted self-immolation. A similar binary opposition, articulating movement and reversal, structures the episode of Taidula's loss of vision. After advocating the execution of the Russian prisoners, as a matter of pragmatic necessity, she nods in approval as the first is beheaded, while the second execution seems to suddenly precipitate her blindness (Fig. 3). While the circumstances suggest that her ailment be interpreted as a form of punishment, possibly of divine provenance, her loss of sight may also be read as a further instance of self-

mutilation, a psychosomatic disorder symbolizing her rejection of Mongol barbarism. Eventually, Taidula's conflicted identity finds resolution in a turn to humanism, first evident as she undergoes treatment for her blindness: as Dzhanibek drives the witch doctor from the room, after his failure to cure Taidula, she stumbles forward with open arms, as if to prevent the violence that awaits the healer.[15]

Despite the persistence of her blindness, the scene marks a transition for Taidula, who eventually adopts a humble faith similar to that of Aleksy; their common trajectory is reinforced with the restoration of her sight, when Taidula also acquires, in metaphorical terms, a new form of vision. In the film's final scene, following the poisoning of Dzhanibek, Taidula refuses to bless Berdibek as the new khan, on the grounds that God does not endorse his rule. When Berdibek presses her for an explanation, she concedes that she doesn't know what God wants, and departs for the darkened steppe on horseback. Her dramatic exit may be read as a modeling of a more "authentic" Mongol identity, in light of her earlier criticism of Dzhanibek's preference for the throne to the saddle, and his retirement from military campaigns. Simultaneously, Taidula's departure from Sarai-Batu recalls Aleksy's earlier departure from Moscow, whereby his self-imposed alienation from Russian culture enabled the pursuit of a greater spiritual truth.

The Ethics and Politics of Vision

In correlating Aleksy and Taidula so closely, *The Horde* elevates the two characters as spiritual ideals for their respective cultures,

[15] Significantly, Dzhanibek expels the witch doctor with the directive: "make sure I never see him again." While the witch doctor is immediately stabbed to death, as if confirming Taidula's fear of pending violence, Dzhanibek's statement evokes the recurrent theme of vision and its delimitation. Moreover, the khan immediately declares that his instructions were misinterpreted, indicating a severed connection between language and action, as well as ruler and subject.

both prepared to embrace the darkness of uncertainty, here represented in the desolate space of the steppe. The pairing of the two is of course ironic: whereas Taidula rides out onto the steppe in the guise of a conqueror, ready to accept an unknown fate, Aleksy embraces the wilderness as a means of atonement— just as he submits himself to the violence of the Mongol suzerains. In this, their pairing may also suggest an integral relationship, of mutual necessitation and completion, shared by Mongol and Russian culture: in this symbolic configuration, the Russian is the object of Mongol domination, epitomized by Taidula's model of the nomad warrior, while the Mongol is the instrument of Russian spiritual improvement through suffering. Carrying this line of inquiry further, *The Horde* may be read as an allegory for Russian self-understanding, dramatizing perceived oppositions within Russian identity, such as domination/subordination; body/spirit; empiricism/mysticism; etc. In this interpretation, the Mongol "other" is reduced to symbolic status, employed as a vehicle for cultural self-reflection.[16] While this approach risks reducing a complex historical narrative to a kind of cultural solipsism, it may account for the film's stereotypical representation of the Golden Horde, as if to foreground and even critique the narrow conception of the Mongols in the Russian cultural imagination. Conversely, it may also provide an explanatory framework for the Mongol influence on Russian culture, though sadly this typically amounts to generalizing truisms in the film. Fed´ka, for example, broken by the experience of slavery, attempts to murder Aleksy, which implies that the younger man has absorbed the violence and cruelty of the Mongols. Prince Ivan, similarly, may be said to recapitulate the political calculus of the Mongol leadership, who approached the suzerainty of the Rus´ lands in predominantly economic terms, through systems of patronage and taxation.

[16] In a similar vein, Andrei Plakhov has proposed reading Proshkin's film in part as a "deep psychoanalysis of the [Golden] Horde as a historical-mythical phenomenon." See Andrei Plakhov, in Further Reading.

While various interpretations can clearly be brought to bear on these broader issues in Proshkin's film, *The Horde* also contains two literal scenes of self-reflection, which further strengthen the connection between Aleksy and Taidula. As she is dressed by servants before an encounter with Dzhanibek, Taidula twice observes her appearance in a mirror. Similarly, as Aleksy conducts the liturgy in Dormition Cathedral, he observes the entrance of the Mongol couriers, on horseback, into the church, as the scene is reflected in the surface of the Eucharistic chalice. These scenes encapsulate the political intrigue that dominates the film, suggesting that vision must be extended to perceive the threat of violence and replacement, actualizing the notion of foresight. In addition, these episodes may be read as metaphors for historical reflection, with the mirror opening a view to the past, which is emblematic of the project of the film itself. In either approach, it is critical to note how the mirrored surface situates the perceiving subject, whether Aleksy or Taidula, within the "scene" that each figure inhabits, enabling them to see themselves in context, amidst their surroundings. It follows that self-understanding is achieved in discerning the self as part of a greater totality—whether synchronically, in the present time of a given cultural space; or diachronically, within a chain of historical sequence.

While mirrors may enhance vision, they can also distort it, and *The Horde* brings considerable attention to the dangers and broader ethics of vision. While Aleksy and Taidula are united in their ability to accept what cannot be seen, they are also defined by their acute perception and comprehension of situations, as if discerning the reality behind appearances. Just as Aleksy is quick to grasp the true reason the Khan has dispatched couriers to Moscow, Taidula immediately understands the two coups at the Mongol court, both implausibly reported to her as accidents. In an exemplary scene, Taidula exposes the "miracle" of a Chinese sorcerer, whose performance has enthralled Dzhanibek, as a mere magic trick. By comparison, the film suggests, a true miracle may be experienced, while its cause and operations remain obscure. As Petrie observes in her review, *The Horde* stresses the imperative of delineating miracle from magic, insofar as the spectacle of the latter may lead its

audience astray, even with dire consequences.[17] Appropriately, the murder of Dzhanibek occurs during a similar magic performance, as he inserts himself in the performance in a buffoonish manner. This detail is hardly incidental, as Proshkin implies that Mongol power was in essence a similar form of spectacle, learned simply by observation and imitation. In elaborating this theme, the film consistently frames Dzhanibek's rival and "understudy," his son Berdibek, as a witness to political intrigue and violence. Whether through sudden cuts to his face, or panning shots indicating his presence in a crowd, the cinematography consistently reminds the viewer that Berdibek is watching and absorbing the tumultuous life at court. These instances also chart the transformation of the character across the film through changes in his outward appearance: while his simple clothing initially casts Berdibek as a boy, the gradual addition of makeup and oriental finery culminates in the coup he orchestrates against Dzhanibek, when the despot emerges in full view.

In the subtle trajectory of Berdibek, almost entirely relegated to the visual background, *The Horde* reinforces the idea that violence is a learned trait. Here and elsewhere, the film stages sight itself as the object of study, repeatedly offering the viewer dramatized scenes of vision. We watch Berdibek watching atrocities as they unfold; he is shaped by them, and moves forward as khan to shape his world in similar fashion. But Proshkin also stages acts of seeing that are not available to the viewer, analogous to the elusive object of true faith. This strategy is consistent in the presentation of Aleksy, culminating in his apocalyptic vision, which the viewer can only infer from his fragmentary raving as he lies in the mud on the threshold of death. When he is discovered in the street the next morning, it is only confirmed that Aleksy is still alive when Dzhanibek opens one of his eyes, and his pupils begin to move. Similarly, in one of the film's most remarkable scenes, discussed above, the viewer witnesses the onset of Taidula's blindness. Walking amidst snow flurries, she looks to the sky, with the camera following her gaze, assuming

[17] Petrie, in Further Reading.

her perspective; when it returns to her face, however, her sight has failed, as she moves forward with faltering steps. The episode anticipates Aleksy's own tendency to look to the sky, seeking signs that may or may not appear, and a vision that is withheld from the viewer. The scene also encapsulates the darkness, here literalized in blindness, through which Aleksy will stagger in his attempt to discern and enact God's will.

The philosopher Jacques Rancière, in outlining the "distribution of the sensible," explains the political structuring and consequences of forms of perception, whereby acts of vision assume a broader significance: "[p]olitics revolves around what is seen and what can be said about it, around who has the ability to see and the talent to speak, around the properties of spaces and the possibilities of times."[18] In different ways, the obscure visions disclosed to Aleksy and Taidula can be read in their own political terms, as challenges to institutional authority—though underwritten, in each case, by the character's institutional identity, in church and political dynasty, respectively. And yet, much as *The Horde* thematizes the forms and significance of vision, it ultimately advances a mystical discourse that valorizes what cannot be seen.

Tom Roberts

[18] Jacques Rancière, *The Politics of Aesthetics*, translated by Gabriel Rockhill (London: Bloomsbury, 2016), 8.

Further Reading

Khokhriakova, Svetlana. "Mongoly nas spasli?" *Moskovskii komsomolets*, February 10, 2012. Accessed June 20, 2017. http://www.mk.ru/culture/2012/02/09/669974-mongolyi-nas-spasli.html.

Maliukova, Larisa. "I imia nam 'Orda.'" *Novaia gazeta*, June 27, 2012. Accessed June 19, 2017. https://www.novayagazeta.ru/articles/2012/06/26/50314-i-imya-nam-151-171-orda-187.

Maslova, Lidiia. "Nemoshchi sviatitelia Aleksiia." *Kommersant*, September 14, 2012. Accessed June 19, 2017. http://www.kommersant.ru/doc/2016122.

Petrie, Maureen. "Andrei Proshkin: *The Horde* (*Orda*, 2012)." *KinoKultura* 39 (2013). Accessed June 19, 2017. http://www.kinokultura.com/2013/39r-orda.shtml.

Plakhov, Andrei. "Sarai zemnoi." *Kommersant*, September 9, 2012. Accessed June 19, 2017. http://www.kommersant.ru/doc/2025215.

Sindelar, Daisy and Rimma Bikmukhametova. "In Russia, 'Horde' Blockbuster Drawing Tatar Objections." *Radio Free Europe / Radio Liberty*, September 19, 2012. Accessed June 19, 2017. https://www.rferl.org/a/the-horde-film-tatarstan-stereotypes-russia/24713352.html.

SHORT STORIES

Rasskazy

2012

105 minutes

Director: Mikhail Segal

Screenplay: Mikhail Segal

Director of Photography: Eduard Moshkovich

Art Design: Vitaly Trukhanenko

Music: Andrzej Petras

Sound: Konstantin Stetkevich

Production: Anastasia Kavunovskaia, Sergei Kretov, RUmedia

Cast: Vladislav Leshkevich (the writer), Dar´ia Nosik (Olia), Andrei Merzlikin (event manager), Igor´ Ugol´nikov (the president), Konstantin Iushkevich (Max), Andrei Petrov (Mitia), Liubov´ Novikova (Maks's girlfriend), Tamara Mironova (the librarian-clairvoyant), Sergei Fetisov (the governor)

LOST IN TRANSLATION[*]

Mikhail Segal (b. 1974) is a man of many talents—a clipmaker, writer, composer, and musician, who earned his reputation as the director of musical clips for the most popular Russian pop and rock singers, as well as commercials for major western and Russian brands. He studied for only a year at the Russian State Institute of Cinematography (Vladimir Naumov's workshop), but withdrew to become a clipmaker. In 2006, he shot his first feature film, a war drama *Franz + Polina,* based on Ales' Adamovich's novella *The Mute (Nemoi).* In 2011 he made a short film, *The World of Fixtures (Mir krepezha),* that won the Grand Prix for Best Short at the national festival Kinotavr. This film novella served as a seed for *Short Stories,* which received the Kinotavr Prize for Best Screenplay and the diploma of the Guild of Film Critics and Film Scholars. After *Short Stories,* he made one more film, also based on his own screenplay, *A Film about Alekseev (Fil'm pro Alekseeva,* 2014), which continued many of the themes of *Short Stories,* although with much lesser resonance.

When *Short Stories* was released, it was prevailingly received as a witty, well-crafted absurdist comedy, and brought Mikhail Segal the reputation of a dazzling creator of "(sm)art mainstream,"[1] one of those rare talents whose work is equally captivating to an undergraduate audience and to a sophisticated viewer equipped to detect its carnivalesque motifs and Foucauldian analysis of the power structure.[2] *Short Stories'* accretion of prizes and awards looks enormous, but consists mainly of critics' commendations and a Grand Prix from only a second—if not third—rate festival. This is, of course, with the exception of Kinotavr. Many critics linked the anthology structure of *Short Stories,* consisting of four "novellas," to the director's previous experience in music video

[*] A shorter version of this article was published in *Kinokultura* 50 (2015).

[1] Zara Abdullaeva, in Further Reading.

[2] See the next essay in this volume by Liliia Nemchenko.

production, alleging that the film inherits the notorious "clip-based consciousness." Instead of chiding *Short Stories* for its "clip-based consciousness," Zara Abdullaeva has expressed this thought in the most nuanced manner:

> This card-film is composed of fragments and splinters (of a mirror). The fragment is a respectable genre of Romanticism, but not the only correct way (as is often believed) to reflect on stereotypes or just visualize the superficiality of the contemporary "clip-like" or "mosaic" consciousness. Segal tells of these stereotypes, of this consciousness and even of the "collective unconscious" lucidly, bitingly, and from a distance.[3]

I would like to argue that Segal masterfully emulates a fragmentary structure as one of the key justifications for his artistic logic, while simultaneously furtively unraveling his vision in a single coherent thread, from the movie's first episode to its last. Segal presents his fragmented composition as a replacement for a "big and totalizing form," about which, in the frame narrative of the movie, the publishing house's editor in chief dreams aloud while rejecting the young author's book of titular short stories.

The "big and totalizing forms" mentioned in the film's beginning seem to dominate the imagination of cultural authorities in the 2010s. Judging by the state-sponsored new releases, from Fedor Bondarchuk's *Stalingrad* (2013) to Shal'opa and Druzhinin's *Panfilov's 28 Men* (*28 Panfilovtsev*, 2016), the dream of fusing Hollywood with Socialist Realism has been reborn. New "epic" films try to repeat what was once done by Grigory Aleksandrov in the 1930s, but now without humor and with lots of CGIs. Segal's film obviously confronts these dreams: his rejection of an overarching narrative also implies his "incredulity to grand narratives."[4] In fact,

[3] Abdullaeva, in Further Reading.

[4] Jean-François Lyotard, "From *The Postmodern Condition: A Report on Knowledge,*" in *The Postmodern Reader: Foundational Texts,* ed. Michael Drolet (London: Routledge, 2004), 123.

each story is about this incredulity—Segal mocks the rationalist belief in the ability to control one's life (resonating with the first chapter of Mikhail Bulgakov's *The Master and Margarita*), as well as Putin's "vertical of power" based on universal bribery, quasi-religious faith in the magical power of cultural traditions, and the intelligentsia's belief in its intellectual and spiritual superiority. However, despite the breadth of his satirical targets, Segal's film is anything but cynical. In fact, *Short Stories'* postmodernism reads as the antithesis of cynicism, which Segal exposes behind every "grand narrative" he tackles; each of them is either used to cover shameless egotism, trickery, and theft, or is blatantly instrumentalized for irrelevant purposes. Ironically, *Short Stories* transforms postmodern irony into the embodiment of idealism—or, at least, a longing for ideas and feelings that would be resistant to cynical corruption.

In an interview that accompanied the screening of *Short Stories* at Kinotavr in 2012, Segal said that the entire film had already been shot in his head when he was making *The World of Fixtures*. (This explains how he managed to spin a fifteen-minute short into a feature-length film within two summer months.) The director emphasized that he did not envision *Short Stories* as an anthology but as a "whole" work. Yet Segal also argues that each installment toys with its own film genre—comedy, satire, thriller, and melodrama. The dissimilarity of the novellas in style and in genre serves the same purpose: to effect the condition of multiple overlapping and coexisting dimensions as the setting for the filmic narrative.

The first ("seed") novella, "The World of Fixtures," intoned with a deadpan black humor, plays with the "European/Russian" dichotomy and is set to a brilliant performance of "Fly Me to the Moon" by Polina Kas'ianova with a *baian* (folk accordion) accompaniment. This opposition has a tangential relationship to the next segment, the satirical parabola "Circular Movement" ("Krugovoe dvizhenie"), which illustrates the motion of bribes in Russian society and bears no relation whatsoever to the mock-mystical thriller "Energy Crisis" ("Energetichesky krizis"), about a clairvoyant from a provincial library who conveys her revelations through verses stylized along the lines of Pushkin's poetry. Then

one can sense the opposition resurfacing in the final novella, "Inflamed" ("Vozgoritsia plamia"), perhaps the most elegant of the four installments in terms of its plot: here, the love affair of two "Russian Europeans" displays a deep generational conflict that eventually leads to *Short Stories'* most frequently quoted line, "What do we have to fuck about?!" ("O chem s toboi trakhat'sia?!").

The dim interior of the café that becomes the stage for plotting out one's entire life in the first novella contrasts with the next segment's motley transformations of the backdrop, from a dirty labyrinth of garages to the shining decorum of the president's vast estate. The mystical provincial coloring of the third novella is likewise irreconcilable with the Moscow milieu favored by the "creative class" in the fourth. These are not just different stories; these are also disparate Russias, which exist without noticing each other, in parallel, yet inevitably overlapping. Thus, the formal structure of *Short Stories* manifests the film's thematic crux: multiple realities, or more precisely, multiple post-Soviet realms, each with its own language (or lack thereof) or, at least, its own semiotics.

In Liliia Nemchenko's words, "All the characters of *Short Stories* are formally united through the location, and conceptually through the absence of a common language, not on the level of semantics and syntax, but on the level of contextual memory. No fixtures will help here: 'The time is out of joint.'"[5] I prefer a more optimistic characterization: *Short Stories* is, altogether, a film about attempted translations and transactions between these manifold realms and dissimilar semiotics.

In "The World of Fixtures," an unflappably professional organizer of family events, hired to plan the wedding and the entire subsequent life of a young couple, appears as a superb translator who connects the present with the future and weds an imaginary "European" style and recognizably "Russian" traditions of wild celebration. In "Circular Movement," a stack of cash serves as the universal translator, crossing hands toward ever-higher planes of authority until a modest editor who pays a bribe for his car's technical

[5] See the following essay.

inspection is linked to the surreal president. The president doubles the operation of universal conversion: first, he elegantly "translates" cynical political manipulations into lofty quotations from Leo Tolstoy, Vasily Kliuchevsky, or Nikolai Karamzin, and vice versa. Second, he translates Russian "cultural tradition" into a malleable virtual reality: during his conversation with the governor, who has delivered a bribe for his "reelection," the president angelically strolls against the background of a shining green landscape, most reminiscent of Microsoft Windows' preprogrammed desktop wallpaper, and at the end of his heartfelt monologue he transmutates into a TV broadcast. In the third novella, "Energy Crisis," the film's unifying principle is presented in its most obvious form: here, the police major Oleg Ivanovich "translates" Anna Petrovna's stylized, versified visions into "normal human language"—that is, a stream of obscenities.

Indeed, the procedures of translation between "European" and "Russian," between present, past, and future, constitute the essence of the post-Soviet epoch. Yet in *Short Stories* the only successful translation appears to be the one associated with money: this is the sole universal language that functions effectively. However, the destructive effect of this successful communication is apparent. All other attempts, based on the languages of rationality, culture, or historical memory, either hopelessly fail or will inevitably fail (as in "The World of Fixtures").

This becomes painfully obvious in the fourth novella, "Inflamed," where an inspired love affair between the middle-aged editor Max and the stunning young beauty, tellingly deprived of a name, ends with the man's disappointment in his female lover. It turns out that the girl has never heard of the Cheka, thinks that the revolutionary Felix Dzerzhinsky was a writer, believes that Lenin lived until 1940, and minimizes the number of victims during Soviet history. Striking scenes of intimacy (probably among the best in contemporary Russian cinema) prove that the heroes are perfectly compatible sexually, but they fail to find a mutually understandable language of communication (Fig. 1).

Max's representation is a trap set by the filmmaker for the viewer. (Segal's aptitude for such traps revealing viewers'

Fig. 1. What do we have to fuck about?

misjudgments is even more apparent in his next feature, *A Film about Alekseev*.) The majority of critics and viewers enthusiastically took Max's side, detecting in this character their own frustrations with the post-Soviet generation, governed by consumerist rather than cultural or historical signifiers. For some reason, however, many of Max's fans failed to notice that his wisdom is an agglomeration of the intelligentsia's clichés (including criminal songs, as sardonically noted by Abdullaeva) and that his girlfriend sincerely wants to learn from him, which he finds rather irritating. "We should talk more!" ("Nam nuzhno bol'she razgovarivat'"), she repeats as a mantra after each séance of their sensational sex.

The culminating scene in the car and afterward, when Max conflates sexual pleasure with an increasingly cruel examination of his lover's knowledge of Soviet history, is almost painful to watch. In fact, he amplifies his sexual domination by the assumed position of a strict and unforgiving teacher, when—with obvious pleasure—he first humiliates and then dumps his lover on the grounds of her

intellectual inferiority. Max's arrogance in these scenes borders on sadism, which admittedly only increases his pleasure.

Max is a member of the "creative class," an editor and, possibly, a writer, who obviously sees himself as the heir to the Russian intelligentsia, but prefers to forget that the Russian intelligentsia held itself responsible for translations between social languages and for (pardon my pathos) the enlightenment of those who need to be enlightened. So it is also Max's fault that his girlfriend does not understand his values. He could have taught her; she was eager to learn. He forgets about these banalities not by accident: it is just much more pleasant to feel angry and disappointed. His noble anger effectively proves—and even more effectively embodies—his cultural and social superiority over post-Soviet consumerist *bydlo* (trash). And this is the key to his character: cloaked in the prestige of the Russian intelligentsia, he has exchanged obligations associated with this affiliation for a position of symbolic power nicely fused with hedonism.

In "Energy Crisis," the librarian Anna Petrovna perishes in flames together with a book, which a girl lost in the woods has burned in the hope of keeping warm (Fig. 2). This is also a signification of the intelligentsia's failure—in this case stemming

Fig. 2. Burning Pushkin.

from the cult of classical tradition, the identification with "sacred" literature. But at least Anna Petrovna tries to provide a translation through her comically and lofty pseudo-Pushkinian revelations. On the contrary, Max's refusal to be patient, his anger at the girl who does not know the basics of the intelligentsia's lexicon but looks into his eyes with trust and admiration, in the view of recent Russian history reads as an unforgiving explanation of the yawning gap between the liberal intelligentsia and the notorious 86 percent of Russian citizens who applaud the annexation of Crimea, the war against Ukraine, rabid nationalist hysteria, and other niceties of the current political situation.

The abandonment of attempts to translate and adapt the intelligentsia's language and values to the worldview of the rest of the population has left a vacuum that has promptly been filled by "fixtures" in the form of quotations from Russian classics adapted to immediate political needs, and especially by the nationalist rhetoric about "Crimea is ours," the aggressive United States, and the decaying "Gayrope."

With its title and its frame setting in a publishing house specializing in fiction, *Short Stories* places *literature* at the center of *cinema*. Oddly, nobody seemed to notice this splendid paradox. All of the film's novellas are about the power of literature—or at least they include such a motif. The main character in "The World of Fixtures" presents a perfect writer for contemporary Russia, albeit of a new kind: one who has already absorbed the Symbolist/Futurist/Socialist Realist Pelevin/Baudrillard lessons of live creation, life construction, and the hyperreality of simulacra. Indeed, he masterfully imagines the future in minute detail, extracting the psychological profile of a client and instantly casting actors for roles in the future play of life. Correspondingly, the president in "Circular Movement" epitomizes a perfect reader and co-creator, who with virtuoso artistry utilizes decontextualized fragments of the sacred classics to justify a cynical regime of universal corruption. Anna Petrovna and Max appear as the professional high priests of the cult of literature: a librarian and an editor. However, they embody contrasting scenarios: the former implements her dedication in an archaic way more fitting to the nineteenth than the twenty-first

century, while the latter abandons his intelligentsia duty for the sake of hedonism. Although both fail, they do not fail to enjoy the position of symbolic power and superiority over their "folk."

At the end of the 1990s, many writers and critics celebrated the end of Russian logocentrism and literature-centrism as the sign of the new era, when Russian culture would join the global world. In the 2000s, the same symptoms were typically interpreted as signs of cultural demise and degradation (Some especially knowledgeable Western analysts seem to be catching up with this trend only now.[6]) Yet all in vain. *Short Stories* clearly demonstrates that the Russia of the 2010s remains a literature-centric country. Literature-centrism certainly has its obvious cultural benefits (one may call them culture-specific), along with less palpable political disadvantages. Segal's film is about the latter.

Short Stories proves that literature-centrism, as a version of much-maligned logocentrism in its post-Soviet incarnation, has become more savvy and more ubiquitous, albeit less obvious than before. Yet like any form of logocentrism, it feeds the illusion of the intelligentsia's innate superiority and lends itself to corrupt power as a respectable outfit (remember "writers" dancing around their desks at the closing ceremony of the Sochi Olympics?). In other words, it secures positions of authoritarianism, political or symbolic, which in today's world does not aid cultural communication, but interrupts it; does not translate but preserves the untranslatability of authoritative languages as the foundation of power. This is why the "Internationale" reworked into rap in the finale of *Short Stories* is not such a silly idea as at first it might appear. After all, Segal has made a truly anti-authoritarian film that not only foreshadows the failures of the liberal intelligentsia, but also suggests the direction of a further quest that might revoke the triumph of logocentric authoritarianism.

Mark Lipovetsky

[6] See, for example, David Brooks, "The Russia I Miss," *The New York Times*, September 11, 2015, accessed June 25, 2017, https://www.nytimes.com/2015/09/11/opinion/david-brooks-the-russia-i-miss.html?_r=0.

TELL ME WHAT YOU KNOW ABOUT RUSSIA?[*]

> Talk so that I can see you.
>
> *Socrates*

The writer Boris Vasil'ev once defined cinema as follows: "Cinema for me begins when I cannot tell with words what I have seen; everything else is literature." The writer Mikhail Segal has given his film a simple yet simultaneously provocative title by proposing a text with a narrative quality already designated in the title. It is largely meaningless to tell the plot of *Short Stories.* The narrative here is not linear and the text is a story that can be told in different ways. From this interpretation of a continuous process in which the author and the hero constantly change places stems also the film's dynamic and energy. The film, in fact, "grows" from a waste paper basket, where the story is thrown after being rejected as a manuscript by an unknown author that lacks topicality. The secretary of the publishing house "kicks off" the engine, reading the first short story and recognizing her own.

The waste paper basket and toilets (as disposal units) are prominent trash elements that serve as a background for the conversation "about the main thing," as in medieval carnival the use of excrement in the script of a holiday specified the value of life. And "the main thing," of course, is choice: marriage, life, death, and love. In three of the four stories the "places for public use" have no utilitarian purpose at all. In "The World of Fixtures" ("Mir krepezha") the toilet in the cafe is the place where the heroine remembers an important moment in her life: when her fiancé proposed to her, and the couple exchanged desires and wishes. But this contravened the main principle of her life: no improvisations! — and that proposal came without any warning. The filthy toilet of the military enlistment office seen in the story "Circular Movement" ("Krugovoe dvizhenie") is a place for the exchange of money that

[*] This essay was first published in *KinoKultura* 39 (2013).

does not smell. The carnivalesque element in this episode is amplified by an incident as a result of which, alas, money may well stink. Finally, the European-style office toilet is a place of erotic fantasies and peaceful rest after stormy sexual encounters for the aging hero-lover, the editor of the publishing house who has rejected the book for publication, but who becomes the hero of the last story (Fig. 1).

Fig. 1. Exhaustion.

In this ambivalence lies Segal's talent: extremely serious and boundlessly ironic. The author operates within the rules of a certain genre ("Circular Movement"), and can easily play with the limits of genres ("Energy Crisis" ["Energetichesky krizis"]). Segal has mastered the laws of classical literature and skillfully employs the narrative strategies of post-classical novels. He authentically recreates the circumstances of life in modern Russia, assuming the role of sociologist-positivist and cultural anthropologist, yet he is not an artist in the traditions of classical realism and classical philosophy, but rather a practitioner and designer of transgression, of "a gesture concerning the limit," à la Michel Foucault. He takes a recognizable situation up to the limit, up to the "impossibility"

which possesses the quality of the ontological characteristic of existence. Modern Russia and its inhabitants, as presented in the film, are not objects of critical analysis, but natural givens who cannot be used in any gnoseological operations. Not accidentally is the story "Energy Crisis" a mix of detective story and mystical thriller, in which the deductive method fails.

The four stories of the film are connected not only through the waste paper basket, whence appear the heroes and circumstances of life. Each part of *Short Stories* tells about mutually exclusive choices of life strategies. The provincial couple who begin a new phase of their life in "The World of Fixtures" is the product of a mass culture with its advice-compulsion and pseudo-rationality. The project business for the arrangement of one's life thus finds understanding from the representative of a new Russian profession: the event manager. The life strategies of the soon-to-be-married couple and the manager coincide: one is assured of the necessity to plan for everything, the other of the possibility to foresee everything. The world is presented as a simple system of linear dependencies, with simple plots—a wedding with a bestowal, a planned extramarital affair, children in a special school with English, and a small variety for the ending (cremation or burial). In general, the variety of choices is reduced to the world of fixtures, where the main thing is the correct selection of materials and sizes. Moreover, the plans are augmented with a mythical European quality (the samples of rice offered to the pair instead of the traditional millet, as in the story from *Twelve Chairs* about the offer of a tea strainer for the cannibal Ellochka).[1]

Segal masterfully shows the logic of the absurd when the Apollonian beginning of the story ignores the challenges of Dionysian chaos. The event manager, like a classical artist, arranges the mise-en-scène, moving the pair away from the window and showing his skill not only in riddles and competitions, but also in designer thinking as he easily navigates the laws of light exposure (at 15.00

[1] The cannibal Ellochka, who loved everything foreign, is a character from Il'f and Petrov's popular 1928 novel.

there is a shadow, at 17.11 sunset, therefore we organize a hearth). After a change of vantage point, the spectator sees a sad urban landscape with a high-voltage line, which does not look creative at all. In this case one even feels sorry for the couple as they strip themselves of the secret of the project called "life." The professional manager, an expert in psychology, masterfully manipulates the consciousness of the young people, putting before them a choice of minor things and thus creating the illusion of independence. The jazz music chosen by the bride and groom at first shows good taste, but Segal is ruthless: the singer who has come with heavy bags, efficiently and wearily putting them down, starts to sing in English with a school Russian accent. Alas, jazz—that relies basically on improvisation—has no place in the world of fixtures.

The rational strategy of the first story is taken to the point of absurdity and then tested in the following three stories. In "Circular Movement" cultural phenomena acquire once again the character of natural phenomena. A bribe, like a drop of water from a lesson about the atmosphere, triggers movement in this world. In this story Segal transforms rhythm, music, and image into a single whole, expressing the tragic discrepancy of a grandiose, perfect nature through nasty and trivial matters of human culture. The cameraman Eduard Moshkovich has "pushed" the real landscapes into bright light (as did the Russian painter Arkhip Kuindzhi) with a glamorous simulacrum in the form of the governor Egor Sergeevich and the president. The camera plays with general takes and panoramic views of East European plains, as well as the awe-inspiring quality of Russian nature. That's how the actor and writer Evgeny Grishkovets would remember things, reflecting on what each Russian should feel when looking at birches through the window of a train. According to Grishkovets he must say, "How beautiful!" So, a white horse, a white suit, white shoes with white socks, the thin white porcelain of tea cups, volumes of Nikolai Karamzin and Leo Tolstoy, and a volume of Vasily Kliuchevsky casually dropped on the grass are images of cleanliness and chastity, of natural and cultural richness. The white color emphasizes the sacredness of authorities, which is elevated like the fields, the lakes, the rivers (Fig. 2). Dirty money, with which imperfect people potter, and authority in snow-white

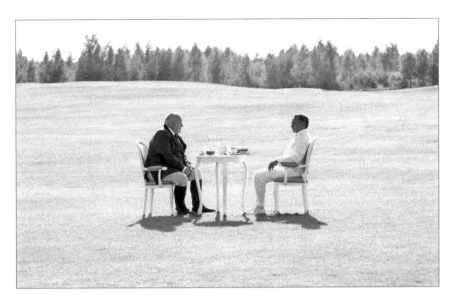

Fig. 2. Governor and President.

clothes make a harmonious pair symbolizing the nature and culture of Russia.

The bribe is like a divine watchmaker-creator who sets the entire world to work. The ward where the old mother of the university professor is hospitalized without any hope for surgery begins working in this way. Later, the tempo-rhythm is reminiscent of Dziga Vertov's aesthetics in *Man with the Movie Camera* (*Chelovek s kinoapparatom*, 1929), when—at the nod of the Creator—the gates of the Bakhmet'ev bus park open. Similarly, for Segal, the professor meets with the head of the ward; the bribe (a pack of money) is put in the table drawer; a call is made to the anesthetists and surgeons; the camera flies downward into the hospital square, where the surgeons—as if on command—throw away their unfinished cigarettes and get up; then the light of the operating theater. And all this is shot without a single word. The emotional and graphic dominant here is the music by Andrzej Petras, which precisely conveys the pressure of the disaster to come and the happiness when the tragedy is averted.

The simulative nature of all kinds of activity from "Circular Movement" (from the car mechanic to the governor and higher) is

taken to the absurd in the third story, "Energy Crisis." Segal here works with the Soviet myth about Russia as a country of bookworms. This myth also incorporates that of the valorous Russian detectives and the story about the "unknown force" of the provincial librarian, Anna Petrovna, who investigates all complex cases in the area. The imitation of activity by a crowd of uniformed people (inspectors, the police), who intensely and attentively listen to the lofty style of Russian poetry (an excellent stylization à la Pushkin) is one of the most absurd scenes. The inspectors and the policemen receive a translation from Russian into Russian of what Anna Petrovna says.

The search for the missing girl turns into a concert of Russian poetry in the open air, but even this concert comes to an end. The symbolic capital of Russian culture is exhausted, and Anna Petrovna senses this perfectly well. She can find maniacs and murderers, swindlers and thieves; she can help victims of violence, but once the girl has set fire to the volume of Pushkin, the librarian takes on the role of the victim and her energy expires. In this story, too, Segal resorts to the demonstration of an exchange: the girl, who saves her life by making a fire in the cold, and Anna Petrovna, who is consumed by the flames, the tragedy of the destruction of the last, even mythical, cultural capital. The time when "manuscripts don't burn"[2] has come to an end, and this is precisely the "energy crisis." No consumer society can find a way out. The simulation continues in the last story, "Inflamed" ("Vozgoritsia plamia").

In "Inflamed" the editor himself is the protagonist. The flame of passion has flared up in a traffic jam, which continues along several Moscow locations (the café Jean-Jacques, the Arts Cinema), and ends in the apartment of the aging bachelor who has grown up on Vladimir Vysotsky and "Murka."[3] His incredibly sexy and

[2] In Mikhail Bulgakov's *The Master and Margarita* Woland's response to the Master's assertion that he has burned the manuscript of his novel about Pontius Pilate is "Manuscripts don't burn" ("Rukopisi ne goriat"). The sense is that justice will prevail: truly talented works will eventually see the light of day.

[3] Vladimir Vysotsky (1938–80), was a Russian actor, poet, songwriter, and performer. He was one of the most popular cultural figures of the 1970s, known for his trenchant songs about Russian life and distinctive performance style.

charming girlfriend at first completely satisfies him (a term from the world of consumption), but a conflict that begins with her not knowing a few words (like "handball" and "Cheka") grows into a clash of worldviews that cannot be resolved even through excellent sex. The leitmotif "we should talk more" leads to the comprehension of an insurmountable precipice, not so much generational as anthropological. The heroine is quite honest: "I don't know much, but you can fuck me." The editor, ready and willing to give and spend, gets little pleasure; the laws of consumer culture with its dialectics of production and pleasure kick in. The conflict of different discourses begins: "I know, the Germans didn't get as far as IKEA"[4] and "What can we fuck about?" The connection of questions on Russian history with desperate, heavy petting in the car is the last attempt at sublimation before the hero's return to his coeval, with whom he can, after all, talk about Trotsky.

All of the characters in *Short Stories* are formally united through location, and conceptually through the absence of a common language—not on the level of semantics and syntax, but of contextual memory. No fixtures will help here: As Shakespeare said, "The time is out of joint."[5]

Segal has made an absurdist comedy, which makes pleasant viewing and entertains through the language of the protagonists (their ability not to hear each other), the ingenuity of the plotlines, the author's fine irony and self-irony. Segal does not assume a position of "You can't live like that!"; rather, his intonations remain gentle and therefore dramatically authentic.

Liliia Nemchenko

Translated by Birgit Beumers

"Murka"—a popular song of the criminal underworld, is now part of what is called "Russian chanson."

[4] The first IKEA opened in 2000 in the town of Khimki, on the outskirts of Moscow.

[5] *Hamlet,* Act 1, scene 5.

Further Reading

Abdullaeva, Zara. "Oskolki. 'Rasskazy'. Rezhisser Mikhail Segal." *Iskusstvo kino* 8 (2012). Accessed June 25, 2017. http://kinoart.ru/archive/2012/08/oskolki-rasskazy-rezhisser-mikhail-segal.

LEGEND NO. 17

Legenda No. 17

2013

133 minutes

Director: Nikolai Lebedev

Screenplay: Mikhail Mestetsky, Nikolai Kulikov and Nikolai Lebedev

Cinematography: Irek Khartovich

Art Design: Viktor Petrov, Vladislav Travinsky

Music: Eduard Artem´ev

Producers: Leonid Vereshchagin, Anton Zlatopol´sky, Nikita Mikhalkov, Mel Borz, Svetlana Migunova-Dalí and Aleksandr Kharlamov

Production Companies: TriTe Studio, TV Channel Rossiia 1 and the Federal Film Fund

Cast: Danila Kozlovsky (Valery Kharlamov), Oleg Men´shikov (Anatoly Tarasov), Svetlana Ivanova (Irina), Vladimir Men´shov (Eduard Balashov), Aleksandr Lobanov (Aleksandr Gus´kov, Valery's friend), Alejandra Grepi (Begoniia, Valery's mother), Roman Madianov (Zvezda coach), Götz Otto (Canadian team captain), Daniel Olbrychski (manager of the Canadian team), Nina Usatova (head surgeon), Boris Shcherbakov (Valery's father)

Fig. 1. Valery Kharlamov and Anatoly Tarasov.

Legend No. 17 was named the most popular Russian film of the past fifteen years by the leading online portal *Kinopoisk*.[1] It is a rousing sports drama, but like many films about sport, it is so much more. It is a ten-million-euros biopic about one of the USSR's greatest ice hockey players, Valery Kharlamov. It is the story of a superstar player and his relationship with an unorthodox coach. It is a sports drama based on real events, many of which have been captured on tape and are easily recalled by hockey fans who saw the team live or on television. It is a patriotic film that arouses audience emotions in support of the national team against great odds, and yet the narrative is critical of systemic corruption in Soviet sports. The film examines the context of the moral dilemma of pitting the world's best "amateur" players against hardened professionals.[2] The action culminates in the first game of the Soviet Union's epic 1972 Summit Series with the Canadian all-stars of the NHL. Structured as a chronological biopic, the film dramatizes Kharlamov's life from

[1] The rating of 8.005 was based on 172,470 votes on *Kinopoisk*, accessed October 30, 2017, https://www.kinopoisk.ru/film/legenda-17-2012-601564/. The International Movie Database recorded a weighted average vote of 7.7 out of 10 from 3,716 IMDb users, accessed October 30, 2017, http://www.imdb.com/title/tt2182001/ratings?ref_=tt_ov_rt.

[2] It should be noted that the Soviet team's amateur status was under dispute for they were, as State employees, in many ways *de facto* professional sportsmen, though formally classified as amateurs.

his seminal childhood experiences in Spain during the running of the bulls to his rise up the ranks of Soviet ice hockey. Tracing the proven formulae of the sports biopic, *Legend No. 17* highlights Kharlamov's female-centered family relationships, his loyal male friendships but, most importantly, his complex relationship with the magical and charismatic super-coach of the Soviet National Team, Anatoly Tarasov (Fig. 1).

Released in April 2013, *Legend No. 17* was scheduled to be distributed ahead of the 2013 World Ice Hockey Championships and the 2014 Sochi Winter Olympics. It became the biggest box office blockbuster of 2013, earning US$29,523,237 in Russia alone with more than 4.2 million viewers. The film went into profit on the domestic release alone.[3] The big-budget, dynamically shot, high octane, and nationally-focused rehabilitation of a crisis moment in national sports, seen through the prism of one key player or a fractious, underdog team and the relationship with a larger-than-life coach, has proven to be a winning formula for producer Leonid Vereshchagin. After the success of *Legend No. 17* he has produced three big budget sports dramas: wrestling in *Iron Ivan* (*Poddubnyi*, 2014), the box office smash hit about basketball, *Going Vertical* (*Dvizhenie vverkh*, 2017), and a focus on soccer with *The Coach* (*Trener*, 2018), just in time for the Russian 2018 FIFA Football World Cup. Indeed, it is worth noting that the high point for the release of Russian sports films was in the lead-up to the 2014 Sochi Winter Olympics that attracted considerable government investment. From 2012 to 2014 there were forty-two sports feature film and television titles released, the majority dealing with some aspect of the Winter Olympics. For the cynical reader, this could be considered canny synchronous populist marketing where the State-funded Olympics are supported through populist, mainstream State-funded cinema. For others it could be read as cinema distribution leveraging cultural context where the debate about national participation and preparation for hosting the games is foregrounded in the national

[3] *Kinopoisk*, accessed October 30, 2017, https://www.kinopoisk.ru/film/legenda-17-2012-601564.

media. Sports films in Russia have exploded in popularity largely due to the impact of *Legend No. 17* from a national mythmaking perspective and, importantly, from a technical- aesthetic approach that revitalized the way sport action was filmed in Russia.

"Adrenalin" is the key word to describe the film, according to one of Russia's leading film critics, Elena Stishova, an avowedly non-sporty viewer.[4] For Stishova, adrenalin fuels the audience's joy at watching *Legend No. 17*, which is only tangentially connected to patriotic themes. In the Soviet context, sporting patriotism was constructed as ideological—winning against the West was proof that the Soviet system was superior. But in today's context, sporting patriotism produces greater audience equivocation, given Russia's recent Olympic exclusions and accusations of systemic State-sanctioned doping allegations. For audiences that are not diehard sports fans, there seems to be an absence of mainstream national sporting heroes to rally behind, along with the responsibility of hosting a major international sporting event. That *Legend No. 17* is set in 1972 during the highpoint of Soviet hockey world domination is cause for nostalgic sporting pride. Inevitably it mobilizes some cross-over resonance for the present day and the construction of a sentimental bridge between the past and the present to allow audiences to invest emotionally in a present day patriotic consciousness.

There is a complex connection between emotionally provoking the audience and generating contemporary patriotic feelings based on nostalgia, which have been re-contextualized as a marketing drive to generate mainstream emotional meaning for the Winter Olympics. The 1970s ideological battle of the Soviet system against capitalism in the face of the Canadian professional players with their huge pay packets is no longer what it was, nor is it as intense. Whether structured as nostalgic patriotism or the power of cinematic affect, the feeling that is generated by an exciting,

[4] Elena Stishova, "Adrenalin. 'Legenda No. 17.' Rezhisser Nikolai Lebedev," *Iskusstvo Kino* 5 (2013), accessed August 20, 2017, http://kinoart.ru/archive/2013/05/adrenalin-legenda-17-rezhisser-nikolaj-lebedev.

well-made, and compelling film about a national team taking on the world's best on their own, hostile territory and winning, is bound to create positive viewer sensations about the triumph of the underdogs. This is a familiar trope for sports film narratives. But in order to amplify audience engagement, *Legend No. 17*, like the best sports films, needed to generate a scopophilic adrenalin rush. This is achieved by a tried and true narrative strategy combined with a dynamic technical approach. The narrative drama is generated by setting up seemingly impossible obstacles that the team—and Kharlamov specifically—need to overcome in the face of a fierce and more powerful opponent. The personal obstacles must combine with a series of team setbacks to shape the larger thematic concept that a superstar player is nothing without a great team. Establishing an underdog status allows for a dramatic transformation and for a previously maligned player to achieve redemption through unexpected feats.

The technical approaches to generating the audience adrenalin rush are a combination of a mise-en-scène structured through a constantly mobile camera, dynamic editing, constant pans, unexpected framing, and points of view that shock the viewer, but do not allow enough time to adjust before moving on to the next set-up. The dynamic, arrhythmic editing unifying various key locations and bringing disparate people together creates a sense of both cohesion and fragmentation—a state of unexpected visual surprises punctuated by emotive music and powerful diegetic sound effects. Constant variation of dizzying speed, driven by a clear narrative purpose, punctuated by moments of stillness and silence, create this sense of aliveness and with it a meaningful adrenalin blast.

Valery Kharlamov was the legendary Soviet ice hockey superstar left-winger who wore jersey No. 17 and represented the Soviet Union at eleven World Championships and three Olympic Games, winning two golds and a silver. He played for TsSKA (Central Army Sports Club) Moscow in the Soviet League from 1967 until his death in 1981. He is a member of the Ice Hockey International Federation Hall of Fame. The casting of heart-throb Danila Kozlovsky as Kharlamov was an inspired decision as he possesses a reasonable degree of physical likeness and a performance style

that blends intense focus with disarming charm. The film traces Kharlamov's life from his youth in Spain until the end of the first game of the 1972 Summit Series, exploring his coming-of-age, his personal relationships, and especially the creation of his legendary status in world hockey. However, the film surprisingly undercuts this one-man mythmaking by featuring coach Tarasov as part god and part demon—the paternal uber-trainer puppet master who shaped and focused Kharlamov's genius, but employed controversial yet creative methods in achieving these results. In the narrative structure of the film Tarasov is the leader and driver of the action. Known as "the father of Russian hockey," Tarasov was coach or assistant coach of the USSR national team from 1958 to 1960 and from 1963 to 1972. Tarasov coached TsSKA Moscow from 1946 to 1975. He was celebrated for his innovative and brutal training methods, his focus on passing, graceful fast skating, and on teamwork and full-field support, with a rejection of individualism. Despite the presence of Kharlamov's father in the domestic scenes, it is Tarasov's omniscient symbolic paternalism on the ice that beats boisterously as the spiritual heart of the film.[5]

Kharlamov was nicknamed "the Spaniard" as his mother was born in Spain and he spent a few months there at the age of eight. The key symbolism of the reluctant matador standing up fearlessly against a cavalcade of raging bulls that Kharlamov experienced as a child in Spain is stunningly utilized later in a critical dramatic moment when the game with the Canadians hangs in the balance. Seen through the eyes of the young Kharlamov and his mother, Begoniia, the film opens in a Spanish village in the 1950s during the festivities that culminate with the running of the bulls. Begoniia explains to her children that only the bravest will run in front of

[5] Tarasov's symbolic paternity is an amalgamation of his father-figure status for the entire Soviet ice hockey establishment (he wrote the book on the *men* in Soviet ice hockey), but I also imply a systemic paternalism—the presence of the State and its pursuit of excellence by any means, a kind of colonization of the bodies of sportspeople by the state apparatus, a combination of scientific rigor and logic of hard training, also peppered with ruthlessness, hysteria, and illogicality, the preserve of autocratic power.

the bulls, but when the young Kharlamov notices a puppy in the path of the rampaging bulls, he races to save it; however, one bull is running loose. With the puppy in his arms, the young Kharlamov bravely faces up to the menacing animal intent on destroying him. Just as he is about to be attacked, his uncle steps in and gracefully distracts the bull.

Later, when discussing what happened, he tells the young Kharlamov, while tying the red kerchief that he used to distract the bull around his neck, "when you find what you love you will be surprised at what you can do." This is followed by a lovely cut to ten years later on an ice hockey field where a big brute bullies Kharlamov, ridiculing him for wearing his mummy's red kerchief. Kharlamov stands his ground. It is clear that he has found what he loves. At that moment the famous national team and TsSKA coach, Tarasov, enters the arena to watch the game. His entrance is cinematically structured as divine grace. Kharlamov and his mate Gus'kov, who have been penalized for a previous fight, charge onto the ice hoping to show off their skills to the celebrated trainer. But Kharlamov overdoes it, playing stylishly yet selfishly without bringing his friend Gus'kov into the game, and he fails to score. Tarasov is underwhelmed by Kharlamov's small stature and his egocentric style. A clever cinematic sleight of hand sees Kharlamov promise Tarasov to go wherever he says, hoping that he means flying to Japan with the national team. But in a delightful editing moment at the airport, we realize that Tarasov sent Kharlamov and Gus'kov to Chebarkul', a smoggy industrial town far from Moscow to play for the local "Zvezda" team under the tutelage of one of his colleagues. It is in the minor league, under smoke-filled iron-grey skies, that Kharlamov learns how hard he has to work to win the respect of his teammates, to become an on-field leader and not a show pony. He intensifies his training, enjoys playing, and caps off his season with thirty-two goals. With the victories, Zvezda moves into the major league and when they earn a draw with TsSKA and Kharlamov stars with his improved skills and gamesmanship, Tarasov invites him to come to Moscow to try out for TsSKA. But first he has to overcome Tarasov's brutal, unorthodox, and provocative training methods and tests of character. In the sports

drama genre the hero needs to experience real obstacles on the way to stardom. In this case, the main obstacle is getting Tarasov's attention and then surviving his unconventional training regime. Tarasov plays psychological games designed to test Kharlamov's ability to fully dedicate himself to hockey and the team. Witnessing this ill treatment, the ambitious Communist Party bureaucrat, Eduard Balashov, befriends the young Kharlamov. He feeds his ego and disappointment at the hands of Tarasov, initiating a series of political intrigues that subsequently lead to major consequences.

Just when Kharlamov is on the verge of giving up, left bruised and battered after training, screaming in the shower, Tarasov unexpectedly invites him to join the team. He eventually passes all of Tarasov's tests and rapidly becomes TsSKA's leading forward. Interwoven into Kharlamov's quest to join the team are brief domestic episodes that show his family's dedication to getting him on the team, as well as his growing attraction to the university student Irina. Kharlamov's rise to fame and fortune is meteoric and he is mobbed by fans wherever he goes. The storytelling here is sharp and poignant with narrative exposition efficiently interwoven with hockey action. At the 1972 Winter Olympic Games, Kharlamov and Gus'kov are finally in Japan as part of the national team. In their first game, the USSR team, heavily backed to win against the Swedes, comes away with a draw. Shocked by their lacklustre performance, players from the various major league component teams that make up the national squad fill the post-game dressing room with a barrage of accusations. Dinamo players accuse the TsSKA players of individualism, while the TsSKA players damn the Spartak players for not scoring. Tarasov witnesses this blame game and pulls all the players back out onto the ice, ignoring the pleas of the tired and injured. In one of the best scenes of the film, borrowed but substantially improved upon from a thematically similar scene from the American film *Miracle* (Gavin O'Connor, 2004), Tarasov has the players skate in a clockwise direction, while intermittently calling out for the players from each of the contributing league teams to suddenly stop. As they do, the rest of the squad crashes into them creating a pileup. This goes on and on relentlessly. The Soviet

bureaucrats observing from the stands become apoplectic with rage as Tarasov ignores their entreaties and continues this merciless drill. It is only when Kharlamov calls out to his far more senior teammates, "don't stop!" and to ignore the commands associated with their domestic teams that Tarasov viciously questions him. As the camera pans across all the sweaty, drained and pained faces of his teammates, eventually settling on Kharlamov, he quietly explains, "we are no longer TsSKA, we are the National Team of the Soviet Union." The point is made and Tarasov finishes the training session. As the players slump in exhaustion, there is a wonderful audio ellipsis as the radio commentator announces that the Soviet National team have won Olympic Gold! Clearly the brutal team building exercise paid off.

A key motif integral to the narrative climax is that, while the Soviet team is the best in the world at the Olympics, they have not beaten the Canadians who have been excluded from the Olympic Games because of their players' professional status in the NHL. The challenge for the Soviets of competing against the best in the world is very clear and the Canadians are constructed as physical monsters and vicious brutes who play hard at the edge of the rules. But Tarasov's lifelong dream of playing the Canadians is undermined through a series of events instigated by the hockey bureaucrat Balashov. He attempts to persuade Kharlamov to sign a document describing Tarasov's supposed ill-treatment of his hockey players, insisting that the time of despots is finished. When Kharlamov refuses to betray his mentor, Balashov orchestrates a scandal during which Tarasov leads TsSKA off the ice in protest to an outrageous refereeing decision in a supposedly friendly game against Spartak with Leonid Brezhnev, the leader of the Communist Party, a Spartak fan watching from the stands. Tarasov's explosive, morally correct but politically naïve action plays into Balashov's trap, leading to his replacement as the head coach of the national team.

Feeling partially responsible for the situation, a distraught Kharlamov leaves the stadium during a rain storm. He crashes his car, severely injuring his leg. Employing a classic sports film trope, rehabilitation from a massive injury becomes a dramatic a race against time, in this case to recuperate and return to the ice in

time for the Summit Series. Unexpectedly, coach Tarasov appears at the hospital, but instead of having a commiserating drink, he takes the injured Kharlamov to a morgue to remind him with symbolic simplicity to stop feeling sorry for himself. Through sheer hard work and with Tarasov's help—a combination of ridicule and robust support—Kharlamov overcomes his injury, reconciles with his girlfriend Irina and is selected to fly with the team to Canada. At the airport Kharlamov keeps looking expectantly at all the arriving cars and buses. It seems that he is expecting to see his beloved come to see him off. But instead it is Tarasov, the deposed national coach, who comes to bid farewell to the team, eliciting an emotional welcome from his former charges and consolidating a special connection with Kharlamov.

In sports films the paternal bonding of coach and player traditionally trumps heterosexual love and family bonds. Although Kharlamov does have a rather devoted father, it is his complex relationship with the coach as a father figure that is far more important. Tarasov is at times sadistic and inexplicable, but is narratively positioned as a wise, omniscient wizard, whereas the women in the film (Kharlamov's mother, sister, girlfriend, and orthopedic surgeon) are painted as overly emotional and hysterical: too passionate, too desperate, too much red lipstick for the orthopedic surgeon, too studious in the case of Kharlamov's girlfriend. Their feminine emotionality is positioned as threatening Kharlamov's opportunities in contrast to Tarasov's masculine discipline and magical powers. Yet it is Kharlamov's mother's cooking that endears him to his new teammates in Chebarkul´ and it is the other women in his life who guide him toward success when he is wallowing in despair.

Arriving in Montreal, the Soviet team are quickly positioned as underdogs with no chance of beating the mighty Canadians, led by the chief antagonists Bobby Clarke and Phil Esposito. The playing of the national anthems unites all the disparate audiences watching the match from around the world in a skillful editing sequence that repeats throughout the match and establishes the supportive viewing positions: Kharlamov's uncle in Spain, his doctors and family in Moscow, Tarasov drinking tea at home, and even cops and

jailed criminals all settle down to watch the game. The Canadians are cocky—demonstratively chewing gun during the national anthem. The prediction of a whitewash seems accurate, with the Canadians going up 2:0 within a few minutes, totally dominating possession and physically intimidating the Soviet team. But with Tarasov wandering around a rain soaked Moscow playground elegantly tracing a stick along the ground as though directing his players from afar, the Soviet team levels the score before the first break. The bureaucrats are ecstatic, hoping for a face-saving draw. This incenses Kharlamov. At the start of the second period he takes the puck from the backline, puts a heavy bump on the Canadian aggressor Esposito, and scores an elegant goal, bringing the USSR team into the lead. Throughout the world, television viewers are ecstatic.

The next phase sees a symbolic association of the Canadians with a stampede of raging bulls opposed to Kharlamov, the graceful, elegant matador. The thumping of the Canadians' skates on the ice matches the bulls stamping on the dirt. Controlling the puck, Kharlamov pirouettes and dodges the charge of the bulls, just as his matador uncle evaded the bull long ago. Intimately connected to this myth of origins, Tarasov conjures his magic on the playground with his stick wand to the soundtrack of Spanish fiesta music. The crescendo comes as Kharlamov scores and the red light flashes. The moment the puck lands on the ice behind the goal is stunning. Silence. It is at the moment when a lone Canadian supporter stands and applauds the magic before an eerily silent stadium that the incredulous USSR team and the broader audience acknowledge that this moment, this goal of individual brilliance, is far greater than competing national teams, far bigger than patriotism—it is a triumphant moment of grand spiritual sporting communion.

At the break the Canadians are furious; their coach declares "this is not hockey, this is war! This is our ice and that No. 17 needs to be dealt with!" Subsequently, Bobby Clarke illegally smashes his stick into Kharlamov's injured leg, knocking him out. In the medical rooms Kharlamov demands that his leg be patched up, accepting the team doctor's threat that this could be his last game. As soon as Kharlamov makes a courageous return to the ice, he is again

Fig. 2. Valery Kharlamov streaming toward the Canadian goal.

illegally targeted by the Canadians. But he refuses to stay down and makes a miraculous save using his body. Although Tarasov is thousands of miles away in Moscow, his presence permeates the game. Kharlamov's miraculous save is spurred on by the memory of Tarasov's words when he was still a kid trying to make it onto the team ringing in his ears: "protect the goals with your whole body, protect them like your kids, as if you are defending the motherland." Kharlamov then uses the Canadians' physical tactics against them, dumping their lead aggressor over the side. When he returns from his foul, his injured leg bleeding, he streams back toward the Canadian goal (Fig. 2). Once again, Tarasov controls the action telepathically with his stick as Kharlamov dances around his opponents. Just before shooting, his leg buckles beneath him, but he effects a pass that is swept by his teammate for a goal. The final score is an unbelievable 7:3 victory for the USSR. After the game, the ecstatic Soviet team crowd around the phone, sharing their victory with Tarasov (Fig. 3), amidst the celebrations reverberating around the world.

What distinguishes *Legend No. 17* from every other ice hockey film is the extraordinary action choreography, the dynamism of the editing, and the exciting way the games were filmed with

Fig. 3. Kharlamov and the team celebrating their victory on the phone
with Tarasov in Moscow.

combinations of close-ups and moving sequences, aerials and crowd
point of view shots, with different audio signatures for each player,
which combined to create an uplifting symphonic work. Virtually
every shot is moving along with the action amplified by a series of
pans going from left to right and contrasted with intermittent tilts.
Cinematographer Irek Khartovich selected different shooting stock
to create specific effects of texture and color. He filmed Kharlamov's
early years on 16mm, the later period in 35mm, while for the Summit
Series, he utilized multiple cameras, including the very mobile wide-
angled GoPros and bird's eye view top of stadium cameras. Hockey
has never been filmed in such a vibrant way. The most exciting
aspects of the film remain the enormously dynamic and fluid
hockey choreography, at once majestic and brutal. It is fascinating
to contrast the film with the readily available archival black and
white coverage of the actual game. The film's choreography follows
that action closely, but Nikolai Lebedev's combination of close-
ups of athletes and audiences' faces, the absence of a wide shot of

the entire field, the dramatic punctuations (when the Soviets score their first goal, the silence is broken by the burst of a chewing gum bubble by a Canadian spectator), and the dynamic skating makes this film exhilarating to watch. The opportunities provided by contemporary live hockey television broadcasts are supplanted by high proximity photography that places the camera in otherwise impossible angles to achieve a highly dynamic quality mobilizing audience engagement and exhilaration.

The director, Nikolai Lebedev, is not a sports fan and there is nothing in his filmmaking biography that would have prepared him for the responsibilities of making a work about a popular legend and especially a high-energy sports drama; however an ongoing theme in his films is the search for personal freedom while negotiating traditional moral codes in complex social situations. Across a range of films, his heroes stand up to traditions and archaic behavioral rules not necessarily as radicals, but as gifted reformers who lead by example. The transformative conflict between the old and the new is the organizing principle of such films as *Soundtrack of Passion* (*Fonogramma strasti*, 2009), *Wolfhound* (*Volkodav iz roda Serykh Psov*, 2006), *Legend No. 17*, and *Flight Crew* (*Ekipazh*, 2016). Lebedev is a revisionist who balances innovation with a recognizable milieu. Due to the strength of *Legend No. 17* and *Flight Crew*, Lebedev is now considered one of Russia's most commercially marketable directors—fourth among the most successful Russian directors on the Forbes list.[6] Lebedev is avowedly a genre director from his very first feature film—the mystery-horror-romance *The Source of Snakes* (*Zmeinyi istochnik*, 1997)—to one of the first Russian action disaster films, *Flight Crew*.

Across eight feature films and one major television series, he has worked in a range of genres including: war, history, mystical horror, fantasy, sports films, action disaster, melodrama, and erotic

6 Lebedev is fourth on the list valued by Forbes at $63.6 million (Alexandra Guzeva, "5 most successful Russian directors from the Forbes list," *Russia Behind the Headlines*, May 19, 2017), accessed June 20, 2017, https://www.rbth. com/arts/2017/05/18/5-directors-from-forbes-list_765459.

adult thrillers. He is one of the few young Russian directors who has made a career of updating Soviet hit films and themes for new audiences. While there is a certain spiritual nostalgia in his films, thematically there is also a complex reappraisal of the Soviet era that is neither a direct critique nor a celebration, but rather a committed working through the aesthetics and moral landscape of the past in seemingly timeless context. His first big break came with *Star* (2002), an adaptation and revisioning of the Soviet era film, *Zvezda* (Aleksandr Ivanov, 1953) about a select group of Soviet scouts who are sent behind enemy lines at the back of the Nazi Tank Division ahead of a major offensive operation. His most recent film, the disaster action movie *Flight Crew*, was a partial adaptation of Aleksandr Mitta's *The Crew* (*Ekipazh*, 1980) and was equally well received by audiences and by critics.

Like *Star* and *Flight Crew*, *Legend No. 17* has a number of resonances and antecedents in both Russian and American hockey dramas. There is a clear dialogue with the ice hockey drama *Miracle* (2004) that pitted the fledgling US squad against the might of a seemingly invincible Soviet team at the 1980 Olympic Games. The narrative focus is on the coach, Herb Brooks, and the story is narrated largely from his point of view. But the feel of *Legend No. 17* is perhaps closer to the 1965 Soviet sports drama, *The Hockey Players* (*Khokkeisty*, Rafail Gol'din) in which there is a complex relationship between the coach, Lashkov, and his emerging new team that needs to battle it out between the young, but unproven players and the experienced "old men" of the team. The themes of friendship, veteran players, and family relationships surrounding sport stars are ones that Lebedev successfully borrows and explores as subplots. But it is the complex character of the coach and his unorthodox methods in *The Hockey Players* that appears to be a prototype for Lebedev's film. The heterosocial relationship between coach and players in the 1965 film is celebrated and expanded upon, while the dynamic presence of a disgruntled player's wife changing the balance is minimized.

Leonid Vereshchagin, the producer of *Legend No. 17*, claims that he came up with the idea for the film while watching Disney's *Miracle*, in which the fledgling US national team beats the mighty

USSR against all odds. Vereshchagin wanted to make a similar film, but from a Russian perspective. The 1972 Summit Series "was one of the few events that could unite all the generations in feeling proud for our squad, for our country," argued Vereshchagin. "I compare it, and I always compare it with Gagarin's flight, this victory."[7] While the influence of *Miracle* is evident, the narrative advances, aesthetic dynamics, and emotional complexity are considerably different, and the Russian film has proven to be far more successful in attracting a broader audience. While the American film is focused largely on the coach, his strategies, and character, the Russian film creates a complex drama between the super-coach Tarasov and his non-traditional methods, the meddling bureaucrats, the well-drilled team, and his star player, Kharlamov, as well as his friends and family. This is a far more universalizing and broad tableau drama. In contrast, the 2007 television movie *Valery Kharlamov. Extra Time* (*Valery Kharlamov. Dopolnitel'noe vremia*, Yury Korolev-Staal') was an earnest, but pedestrian effort that eschewed any drama on the ice, preferring to focus on dialogue-heavy family relationships. There was no mythmaking heroism in this telemovie.

Legend No. 17 is a sports drama exhibiting many of the themes and tropes associated with the genre, the most important of which is overcoming major obstacles. The film's three key dramatic conflicts are: the bruising relationship between a brilliant, but undisciplined sports star and his tough, but unorthodox coach; the battle of the "underdog" Soviet amateur team against the might of the Canadian professionals; and the clash between the hockey players under Tarasov's unconventional charge and the phony hockey bureaucrat Balashov. Contrary to some critics' condemnation of the film as patriotic propaganda, it is worth noting that the Balashov narrative offers a critique of the national sports system and its endemic corruption. The subject matter lends itself to a patriotic drama, but the tone of the film does not foreground patriotic posturing.

[7] Konstantin Meerov, "Kak sozdavalsia fil'm *Legenda No. 17*," *Film Pro*, April 25, 2013, accessed November 8, 2017, https://www.filmpro.ru/materials/18828.

Legend No. 17 innovatively blends two separate sports film traditions. American sports films, as Aaron Baker argues, "generally frame history as adequately represented by the individual desires, goals, and emotional dramas of the main characters, often in a biopic story."[8] Soviet sports films tended to eschew this individual focus, often excluding the complexity of historical concerns and privileging teamwork and the collective. *Legend No. 17* balances these binaries—the utopian focus on individual brilliance with the *a priori* sports film patriotism that unifies teammates, and mobilizes love of country and the belief in the dominance of one's country over others in the figure of the national team. Lebedev gives us a team that was shaped by Tarasov's unique and uncompromising style, a style that was deemed too despotic by Balashov, too focused on the cult of personality of a charismatic leader to benefit the community of hockey players, but a style that was validated by the narrative outcome. Balashov hides his nefarious intentions under the cover of a crusading, morally righteous, liberal anti-Stalinism, trying to paint Tarasov as an outdated tyrant who imposes his will on the players without consultation and destroys talented youth by his brutal methods. Yet it is Balashov who is the obvious villain of the film, the actual despot and master of subterfuge. The audience may wonder whether the director was contemplating the current socio-political scene in suggesting that the reasons for the Soviet team's success and Kharlamov's heroic status were a strong paternal figure and a dialectic between political control of an exacting system and a little magical chaos defined by a strong and unpredictable personality. Kelly Trimble notes that President Putin was the film's most faithful advertiser. At the premiere screening "he greeted the young Russian team with a brief introduction about the real Kharlamov, his character, and the challenges that he faced during his life: "And not only did he deal with it, but he became an outstanding player not only on our team, but in global

8 Aaron Baker, "Sports Films, History, and Identity," *Journal of Sports History* (Summer 1998): 218.

hockey."[9] Dealing with "it," meaning challenges and obstacles, is clearly what Putin felt made Kharlamov a world-class player.

An integral part of the film's authority is the truth claim of the biopic—a biography of a central character that is based on real events that for some viewers would be a part of a shared cultural memory. These events have entered into national folklore alongside game broadcasts, player highlight reels, and archival ice hockey materials readily available for review on a number of online platforms. Moreover, Kharlamov's son was involved in the development of the project, creating a high burden of responsibility in presenting a balance between realistic and mythological representation. As a biopic, *Legend No. 17* has a complex set of requirements—the demand for veracity, but without failing to deliver a dynamic hagiography that would maintain utopian individualism and audience mobilization. Clearly these demands require compromises. *Legend No. 17* has been criticized for straying from the documented truth. For example, Kharlamov was twice injured in a car accident, the second time, fatally, but the first incident occurred in 1976 and not in 1972, as depicted in the film. The car accident in the rain, precipitated by political meddling and dark intrigues, worked to create an effective dramatic obstacle to Kharlamov playing in the Summit Series and provided the later drama of playing with an injured leg. Lebedev and his scriptwriters successfully amalgamated some events of Kharlamov's life and changed their sequence, while ignoring other aspects in order to comply with the proven genre demands of the sports drama.

Some critics were dismayed by Lebedev's revisionist ideological agenda. Sergei Dobrynin argued that the rigged game with Spartak was an invention where "history is manipulated to present the 'dark side' of the Soviet system." Dobrynin explains, "There never was such a game. Brezhnev was a fan of TsSKA (Kharlamov's team), not Spartak. Tarasov quit the national team leadership in 1972 and would be fired from TsSKA only in 1975, for different reasons.

[9] Kelly Trimble, *"Legend No. 17," Kino-Ivory Symposium 2017,* March 22, 2017, accessed October 17, 2017, http://www.rusfilm.pitt.edu/legend-no-17/.

Kharlamov would get in his first (non-fatal) car crash in 1976, and it will not be politically or emotionally related."[10] Moreover, the character of Balashov seemed to be fictional, as no doubt was the reckless "training" scene on the powerlines. However, the poetic license in reordering of events should not diminish the film's authenticity. Kharlamov's connection with Balashov, his refusal to betray Tarasov despite his initial ill-treatment and the subsequent clashes they experience in Japan form an integral dramatic structure that works remarkably well to create additional obstacles for Kharlamov and his team to overcome. Whereas Kharlamov's actual story may not have possessed such political intrigue, Soviet sport was ideologically charged and corruption and personal vendettas were undoubtedly an aspect of Soviet sports. If Lebedev was critical of the Soviet system, he was equally critical of the Canadians with their suspect refereeing, unsportsmanlike coaching, and unbridled commercialism. Curiously, he made other choices, such as the exclusion of real events of patriotic fervor, to better balance the film's drama. Elena Stishova recalls that the coach entered the Soviet team's dressing room at halftime to inspire his charges by singing the national anthem. Clearly including a similar scene could have been a potent patriotic cinematic highlight, but Lebedev chose a more nuanced path.

Traditionally, a biopic has an individual focus, but Lebedev's binary approach is to focus on Kharlamov for the chronological coming-of-age action, while Tarasov provides the out-of-time spiritual guidance. Kharlamov is predictable, while Tarasov is shrouded in mystery and unpredictability. One moment he is a cunning strategist, and in another he is either a kind, paternal figure or a strict, sadistic despot and then suddenly a radical challenger to the leader of the Communist Party. But, most importantly, he is a magician, guiding the action with a little stick on a playground late at night while everyone else is helplessly glued to their television sets

[10] Sergei Dobrynin, "Nikolai Lebedev: *Legend No. 17* (*Legenda No. 17*, 2012)," *KinoKultura* (2013), accessed August 18, 2017, http://www.kinokultura. com/2013/42r-legenda17.shtml.

watching the Summit Series. *Legend No. 17* is as much a film about Tarasov's magical paternalism as it is about Kharlamov's genius. All other relationships are minimized, especially those involving the female characters (mother, sister, girlfriend, and surgeon).

In the context of government funding for sports and cinema, there is an assumption that this interrelationship is effective in mobilizing positive national sentiments, unity, and affect through a shared national consciousness. It is perhaps not surprising that *Legend No. 17* was distributed in the year leading into the 2014 Sochi Winter Olympics. The majority of Russian films are produced for domestic consumption and this film was geared to engage and stimulate a domestic audience to recall the former glories of the national ice hockey team and to mobilize their engagement with the current national team, less dominant than the teams of the 1970s, but still ranked in the top three at the time. It may be cynical to assume that government funding invariably translates into friendly cultural PR as some critics condemned the film for serving government interests. However, we should look beyond this easy condemnation and accept that sports films are *a priori* patriotic and mobilize positive national sentiments and unity through optimistic moral fables of team success standing in for communal, national success. Aaron Baker explains that the best of the new historical sports films demonstrate that "history is a complex drama of multiple actors and interests whose representation involves interpretation and revision and is influenced by the dynamics of social power, including that of the media to influence (and here revise) public memory."[11] Most historical sport films make claims about the past through the lens of present issues and seek to translate the victories of the past into future triumphs shared nationally. *Legend No. 17* is explicitly patriotic as it celebrates the achievements of the national team against a feared opponent. The Canadians are not constructed as opponents on the basis of ideological difference, but rather for a brutal style of play at odds with the Soviet system that privileges grace, teamwork, and inventiveness. Lebedev

[11] Baker, 230.

successfully emotionalizes history, mobilizing feelings of outrage at the way that the Russian players and coach were at the mercy of rogue bureaucratic meddling. Notwithstanding their symbolic characterizations as raging bulls, the key villains in the film are not the Canadians (there is grudging mutual respect at the conclusion of the film), but rather the grey Soviet cardinals who interfered with the magical team management. This line of conflict has no triumphant winners and is not patriotic, but it does mobilize audience outrage and sympathy for the victims, highlighting the complex drama and competing interests in this sporting story. *Legend No. 17* revitalizes the Russian biopic sports drama, employing conventional themes and tropes, but also skillfully inverting them.

Greg Dolgopolov

Further Reading

Babington, Bruce. *The Sports Film: Games People Play*. London: Wallflower Press, 2014.

Cermak, Iri. *The Cinema of Hockey: Four Decades of the Game on Screen*. Jefferson, NC: McFarland Books, 2017.

Riordan, James. *Sport in Soviet Society: Development of Sport and Physical Education in Russia and the USSR*. Cambridge: Cambridge University Press, 1980.

Briley, Ron, Michael K. Schoenecke, and Deborah A. Carmichael, eds. *All-Stars & Movie Stars: Sports in Film and History*. Lexington, KY: The University Press of Kentucky, 2008.

HARD TO BE A GOD[*]

Trudno byt´ Bogom

2013

177 minutes

Director: Aleksei German

Screenplay: Svetlana Karmalita, Aleksei German

Cinematography: Vladimir Il´in, Iury Klimenko

Art Design: Sergei Kokovkin, Georgy Kropachev, Elena Zhukova

Composer: Viktor Lebedev

Producers: Rushan Nasibulin, Viktor Izvekov

Cast: Leonid Iarmol´nik (Rumata), Iury Tsurilo (Baron Pampa),
 Natal´ia Moteva (Ari), Evgeny Gerchakov (Budakh), Aleksandr
 Chutko (Don Reba)

God Complex

Hard to Be a God—the most important Russian film of the twenty-first century so far and the last testament of Aleksei German, considered the greatest Russian filmmaker after Andrei Tarkovsky—is a tough nut to crack. It not only intrigues, it irritates. It not only delights, it exasperates. It will leave you not only with thoughts and feelings, but maybe a headache. Watching it may become torturous, but you may be permanently changed—although you would need to see it more than once for that to happen. This is a guide that will make it possible for you to survive your encounter with this film and come out of the screening satisfied.

> I was never taught, hassled, or had my nose rubbed in shit by any director. I'm a nonprofessional, and that forces me at every stage to invent cinema—my own, the kind of cinema that interests me. One that's somehow different from everybody else's. It's never been done this way before? I'll try it. It's not working? I'll swerve in another direction.[1]

The Strugatskys

Hard to Be a God is an adaptation of the cult novel written in 1963 by brothers Arkady and Boris Strugatsky, the most famous science-fiction writers in the USSR. Several important Russian films were based on the Strugatskys' books—most notably Tarkovsky's *Stalker* and Aleksandr Sokurov's *Days of Eclipse*. The protagonist of *Hard to Be a God* is young historian Anton from planet Earth, who lives incognito on the distant and benighted medieval planet of Arkanar, where he tries to protect the local intellectual elite from persecution and murder. German made many changes to the original material: specifically, he left the hero nameless and depicted Earth as a dark, hopeless place, nothing like the Strugatskys' invented Utopia. The end is radically different: in the book Anton returns to Earth and

[1] All italicized quotations are from interviews with Aleksei German. See Anton Dolin, in Further Reading.

undergoes a course of rehabilitation, whereas the film's hero finds no reason to go home.

> I worked on the first version of the script with Boris Strugatsky. He would come over, ask for tea with caramels—and for half the time we would argue about the political situation in the world. He was very well educated, peremptory, knew everything . . . and nothing he said corresponded to reality. He was wonderful to work with and very difficult to be friends with, yet we managed to be friends.

Fig. 1. Don Reba.

Plot

The reputed plotlessness of *Hard to Be a God* is a myth. German, who constantly fought against the hackneyed narrative conventions of Soviet cinema, is famous for paying close attention to the supporting characters, and his final film is no exception. *Hard to Be a God* retains all of the book's plot turns—you just have to listen carefully to the dialogue. All becomes clear then: the nature of the mission of the Earthman who assumes the identity of Don Rumata; his romantic relationship with an Arkanar girl as well as his friendship with "the Arkanar Porthos," Baron Pampa, played by one of German's favorite actors, Yury Tsurilo, whom the director discovered when he made

Khrustalyov[2]; the intrigue involving a coup d'état led by the minister Don Reba (Fig. 1); and the encounter with rebel leader Arata the Hunchback. Strugatsky scholars consider German's screen version to be very faithful.

> The film's plot has to do with a vile medieval state, where intellectuals, bibliophiles, and thinkers are murdered, and there comes a moment when the hero himself turns into an animal, a beast.

Camera

German's approach: to reject beautiful visuals, to imitate the eclectic and grotesque world of Bruegel the Elder and Bosch. The film's first cinematographer, Vladimir Il'in, died from cancer in 2006 in the middle of the shoot and his place was taken by Yury Klimenko. The production design aimed to show the world of Arkanar from within, exploring every detail. It is of no small importance that, per the book's plot, Rumata wears on his forehead a ring containing a jewel (Fig. 2). The jewel is, in fact, a hidden camera, and much of the film consists of the "documentary" footage it captures.

The Middle Ages

It's not by chance that the film's action unfolds on another planet: these are not the Middle Ages of our own history. And so, the inhabitants of Arkanar are familiar with potatoes and tobacco but have never seen a Gothic cathedral. Monotheism and religiously inspired art do not exist here: a pagan world lies before us, where, nonetheless, monastic orders and the inquisition hold sway. Not just dissidents arc persecuted on this planet, but also any intellectuals or artists. Arkanar is nothing if not a transparent allusion to present-day Earth.

> We were making a film about all of us. Arkanar is no different from us: the same denunciations, the same baseness, the same

[2] *Khrustalev, My Car!* (*Khrustalev, mashinu!*, 1998).

prisons, the same Blacks, the same Grays. We have achieved nothing: whatever we had in the 16th century we have in the 21st. As for the Earthmen, they are far from being God's best creation.

Politics

Political parallels between what happens in the film and certain contemporary events suggest themselves, but they have to be drawn with the utmost caution: after all, the project is half a century old and the script was completed about 20 years ago. Nevertheless, many interpreters see Putin in the protagonist, Rumata, and view the final massacre as a metaphor for the Chechen war or, more broadly, for the inability to change anything in Russia without bloodshed. In any case, its scene of mass murder occurs offscreen, leaving the field wide open for interpretation.

> Putin was giving me an award, and I told him I was making a film called *Hard to Be a God* and that he would find it most interesting. Such a deathly silence descended on that room — until he stirred.

Protagonist

Unlike everybody else in the film's world of dirt and filth, Don Rumata is the only one wearing an invariably clean white shirt (which, moreover, serves as his body armor) and he seems to be the only one who knows what washing up is. His attempts to cleanse himself of Arkanar, to get rid of its smell, are futile; in the end, he finds himself sprawled in a puddle, without any pants, and finally decides to remain on Arkanar for good. German's Rumata is not the young idealist of the Strugatskys' book but an aging knight who lost his faith in his mission, Don Quixote and Hamlet at the same time. (In one scene, he quotes Boris Pasternak's celebrated poem about the Danish prince.)[3]

[3] See "Hamlet" in Boris Pasternak, *Doctor Zhivago*, translated by Richard Pevear and Larissa Volokhonsky (New York: Vintage Classics, 2011), 614.

Fig. 2. Rumata.

Rumata is played by Leonid Yarmolnik, famous in Russia as a comic supporting actor and popular TV host. His casting shocked people, but German has a history of using non-serious actors for the main roles in his films: Rolan Bykov in *Trial on the Road*, Yury Nikulin in *20 Days Without War*, Andrei Mironov in *My Friend Ivan Lapshin*.

> Rumata is a human being from contemporary Earth—he flew over from us. He's a dissident. The other astronauts flew away in the end and flipped Arkanar off. Whereas he stayed behind.

Humor

You may find *Hard to Be a God* funny, don't be afraid to laugh—German's fine sense of humor is aligned with that of Flemish

painting and Russian satirical prose, from Nikolai Gogol and Mikhail Saltykov-Shchedrin to Mikhail Zoshchenko and Mikhail Bulgakov. It is also possible that you will *not* find it funny, despite elements of purely Russian absurdism, of which German was a master, this film is ultimately a tragedy.

> Russia has always suffered from two misfortunes: terrible harvests and huge, excellent harvests. And we always lived between the two; there was no difference. If the harvest was tremendous, the newspapers would write about it for a long time, then start timidly saying that the harvest rotted away for such and such a reason, and things would get even worse than in the previous year when the harvest was very poor.

Death

If we leave behind the political, satirical, metaphorical, anti-utopian, and historical planes and shift to the metaphysical one, *Hard to Be a God* is undoubtedly a film about death, in the tradition of the medieval *danse macabre*. It's no surprise that Ingmar Bergman's *The Seventh Seal* was German's favorite film. In a way, it's no shock that so many people passed away in the course of making *Hard to Be a God*, culminating in German's own death. In the film's last frames, a girl complains that Rumata's music gives her a stomach ache. It is one of the keys to the film. Life is inseparable from pain, but as long as you feel this pain, you won't succumb to indifference and oblivion.

> It's a film about the search for a way out in this world: to slash, to be gentle, to observe, to help—how is one to live? If there is no way out no matter what the hero does, everything turns to blood. You don't want to kill, you want to be kind— it'll be the way it is, nothing will change for the better. You want to kill—well, reforms will begin, but nevertheless you'll become a terrible man with blood on your hands.

Anton Dolin

Translated by Oleg Dubson

ALEKSEI GERMAN. FROM REALISM TO MODERNISM

No Russian director can compete with Aleksei German in terms of the number of interviews given to critics and journalists. This record could be ignored if at least three books about his work were not based on his one-size-fits-all monologues. The first was Aleksandr Lipkov's *German, Son of German* (1988),[1] then Anton Dolin's *German. Interviews. Essays. Scenarios* (2011)[2] and finally, Aleksandr Pozdniakov's *The Great German* (2016).[3] Aleksei Iur'evich always "held the floor," even in friendly conversation. No one attempted to interrupt his monologue, which was not addressed to anyone personally, but captivated all who found themselves in the same space. There was something magical in his plotless stories that continued even when, along with him, we were kicked off the premises at the end of the workday. It was the same magic as in the famous ten-minute-long pilot-captain's monologue from the film *Twenty Days Without War* (*Dvadtsat' dnei bez voiny*, 1977), shot in one take in a train car.

At that time, at the end of the eighties, I had the feeling that German remained in a round-the-clock regime of inner monologue. If there was a reason and listeners, he would continue it aloud. Much later, I understood that the flow of German's speech was congruent with the poetics of his films, in which the first, second, third, and further planes were equal and woven into a bundle scanning the flow of life itself with its mainstream and "hasty chance occurrences." At the time of his first cinematic experiments, when he was working with Vladimir Vengerov on *The Workers' Settlement* (*Rabochii poselok*, 1965), German was already renowned as a "virtuoso of the background." He got his cinematic education with Vengerov, a Lenfilm classic. By profession he was a theatre director, worked in the legendary Bol'shoi Theatre with the great

[1] Aleksandr Lipkov, in Further Reading.

[2] Dolin, in Further Reading.

[3] Aleksandr Pozdniakov, in Further Reading.

Georgy Tovstonogov, and never studied at VGIK (the State Film Institute), of which, by the way, he was proud.

German's method was called hyperrealism or suprarealism. This term captures the supporting construct of style, but does not fully explain it. To describe the late German style is no less complicated than the "muttering of life," as Anton Dolin called it, comprehensible to the director, but unintelligible to many, confusing, and, alas, never understood. But his last masterpieces, *Khrustalev, My Car!* (*Khrustalev, mashinu!*, 1998) and *Hard to Be a God* (*Trudno byt´ Bogom*, 2013) grow precisely from this material. Many critics are convinced that the late German style does not develop the stylistics of his first works but, on the contrary, opposes them. Dolin is convinced of the opposite: the author of the realistically transparent *Trial on the Road* (*Proverka na dorogakh*, 1971) must inevitably arrive at a modernist poetics that has no analogue in Russian culture, unless perhaps Anton Chekhov's plays and, of course, Andrei Tarkovsky's *The Mirror* (*Zerkalo*, 1974).

German's creative path turned out to be a devilishly planned inversion, exceptional even in the time of censorship. He was the recordholder of the "shelf."[4] His debut project, *Hard to Be a God,* was closed down for ideological reasons in 1968, and later became his final film. His actual debut, *Trial on the Road* (original title *Operation Happy New Year!*), filmed in 1970, reached movie screens in 1985, after the beginning of perestroika and the abolition of censorship. During these years he was fired from Lenfilm studios more than once as a poor production worker and an "inconvenient" person. He was not among the studio leadership's favorites and was disliked by his film crew. The Soviet film industry was so organized that a film that was not accepted by the leadership was not rewarded. Everyone who worked on the film lost their pay.

German's first released film, the war drama *Twenty Days without War*, based on Konstantin Simonov's novel *Lopatin's Notes* (*Zapiski Lopatina*) was actually his third project. Protected by Simonov, the film was released, although not without hindrances,

[4] Films that could not be released during the Soviet era were put "on the shelf."

and was received enthusiastically by critics. In the journal *The Art of Film* (*Iskusstvo kino*) Iury Khaniutin wrote about the "riddle of the author." The critic, whose childhood coincided with the war, was stunned by German's accuracy in recreating the spirit and letter of a time the director could not possibly remember: born in the summer of 1939, he was still a baby during the first years of the war. Inspired by German's cinema, the discourse of genetic memory in post-war culture arose with the appearance of *Twenty Days without War*.

The film is a narrative about a war correspondent who is given a two-week leave in order to reach Tashkent in the rear, the city of mass evacuations of Soviet people threatened by enemy occupation. He wants to see the widow of his dead colleague and formalize his divorce from his wife. The encounters in Tashkent, where the war is not audible, but governs all of city life, form a puzzle in which brutality, betrayal, kindness, love, and sacrifice are woven into a whole called life.

Simonov's intercession continued the collaboration between the eminent writer and the disgraced German. Thanks to the efforts of a man so influential that he had access to power right up to Iury Andropov, the First Secretary of the Communist Party, the film *My Friend Ivan Lapshin* (*Moi drug Ivan Lapshin*) was taken off the shelf. *Lapshin* was released in 1984, preceding *Trial* by two years. Classified as an action film, its heroes were the employees of the Criminal Investigation Department in the poor Russian provinces. The main operation was the armed capture of a band of criminals that controlled the town, endangering its inhabitants as well as the Soviet government. Ivan Lapshin, the main figure of the film, is the head of the Criminal Investigation Department, a participant in the Civil War, a communist who believes in the bright future of his country. A concussion acquired during the Civil War occasionally results in epileptic attacks. Thanks to directorial art and a deep understanding of the historical process, this sketchy plot related something greater about that time—about the 1930s and the beginning of the Stalinist repressions. It was clear that the heroes of the film, Lapshin, his colleagues and friends, who had laid down their youth for communist ideals, did not have long to enjoy

their freedom. The Revolution devours its children and will devour these, even the most devoted and faithful ones.

The ripening of a new style is already visible in *Lapshin*. The director reached the height of innovation in his experiments with asynchronic, "non-studio" sound. Here a kilometer of the film's semantic space is shifted behind the frame of a shot, counting on Bakhtin's "surplus knowledge," in other words, the historical experience of the eighties' audience, while the narrator is a half-century younger. He is a contemporary of the film's heroes, people of the thirties. The hidden plot of the film about the knights of the communist idea, the victims of Stalinist repressions, was deciphered of course, but its literal interpretation in the year of *Lapshin*'s release (1984) would have meant a public denunciation of the author, who was already under close observation by the "appropriate authorities" (the KGB) after the ban on his directorial debut *Trial on the Road* (1985), released during the first official year of perestroika—fifteen years after completion of the film. The director's first films that saw the light of day after his third project only poured oil on the flames of the controversy surrounding the German phenomenon. After all, both *Trial on the Road* and *My Friend Ivan Lapshin*, which referred viewers to the prose of the director's father, Iury German, a very popular Soviet fiction writer, encouraged a struggle with the secret of the unique "retentive memory" of the master. In our time memory is a topical cultural studies discourse intersecting time and again with political interest. In truth, the fuss around German's films flared up because, as the leadership of Goskino and the Ideological Commission of the Central Committee saw it, this arrogant fellow remembered the wrong things and in the wrong way, scorned the heroic style, as well as the entire dogmatics of Socialist Realism. German "destroyed Socialist Realism as a system of conventions."[5] I would say it even more bluntly: in reconstructing reality, the reality in which he had not lived, but which he passionately desired

[5] Sergei Dobrotvorsky, "Moi drug Ivan Lapshin," *Seans*, February 21, 2013, accessed November 13, 2017, http://seance.ru/blog/reviews/moy_drug_ivan_lapshin_german/.

to understand, he created his own method of working with realities on screen, having rejected the conventions of realism as a way of reflecting life. He evolved in the direction of "stream of life," the basic foundation of modernism. In his extensive interviews, German speaks at length and very interestingly about his preferences. For example, why he recognizes only black and white cinema:

> The bourgeoisie devised sound—and killed Chaplin, for example. No matter what you say, it's boring to watch him today, but earlier they idolized him. They inflicted a terrible blow to the skull with a hammer, having created a completely different art. But silent and sound film should have coexisted like painting and photography. But even this was not enough for them. They devised color in film. Bad color, as a rule. In life we don't notice color, apart from those occasions when we switch on a special sensor in the head. We perceive the world as black and white, whether dreaming or awake. I see the world as black and white. And I notice colors only when I begin to specially pay attention to this. It seems to me that a black and white film forces some brain cells to move differently and still see color. For me black and white is not the absence of color, but its greater presence. A black and white sea is being filmed and to me it seems blue, green or yellow. A black and white image forces your brain, which is used to color, to complete the image. Consequently, the less color in film, the better. One simply has to know how to film in black and white. Not the way it was done in the 1920s.[6]

(Black and white Kodak film was more expensive than color, but there was no point in trying to convince German to use color.)

He talked willingly and in detail about the principles of his anti-star casting and his actors. The director's assistants found stars in godforsaken provincial theaters, and if German invited famous actors, he discovered them anew, in ways that no one knew them. But here is a riddle: never did German make any attempt at theorizing, nor did he ever say a word about modernism or hyperrealism. In reflecting on German's aesthetic challenges, one would like to rely

[6] Dolin, 275, in Further Reading.

on authorial self-analysis. But the volumes of directorial statements do not provide an answer as to how and why the author of *Lapshin* and *Trial*, still conventional films, rejected an accustomed syntax for the sake of a new poetics in the *Khrustalev, My Car!* project. Here is the only statement in which the director, in conversation with Petr Vail´, categorically repudiates realistic art:

> It seems to me that only two of my films could be called realistic — *Trial on the Road* and *Twenty Days Without War*. I think that neither a film nor any other work of art is made for any particular reason. It is made in opposition to something and those films were also made in opposition to official propaganda. Do you know in what year prisoners of war were rehabilitated in the USSR? You'll probably say 1956. And you don't want 1989? Before 1989 they were all state criminals. They were rehabilitated at the end of Gorbachev's reign. In general, why be surprised that one film or another was banned. After that I completely lost interest in realistic art.[7]

German could not stand "concepts" or "discourses"; all of this pseudoscientific terminology was alien to him. Just like speculation. He followed his own powerful intuition, and it was by definition irrational. It is important that *Khrustalev* was German's first project lacking the support of a literary primary source. His father's aesthetic and then that of Simonov did not prevail over it. The original scenario was written by German with coauthor Svetlana Karmalita. Here he attempted to be equal to himself, to his internal monologue, and bombarded the viewer with an incredible quantity of bits of information. In other words, German produced a *stream of consciousness*. The fabric of his late films resembles a palimpsest. If one wishes, one can examine them by layers, carefully removing one after another.

By genre, *Khrustalev, My Car!* is a tale about adolescence, told by a teenager, the witness, and participant in the family, without

[7] Petr Vail´, "Zhizn´ pri Germane," *Rossiiskaia gazeta* 4710 (July 18, 2008), accessed November 13, 2017, https://rg.ru/2008/07/18/german.html.

knowing that the events are historical. "I began *Khrustalev* without imagining what this would turn into in a ruined country. I shot it as if it were my last film; I was getting ready to die. Although afterward my nerves weakened, I went to the clinic for a checkup, and they found nothing dangerous. However the idea of 'dying and leaving' was already and remained the leading idea of the entire film," said German, naturally for him, circumventing the underwater stones of "lofty ideas."[8] The scandalous failure of the film at the 1998 Cannes festival affected German's health, but a year later the film world adopted the film, publicly apologized to the "ridiculed prophet," and called *Khrustalev* a masterpiece. The prestigious cinema journal *Cahiers du Cinéma* rated it among the best fifty films in the history of cinema.

So, what was the reason for the initial rejection of *Khrustalev* by its first viewers? After all, the Cannes selection committee does not pick conventional mainstream for its programs, but rather highbrow arthouse. It is difficult to stump the experienced Cannes viewers; they have learned to read the most complicated cinematic codes. But even highly experienced cinephiles found themselves confused: "The eye cannot encompass such a multitude of planes, habitually concentrating only on the foreground; the ear does not grasp the polyphonic chorus."[9]

The complex response to *Khrustalev* is explained not least by the collision of the entrenched perceptual stereotypes of "Soviet film" with a new cinematic language, which destroyed the accustomed image of a closed world, almost the world beyond, that had just been revealed and began to speak in a language cutting across the established laws of perception. Both in the West and in Russia, on German's home turf, audiences had difficulty comprehending lines pronounced in parallel, often not fully expressed, spoken in a half-whisper, or muffled by everyday noises. They also could not make out what sort of phenomenon was "a man of the system." This was

8 Dolin, 232, in Further Reading.

9 Petr Vail', "Navazhdenie," *Kommersant* 155 (August 28, 1999): 7.

the main hero of the film, general of the medical corps Iury Klensky. The giant in uniform shone with his shaven skull and the tops of his calfskin boots polished to a mirror finish. Family and colleagues trembled before him, all women were prepared to give themselves to him, his wife was hysterically jealous and sniffed over his military tunic sampling the female odors, his teenage son was afraid of him and kept his distance, just in case. In a word, an authoritarian individual, the reflected hypostasis of the Kremlin tyrant.

The action of the film dates back to February 1953, when the last of the ferocious Stalinist repressions rampaged through the country: the case of "rootless cosmopolitans" and the doctors' plot, suspected of a conspiracy against the party leadership and the government. Klensky understood that they would come for him too, if not today then tomorrow and chose the only correct tactic: to disappear, to slip away, to dissolve into space. He did not return home, but made loops around Moscow, hiding in the homes of women he barely knew, aiming to get out of the city unnoticed. He changed cars, transferring from one to another, but state security caught up with him at a small train junction outside the city. Dressed shabbily, with a sack on his shoulder, the general seemed to fit in with the crowd. But the criminals sent by the *okhranka* provoke a fight with him. And there the falcons of Beria, the almighty minister of state security, tie up Klensky. There, in a covered delivery truck with the sign "Soviet champagne," the general is raped by some twenty criminals. World cinema knows no such rape scene. The director himself interpreted it as the image of a "raped, degraded country." Humiliated and crushed, Klensky flops out of the truck onto the melted snow like a mortally wounded animal, crawls on all fours, scoops the snow into a heap, and sits down on it with his bare behind. Suddenly KGB operatives lift him up, drag him to some room, fix him up like a god, and take him away in a limousine. Finding himself at Stalin's near dacha, in the dying tyrant's rooms, the sobbing Klensky kisses his pockmarked dead hands like a loving son. The visit concludes with Beria's order to bring a car for the general: "Khrustalev, my car!" The command is directed at a real person, Khrustalev, a low-ranking KGB employee. At the end of the film the general stops by his home to move his family from the communal apartment to which

they were shifted after his arrest, back into their old apartment. And disappears. He will vanish into the spaces of unwashed Russia and settle for good in its stinking, smoke-filled trains.

The modernist text of *Khrustalev* does not resist retelling, despite the complexity of its narrative construction. Here the main character, General Klensky, still remains the factor creating meaning. In German's next project, *Hard to Be a God*, Rumata, the main hero of the film, loses this function.

There are no protagonists in German's cinema. There is no hero who is given the author's cherished message. And even the offscreen narrator—there is one in both *Lapshin* and *Khrustalev*—is not identical to the author. However, it is the author who, if not the main hero of German's films, is then the bearer of the moral imperative—the highest ethical authority. Ethics is exceptionally important for this artist. At times his ethical sensitivity moved him to publicly declare his civic position although social activism as a way of life was not characteristic of German.

The lack of a hero in German's cinema that so spoiled his life during the time of censorship may be considered one of the harbingers of the modernist poetics with which the master allied himself in *Khrustalev* and followed in his final project, *Hard to Be a God*, not intuitively but consciously. The author's radicalism points to a seminal change in the master's perception of the world, experienced as an acute crisis of worldview, having understood that perestroika had failed and the concomitant hopes for the rebirth of the country and the nation had not materialized. The humanitarian values on which he had been brought up and which he believed in, no longer functioned in the civilized world or in his homeland where, due to historical reasons, idealism lingered much longer than in Europe. But it also came to an end in Russia exactly at the moment when the country rushed toward a new life with the beginning of perestroika. But let us wind the film backward. Perestroika arrived like a thunderclap, radical changes began, and it was the right time to return to the project he had not forgotten—*Hard to Be a God*. In the pipedream of perestroika everything impossible seemed possible.

The project for a screen adaptation of the recently published novel by the Strugatsky brothers, *Hard to be a God*, dates back to

1968. The film was supposed to be German's directorial debut. By that time he had shot the drama *The Seventh Companion* (*Sed'moi sputnik*, 1968) together with Grigory Aronov, but German did not consider the work his own and did not include it in his filmography. In August 1968, while waiting for the beginning of filming, the newly minted filmmaker went on vacation in Eastern Crimea, to the village of Koktebel', the favorite vacation spot of the muscovite artistic intelligentsia. A telegram from Lenfilm studios arrived. The studio editor notified him about the closing down of the project and advised the failed debutant to forget about this idea and throw the Brothers Strugatsky novel far, far away. Such a turn was expected. The Prague Spring—mass protests in then Czechoslovakia, which had rebelled against the Soviet regime—aggravated the political situation in the entire socialist camp. On August 21, troops of the socialist community entered Prague to suppress the sedition, which portended the potential collapse of the entire Soviet bloc. Ideological purges began in the USSR, of course; the struggle against dissident thinking began. There was no hero among the bureaucrats of Goskino who would take on the responsibility for launching and financing the film: an allegory about a certain planet inhabited by barbarians who consign wise men and men of the book to execution. The hint at the land of the Soviets was easily deciphered, Aesopian language was a pure convention, incapable of saving the situation. Compensation for the artist who had lost his work was his acquaintance with the girl who would become his beloved wife and only co-author, Svetlana Karmalita. The next two variants of the scenario were written with Karmalita, as were all other texts.[10]

After deciding to return to his first project, the director happened to find out that the German director Peter Fleischmann had stolen a march on him. The new leadership of Goskino now curries favor with artists and promises financing, while simultaneously another organization, Sovinfil'm, having obtained the rights to the film,

[10] Karmalita passed away in July 2017, having outlived her husband by four years.

launches Fleischmann in Kiev, while ignoring the categorical objections of Boris Strugatsky, one of the novel's authors. Out of curiosity, German traveled to Kiev to assess the level of production. Fleischmann had financial problems and was ready to give the film to German. But by nature German could not exist in another's idea, another's aesthetic.

However, his voluntary refusal of the film was dictated by other—and not creative—motives. After German's return from Kiev the minister of cinematography made him a proposal:

> "OK, we're giving you a million, go and film. We'll compare whose picture is better; it will be an experiment." And we began to write. But just at this time Gorbachev came on the scene. Everyone rejoices and sings. Tomorrow we're democrats, the day after it was completely unclear what happened to the sausage, the day after that Sakharov appears. This absolutely did not correspond to the possibility of filming the gloomy Middle Ages and a fascist invasion. All evil had been defeated! And we backed out.[11]

In the meantime, Fleischmann had finished filming and his version was released. The film had no resonance whatsoever. Science fiction in plywood and plastic sets did not find an audience. German understood that Fleischmann was not a rival and decided to try a third time ten years after he had voluntarily refused the second opportunity.

What was the reason? The shattering of perestroika hopes and frustration returned German to his abandoned project. He and Karmalita again began working on the scenario, but from their pens came not science fiction but rather a dystopia. The official launch date of the film was 1999. The third variant of the opus *Hard to Be a God* was long in development, almost fourteen years. During this time legends and apocrypha arose about the filming process, about the director's despotism and rudeness. The documentarians Pavel Kostomarov and Antoine Cattin, who were allowed on set, filmed

[11] Dolin, *266*, in Further Reading.

an uncomplimentary reportage, a drama in which German, in the fateful moments of the creative process, reacted to something that was not going right and his nerves gave way. The director himself commented on such minutes and even hours: "Yes, I'm a brute. But hold the complaints until after filming."[12] The feature-length documentary *Playback* was shown at international festivals in 2012, when the film had not yet been completed.

The incredibly complex filming was completed in 2006. A great deal of time was spent on recording and re-recording the sound. The director's perfectionism, multiplied by a new, more complex technology of sound recording, made this work truly hellish. German was ill for extended periods, there was no financing, and he had to search for new sources of funding; these three factors held up completion of the work. Different sources give different figures for the total budget of the film.

It is hardly possible to imagine the labor-intensive filming process developed by German if one had not been on the set and kneaded the mud with one's own feet. German rejected CGIs and viewed even composite shots with suspicion. Lifting such a monster—and by hand—is hard even to imagine in our time. But it was that way and only that way that German sought to represent the realistic quality of an event, in view of what was well known to all: the plot is not merely fictitious, it is fantastic.

> It's an indescribable high to create a world that never existed. For me the most interesting thing in all of this—[. . .] was the creation of a world that never was, so that you would believe that this world is and was, that it's like this. I may fail, but I want to compose and invent all this within myself, so that an emotionally moving world appeared resembling us in some way, and repellent in some way [Fig. 1]. We assembled it in the Czech Republic from seven or eight castles—this part here, that part there, a side street here, a royal palace there.

[12] Lilia Gushchina interview, "Aleksei German: Da, ia kham, no vse pretenzii posle s"emok," *Novaia gazeta* 146 (December 27, 2013), accessed November 13, 2017, https://www.novayagazeta.ru/articles/2013/12/27/57827-aleksey-german-da-ya-ham-no-vse-pretenzii-151-posle-s-emok.

Fig. 1. The Town.

I said from the very beginning: let's try to make a film that has a smell to it. Film the Middle Ages through a keyhole, as if we used to live there.[13]

The fabula of the film is maximally weakened, and it is not required in any case. The viewer who tries to trace the actions of the main hero Rumata from beginning to end is making a mistake. Such a viewer risks understanding nothing and accumulates innumerable questions at the end. Where is the promised Arkanar massacre? Why did it not happen? Why did Rumata not avenge the murder of his lover? Why did the "blacks" who had come to power get away with their atrocities (Fig. 2), purges of wise men and men of the book for whom Rumata searched and whom he hid? It is not the logic of the plot, always imaginary, that steers things, and not the logic of the genre, according to which the hero must be victorious. The laws of real life function here, where the righteous more often suffer defeat for, in the absence of a moral imperative, evil is by

[13] Dolin, 274, in Further Reading.

Fig. 2. Prisoners.

definition stronger than good. For the "blacks" the end justifies the means, but the hero must make a choice: use the enemy's strategy and draw level with him in immorality, or win or suffer defeat, but remain true to humanistic ideals. There is a fine line between good and evil.

The massacre did happen after all, but not on screen. German's decision was motivated by the inability of Russian filmmakers to shoot such scenes on a level that would satisfy him, the director: "It would have been very bad. We can't do this. The Americans with their trained extras can. We can't even shoot properly from a crossbow. And our crossbows don't shoot."[14]

German's perfectionism, as it was called, entered the record books. Each frame of *Hard to Be a God* is a highly complex composition, more comparable to painting than cinematic analogues. The depth of field of the German shot in this film surpassed all the famous masters in this area. Formerly an adherent of long and middle shots, here he uses extensively both tracking shots, that give the film epic

[14] Ibid., 274–75.

scale, and closeups, but these are not in any way salon portraits. Body parts, individual facial features, hooks, ropes, rags, a piece of bast hanging in front of the camera lens land in the frame. And some of the Arkanarites contrive to glance into the camera, smiling idiotically with their gap-toothed mouths. Short focus optics distorts faces, ensuring similarity to Bosch's characters.

German had long wanted to film his created world as if from the inside, immersing himself in it along with his characters. And he did it! But the first attempt was in *Trial on the Road*, his first work. The film begins with a closeup of a man, shot from the back. In the first minutes it seems that there is no space between the camera and the filmed object, that this is amateur work, and it dumbfounds you. In reverse projection you understand that these several shots set the tone of the film, in which the world is presented without acting, like a document.

German believed that it is possible to understand past epochs, their atmosphere, primarily by a scrupulous re-creation of the material world through textures (*faktury*): for example, the famous nickel-plated bed with little pinecone knobs from *Lapshin* that he remembered from infancy. There was one in his parents' bedroom. It marked the era; it was a product of Soviet light industry.

German used music in a shot very sparingly, fearing to disturb the flow of life as it is. He preferred diegetic sounds, distant sounds, the unintelligible gabble of the radio. In a word, he was impressed by music as a dramaturgical element of a film. In *Trial on the Road*, in the tense moment when the partisans track down the enemy and are ready to blow up the bridge, the stern of a barge enters the frame and the song "Na zakate khodit paren'" ("A young fellow walks at sunset"), popular before the war, sounds simultaneously.[15] The shot moves and the speechless partisans see a record player with a vinyl record and a German convoy guard-music lover. He cranks up the record player; in front of him on the deck sit Soviet prisoners of war.

[15] The lyrics to the song were authored by Mikhail Isakovsky in 1938, with music by Vladimir Zakharov. The popular "Na zakate" is now considered a folk song.

In his last work German decided to have a melody sound from time to time in the soundtrack of the film. He invited the composer Vladimir Lebedev to work on the film and put a flute in Rumata's hands. On the other hand, the director excluded psychological drama from his toolkit. The main elements of this project were representation and crowd scenes. He oriented his cameramen Vladimir Il'in and Vladimir Klimenko toward his favorite artists: Hieronymus Bosch and Pieter Brueghel the Younger, nicknamed Hell Brueghel. The artist's message is read through images and textures, reconstructing the imaginary world of the Middle Ages with German's well-known meticulousness. Here too he personally controlled each individual from the crowd—"to the buttons, to snot, to unshavenness."[16] German believed that "life in film—is the crowd scene." He inscribed great crowd scenes in the history of film, created on the basis of new material, in a new genre, epically powerful panoramas based on plots from Russian history, disguised as imaginary extraterrestrial ones: Living sculptural groups, as if crafted from damp clay, at times resembling plasticine animation, at times high reliefs along the facades of gnarled, crudely hammered together structures, resembling camp barracks more than human dwellings. Primeval chaos rules here in Arkanar and it has no end. In accordance with the literary original, the envoy from Earth, the noble Don Rumata, is a man from the future. He is older than the inhabitants of Arkanar by several centuries. He possesses excess knowledge, perceives the present as the prehistoric past of rational man. He imagines the path of this planet and the future unknown to it, and tries to accelerate this movement. And therefore he is like God.

The exposition, the arrangement of antagonists remained as before, thirty years ago; however, the idea evolved. During ten years of waiting for its moment, it was nourished by the director's

[16] Aleksei Zlobin, "German—chelovek bozhii. Dnevnik assistenta po ploshchadke," *Iskusstvo kino* 2 (2014), accessed November 13, 2017, http://kinoart.ru/archive/2014/02/german-chelovek-bozhij-dnevnik-assistenta-po-ploshchadke.

experience, having gone through his Golgotha from debutant to classic. It was enriched by the lessons of the most recent national and world history. German's planet Earth is no longer the promised paradise, and its envoys, including Rumata, are not at all the idealist-romantics, as the people of the 1960s were imagined. These are pragmatic people, this is simply their work—to follow what is happening in other civilizations, on other planets.

Hard to Be a God is postapocalyptic, a landscape after a universal catastrophe. The result of mutations in negatively directed anthropogenesis. Do not be led astray by pathways, do not be disturbed by the grotesque or shocked by the impassable mud, the sewage, the smoking garbage heaps, by the cesspools in which men of the book are drowned or by intestines spilling out. Do not be surprised either by the gallows sticking up everywhere (Fig. 3) or the corpses rotting under the drizzling rain, adapted by the local children for their games.

The freaks who have stepped out of Bosch's canvases, are half-human, from nowhere but the underworld, and playfully glance into the camera, like local aborigines. It is easy to read these frames as a collective portrait of a degraded society put through the meatgrinder of Leninist-Stalinist selections—and more than once.

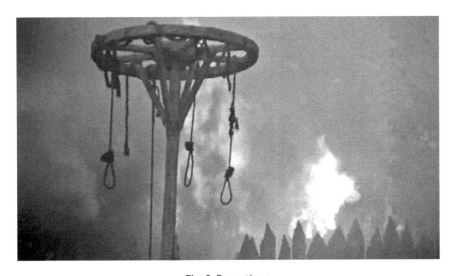

Fig. 3. Executions.

The planned creation of the "New Man" suffered a complete victory and launched the destruction of a formerly mighty ethnos that had already crossed into the stage of obscurantism.

Symbolic reminders are set up around the Czech castle Tochnik, each of which has a concrete historical reference, remembrances of the recent Soviet past. Some could be developed into a realistic documentary film, shot for example at the construction site of the Belomor-Baltic canal, where Soviet prisoners far surpassed Roman slaves who built an aqueduct by hand. Or in the depths of Siberia, in the settlements of families of "enemies of the people," who had to dig out *zemlianki* (underground dwellings) in the permafrost.

There is authoritative scientific evidence explaining the current "deterioration of manners and customs" not by the confluence of unfavorable circumstances, but rather out of the depths: "Any kind of growth becomes an odious phenomenon, hard work is subjected to ridicule, intellectual joys elicit rage. Style declines in art, in science original works are displaced by compilations, corruption is legalized in public life. [. . .] Talent is not valued, but rather its absence, education is not valued but rather ignorance, tenacity of opinions is not valued, but rather lack of principles."[17] These lines were written in the 1960s by Lev Gumilev, the son of the great Russian poets Anna Akhmatova and Nikolai Gumilev. In describing the stage of obscurantism, the typology of its manifestations in social life, he relied on the example of long disappeared superethnoses, but landed in our time, the new Middle Ages, which apparently has, for the present civilization, replaced the "end of the world" that never occurred.

German did not live to see the premiere of his colossus. He died on February 21, 2013. The film premiered at the Rome festival on November 13, 2013 in the presence of his widow and co-author and their son, Aleksei German Jr. In accordance with German Sr.'s will, the film was shown outside of competition, which did not prevent the jury from awarding the author the Golden Capitoline Wolf award for his contribution to world cinema.

[17] Lev Gumilev, *Etnogenez i biosfera zemli* (St. Petersburg: Kristall, 2001), 461–62.

One of the first viewers of the film was the writer and culturologist Umberto Eco. He gave the text of his speech at the conference following the premiere to the Moscow *Novaia gazeta*: "In this hell created out of intolerance and fanatical cruelty, from disgusting manifestations of brutality, you can't exist separately, as if it's not about you, the *fabula narratur* is not about you. No, the film is precisely about us, about what may happen to us, or even is happening now." Eco ended his essay with some humor: "In general, no matter what you say, I wish you a pleasant journey into hell. Compared to German, Quentin Tarantino's films—are Walt Disney."[18]

Elena Stishova

Translated by Rimgaila Salys

[18] "Umberto Eko: 'Imenno o nas, o tom, chto s nami mozhet sluchit'sia," *Novaia gazeta* 126 (November 11, 2013), accessed November 13, 2017, https://www.novayagazeta.ru/articles/2013/11/11/57142-umberto-eko-171-133-imenno-o-nas-o-tom-chto-s-nami-mozhet-sluchitsya-187.

Further Reading

Anemone, Anthony. "Aleksei Gherman: The Last Soviet Auteur." In *A Companion to Russian Cinema*, edited by Birgit Beumers, 543–64. Chichester, West Sussex: John Wiley & Sons, Inc., 2016.

Bykov, Dmitry et al. "Posle pervogo prosmotra." *SeansBlog*, March 9, 2008. Accessed September 23, 2017. http://seance.ru/blog/tbb/.

Condee, Nancy. *The Imperial Trace. Recent Russian Cinema.* Oxford: Oxford University Press, 2009. See in particular pp. 185–216.

Corney, Frederick C. "Aleksei German's Empire of the Senses." *KinoKultura* 46 (2014). Accessed September 23, 2017. http://www.kinokultura.com/2014/46r-trudno-byt-bogom.shtml.

Dolin, Anton. *German: Interv´iu, Esse, Stsenarii.* Moscow: Novoe literaturnoe obozrenie, 2011.

Lipkov, Aleksandr. *German, Syn Germana* Moscow: Kinotsentr, 1988.

Maguire, Muireann. "Back to the Future in Arkanar. The Strugatskiis, Aleksei German Sr. and the Problem of Injustice in *Hard to Be a God.*" *Science Fiction Film and Television* 8, no. 2 (2015): 233–53.

Pozdniakov, Aleksandr. *Bol´shoi German.* St. Petersburg: Kinostudiia "Kino-mel´nitsa," 2016.

Zvonkine, Eugénie. "The Artistic Process of Aleksei German." *Studies in Russia and Soviet Cinema* 9, no. 3 (2015): 154–83.

LEVIATHAN*

Leviafan

2014

141 minutes

Director: Andrei Zviagintsev

Screenplay: Oleg Negin, Andrei Zviagintsev

Cinematography: Mikhail Krichman

Production Design: Andrei Ponkratov

Music: Philip Glass, "Akhnaten," and Andrei Dergachev

Sound Design: Andrei Dergachev

Production: Aleksandr Rodniansky, Sergei Mel´kumov, Non-Stop
Prodakshn, Ruarts Fund for the Support of the Development
of Modern Art, with the support of the Federal Fund for the Social
and Economic Support of National Cinema (Fond kino) and
of the Ministry of Culture of the Russian Federation

Cast: Aleksei Serebriakov (Nikolai Sergeev), Elena Liadova (Lilia
Sergeeva, his wife), Sergei Pokhodaev (Roma Sergeev, his son),
Vladimir Vdovichenkov (Dmitry Seleznev), Roman Madianov (Vadim
Sheleviat, the Mayor), Valery Grishko (the Bishop), Anna Ukolova
(Anzhela), Aleksei Rozin (Pasha), Igor´ Sergeev (Fr. Vasily)

* An earlier version of some of the material in this article appeared in my review
of the film for the online journal *KinoKultura*. See Julian Graffy, in Further
Reading.

Leviathan is the fourth feature film (after *The Return* [*Vozvrashchenie*, 2003], *The Banishment* [*Izgnanie*, 2007], and *Elena* [2011]) by Andrei Zviagintsev, an overview of whose career is available elsewhere in this volume. Set in the distant north of the Russian Federation,[1] it tells the story of Nikolai (Kolia) Sergeev, a mechanic whose family have lived for generations in a beautiful house on the seashore with a stunning view of the bay. But it soon emerges that sinister forces, led by the local mayor, Vadim, are attempting to dispossess him, for reasons he does not understand, and he has summoned an old army friend, Dmitry (Dima), now a successful Moscow lawyer, to help him fight his case. The local court finds against Kolia, so Dima attempts to influence the mayor to change his decision by means of the dossier of compromising material that he has gathered against him. After an unsuccessful attempt to register a complaint, undermined by Kolia's irascibility, his wife Lilia, worn down by his obsessions, and by the abuse she is enduring from her teenage stepson, Roma, turns to Dima for solace and they sleep together in his hotel room.

The next day they join their friends, the policemen Stepanych and Pasha, and Pasha's wife Anzhela on a trip out into the countryside during which Roma discovers his stepmother with Dima, leading the devastated Kolia to beat them both up. Meanwhile, Vadim consults the local bishop about how he should now act and then summons Dima to a second meeting. He drives him out into the countryside and gets his heavies to rough him up before staging a mock execution and ordering him back to Moscow.

Pressure in the beautiful house is now intense as Roma makes his hatred of his stepmother explicit. She leaves the house early, ostensibly for her job at the local fish factory, but in fact walks off toward the shore. At the end of the day, learning that Lilia is missing, Kolia assumes that she has gone off to Moscow with Dima. But the next morning he is woken to be told that her body has been found.

[1] *Leviathan* was filmed in the village of Teriberka and the town of Kirovsk on the Kola Peninsula, in the Murmansk Region, with additional filming in the small local towns of Monchegorsk and Olenegorsk.

Fig. 1. Aleksei Serebriakov as Kolia and Elena Liadova as Lilia.

In this devastated state he meets the local priest, Fr. Vasily, who attempts to console him by likening his fate to that of the biblical Job and counsels him to have faith.

Pasha and Anzhela, recalling Kolia's threats when he had discovered his wife's betrayal, wonder whether he has killed her and report their fears to the authorities. Kolia is arrested, swiftly found guilty, and taken to prison. The beautiful house is destroyed by a bulldozer.

In a stunning final twist, the plot where Kolia's house once stood is revealed to be occupied by a new Orthodox church. At the service of its dedication the bishop delivers a sermon speaking of truth and freedom, of enemies, and of the need to defend Orthodoxy. A storm breaks on the desolate northern shore.

By the time he made *Leviathan*, Zviagintsev had a firmly established team of collaborators. He had started working with the scriptwriter, Oleg Negin, in 2001, and they have completed several screenplays together, of which *Leviathan* was the third to be filmed, after *The Banishment* and *Elena*. Negin describes how their collaboration begins by working ideas into a theme, after which

he goes away and writes the script, which is then reworked with Zviagintsev, and with additional input from the cinematographer Mikhail Krichman and the production designer, Andrei Ponkratov. He calls his work with Zviagintsev "that cherished union of the intelligentsia and the working class," adding that "all the evil and calamity comes from me and all the fine and lofty elements from Zviagintsev." He has been present during the filming of all of his scripts.[2]

Mikhail Krichman has collaborated with Zviagintsev since even earlier—he has been the cinematographer on all the director's short films and features going back to 2001. He has described how Zviagintsev "uses few camera movements and most of the time prefers very sedate, very simple arrangements." He adds that on *Leviathan* Zviagintsev "wanted a very realistic effect, in every sense of the word."[3] So the camerawork on the film is, for the most part, unostentatious, relying on editing rather than camera movement and mainly consisting of frontally shot sequences with a static camera that allows the savage grandeur of nature, the intimacy of objects, and the facial expressions and movements of the actors to speak directly to the viewer. Occasionally, at points of heightened tension or significance, the camera zooms in on a person or an object, as in the scene in which Kolia looks at mobile phone footage of his wife in happier days. The general unobtrusiveness of the cinematography also draws attention to formally more complex sequences, including one of which Krichman is justifiably proud, which involves an 180-degree pan around the inside of a moving bus before homing in on Lilia's anguished face.

[2] Oleg Negin, 38, in Further Reading. Despite Negin suggesting that Zviagintsev's contributions to the script were mainly lofty, Zviagintsev told Oleg Sul'kin that it was he who was responsible for the banter between Kolia and Dima about grabbing the mayor by the "Fabergés," a euphemism which plays on the fact that the Russian equivalent of the English vulgarism "balls" is *iaitsa* (eggs), and which he claims to have heard used by a man "with access to the very top." See Andrei Zviagintsev, "Narod vse prekrasno poimet," in Further Reading.

[3] Mikhail Krichman, in Further Reading.

Other members of Zviagintsev's crew have also worked with him for some time. Anna Bartuli has been responsible for the costume design on all his feature films, while Andrei Dergachev (music and sound design), Anna Mass (editor), and Andrei Ponkratov (production design) all worked on *The Banishment* and *Elena*.[4]

Parts of the Third Symphony by the American composer Philip Glass had been sparingly used to evoke mood in *Elena* and Zviagintsev turned to Glass's work once again in *Leviathan*. The film opens and closes with scenes of the majestic northern coastline and waves lashing the shore, set to the pulsating, insistent music of Glass's opera *Akhnaten* (1983), which tells the (highly relevant) story of a Pharaoh who achieves great power but whose dynasty is eventually destroyed. But Glass's music is not used during the film narrative, since, as Zviagintsev has explained, he realized that "it absolutely doesn't blend with the image, it flies out of it like a cork."[5] Rather, this "overture" and coda serve to place a story about specific Russian realia in a grand, elemental context.[6]

Its central narrative concern, the examination of a family experiencing crisis and betrayal, also makes *Leviathan* immediately recognizable as a "Zviagintsev film," while the physical destruction of the family house has been prefigured by the abandonment or loss of home in the earlier films. But while it shares with his earlier features a formal ambition and a desire to offer a commentary on the human condition, the reticence and distance that marked all those works has now been replaced by a ferocious urgency and civic passion. Neither *The Return* nor *The Banishment* made explicit reference to contemporary Russian reality and *Elena* (discussed by

4 Negin, Krichman, Mass, Dergachev, Ponkratov and Bartuli also worked on Zviagintsev's most recent film, *Loveless* (*Neliubov´*, 2017).

5 Andrei Zviagintsev, "Superproekt. 'Leviafan.' Razbor po kostochkam. Glava 1: Uvertiura, pervyi kadr," January 1, 2016, accessed July 18, 2017, http://www. filmz.ru/pub/77/30069_1.htm. This ambitious but alas aborted project (which ran to fifteen conversations) involved Zviagintsev describing the motivations behind sequences of his film and the process of filming them.

6 There is almost no non-diegetic music in the film; on rare occasions conventional "atmospheric" music is used in sequences without dialogue.

Elena Prokhorova in this volume), though set in two flats at opposite ends of the economic scale in contemporary Moscow, was nuanced in its social commentary, leaving much to the viewer's imagination. *Leviathan*, on the other hand, makes constant and explicit reference to the pressures and tensions of life in the contemporary Russian hinterland.

At the center of *Leviathan* is a compassionate tale of human frailty. All of the central characters are complex, and all are believably flawed. Kolia loves both his wife and his son and attempts to smooth away the tensions between them. He is so kind-hearted that he is constantly being imposed upon. When a group of men arrive unexpectedly at his house, his initial words are "What, fellows, do you need help?" (It is only when he realizes that it is his nemesis the mayor that his mood darkens.) Then, near the end of the film, despite asking Fr. Vasily if his story of Job is "a fairy-tale," he insists on carrying his heavy load. But he is also irascible, violent when drunk, pig-headed, and emotionally clumsy.

Lilia, his second wife, is exhausted by his fixation on the court case and obsession with his family history. Finally worn-down by Roma's antagonism, she betrays her husband, but feels both guilt and remorse and they seem to be reconciled. Roma is verbally brutal and aggressive, but he is a teenager, traumatized by the death of his mother. All three members of the family are to some degree "responsible" for Lilia's death which is left satisfyingly unexplained. Is it a suicide, motivated by Lilia's anguish over her disloyalty and/or despair at Roma's anguished accusations? Did Kolia kill her? The prosecutor indicated that a hammer capable of inflicting the blow to the back of the head which caused her death was found in the house, but Kolia is a mechanic who would have such tools lying around, and besides, the prosecutor may be lying. Did Roma kill her? He wanted her dead and he exclaimed, "It's not true," the moment he learned that his father had been accused.

This nuanced characterization extends to the minor characters. Pasha, Anzhela, and Stepanych are all friends of the family. Anzhela tries to find them a new flat, while, early in the film, Pasha helps Kolia out of detention after he has lost his temper in the police station and been arrested "ni za chto" (for nothing). Stepanych invites

Fig. 2. Roman Madianov as the Mayor.

them to his birthday celebrations. Yet they all denounce Kolia when Lilia dies. Even the terrifying mayor is revealed to be uxorious and a doting parent. The erring, believable humanity of these characters is further expressed through the men's vigorously salty language,[7] while all their most lamentable behavior takes place when they have been drinking heavily, in celebration or in despair.

But this existential drama of human frailty is placed in a number of contexts, spatial, societal, and cultural, which add specificity to its meaning, allowing viewers to interpret it on a number of levels. If people are betrayed in *Leviathan*, then so is place. The house that the family inhabits is not only beautifully situated, it has an attractive lived-in feel, with rows of potted plants on the window, piles of crockery waiting to be washed, bookshelves and family photos on the wall, and jars of preserves lovingly stored in the cellar. It is a place of refuge and memory, set in the natural world, like the

[7] The film's use of "mat" ("non-standard language") caused it to fall foul of new legislation banning certain swearwords from the showings of films in cinemas.

houses in Andrei Tarkovsky's films *Solaris* (1972), *Mirror* (1975), and *The Sacrifice* (1986). And, like the house in that last film, it is dramatically destroyed. The bulldozer that mercilessly pulverizes not just a building but a way of life at the end of the film (in a scene made all the more effective by being partially shot from inside the house) is just one of the several Leviathans that inhabit the film: the natural (the whale carcass by which Roma sits, the whale seen by Lilia); the material (an uncompleted apartment block, the fish factory, the incongruous new church); the human (the bishop, the mayor); and the abstract (state power). And this sense of a beautiful place profaned by human activity has pervaded the film from the start. With its wild waves in a vast sea and its rocky landscape, this is a grander, harsher, more elemental natural environment than that seen in *The Return*, Zviagintsev's other "northern" film. But from the start, we also see evidence of man's disruptive presence, through pylons, a road savagely hewn out of the rock, the detritus of rotting boats. The film's characters are also directly complicit in the trashing of this pristine wildness. Stepanych's birthday "picnic" involves driving to a tranquil spot by a lake. "Let's relish the silence," he says, before setting up a row of bottles and reducing them to fragments with his Kalashnikov. Later, the attack on Dima by the mayor's heavies and his mock execution will also take place outside of the town, in a quarried landscape rendered ugly by human activity. Not that the town itself is anything but a blot on the landscape. The stucco is peeling from the walls of the ugly Soviet apartment blocks and the fish factory where Lilia and Anzhela work is grey and depressing.

The sense of devastation and abandonment is underlined by recurring images of empty carcasses, from the boats left to rot at the start of the film, to a ruined, roofless church in which Roma and his friends drink beer around a bonfire, to the horrible ugly flat which Anzhela shows Lilia and which she insists can be redecorated ("not a European-style renovation, of course, but done with soul," ["ne evroremont, konechno, no zato s dushoi"]), to the unfinished apartment block seen from the bus taking Lilia to work, and finally to the skeleton of a whale, which Roma sees when he runs to the beach in despair. This is a film told not only in words

but visually, through images, through *things*, which range in tone from the beautiful and the consoling (the family photographs that explain why Kolia fights to stay in his house) to the ugly, dark, and desolate.[8]

As its very title suggests, and as might be expected of a film with a greater degree of direct civic involvement, *Leviathan* engages far more broadly with other texts than was the case for Zviagintsev's earlier films. It has been widely asserted that the initial idea for the script (co-written with Negin) was a *fait divers* from contemporary American life, the case of Marvin John Heemeyer, the owner of an automobile repair shop in Colorado, who sought vengeance against the authorities who had found against him in a zoning dispute on June 4, 2004. While broad links with this case are clear, Zviagintsev later repeatedly insisted that no trace of the original story remains in the completed film.[9] It is much more productive to consider the film's relationship with weightier philosophical, religious, and literary texts. The *Leviathan* that will probably first come into the mind of viewers is the 1651 treatise on the relationship of state, government and society by the English philosopher Thomas Hobbes, which discusses the "social contract" that should legitimize the relationship between the state and the individual. Hobbes, of course, took his title from the biblical book of Job and, indeed, quotes from it at the very top of the frontispiece of the first edition

[8] In this context, it is interesting to quote Zviagintsev's insistence upon allowing visual images to retain the power of suggestion. When asked the meaning of the "symbol" of the white horse in *Elena*, he retorted: "Are you really so programmed to consider secret meanings that you react in that way to any image? It seems to you that there must definitely be some enciphered, coded signal and all you can think about is deciphering it. Who taught you to look at images in this way? There are no metaphors or symbols here." See Andrei Zviagintsev, "Nikakikh simvolicheskikh smyslov," in Further Reading.

[9] This process is similar to what happened both with *The Banishment*, for which the original source was the story "The Laughing Matter," by the American-Armenian writer William Saroyan, and with *Elena* which started life as "Helen," a script commissioned by a British producer.

of his book.[10] Zviagintsev asserted that Hobbes's work had been a major influence on the film "in the plane of ideas,"[11] but explained that he had learned about Hobbes's *Leviathan* only after work on the project had begun.[12] Their reading of the relationship between the individual and power is certainly not the same.

Another inspiration Zviagintsev mentions for the film's narrative is Heinrich von Kleist's novella "Michael Kohlhaas." Written in 1810 and set in the sixteenth century, "Michael Kohlhaas" tells the story of a horse trader who suddenly becomes the victim of arbitrarily imposed new tolls and permits. When he seeks redress, he is tricked and exploited by a representative of power. The rest of the story concerns Kohlhaas's obsessive search for justice. He hires a lawyer, who initially seems to be fearless in his support and confidently demands fairness for his client, but who quickly lets him down. His attempts to help himself are thwarted by a labyrinth of legal complexity, bureaucratic detail, and cronyism. His wife dies from a freak accident. All of these developments, as well as the nightmarish elaboration of how the law works against the weak individual, are very close to the experience of Zviagintsev's Kolia, but Kohlhaas simultaneously embarks upon a campaign of vengeance, making him a close brother of Nikolai Gogol's Captain Kopeikin in *Dead Souls* (*Mertvye dushi*, 1842), another simple man who turned to violence following mistreatment and humiliation by authority figures. Kohlhaas is eventually arrested and taken to execution.

Marvin John Heemeyer, Michael Kohlhaas, and Captain Kopeikin are all "little men" whose sense of frustration and injustice led them to violent resistance; but Kolia, for all his threats that if the mayor constructs a "palace" on his land he will burn it down,

[10] The close relationship between Zviagintsev's film and the biblical story of Job will be discussed later in this essay. For an insightful interpretation of the use and "inversion" of biblical sources in Zviagintsev's films, see Nancy Condee, 569–72, in Further Reading.

[11] Andrei Zviagintsev, "'Chto za zhizn. . . ',," in Further Reading.

[12] "Sobchak zhiv'em: Andrei Zviagintsev," in Further Reading.

refrains from taking this path. Zviagintsev explained this narrative choice by insisting that "if we had ended in rebellion, the viewer would have left the cinema satisfied" and asserting that his own quiet, inconsolable resolution of the narrative was considerably more terrifying.[13] This interpretation is echoed in a brilliantly thoughtful and incisive analysis of the film by the film critic Anton Dolin, who stresses its "social and psychological truthfulness" and describes this "gun [which] does not fire" as the thing that makes the script of *Leviathan* "so sensational."[14]

Kolia shares an initial not only with Kleist and Kohlhaas but with a great admirer of Kleist's story, Franz Kafka, and with some of Kafka's most famous literary creations. His conflict with deadening, shadowy bureaucracy at the start of the film connects him to K in *The Castle* (1926; in which inaccessible bureaucracy is represented by the enigmatic and inaccessible Klamm,) while his arrest for a crime that (to our knowledge) he has not committed resembles the fate of Joseph K in *The Trial* (1925). Viewers of the film will think not only of Kafka but also of the writings and ideas of Fedor Dostoevsky, whose novels consistently address questions of family crisis, rupture and guilt, use the trope of violent death, contain theological debate, and discuss the hero's path to humble resignation (smirenie). Zviagintsev had said in a 2012 interview that for five years he "lived out of Dostoevsky" and that Dostoevsky was the figure from history he would most like to meet. He expressed particular admiration for the novel *The Brothers Karamazov* (1880).[15] All the Dostoevskian tropes just mentioned are present in *Leviathan* and the mayor, expressing his contempt for the inconsequential Kolia, uses the term "louse" (vosh′) that Raskol′nikov applies to the pawnbroker he has killed in *Crime and Punishment* (1866).

[13] Andrei Zviagintsev, "Zdes′ vsego cherez krai," in Further Reading.

[14] Anton Dolin, 48, in Further Reading.

[15] "Pozner. Andrei Zviagintsev," in Further Reading.

Fig. 3. Sergei Pokhodaev as Roma and the carcass of a whale.

The lawyer, Dima, is a particularly Dostoevskian figure, who, like Dostoevsky himself, experiences a mock execution. And a key scene in the film, in which he speaks to Lilia after Kolia has found out about their betrayal, is steeped in the concerns *The Brothers of Karamazov*. One of the most important elements of the teaching of Fr. Zosima, the spiritual elder in the novel (and the antipode of the bishop in *Leviathan*) is his insistence that "truly, everyone is guilty before everyone and for everyone [voistinu vsiakii pred vsemi za vsekh vinovat], it's just that people don't know this, but if they did there would now be paradise." This question of guilt is taken up by Lilia, who says "It's all my fault" (literally "I am guilty of everything," ["vo vsem vinovata ia"]), echoing words repeatedly spoken by Grushen'ka, her double as "fallen woman" in the novel. This is a lesson that Dmitry Karamazov, Dima's namesake in the novel and his double through his passion for Grushen'ka, also learns. Though he is not his father's murderer, he is ready to be sent to Siberia for the killing, "since all are guilty for all" ("vse za vsekh vinovaty"). But this is not Dima's reaction. He replies to Lilia's words in exasperation: "No one is guilty of everything. [Vo vsem nikto ne vinovat.] Everyone is guilty of something of their own. Even if we confess, according to the law a confession is not a proof of guilt.

A person is innocent until the opposite has been proved. And who is going to prove it? To whom?" These words shock Lilia and lead her to ask him whether he believes in God, which echoes the mayor's earlier question whether he has been baptized and provokes a similar angry response: "Why do you all go on about God? I believe in facts, I'm a lawyer, Lilia." In this sense his question, "to whom" guilt needs to be proved suggests that he is, in fact, less a double of Dmitry Karamazov than of his "rationalist" brother, Ivan, with his theory that "there is no immortality of the soul, so there is no virtue, which means that 'everything is permitted.'"[16] But he lacks Ivan's moral passion, making him a cold, degraded double, appropriate to the early twenty-first century. Where Ivan insists to his younger brother "It's not God that I'm not accepting, Alesha, it's just that with the utmost respect I am returning him my ticket," Zviagintsev's Dima dismisses all talk of God with contempt. The suggestiveness of reading Dima's behavior through the prism of Dostoevsky is only increased during his cowed train journey back to Moscow in which he has a mysterious encounter with a very young girl that echoes the actions of the handsome sensualist Svidrigailov in *Crime and Punishment*, another Dostoevskian character who considers that all is permitted.

There were religious allusions in all of Zviagintsev's earlier films, but the religious dimension is much more pervasive in *Leviathan*, both through the references to Dostoevsky and the book of Job, and through the introduction into the film's dramatis personae of two men of the cloth. By the explicit and sustained contrast of the bishop and the village priest Fr. Vasily, the gap between official religion and true faith caused by the alliance between the Orthodox Church hierarchy and the state, which is the subject of extensive discussion in contemporary Russia, becomes a key concern of Zviagintsev's film.

[16] It is Kolia, in fact, with his drinking, his propensity for physical violence, and even his threat to murder a family member, who is the closest character in the film to Dostoevsky's Dmitry.

While Fr. Vasily is modestly dressed and lives in a modest house, the bishop is seen in lavish vestments and a grand palace. While Fr. Vasily buys bread in the village shop in preparation for Lilia's funeral, and his wife then gives a loaf to a poor neighbour, the bishop is seen eating a hearty meal and drinking vodka, pointedly in front of a fresco of the Last Supper. While Fr. Vasily admits that he cannot answer all of Kolia's questions but trusts in God, the bishop is not assailed by doubt and has no hesitation in announcing what is true and what is false. If Fr. Vasily is explicitly connected to the outcast Kolia at the end of the film, both of them marked by acts of generosity (it is notable that even before his encounter with Fr. Vasily, Kolia has shown himself capable of the Christian virtue of mercy, telling Roma to forgive Lilia because "she's a good person"), then the bishop has a double in the mayor. They eat and drink together and they use the familiar form of address (they call each other "ty"). They have the same aggressive-defensive mentality. The Russian title used in the film, *Vladyka*, can refer to a range of members of the higher clergy, a bishop, an archbishop, a metropolitan, and its semantic association with the wielding of power comes from its etymological connection with the word *vlast'*. *Vlast'* (power) is a word that both the bishop and the mayor are very fond of using: the bishop's mantra is that "all power is from God" ("vsiakaia vlast' ot Boga"), while a drunken Vadim tells Kolia that he must be able to recognize the face of power ("Vlast', Kolia, nado znat' v litso"). Both express concern about "enemies." Vadim is so hysterical about imagined attempts to undermine him that the prosecutor, Goriunova, has accused him of seeing phantom enemies all around: "—It's paranoia. You should drink less.—I'm surrounded by enemies [vragi okruzhaiut]." The bishop uses the phrase "the enemy is not sleeping ("vrag ne dremlet"), which, though it has its source in the First Letter of St. Peter, is more immediately associated with Soviet calls to vigilance against foreign spies and saboteurs. This militaristic dimension to his discourse is adumbrated when he reminds Vadim that they are "co-workers," involved in the same cause "only you have your front and I have mine." Tellingly, these words are followed by a close-up of a statue of Christ in a crown of thorns, bearing the inscription "Ecce Homo" (Behold the Man), the

words used by Pontius Pilate when he presented him to the crowd before his crucifixion. To its right is a statue of St. Vladimir, the prince who brought Christianity to Kievan Rus' in 988, bareheaded and holding aloft a large cross. To its left is another statue of the same ruler, this time wearing the crown that marks him as a secular prince. So the suffering Christ, betrayed once more, stands between religious and secular power, ironically (as in the bishop) embodied in the same man. Yet while these two statues allude to the clash between heavenly and earthly power, the two men's ambiguous lexis seeks to elide it. The bishop urges Vadim not to forget the "heavenly kingdom" (*tsarstvo nebesnoe*). Later, when Vadim learns of Kolia's sentence, while enjoying a solitary meal in a fancy restaurant, he shows that he has learned his lesson by exclaiming "Fifteen years. Well thank God".

Both the bishop and Fr. Vasily are given a scene near the end of the film in which they deliver a "sermon." While Fr. Vasily's is given in the street, and the only person to hear it is Kolia, the bishop delivers his at the service of dedication for the imposing new church.

Just before his encounter with Fr. Vasily, Kolia has visited the ruined church where his son would drink with friends. Casting his head back to drink vodka from the bottle, he has seen a fresco of Salome bearing the head of John the Baptist on a platter, a beheaded saint in a beheaded church. The relevance of this scene to his own fate is not yet apparent to him. A litle later, after viewing his wife's dead body on the pitiless beach and calling out to God for explanation, he meets Fr Vasily in the village shop. "Where is your merciful God?," he asks. When the priest replies that his God is with him but that he does not know where Kolia's is since he has never seen him in church, Kolia retorts, with heavy irony, "If I lit candles, would my wife be resurrected, would my house be restored to me?" When the priest cannot provide an adequate answer, Kolia asks him what he does know and offers him vodka. It is this that leads Fr. Vasily to tell him the story of Job. Some critics have objected to the "crudity" with which the subtext of the story of Job is made explicit in the film, but it is important to point out that it is introduced only after Kolia has complained of the vicissitudes that he has undergone and that it is

a natural parallel for a priest to draw. Fr. Vasily explains that Job "like you, asked himself the question of the meaning of life," and quotes the words in Chapter 41, Verse 1, "Canst thou draw out Leviathan with an hook?," which have given the film its title. The story of the Book of Job was told to Alesha Karamazov by Fr. Zosima in Book 6, Chapter 2 of *The Brothers Karamazov*. In the section "Of the Holy Writ in the Life of Father Zosima," the Elder Zosima tells Alesha that when he heard it for the first time at the age of eight he was overwhelmed. By contrast, Kolia's reaction to hearing it verges on the blasphemous. When Fr. Vasily has finished his narration, telling him that Job lived to the age of 140 and saw his sons, "even four generations," Kolia replies "Is it a fairy tale?" ("Skazka, chto li?").

Parallels between Kolia and Job are extensive. Both of them are visited and tested by a succession of seemingly arbitrary and unjustified calamities. Each of them laments and rails against God, asking the reason for his suffering. Kolia's question, "What for, oh Lord?," is prefigured by Job's complaint that God "breaketh me with a tempest and multiplieth my wounds without cause" (9:17) and by his asking "Why do you persecute me as God, and are not satisfied with my flesh?" (19:22). Zviagintsev has said in an interview, however, that though the title of his film comes from the book of Job, it is not an illustration of the biblical text. Rather the shadow of the Book of Job throws light on the hero of the film. When the plot was taking shape he realized that he could take a "proto-plot" (protosiuzhet) from the book of Job. So the film's title is "brazen, a challenge," but he feels that despite the mundanity of the plot "the emotional intensity [*pafos*] and scale of this title will be justified." And there is an important way in which Kolia's fate will differ from that of Job. The visit of God to Job and the mention of his mercy with which Fr. Vasily concludes his narrative come at the very end of the book of Job, but this is far from the end of Kolia's suffering. He does not yet know that he is going to be charged with killing his wife and sentenced to years in a harsh regime Russian prison, nor that his land is to be expropriated by the worldly priest who is the ally of his tormentor, Vadim. This further twist to the Job story only underlines Zviagintsev's bleak vision of his country as a land from which God has been banished. He insisted, in the same

interview, that there was "no possibility of allowing the audience to breathe out at the end," adding that whatever positive ending he might have come up with would have been fake.[17]

The bishop's sermon, by contrast, in the film's devastating coda, exudes strength and worldly power. Though he speaks of truth and of the love and wisdom of God, he also stresses the importance of loyalty to Orthodoxy and gives the values he has spoken of a specific relevance both to national patriotism and to the current situation in Russia. He speaks of "multiple victories over the enemies of faith and the fatherland" ("mnogochislennye pobedy nad vragami very i otechestva") and ends the sermon with an injunction to "defeat the enemies" and to "stand in defense of Orthodoxy." He makes veiled reference to the performance by Pussy Riot in the Cathedral of Christ the Saviour in Moscow, on February 21, 2012, speaking of those who "blasphemously call devilish rites a prayer."[18] It is a measure of where power lies in the church that Fr. Vasily and his wife are among those present at this service, though the priest's wife is noticeably distracted, the only member of the congregation not listening with rapt attention. As the poet Ol'ga Sedakova has pointed out, in a fascinating analysis of links between the two films, the devastating finale of *Leviathan* is also in dialogue with the ending of another film which came to symbolize the moral and societal concerns of an epoch, in this case perestroika, Tengiz Abuladze's film *Repentance* (*Monanieba / Pokaianie*, 1984).[19] *Repentance* concludes memorably with an old woman asking what good a road is if it does not lead to a church. There is indeed a church at the end of *Leviathan*, but when the mayor's young son looks up into its lofty dome, there is no mosaic or fresco of Christ the Pantokrator, as

[17] "Sobchak zhiv'em: Andrei Zviagintsev," in Further Reading.

[18] The liturgical term that he uses, "moleben," was the one that the members of Pussy Riot used for their "Punk Prayer" (*Pank-moleben*). A report on Pussy Riot, whose main accusation against the church that it was in league with political power is directly echoed in *Leviathan*, had been showing on the television in the earlier scene in which Kolia was arrested.

[19] Sedakova, in Further Reading.

is normally the case in the churches of Orthodox Christianity, merely an ugly electric light. This is a church where Christ does not dwell.

If the religious component of power in contemporary Russia is scrutinized through the bishop and political authority through the mayor, then so too are other key parts of the system, the police, and the law. An early scene has Kolia standing in court before three women judges, the middle one of whom is reading the judgment against him on the property issue at such an absurd pace as to render it completely incomprehensible. This demonstration of his powerlessness will be precisely repeated when he is found guilty of raping and murdering his wife at the end of the film. When the mayor turns up drunk at Kolia's house after the initial judgment, he tells him: "You have never had any rights, you haven't any now and you never will have any." That the different aspects of power are connected in a sinister web of Kafkaesque bureaucracy is made apparent the following morning, as Kolia, Lilia, and Dima attempt to lodge an appeal, moving unsuccessfully from the police station to the prosecutor's office to the court. Later, having read Dima's file of compromising material on him, the furious mayor summons the prosecutor, the police chief and the judge to his office, reminding them that elections are imminent and that if he loses it will be the end of their foreign holidays and fancy houses.[20] His fury with those below him in the pecking order contrasts with his fawning on the regional governor at the end of the film. That these chains of patronage and influence go to the very top and always have done, is repeatedly made apparent. A picture of a sullen looking President Putin presides from the mayor's wall over both his meeting with Vadim and his vituperative attack on the town's officials, while a vast statue of Lenin broods over the town's main square, where all the official buildings are situated. The undiluted antagonism that this

[20] This scene of a provincial mayor reminding local officials that they are all implicated in endemic corruption links the film to another central text of nineteenth-century Russian literature, Nikolai Gogol's *The Government Inspector* (*Revizor*, 1836).

causes in ordinary citizens is engagingly captured during the target practice at the picnic, in one of the film's rare comic scenes. Berated for mowing down all the bottles at once and putting an end to the fun, Stepanych announces that he has "more interesting targets" and produces a batch of official portraits of Andropov, Brezhnev, Lenin, Gorbachev, and an upside down Chernenko. When Kolia asks him whether he has any of "the current lot," he replies that their time has not yet come, they have "too little historical distance." In this context of interconnected power, of winners and losers, it was indeed naïve of Kolia to put his faith in the law. With his smart suit and his briefcase, his legal jargon, his links to men of influence, and his readiness to make threats, Dima is the synecdochic expression of the arrogant new Moscow. But once he is threatened and attacked himself, he shows loyalty neither to his former army comrade Kolia nor to his sexual partner Lilia and beats a cowardly retreat.

The increased direct attention to the detail of modern Russian life displayed in *Leviathan* is paralleled by a far greater discourse with the work of other contemporary Russian filmmakers than in Zviagintsev's earlier films. Particularly close links can be drawn with Boris Khlebnikov's *A Long and Happy Life* (*Dolgaia schastlivaia zhizn'*, 2012), and with Iury Bykov's *The Fool* (*Durak*, 2014), both of which tell the story of little men attempting to stand up to all powerful authority.[21] But the film with which *Leviathan* is in the most thoughtful and suggestive dialogue is Aleksei Balabanov's *Cargo 200* (*Gruz 200*, 2007), one of the most important Russian films of the twenty-first century and a film for which he has expressed his admiration.[22] Both films show a landscape scarred by human intervention. Both of them offer analyses of the state of Russia and both are imbued with civic concern. Both are set in and around the "town of Lenin," *Cargo 200* through the repeated image of the

[21] I consider the relationship between *Leviathan* and these and other contemporary Russian films in Graffy, in Further Reading.

[22] See Viktor Matizen, vol. 2, 658, in Further Reading. *Cargo 200* is discussed in this volume by Anthony Anemone.

road sign marking entry into Leninsk, *Leviathan* by recurrent shots of the statue of Lenin in the town's main square. *Cargo 200*, while set in 1984, at the end of the Soviet era, uses the same stratagem of portraits of Soviet leaders applied in *Leviathan* to excoriate the whole Soviet period, and its forward-looking coda links it to the period of Zviagintsev's film.

Excessive drinking and its dire consequences pervade both films, in each of which teenagers are seen drinking in a desecrated or ruined church, its holy frescoes now scarcely visible. The trope of unseen observation, so important in Zviagintsev's films, is also crucial to *Cargo 200*. Both films show the machinations of the triad of forces that impose state power—in *Cargo 200* the army, the Communist Party, and the police, in *Leviathan* the civic authorities, the police, and the judicial system. In both cases this triad of power reaches its peak in a single sinister, violent figure, the policeman, Zhurov, and the Mayor, Vadim. But in a measure of the changes that have taken place in Russian society in the post-Soviet years, *Leviathan*'s mayor is himself answerable to two other wielders of power, the bishop, and the regional governor.

Perhaps most interesting of all are the links between the two central characters, both played by Aleksei Serebriakov: Aleksei, in *Cargo 200* and Kolia, in *Leviathan*. Both of these men are outsiders, who live in a solitary house by water, some distance from the town, and each is visited by the sinister representative of authority—the policeman in *Cargo 200,* the mayor in *Leviathan*. Kolia fixes cars, Aleksei employs a man who does so. Both are driven to violent and impulsive actions by drink. Each of them oppresses and unsettles his wife. When drunk, each of them becomes a homespun philosopher, desperate for a better society: Aleksei's obsession with Tommaso Campanella's City of the Sun in *Cargo 200* is echoed in Kolia's dogged search for justice. Both of them are God-seekers, engaged in conversations about belief: Aleksei's discussion with a professor of Scientific Atheism and his quotation of Dmitry Karamazov's report of his brother Ivan's contention that "If God does not exist, then all is permitted" prefigure Kolia's asking Fr. Vasily: "Where is your merciful God?" and his despairing cry after the death of his wife: "What for? What for, oh Lord?" Both

are found guilty of a murder they did not commit and both are the victims of grievous miscarriages of justice—the two scenes of the rushed, contemptuous reading of a verdict by the woman head of a trio of judges in *Leviafan* are borrowed from exactly the same treatment of the trial of Aleksei in *Cargo 200*. Balabanov's Aleksei is shot by the authorities in a prison corridor while Kolia's prison fate is left unexamined. But in his passionate commitment to learning lessons from Russian society's past and present and his concern about its future Zviagintsev is surely Balabanov's heir.

It was precisely the vigor of its analysis of contemporary ills that provoked such a backlash against the film in Russia and accusations that it "blackened" the country. Most notorious among its detractors was the Russian Minister of Culture, Vladimir Medinsky, who complained to the *Izvestiia* newspaper website that there were no "positive heroes" (a formulation comically redolent of Soviet textbooks) before slanderously suggesting that the film had been made out of an opportunistic chase after "Western prizes" and a love of "glory, red carpets and statuettes."[23] Other viewers found elements of the narrative implausible or excessive, in which context it is perhaps illuminating both of his method and of his intentions to remember Zviagintsev's insistence that "in cinema, reality is relative" ("v kino real'nost' otnositel'na").[24] Like his earlier films, *Leviathan* can be read both as a concrete narrative of personal trial and as parable, an abstract-philosophical engagement with issues of universal concern. As Zviagintsev puts it: "What is Kolia? A projection of our fears, hopes, our sympathy, our love. Kolia is we ourselves."[25]

This bold and exhilarating combination of the specific and the universal gave Zviagintsev his greatest international success to date. *Leviathan* won the award for best screenplay at the 2014

[23] Vladimir Medinsky, in Further Reading.

[24] See Matizen, *Kino i zhizn'*, vol. 2, 661.

[25] Andrei Zviagintsev, "Russkoe terpenie pereplavilos' v pokornost'," in Further Reading.

Cannes Film Festival, was judged Best Foreign Language Film at the Golden Globe Awards in January 2015, and made the shortlist for the Oscar for Best Foreign Language Film in the same year.

Julian Graffy

FURTHER READING

Condee, Nancy. "Knowledge (imperfective): Andrei Zviagintsev and Contemporary Cinema." In *A Companion to Russian Cinema*, ed. Birgit Beumers, 565–84. Malden, MA: Wiley-Blackwell, 2016.

Dolin, Anton. "Tri kita." *Iskusstvo kino* 7 (2014): 45–53.

Graffy, Julian. "Andrei Zviagintsev: *Leviathan* (*Leviafan*, 2014)." *KinoKultura* 48 (April 2015). Accessed June 25, 2017. http://www.kinokultura.com/2015/48r-leviafan.shtml.

Krichman, Mikhail. "Cinematographer Mikhail Krichman, RGC, discusses his work on 'Leviathan,' by Andrei Zvyagintsev." *Association Française des Directeurs de la Photographie Cinématographique*, September 17, 2014. Accessed June 25, 2017. http://www.afcinema.com/Cinematographer-Mikhail-Krichman-RGC-discusses-his-work-on-Leviathan-by-Andrei-Zvyagintsev.html?lang=fr.

Matizen, Viktor. *Kino i zhizn´. 12 diuzhin interv´iu samogo skepticheskogo kinokritika: v 2 tomakh.* Vinnitsa: Globus-Press, 2013.

Medinsky, Vladimir. "Vladimir Medinsky. 'Leviafan' zapredel´no kon"iunkturen." *Izvestiia*, January 15, 2015. Accessed June 25, 2017. http://izvestia.ru/news/581814.

Negin, Oleg. "My i est´ soiuz intelligentsii i rabochego klassa." *Ogonek* 22 (June 9, 2014): 38–39. (Negin interviewed by Andrei Arkhangel'skii).

"Pozner. Andrei Zviagintsev," 2012. Accessed June 25, 2017. Available at https://www.youtube.com/watch?v=KZDxiLJ7rKg.

Sedakova, Ol´ga. "'Pokaianie' i 'Leviafan.' Interv´iu dlia 'Geftera'." January 28, 2015. Accessed June 25, 2017. http://gefter.ru/archive/14108.

"Sobchak zhiv´em: Andrei Zviagintsev." *Telekanal Dozhd´*, January 15, 2015. Accessed June 25, 2017. Available on Andrei Zviagintsev's website at http://www.az-film.com/ru/.

Stishova, Elena. "Dekalog ot Andreia Zviagintseva." *Iskusstvo kino* 7 (2014): 56–60.

Trofimenkov, Mikhail. "Metafizika pustogo cheloveka." In *Seans Guide: Glavnye rossiiskie fil´my 2014*, compiled by Mariia Kuvshinova, 145–47. St. Petersburg: Masterskaia "Seans," 2015.

Zviagintsev, Andrei. "Nikakikh simvolicheskikh smyslov." *Iskusstvo kino* 4 (2012): 98–117.

———. "'Chto za zhizn´. . . .'" *Iskusstvo kino* 8 (2014): 35–49.

———. "Zdes´ vsego cherez krai." *Novaia gazeta* 56 (May 26, 2014): 21 (Zviagintsev interviewed by Larisa Maliukova).

———. "Russkoe terpenie pereplavilos´ v pokornost´." *Ogonek* 23 (June 16, 2014): 36–37 (Zviagintsev interviewed by Sergei Sychev).

———. "Narod vse prekrasno poimet." *The New Times* 29 (September 15, 2014): 60–63 (Zviagintsev interviewed by Oleg Sul´kin).

Internet Resource

Andrei Zviagintsev's personal website. Accessed June 25, 2017. http://www.az-film.com/ru/.

THE LAND OF OZ

Strana Oz

2015

95 minutes

Director: Vasily Sigarev

Screenplay: Vasily Sigarev, Andrei Il'enkov

Cinematography: Dmitry Uliukaev

Art Design: Anton Polikarpov, Nadezhda Vasil'eva

Sound: Vladimir Golovnitsky

Producers: Sofiko Kiknanelidze, Dmitry Uliukaev

Production Company: Beloe Zerkalo

Cast: Iana Troianova (Lena Shabadinova), Gosha Kutsenko (Roman), Andrei Il´enkov (Andrei), Aleksandr Bashirov (Diuk), Inna Churikova (the mother), Vladimir Simonov (Aleksei, the Bard), Evgeny Tsyganov (driver on drugs), Svetlana Kamynina (Bard's wife), Alisa Khazanova (Snegurochka #1), Dar´ia Ekamasova (Snegurochka #2), Evgeny Roizman (mayor of Yekaterinburg)

In 2009 Vasily Sigarev, a well-known playwright in Russia and abroad, became a filmmaker. His first film, *Wolfie* (*Volchok*, 2009), literally exploded the measured festive flow of the Sochi Kinotavr, the main festival of Russian cinema. Emerging five years before Andrei Zviagintsev's *Leviathan* (*Leviafan*, 2014), the film divided critics, and later viewers, into those who unconditionally accepted the director's new artistic reality, were able to hear and see, understand and accept the raw nerves, baseness, tragedy, and passion of the

main heroine, whose essence was so powerfully expressed by Iana Troianova, and those who blamed Sigarev and all of Russian cinema along with him, for relishing the hideous, for what people labelled *chernukha*. Three years later at the same Kinotavr, after the premiere of the second film, this time with an affirmative-questioning title *Living* (*Zhit'*, 2012),[1] everyone began talking about the phenomenon of Urals cinema. It was then that Sigarev announced that his new film would be a comedy. Those who were not familiar with his play *The Lie Detector* (*Detektor lzhi*, 2011) simply could not imagine Sigarev laughing. The author kept his word and the "bleeped out" film[2] obtained a distribution license, while audiences gained the opportunity to walk and ride around New Year's Yekaterinburg together with the heroine, Lenka Shabadinova, who never does find Torforezov Street.

Sigarev's cinema emerged from his dramas. The uniqueness of his success comes from his absolute independence in mastering cinematic language (Sigarev never studied film) and an intuitive comprehension of the laws of visual representation. As for writing, he has always aspired to it, and this yearning for the written word enabled him to survive in the depressing milieu of a provincial Urals town.

Sigarev was born in 1977 in Verkhniaia Salda, a small town in the Sverdlovsk region. The author's coming of age coincided with the fall of the Soviet Union and the collapse of the Soviet economy. It was precisely at that time, during the 1990s, that the main enterprise in Sigarev's town was closed, and people experienced unemployment firsthand. The consequence of such socioeconomic problems was the emergence of traditional societal illnesses—alcoholism and drug addiction. All these troubles had an impact on

[1] *Living*, rather than the literal "To live," is the title of the American release.

[2] It was "bleeped out" (censored) because, according to the law that was passed one year before the film's release, obscene language was forbidden in films. One of the best contemporary Russian films, *The Hope Factory* (*Kombinat "Nadezhda*," Natal'ia Meshchaninova, 2014), was never released for this reason.

Sigarev's family as well. Sigarev was forced to observe the whole clinical picture of addiction on a daily basis. (His brother was a drug addict.) That is why many of his characters and plotlines are quite autobiographical. For example, the mass epidemic of drug addiction that has completely devastated Nizhniaia Salda becomes the theme of fatal drug dependence in several of Sigarev's plays: *The Pit* (*Iama*, 2002), *The Family of a Vampire* (*Sem'ia Vurdalaka*, 1999), *Ladybugs Return to Earth* (*Bozh'i korovki vozvrashchaiutsia na zemliu*, 2001). This is how the author of *The Family of a Vampire* describes the existential state of the misfortune: "Plague, plague came to my town. It walks along the streets, wipes out the sick, the healthy, the weak, the strong, everyone. It walks, examining everything, as if looking for something. Maybe for my street, my house, my entrance, my floor, my door?"[3]

However, Sigarev found the strength to resist external circumstances. He had begun to write when he was still in school, dreaming about the Literary Institute in Moscow. Instead of Moscow (which was too far away and expensive), he was accepted to a pedagogical institute in Nizhny Tagil, the second largest city in the Sverdlovsk region. He left the institute during his junior year after he saw an advertisement for director and playwright Nikolai Koliada's recruitment of a class for the Sverdlovsk Theater Institute. Although Sigarev was not really interested in drama or the theater, which he had never even visited, a small side note played a pivotal role in his decision to enroll: "Instruction follows the program of the Literary Institute." The fate of the future playwright and movie director was sealed. It was indeed a unique class whose seminars produced the now famous playwrights Oleg Bogaev, Aleksandr Arkhipov, and our hero, Sigarev.

Plasticine (*Plastilin*, 2000), the first text by Sigarev, published in the magazine *Ural*, became a huge success.[4] *Plasticine* has been

[3] Vasilii Sigarev, *Sem'ia Vurdalaka*, accessed July 17, 2018, http://vsigarev.ru/doc/cvurda.html

[4] In 2000, *Plasticine* won the "Debut" and "Antibooker-2000" awards, and in 2002, the "Evening Standard-2002" award. During that time, Sigarev participated

translated into English, German, Polish, Serbian, Finnish, French, Danish, Swedish, Dutch, and other languages.[5] In Russia Kirill Serebrennikov, the leader of contemporary Russian directing was among the first to stage it. Maksim, the main character of *Plasticine*, is a fourteen-year-old teenager, loved only by his grandmother. He is sculpting his own world, desperately resisting the violence of the meaningless world of adults. He is the object of symbolic violence by the principal of his school, physical violence by his neighbor, classmates, and criminals.

Like Sigarev's later plays, *Plasticine* became one of the corpus of texts in "New Drama." "New Drama" is a provisional title, uniting different texts that are not so much analogous semantically and stylistically, but which share a pragmatic unity; all of them, according to Mark Lipovetsky and Birgit Beumers's definition, are "performative."[6] Their common subject field is the exploration of marginals, for whom the main language of communication becomes one saturated with obscene vocabulary and bodily practices of aggression. "New Drama" is usually described in terms of such concepts as violence and transgression.

in prestigious festivals of contemporary dramaturgy—"Liubimovka-2000," "Shchelykovo-2000," "Bonner-Biennale-2002." *Plasticine* was produced in Moscow at the Center of Dramaturgy and Stage Direction. (This performance participated in the Bonne biennale-2002 festival [the live performance can be seen on the ARTE TV channel]), in the Royal Court Theatre (London), on BBC radio (radio-version), and in the Schauspielhaus Theater (Hamburg). The play is currently being produced in Norway (Bergen, Oslo—the National Theater), Sofia, Belgrade, Porto, and other cities in Europe. The play was published in the anthology of the contemporary Russian drama *Gvozdeni vek*, Belgrade, in the collection *Plastilin*, in the collection of plays *Repetitsiia*, in the magazines *Ural*, *Theater Heute* (Germany), *Dialog* (Poland), and other European magazines.

5 See Sigarev's website, accessed August 10, 2017, http://vsigarev.ru/about.html.

6 Mark Lipovetsky and Birgit Beumers, *Performing Violence: Literary and Theatrical Experiments of New Russian Drama* (Bristol: Intellect Books Ltd., 2009), 240.

Sigarev himself, like other representatives of "New Drama," believes that sincerity is an essential prerequisite for creativity:[7] "The artist's self-restraint is his sincerity. You have to know how to limit yourself in lying, something that many don't know how to do. And if morality lies, it ceases to be morality; it becomes hypocrisy in the cloak of morality. In order to cleanse oneself, one has to see the dirt, touch it, rub it off."[8]

All of Sigarev's plays and films are about the world's ontological tribulations. The plays include *Ladybugs Return to Earth*, *Phantom Pains* (*Fantomnye boli*, 1999), *Black Milk* (*Chernoe moloko*, 2000), and *Ahasfer* (*Agasfer*, 2000). It was not only marginal, troubled heroes who moved from dramaturgy into cinematographic reality, but the very topography of provincial industrial towns was transferred there as well. Sigarev himself mentioned several times that he cannot spend more than three days in Verkhniaia Salda because the town's space is depressing and suicidal. In his article about Sigarev, Sergei Anashkin describes very precisely the space of Sigarev's plays, and later the space of his first films, *Wolfie* and *Living*: "An ugly specimen of urbanism, still Soviet. A depressing—in the literal and figurative senses—bedroom annex to the factory."[9] The faceless urban space of the play *Ladybugs Return to Earth* is presented expressively: "At first there was nothing here. Then came a man and built a city. There appeared houses, streets, squares, stores, schools, factories, communal gardens. The streets became cobblestoned, and then were paved, with curbs whitened for the holidays. People began to walk in the streets, began to sit on the benches, began to sneeze from the poplar fluff, began to sell sunflower seeds by the factory entrance, began to fall in love. People began to be born—began to

[7] Liliia Nemchenko, "The Concept of Sincerity in 'New Drama,'" *Journal of Siberian Federal University, Humanities & Social Sciences* 5 (October 2017): 759–67.

[8] Vasilii Sigarev, "Ia prosto rasskazyvaiu o strastiakh i bedakh chelovecheskikh," *Teatral'naia afisha*, May 2003, accessed January 2, 2018, http://www.teatr.ru/docs/tpl/doc.asp?id=605.

[9] Sergei Anashkin, in Further Reading.

die...."[10] This rhythm is reminiscent of an Old Testament narrative, thereby transforming everyday discourse into the existential.

Sigarev's dramaturgy occupies the border between a neo-realistic, sometimes hyper-realistic or naturalistic tradition, and parable. It is precisely this feature that surfaced in *Wolfie*. The title itself—a play between two meanings—a child's spinning toy that begins revolving after a push (the symbol of everlasting movement and return) and a diminutive, the predator-wolf's pup, that same pup (wolfie, *volchok*) that can grab you by the side (*bochok*) in a Russian lullaby. By sheer luck the screenplay fell into the hands of producer Roman Borisevich, who had supported the new wave of Russian cinema (Boris Khlebnikov, Aleksei Popogrebsky, Nikolai Khomeriki) in the artistic association "Koktebel'." "He called and offered to acquire my screenplay," recounts Sigarev. "I set a strict condition: I will sell it only if I direct the film."[11] And Borisevich agreed to this stipulation. The debut had the same incredible success as *Plasticine*. In 2009, *Wolfie* was recognized as the best film of the Kinotavr, the Douro Film Harvest festival (Portugal), in Zürich, and in Honfleur (France).

Wolfie is the story of a girl's devoted, selfless love for her good-for-nothing mother. The realism of the film achieves its opposite—a parable. The town has no name; neither do the mother and daughter. There are just Mother, Grandmother, Daughter, and Boy. Despite the external harshness of Sigarev's film (manifested in the author's intonation and the scene of the Girl's conversation with the dead Boy), it is surprisingly chaste.

Iana Troianova, who plays the role of the mother, is the embodiment of a natural biological entity, void of any kind of cultural or social content. The mother runs away from the daughter; the daughter runs after the mother; at one point this running stops. An interesting thing occurs in Sigarev's film: on the one hand, the viewer cannot directly identify him or herself with the heroine, but

[10] Vasilii Sigarev, *Bozh'i korovki vozvrashchaiutsia na zemliu*, accessed January 2, 2018, http://vsigarev.ru/doc/korovki.html.

[11] Anashkin, in Further Reading.

at the same time, a socially distant heroine demands a lot of attention to her character, forcing respectable women to remember their own thoroughly hidden egoism. The film made everyone desperately want to run to their own children, to hug and hold them close, and be ashamed of the betrayal that every working woman thinks she is guilty of—perhaps not as significant as the one in the film—but still a betrayal.

In *Plasticine*, and *Wolfie* too, Sigarev contests a classic formula of Russian literature: "Man! That has a proud sound!" In *Wolfie* there is no Man with a capital "M," but rather a cruel, predatory animal. In this regard, Sigarev is closer to French naturalism, which interprets man, first and foremost, as a biological being, and equates the artist with a natural scientist. Indeed Sigarev can be compared to a natural scientist. The director's ethological optics led, as is the case with tragedies, to an epiphany; in *Wolfie* it is that a child cannot but love the mother, but a mother has the right not to love her daughter and still love life in the purely biological, Nietzschean sense.

Sigarev's second film, *Living*, is a story about the possibility and impossibility of overcoming the most horrific trauma—loss, and subsequently experiencing the death of loved ones. The author himself mentioned that the film's title "Zhit'" ("To Live") should be understood, first and foremost as a verb, and then, as a noun. Three stories—three life strategies of excruciating "living-through" ("pere-zhivanie"), comparable to ancient tragedy by level of generalization, where even the gods couldn't do anything about their fate. One of the most heart-rending episodes of the film is when the heroine runs after the priest, asking,"why?" There is no answer. Sigarev's answer is "to live."

In Sigarev's films, from the dreadful realia of everyday life, unacceptable for life, there emerges one of the laws of existence—the law of love, unifying the living and the dead; and it is this connection that supports the world.

Sigarev's turning to comedy also had its roots in drama. Some of his most frequently staged plays with elements of comedy include *The Lie Detector* and *Love by the Toilet Tank* (*Liubov' u slivnogo bachka*, 2004). Sigarev's comic world is the realm of the absurd in which the innate and not particularly refined characteristics of human

nature, which are concealed by "culture," are exposed. These non-didactic devices revealing the essence of a human being will also be demonstrated in *The Land of Oz*.

It so happened that the Russian release of *The Land of Oz* (December 3, 2015) coincided with the paying of last respects to El'dar Riazanov, the director of *The Irony of Fate* (*Ironiia sud'by*, 1976), the film that has a permanent place on Russian TV for New Year's Eve, and now forever. The loss of the Master, who was able, albeit for a few hours, to unite first Soviet and then post-Soviet audiences each year, was symbolic. The era of art that unifies is gone and the phenomenon of a simple good man has long disappeared which is why, for a thinking artist, Esenin's formula "the poet's gift is to caress and scratch" is correct only in its latter part—the poet's gift is "to scratch." As for caressing, the powerful industry of mass culture accomplishes this, and part of our "atomized" society receives a dose of belly laughs (*rzhaka*) from our domestically produced comedies, filmed according to the *Elki* recipe. Sigarev, not coincidentally, defined the genre of his film as "anti-*Elki*."[12]

And so, let us return to Esenin's formula. We have already mentioned that Sigarev's gift for "scratching" was known before he picked up a camera. His *Plasticine*, *Black Milk*, and *Ladybugs Return to Earth* opened up a world and milieu with which one seemingly does not have and does not want to have any connection, but it is precisely in this world, which is foreign to one, that the familiar phobias and affects, suppressed by official culture, could be discovered.

Sigarev's cinema (now after his third film, we can certainly talk about the distinctiveness of his filmic world) is genetically connected with his plays, wherein a marginal space becomes the place to explore the important anthropological features of the modern-

[12] *Elki* is producer Timur Bekmambetov's almanac film, released on December 16, 2010. The film was comprised of eight novellas shot by six different directors. Since then, *Elki* has been released every year; *Elki-5* came out in 2016. The comedy is popular among less-educated viewers, which is why *Elki* became synonymous with bad taste.

day human, and wherein violence exhibits a routine, accustomed character. Not by coincidence, the working title of the comedy *The Land of Oz* was "Amusing Ethology." Like a natural scientist, Sigarev analyzed individuals in their natural habitat. The title *The Land of Oz* is provocative since, on the one hand, it refers to a fictional country from a well-known book, *The Wonderful Wizard of Oz* (1900), by the American writer L. Frank Baum. On the other, Baum's stories were interpreted and translated into Russian by the writer Aleksandr Volkov in his fairy-tale *The Wizard of the Emerald City* (*Volshebnik izumrudnogo goroda*, 1939). Baum's Dorothy became Ellie and the nameless evil sorceress (the Wicked Witch of the West) received a name in Volkov's version, becoming Bastinda—a name that will sound in the film as a threatening incantation, pronounced by the marginal hero, Diuk. The only character that remained unchanged in both the American and Russian versions of the book is the little dog Totoshka (Toto), who became Diudia in the film. Certainly, the viewer can find associational connections between Dorothy/ Ellie and Lenka, the heroine of the film: all of them are searching for good while getting mixed up in incredible situations along the way. However, Baum and Sigarev's heroines have different final goals: Dorothy wants to return to Kansas; Lenka would return to her unloved native town only by necessity.

The title also has a second meaning, not connected to any literary reception. The film evokes the phone number for an ambulance. Russian "Oz" can be written in capital letters as "O3." The Russian letter "3" looks like the number three (3), and the letter "O" can be read as zero (0). As a result, the film may be interpreted as the story of the country that symbolically requires the services of an ambulance. That said, the ambulance itself appears in the film not only obliquely but also explicitly, saving the main characters in the film's finale. Thus, from the very beginning, Sigarev offers his audience a game of associations.

Love must certainly be present in a New Year's comedy, and it is consequently the romantic date of the heroine's sister that opens the film. The date with a hot-tempered Greek man will result in the girl from the Urals being forcefully thrown out the window into the snow, and receiving a broken tailbone. It is this event that gives the

heroine her trademark phrase "My sister has a broken tailbone," with the help of which she will begin conversations with strangers, trying to find out how to get to her place of work in a kiosk, where she will be paid fifteen thousand rubles.

The events of the film unfold according to the plot of a math problem: "They departed from point A going to point B . . ." Point A is Yekaterinburg, Ploschad' 1905 goda; point B is a kiosk on Torforezov Street where Andrei is waiting for his replacement, Shabadinova. The problem becomes more complex with the appearance of a new character, Diuk, an old pal of Andrei who knocks on the kiosk window on the unknown Torforezov Street. Point B is a variable: a kiosk, wherein philosophical discussions on the meaning of existence, morality, dignity, and creativity take place between Andrei, who writes "for the desk drawer," and his friend, Diuk, whose tattooed body could serve as a textbook for future lawyers. Director-ethologist Sigarev provides an incisive description of the peculiarities of the infantile mind, so characteristic of the majority of our population, and expressed particularly among those who are serving time or have finished serving time. This includes an interest in everything below the waist, constant fecal jokes (which according to Freud characterize a child's anal stage of psychosexual development), hyper-moralizing (coming from a closet homosexual), and a philosophy of coitus as the main law of existence. Opposed to Diuk's stream of philosophizing is Andrei's dream of a prerevolutionary drawing room, where he is a man of dignity and honor. Point B will never see its unknown traveler from point A. It will burn up, and in response to the question of a boy who comes in the morning to buy something, "Where's the kiosk," Andrei responds: "In the Land of Oz."[13] And the writer who now has lost his job will walk the streets of Yekaterinburg and will happen upon a magic ship, on which stands Shabadinova, the replacement who

[13] Sigarev suggests a play on language, rhyming "kiosk" with "Oz." This is a euphemism for a set expression of obscene vocabulary, "Gde, gde?" — "V pizde" ("Where, where?" — "In the pussy"). The words express the ironic emotional state of the speaker.

Fig. 1. Lena Shabadinova and Diudia.

never did reach Torforezov Street. The appearance of a giant ship in the Sortirovka district[14] is not simply the sign of a romantic dream, but also a message to those initiated into the strange toponymy of Yekaterinburg, for nothing can be more absurd than the street name "Steamship Passage" in the landlocked, snowy, industrial city.

While the friends on Torforezov Street wait for their replacement (the kiosk will burn down only at the end of the film), Lenka, who has come from Malaia Lialia (the only distorted geographical name), is honestly trying to get to the kiosk. Having sent her cousin with a broken tailbone to the hospital, the heroine, who has miraculously survived a trip with a drug addict driving on the wrong side of the road against oncoming traffic (one of the most terrifying and naturalistic episodes of the film), and who has refused help from the (actual) mayor of Yekaterinburg, begins her involuntary voyage along the streets of the city on New Year's Eve.

New Year's Eve miracles soon appear. The loud merrymaking of crowds gives way to the loneliness of a credulous, sincere, small

[14] Sortirovka is a rough, marginal district of Yekaterinburg, far from the center. Its name comes from the railroad station "Sortirovochnaia," the place where trains from all points stop.

Fig. 2. Roman.

person with a little dog (Fig. 1), belonging to Roman, whose head is almost torn off by "Hiroshima" fireworks (Fig. 2). The "Hiroshima" explosion (a horrible name for a sideshow in an amusement park) forces Lena into contact with city dwellers—nervous, suspicious looking, and malicious, even while standing near the beautiful tree. The external tinsel of the New Year's city rhymes with the falsity of specific characters. The bard, an active internet user, is a wonderful parody of a pseudointellectual, who is as infantile as Diuk, an amoral moralist, taking the name of God in vain, and an insecure fan of tantric sex. It is in this weird apartment with its clean bathroom (it would be nice to have the same one in the kiosk on Torforezov Street), where posters of priests who give solo concerts with live music in the Lenin House of Culture hang on the walls, that one more miracle occurs. Pushed out and off the apartment balcony by the spiritual bard, Lena, along with the little dog, is not hurt and does not even break her tailbone, but finds herself on a different balcony next to hundreds of homemade *pel'meni* and a pig's head, ready to be used for making jellied meat. The owner of the apartment walks out onto the balcony to fetch the *pel'meni*, and we become the witnesses of one of the most brilliant scenes in the film—psychologically accurate, naturalistically detailed, and superbly acted.

Fig. 3. An LDPR son scolds Lena.

The owner of the apartment is the mother of three post-pubescent sons, who support LDPR[15] and race virtual tanks on their computer. She will shelter Lenka for a time, thinking she is a prostitute, talk to her, feed her, and offer her Avon cosmetics. Conversation in the kitchen is an essential part of Russian daily life, so it is in the kitchen that Lena will finally explain why she left Lialia. She will explain simply and matter-of-factly: "My husband beat me," but her intonation makes your heart ache. The same is true of the mother's intonation: she is patient and resigned to life as it is, trying to convince her son that the stolen virtual tank will be found. The dialogue between the two women is interrupted by the sons' using the bathroom. Their movement back and forth is unified not only by their common goal—to get to the bathroom, but also by their appearance—slovenly underwear and hanging beer bellies (Fig. 3), as well as their habit of leaving the door open in the bathroom. This detail provides an important characterization of these heroes—infantile, shameless, aggressive, and no longer heeding any taboos.

[15] LDPR (The Liberal-Democratic Party of Russia) is an extreme nationalist organization headed by Vladimir Zhirinovsky.

Silent, imperturbable, and tolerating all misfortunes without complaining, Lena twice comes out of her half-frozen state: she stands up for the mother of the three LDPR supporters, for which the younger son hits her over the head, and she beats up the prostitutes wearing Snegurochka costumes, while being detained at the police station. Shabadinova loses patience when people infringe on simple things, such as, you should not call your mother names, you should not let people make fun of you. . . . These two episodes are crucial in understanding Sigarev's heroine and the author's position. Sigarev is arguing against the sexist position of Diuk, whose space is limited by the static kiosk, where a homegrown philosophy is born from a primitive understanding of Fyodor Dostoevsky's novels, leading to disdain toward women. A woman, from Diuk's point of view, is defined as a second-rate, dependent creature because she does not have a penis, as a being created to be humiliated.

Shabadinova, and also Sigarev, give a completely different version of what a woman is, one which can even be considered feminist. In Shabadinova's dynamic space certain situations emerge where she must combat humiliation. The quiet and patient Lenka uses her fists against the prostitutes because they provoke her with an artificial penis, laughing disgustingly all the while. Her action is the protest of a woman with a sense of her own dignity, fastidious in a good way toward human vulgarity, and truly pure. Even the little dog Diudia knows how it should behave, where it can and cannot pee. Here you have the justification for the first title, "Amusing Ethology."

Wandering alone in the city, Shabadinova will fulfill a duty: she will find the owner of the dog, and Roman, the owner of the dog, will rescue Shabadinova from jail, and then will save her once again when she is injured by two idiots, celebrating New Year's Eve and playing "war" in an expensive car.

All the great directors discovered their actors. Troianova is Sigarev's actress, but in this film we see a completely new Troianova—quiet (because of her slightly frozen demeanor, Roman will ironically call her "boisterous" [*shebutnaia*]), gentle, vulnerable yet simultaneously proud and strong, and very sincere. The heroine's sincerity is evident both in her desire to return the little dog

to its owner, and in her simple answers. This is how, for example, she returns all of us who spend a lot of time online—to reality. When asked about social media ("Where are you?"), she responds: "Here." This "here" is a distinctive feature of her authenticity, as is her decision to return to Lialia. The reason to return is simple: "I didn't fit in."

Sigarev also discovered an unexpected degree of sincerity in Gosha Kutsenko (Roman), who abandoned his showman past, with his usual techniques and clichés, during the shooting of the film.

Russian merrymaking is akin to Russian revolt—senseless and pitiless. It is no accident that the title of the film refers to the ambulance number which, in the director's opinion, every character needs: Shabadinova, who ends up in a hospital ward as a result of her New Year's adventures, her sister with a broken tailbone, Andrei with his phobias, and Roman—otherwise he would not have composed and sung the song "I love you to tears" off-key. And most importantly, we would not have witnessed the final smile of Iana Troianova—Lena Shabadinova, who honestly admits: "I don't know how to live."

After following the path of classical culture from tragedy to comedy, Sigarev is moving toward genres unknown to classical culture. As a modern artist, he cannot ignore the genres of mass culture, which is why his next choice for a film is a story about a zombie.[16] And here we find again the gaze of an anthropologist and natural scientist, attempting to find new stories about human nature, examining it from the other side of reality.

Liliia Nemchenko
Translated by Julia Gerhard

[16] Sigarev's preliminary short film on the topic is available at: https://vimeo.com/214057590.

Further Reading

Anashkin, Sergei. "Portret dramaturga i rezhissera Vasiliia Sigareva. 'P'esy rastut, kak derev'ia'." *Iskusstvo kino* 8 (2009). Accessed January 3, 2018. http://kinoart.ru/archive/2009/08/n8-article13.

Kaminer, Jenny. "Vasilii Sigarev's Post-Soviet Dramas of the Provincial Grotesque." *The Russian Review* 75 (July 2016): 477–97.

Official Website of Vasily Sigarev. Accessed August 10, 2017. http://vsigarev.ru/about.html.

MY GOOD HANS

Milyi Khans, dorogoi Petr

2015

124 minutes

Director: Aleksandr Mindadze

Screenplay: Aleksandr Mindadze

Cinematography: Oleg Mutu

Music: Valery Siver

Producers: Andrei Annensky, Liza Antonova, Len Blavatnik, Heino Deckert, Valery Kharkov, Oleg Khokan, Aleksandr Mindadze, Martin Schlüter

Production Companies: ma.ja.de. fiction, Passenger Film Studio, Sota Cinema Group

Cast: Jakob Diehl (Hans), Mark Waschke (Otto), Birgit Minichmayr (Greta), Marc Hosemann (Willi), Andryus Daryala (Petr), Roza Khairullina (Nina)

Aleksandr Mindadze's life in cinema has followed two paths. The first began after he gave up his initial career in law to study at the famed All-Union State Institute of Cinematography (VGIK). Trained in Katerina Vinogradskaia's screenwriting workshop, Mindadze graduated in 1971: his direct supervisor was Gennady Shpalikov, who wrote the screenplays for Georgy Daneliia's *Walking the Streets of Moscow* (*Ia shagaiu po Moskve*, 1963) and Marlen Khutsiev's *I am Twenty* (*Mne dvadtsat' let*, 1964). Mindadze entered the school after the so-called Thaw under Nikita Khrushchev, but trained under people associated with its films and their focus on human behaviors.

After graduation, he embarked on a long, creative partnership with director Vadim Abdrashitov: the pair made eleven films together between 1976 and 2002. Their collaboration, as Nancy Condee has described, is best understood as a hybrid one, consisting of art films "for a mass audience, consistently drawing substantial attendance through the late Soviet period."[1] Just as importantly, Mindadze and Abdrashitov represent a critical cultural continuum from the late Soviet to the post-Soviet years.[2] Mindadze, who was born in 1949, first wrote his scripts in the context of late Soviet, Brezhnev-era cinema, which enjoyed tremendous successes domestically, but also had to go through state censorship. When he has recalled this process in interviews, Mindadze has suggested that the censorship requirement formed part of the creative process: knowing your film had to be submitted for review, in other words, forced you to think about how best to create, how best to encode your scripts with hidden subtext.

The second journey Mindadze has taken began in 2007, when he directed his first solo film, *Soar* (*Otryv*). At fifty-eight, Mindadze was eligible for the "debut" directing prize in the first festival his film entered. *Soar* is ostensibly about what happens after a plane crash; that being said, most critics and viewers described the film by using phrases such as "incomprehensible," "too hard to interpret," "meandering," or a lesson in "organized chaos." The director himself explained the title as an exploration in "when a person soars from reality," and "unexpectedly discovers a quality previously unknown to himself," "a new face," or "a new birth." Others disagreed: one reviewer for *KinoKultura* declared it "one of the most intelligent film narratives in today's Russian cinema" because it "treats individual trauma as a highly political matter, touching upon all symptoms of the catastrophic nature of Russia's governmental collapse."[3] Regardless of one's take, the Russian

[1] Nancy Condee, 143, in Further Reading.

[2] Ibid., 3–4.

[3] Barbara Wurm, "Aleksandr Mindadze: *Soar* (*Otryv*, 2007)," *KinoKultura* 19 (2008), accessed July 6, 2018, http://www.kinokultura.com/2008/19r-otryv.shtml.

Guild of Film Critics awarded Mindadze their annual award for Best Screenplay.

Mindadze's second film, and second foray into meandering, organized chaos, was 2011's *Innocent Saturday* (*V subbotu*). It too explores a traumatic event, this time the 1986 explosion at the Chernobyl nuclear plant, yet it too, as the director made clear, was not about the disaster per se as much as "the flourishing of life during minutes of mortal danger." It too provoked a host of mixed reactions. The Russian Guild of Film Critics did not award it any prizes, but the film, Mindadze the director, and Mindadze the screenwriter all made the shortlist for their award.

Mindadze is therefore an intriguing case study in the world of contemporary Russian film. He is still known primarily for his work with Abdrashitov, a partnership that enjoyed critical and some popular success in the late Soviet and early post-Soviet periods. The critical acclaim has continued since 2007, when Mindadze debuted as a director: his third film, *My Good Hans*, received Best Picture, Best Director, and Best Screenplay awards from the Russian critics and Best Fiction Film and Best Screenplay at the Nika Awards. By the time he became a director, Mindadze had also begun to be affiliated loosely with a group of Russian filmmakers who turned their backs on the increasingly commercial, American-style blockbusters that dominated Russian cinema in the 2000s. Dubbed the "new quiet ones" by Sergei Shnurov, lead singer of the ska-punk band Leningrad, these directors made films that tended to be slow-paced, visually-oriented, with stories that delved into the loneliness of life, human psychology, morality, and even politics. The directors associated with these films were "young," having begun their careers in the 2000s and even their film schooling after the collapse of the USSR in 1991 (Boris Khlebnikov, Aleksei Popogrebsky, Kirill Serebrennikov are the usual suspects listed in this group, with Andrei Zviagintsev as a kind of spiritual forefather). Mindadze does not fit this grouping by physical age; however, his style of directing and 2007 debut can be seen as part of the "new quiet ones."

My Good Hans, Mindadze's third film as a director, is unusual in many ways, but loosely follows his approach to cinema mapped out

in his previous two movies. It is a war film that features no battle scenes and that largely takes place outside of battle zones. Mindadze and his collaborators deliberately made a complicated film in order to counter what they saw as a growing Soviet-like veneration of the victory in World War II. In what follows, I will explore this complex film in two ways: first through the cinematic language Mindadze and his cinematographer, Oleg Mutu, employ; and then through the historical and political contexts Mindadze engaged with in *My Good Hans*. The film gained notoriety not for its complex plot but for the politics surrounding its release: the Russian Minister of Culture, Vladimir Medinsky, threatened to withhold state funding for the film because he agreed with the pronouncement of the Military-Historical Society that it "falsified history."

In a 2015 interview for a Russian film journal, Mindadze explained several ideas that help when evaluating his film. The director, when asked about the historical setting, answered that he did not want to create a literal reconstruction of the past; instead, his film represented an "author's reconstruction [*avtorskaia rekonstruktsiia*]" of history.[4] In this sense, Mindadze referenced his initial career as a screenwriter: for him, the writing process and composing a "literary scenario" are keys to creating an atmospheric film, one that might speak to universal truths rather than just a narrow interpretation of a particular event. In order to create this atmosphere, Mindadze stated, he relies heavily on his cinematographer, Oleg Mutu. After Mutu reads the script, they meet to discuss the filming without the use of storyboards. (Mutu, Mindadze related, hates storyboards.) Instead, Mutu works out the spaces he will film, the settings, the moods, and almost intuitively grasps what Mindadze wants: in this case, a mise-en-scène that is packed full of symbols. Finally, as he explained to his interviewer, Mindadze sees his actors as characters performing a function; namely, conveying through "psychological and physical manifestations"—gestures, relationships with

4 Vasilii Koretskii, "Aleksandr Mindadze: 'Ia vsegda videl ekran i pisal ekran'" *Seans*, October 22, 2015, accessed July 2, 2018, http://seance.ru/blog/interviews/mindadze-interview/.

objects—the essence of the film's plot. The key to watching a Mindadze film, in other words, is in recognizing that it will be complex.

My Good Hans opens with a shot of a cauldron inside a factory filled with magma-like, red-hot slag. We hear the bubbling, see a bit of movement within it, acting as a warning to the slow burn of the plot and the boiling over of emotions that will ensue. Words appear onscreen that set the temporal boundaries for the film: it is set after the signing of the Molotov-Ribbentrop Pact in 1939, and explores the commercial agreements of that diplomatic agreement that saw raw materials sent from the USSR to Nazi Germany in exchange for German engineers to help with various industrial projects. Later, we will get a more exact chronology: the film is set in May 1941, just before the Nazis will break the Pact by invading the Soviet Union. After establishing this setting, we hear breathing, then see a close-up shot of an eye. The breathing and eye belong to Hans, a German engineer at work in the USSR on a project to make a new lens for German and Soviet soldiers to use in their scopes and binoculars. If the cauldron of slag provides an opening metaphor that events will soon heat up and boil over, so too does this next shot: *My Good Hans* is a film about spying, about claustrophobia, about fear. The continued work on the lens, as well as frequent references to looking, to sight, add to this interpretation. The cinematographer, Mutu, employs his camera to capture scenes as if we are voyeurs, with frequent closeups, particularly of Hans's face, and using many shots of the backs of characters' heads, placing us into the scene.

The atmosphere introduced in the opening frames matters more than plot structure, which tends to move rather slowly, almost painfully at times from vignette to vignette. Hans is one of four Germans sent to the factory to work on this project. (With the exception of Jakob Diehl, who plays Hans, the other three actors are well-known in Germany.) They struggle to complete the task and in their exertions, particularly after they arrive back to their shared apartment, tempers run hot and boil over. Pressure from home, combined with fears that Otto, the group's leader, as well as their new Russian comrades, will denounce them, help to create

Fig. 1. Four Germans on the verge of a breakdown. Hans, Otto, Willi, and Greta after the accident.

a poisonous atmosphere among the four. The major plot point comes when Hans, frustrated by their lack of progress, rushes to the factory and adds too much coal to one of the furnaces, causing it to explode (Fig. 1). Two Soviet workers die and Hans's face is burned. The Russians receive the blame and admit fault in the accident, a verdict Hans quietly accepts. The only witness to what really happened is Petr, a Russian worker (the Russian title to the film is *Kind Hans, Dear Peter*). The two men begin a friendship of sorts, one where Hans comes over to Petr's home and shares food and drink with his wife and their friend. Hans dances with the friend, then kisses her as they walk home. This moment where intimacy is almost achieved between two people from two nations proves fleeting, however: Hans runs away. Chased by dogs, he leaves a footprint in a patch of drying concrete. The scene has a reprise of sorts later, when Hans nearly joins Petr and his wife as they flee from the factory. He jumps onto their truck before jumping off once he sees their children, thinking of his own back home. Upon arrival back in the factory town, a group of Russian men try to beat him up. Russians and Germans, it seems, cannot truly become comrades.

Before the explosion, there is another fleeting moment when the Germans and Russians attempt to understand each other. Otto proposes a break from the work and invites a few Russian factory workers to a beach; the Russians sit uneasily by while the Germans

Fig. 2. Back in the USSR. Hans, now a Wehrmacht officer,
uses the lens he helped to make.

mostly ignore them. In addition, after his encounter with Petr's friend, Hans forges a more important relationship with a dog that he befriends, named Greta, and cares for more than his fellow humans.

Eventually, one of the German engineers, Willi, kills himself before they go home, throwing himself under a train. The lens is successfully made and Otto declares that Hans has created it because he has "gone mad." Hans peers through a microscope, seeing the new lens. The very next scene has Hans peering through binoculars using the lens (Fig. 2). He has returned to the village as a Nazi Wehrmacht officer. The dog, Greta, runs to him and Hans hugs her. He walks through the same locales he did a few months earlier, this time as a would-be conqueror, even stepping in his now-dried footprint. The film ends with as much ambiguity as it began, and with another portent: Hans sees the Russian woman with whom he danced at Petr's apartment and whom he kissed. He sits down in a building once used for the project, connected therefore to the industrial crime he escaped, in order to receive a shave from her. "You see," he says, "I have come back." She begins to shave him, drawing the razor slowly under his jaw. Hans leans back, thrusts his neck out, closes his eyes, invites her to punish him for his earlier sin. She moves the razor near his throat (Fig. 3). The film ends. Did she slit his throat or not?

The movie contains several sequences that are dream-like and hallucinatory. *My Good Hans* is more about atmosphere, about visual language, about set pieces between characters that are long, deliberate. The film attempts through its sparse use of language and dialogue to convey emotions and impending disaster, an interpretation also conveyed through the symbols Mindadze and Mutu pack into their film. The slag that threatened to boil over in the beginning shot symbolizes the simmering feud between the German engineers, who argue about politics and Nazism, and between Russians and Germans, who never truly interact meaningfully even if they can glimpse their shared humanity. The slag boiling over, which helped to produce the fought-over lens, therefore becomes the metaphor for the end of the Nazi-Soviet Pact and with it, the beginning of the Great Patriotic War. The spying eye of Hans at the beginning works similarly. It too captures a mood, a sentiment, a feeling. Both the Nazi and Soviet systems, and the factory work that came about after the Pact between the two, are defined by surveillance. Violence constantly lurks beneath the surface. The film's visual style also attempts to explain the impact of these totalitarian systems on individual lives. Some characters become hysterical, others are fearful, others conform, others adapt. Hans becomes a Nazi, an "ordinary man" in the fashion Christopher Browning helped to flesh out in his seminal work: Hans, in other

Fig. 3. Will she or won't she? The final scene.

words, does not resist, and instead takes part in crimes without necessarily being a true Nazi ideologue.[5]

Of course, other readings of *My Good Hans* are possible. Mindadze's concept of the "author's reconstruction," the use of actors to perform certain functions through inner dialogues and gestures, the symbolic aspects of Mutu's camerawork, the nearly exclusive use of German (a language Mindadze himself does not speak), all invite debate, different interpretations, subtle disagreements. Hans's dog and the recurring images of trains, to pick just two examples, could both be explored for their symbolic importance and how they extend Mindadze's reconstruction of history in this complex film. Above all, Mindadze wants to make his viewers work at decoding his plot, its interpretations of the past, and the relationships between the Germans and the Russians.

There are two broader contexts that also help when evaluating Mindadze's complicated film and both are political in nature. The first is how the film takes part in the ongoing political battle over historical memory. The Soviet state invested a great deal of political capital in turning the victory over Nazi Germany into an anchor for Soviet identity. The victory, as numerous scholars have argued, functioned as a sacred state cult. Certain narratives and interpretations became vital to this state-led cultural campaign. The basic gist of the victory narrative was that it was one earned by the Soviet leadership and the Soviet people. The people themselves suffered horribly at the hands of the beastly Nazis. Eventually, through the heroism of the Soviet people, particularly the Russians, the USSR triumphed and in doing so, saved the world from fascism. Like all myths, this Soviet one rested on kernels of truth. Like all sacred myths, trying to stray from it proved problematic for historians, writers, and filmmakers. Taboo subjects such as collaboration with the Nazis, life under occupation, the failure of the Stalinist leadership to prepare for the invasion, and less-than-heroic acts by Soviet citizens, remained impermissible.

[5] See Christopher Browning, *Ordinary Men: Reserve Police Battalion 101 and the Final Solution in Poland* (New York: HarperCollins, 1992).

Soviet film played an important role in this construction of historical memory. While propagandistic films such as *The Fall of Berlin* (*Padenie Berlina*, 1949) that trumpeted Stalin's role in the victory gave way to nuanced, brilliant films such as *The Cranes are Flying* (*Letiat zhuravli*, 1957) and *Ballad of a Soldier* (*Ballada o soldate*, 1959), both movies that explored the human cost of war, certain taboos could not be exposed. Late Soviet-era filmmakers could focus on the human costs of war, but could not undermine the basic narrative outlined above. During the Brezhnev era, the period when Mindadze became a scriptwriter and a time that the state constructed the cult associated with the war, films such as *They Fought for Their Motherland* (*Oni srazhalis' za rodinu*, 1975) captured an earthy patriotic spirit that seemingly guided the Soviet people to victory. Even later films such as the dark, disturbing, hellish vision of war presented in Elem Klimov's *Come and See* (*Idi i smotri*, 1985) had to conform in part to the state script: in this case, casting the invaders as beastly, inhuman Nazis who laid waste to Soviet resources and its people. Films that attempted to tackle more difficult subjects were shelved. Aleksei German's *Trial on the Road* (*Proverka na dorogakh*, 1971), to cite one example, sought to complicate the black-and-white "heroes" and "traitors" of the war by exploring the topic of collaboration. Although it was finished in 1971, the film was shelved and released in edited form only in 1986.

The collapse of the USSR did not immediately change the cinematic exploration of the war, mostly because the ensuing economic collapses severely limited film budgets. By the early 2000s, however, buoyed by rising oil prices, the Russian economy recovered and with it, the Russian film industry. Interest in historical films soared, and now that Soviet censorship had disappeared, Russian filmmakers began to tackle formerly taboo subjects. Nikolai Lebedev's *The Star* (*Zvezda*, 2002) got this revival started. Although the film mostly plays it safe in terms of its exploration of the war, the end credits note that the soldiers who died over the course of the film would not have been recognized by the Soviet state because their bodies were not discovered. When the film did reasonably well at the box office and reasonably well with critics,

who noted that the history lesson offered at the end was a much-needed one, other films and television serials began to delve more deeply into the dark corners of the war. In *The Cuckoo* (*Kukushka*, 2002), Aleksandr Rogozhkin places two men ruined by the war, a Finnish soldier conscripted by the Nazis and left to die and a Soviet soldier convicted of anti-Soviet activities, in the company of a Sami woman whose entire life has been affected by the conflict. All three protagonists would have not been permitted to occupy Soviet-era screens. Dmitry Meskhiev's *Our Own* (*Svoi*) was set in a village under German occupation, shattering the taboo on that subject on its way to winning Best Picture at the 2004 Moscow Film Festival. Nikolai Dostal's sensational television series, *Shtrafbat* (*Penal Battalion*, 2004) and Aleksandr Atanesian's 2006 film *Bastards* (*Svolochi*) both explored how the Stalinist state brutalized its citizens during the war. Russian films in the 2000s both revived the patriotic culture associated with the Great Patriotic War while also offering more meaningful historical lessons about it.

In 2003 Petr Todorovsky released his film based in part on his own wartime experiences, *Under the Sign of Taurus* (*V sozvezdii byka*). The plot consists of a love triangle between three young people in a *kolkhoz* village near Stalingrad. The war is an important factor in placing the three together: one of them, Igor', is an evacuee from Rostov, while his local rival, Vania, tries to protect the livestock from both Nazi and Soviet thieves. The Nazis occupy the village while the two young men are out on the steppe. They take a German soldier prisoner, but decide not to kill him. Instead, they learn that he too is human and even handy: he is a medical orderly and treats Igor's wounds. The three share a love for poetry and a love for life, and help each other back to the village only to meet a more violent fate. By showing Germans as humans, Todorovsky altered the usual script of Soviet-era narratives. That same year, Aleksei German Jr. took this revision even further in his *The Last Train* (*Poslednii poezd*), which became the first Russian war film ever to feature a German character as its main protagonist. It follows a doctor, Fischbach, who works at a hospital in the occupied USSR. As the Red Army approaches, Fischbach is abandoned by his own men and instead wanders through the violent wreckage the war has brought.

These explorations in "getting to know the former enemy" would continue. In films such as Aleksei Karelin's *A Time to Gather Stones* (*Vremia sobirat' kamni*, 2005), the focus was on a German explosives engineer who decided to remain in the USSR after the war in order to serve as a minesweeper. Artem Antonov's *Twilight* (*Polumgla*, 2006) recounted the experiences of German POWs held in Soviet camps. Mikhail Segal's *Franz + Polina* (2006) represents an apex of sorts of these post-Soviet attempts to humanize the formerly beastly enemy. The two titular protagonists are a young Belarusian girl who falls in love with a young German SS member who joined only because his mother told him he had to serve the motherland. The Germans have occupied Polina's village, bringing Franz into her world and her home. The first half of the film is idyllic, one interrupted when more German soldiers arrive. They burn the village to the ground and massacre its inhabitants. Franz is ordered to shoot Polina and her mother; instead, he kills the officer giving the command. The remainder of the film tracks their attempts to escape the horrors of war and the consummation of their relationship.

What matters in these cinematic explorations, and a topic Mindadze also took up in *My Good Hans*, is the way they treated Germans as human beings. This treatment may not seem revolutionary in other cinematic traditions, but given the way the war operated as a myth in Soviet culture and the way that mythic narrative stressed the inhumanity of the Nazi invaders, these films proved revelatory. Mindadze's film furthers this cinematic revision of the past: the primary language of the film is German and the only characters developed fully are the four German engineers. We learn their backstories, gaining details about their lives that also allow us to see them as distinct, different people. Greta has left her toddler son back in Germany with her sister and wonders if that was the right decision, but laments that working in the Soviet Union is the only way to put food on her family's table. Her husband, Matthias, has abandoned her and gone to fight at the front. Willi, who is anti-Nazi, has abandoned his house in Mölln and worries about repaying the loan he has taken out to build it. His death, we understand, comes in part because he does not want to return to "torch-lit parades." Otto, by contrast, is more of a true Nazi ideologue and

more prone to Hitler-like outbursts. He worries that failure will have repercussions back home and is willing to use any means to achieve the end result. Hans is a cypher, his face seemingly trusting enough to win both the confidence of his fellow Germans and Petr's extended circle of Russians. He is, as he states, someone who does what he is told, a trait that explains his return in the end as a Wehrmacht officer. In the interactions between the four Germans, Mindadze also subverts traditional stereotypes of Germans often prevalent in Soviet cinema: the four bicker, are emotional, like to enjoy leisurely swims, get drunk, reveal a religious faith, and worry about their commitment to German patriotism. The four are far from the robot-like, unemotional, ruthlessly efficient German often presented onscreen in Soviet-era films.

In contrast, the Russian characters are not well developed. Petr only appears forty minutes into the film and the first extended conversation in Russian takes place almost a full hour into the movie. Russians are peripheral to the story; they work in the factory and mostly provide backdrop faces to our four protagonists. The Russian characters are by and large depicted positively, often through visual scenes: Mindadze films Nina, the mother of the woman who dies in the accident, in one long, silent scene so that we can see her grief. Importantly, however, it is the Germans who see (or do not see) the Russians as fellow humans—a point stressed during a scene when everyone is riding on a train into the factory and the Germans gaze across at their Russian counterparts. This is a journey that they have taken every day they have worked in the USSR, seeing the Russians around them either as potential spies or just cogs in the factory wheel. (In one scene, Willi makes lascivious remarks in front of a Russian worker because he knows she cannot understand him.) It is only as their task nears completion, however, that the Germans bother to look outside of their own train car to see another one running beside it, full of Russian workers. As they gaze on the other car, they briefly glimpse themselves in their Russian counterparts. Crucially, however, this glimpse does not lead to any meaningful contact: the two sides remain apart, separated. This scene has parallels with Hans's brief encounters with Petr's family, when the two realize that they resemble each other, they were both

born on the same day, and both have two children the same ages. Just as it seems that the divide between the two men and their two nations has been bridged, when Hans joins Petr as they flee, it too ends abruptly and quickly: Hans jumps off the truck and returns with his dog.

My Good Hans would be a fairly unremarkable film in the mid-2000s in terms of the politics of memory, in the midst of the burst of films cited above that all humanize Germans. What made it more notable, however, was the changed nature of the Russian government's involvement in cinema. Beginning during Dmitry Medvedev's term as President, the Kremlin in 2009 established a commission to counter attempts to falsify history to the detriment of Russia's interests. While the commission disbanded in 2012, and did not produce anything substantial, it did leave important legacies. The organization was particularly concerned with anyone who seemingly denied the Soviet contribution to victory in World War II. In part, the rationale for the commission came because of the continued perception that the Soviet victory was not "properly" acknowledged in the West, but the cinematic and other popular revisions of the mid- to late-2000s contributed to the state's concerns: they did not present the war and its heroes patriotically enough. The Kremlin's interest only continued after Putin returned to the presidency and after the 2011 Bolotnaia Square protests. Fearing a "color revolution" at home, Putin and his officials increasingly clamped down on any sources of dissent, including historical narratives.

In his study of recent Russian cinema, Vlad Strukov even suggests that the Putin era, which began on December 31, 1999 when then-President Yeltsin resigned, ended in December 2011. The era, as Strukov argues, was defined politically by the stress on a vertical of power, while the cultural arena "marked the victory of the society of spectacle."[6] Cinematically, the market economy dominated in a way it never had before, while film producers became more and more important. Since 2013, Strukov suggests, the Putin government "has

6 Vlad Strukov, 1–2, in Further Reading.

attempted to exercise more political control over the film industry in an increasingly conservative environment."[7] The new cinematic style that developed in this era, and one that has continued to the present, is one Strukov characterizes as a symbolic mode, defined "by the use of highly abstracted concepts and symbolically charged visual language," accompanied "simultaneously [by] a particular visual style, philosophical system, and sensibility."[8] Mindadze's *My Good Hans* fits well within this schema: certainly the director's decision to film a controversial historical subject was a direct response to the increasing cultural conservatism after 2011. In turning to abstract concepts and a striking visual style to make *My Good Hans*, Mindadze also returned to the cinematic language he had once used as a screenwriter during the Soviet era.

Vladimir Medinsky, the Russian Minister of Culture, played a particularly important role in the political controversy surrounding Mindadze's film. He threatened to withhold funding for the movie on the basis that it "falsified history," a strategy he had employed earlier, most notably with Khusein Erkenov's *Ordered to Forget* (*Prikazano zabyt'*), a 2013 film about the deportation of Chechens during World War II.[9] Medinsky did not ultimately carry out his threat, but his very public pronouncement colored reactions to the film in Russia: all the critical reviews referenced it, and the decision by the Russian Guild of Film Critics to shower *My Good Hans* with awards was as much political as artistic.

In an interview with Alena Solntseva just before the movie debuted, Mindadze discussed why he made the film, who his audience was, and the controversies surrounding it. He noted that people in Russia today do not go to art house cinema because for many, the subjects he and others explore "are simply uninteresting." During the Soviet era, film was a "source of information," but "now

[7] Ibid., 6.

[8] Ibid., 22.

[9] Medinsky had previously served on the Presidential Commission to Counter Attempts to Falsify History. He has a Ph.D. in History, but has been caught up in ongoing exposés regarding his plagiarizing parts of his dissertation.

everything is different." With his audience in mind, Mindadze noted that he did not aim to be clear in his film, for he did not see appeasing a broad audience as his mission. Instead, he was just interested in cinema itself, particularly aimed at an "advanced viewer." In working with German actors in their native language, Mindadze stressed that they should treat their performances as ones capturing "a premonition of a disaster." As to the controversies about historical accuracy, Mindadze rebuffed them, stating that he had based his story in part on a veteran's memoir that stated he drove a tank in June 1941 into places where six months previously he had been helping his Red Army counterparts conduct maneuvers. The episode prompted the director to think about the collaboration between the two powers under the Molotov-Ribbentrop Pact; he even discussed specifics with Iuliia Kantor, a historian of the period. Kantor told him about the attempt to use German engineers to help create a new lens, the basic plot of the film.[10]

Angry at the increasing government involvement in the film industry, Russian critics responded by praising the film in their reviews and critiquing Medinsky's pronouncement. Andrei Arkhangel'sky reported that Mindadze became a sensation at the Moscow International Film Festival, where the movie had its Russian debut, because of Medinsky's statements. Arkhangel'sky compared it to German Jr.'s *The Last Train* and praised how it ran counter to the usual, straightforward film about the war where it is easy to tell good and bad. Instead, *My Good Hans* explores how "Nazism begins with psychology," and reveals "the moment before dehumanization," one where Germans "are human beings," "individuals, people, engineers, professionals," not beasts.[11] One of the most insightful reviews came from Mariia Kuvshinova, who noted how each of the Germans represented a type of capitulation to internal fascism, through denunciations (Otto), Stockholm

10 Alena Solntseva, "'Ia nikogda ne pital illiuzii'," *Ogonek*, March 7, 2016, accessed July 5, 2018, http://kommersant.ru/doc/2926906.

11 Andrei Arkhangel'skii, "Nechelovecheski prosto," *Ogonek*, June 29, 2015, accessed July 5, 2018, http://www.kommersant.ru/doc/2949127.

Syndrome (Greta), a willingness to follow orders (Willi), or a surrender to the seeming inevitable (Hans).[12]

Critics also highlighted the atmosphere Mindadze created as a statement about the past, the anxieties of the Germans as a statement about the "mad descent into fascism" (as one put it).[13] Many suggested that the film managed to offer a meaningful statement about the century itself and its totalitarian systems, noting that the film's forays into deception, discomfort, claustrophobia, and emotions captured essential aspects of twentieth-century experience. The bubbling tub of smelt was also seen as a key metaphor for an explosion waiting to happen, even a holocaust. Most critics also saw Mindadze's willingness to compare Nazism to Stalinism, to suggest the emotions of both bore similarities, as a crucial aspect of the film's significance. In the end, this critical response captures precisely what makes *My Good Hans* an important case study of recent Russian cinema: it offers a complex picture of an understudied historical era, is rich with symbolic language, and requires the viewer to work at interpreting it.

Stephen M. Norris

[12] Mariia Kuvshinova, "'Milyi Khans': samyi nedootsenennyi fil´m goda," *Seans*, August 12, 2015, accessed July 5, 2018, http://seance.ru/blog/reviews/hans/.

[13] Igor' Gulin, "Nemets na grani nervnogo sryva," *Kommersant*, March 11, 2016, accessed July 5, 2018, http://www.kommersant.ru/doc/2928415.

FURTHER READING

Condee, Nancy. *The Imperial Trace: Recent Russian Cinema*. New York: Oxford University Press, 2009.

Marcucci, Giulia. "Interview with Aleksandr Mindadze: From Scriptwriter to Director." *KinoKultura* 19 (2008). Accessed November 17, 2017. http://www.kinokultura.com/2008/19i-mindadze.shtml.

Norris, Stephen M. *Blockbuster History in the New Russia: Movies, Memory, Patriotism*. Bloomington, IN: Indiana University Press, 2012.

———. "Guiding Stars: The Comet-Like Rise of the War Film in Putin's Russia: Recent World War II Films and Historical Memories." *Studies in Russian and Soviet Cinema* 2, no. 1 (February 2007): 163–89.

Strukov, Vlad. *Contemporary Russian Cinema: Symbols of a New Era*. Edinburgh: Edinburgh University Press, 2016.

Youngblood, Denise J. *Russian War Films: On the Cinema Front, 1914–2005*. Lawrence, KS: Kansas University Press, 2006.

PARADISE

Rai

2016

126 minutes

Director: Andrei Konchalovsky

Screenplay: Elena Kiseleva, Andrei Konchalovsky

Cinematography: Aleksandr Simonov

Art Design: Irina Ochina

Music: Sergei Shustitsky

Producers: Andrei Konchalovsky, Florian Daile, Olesia Gidrat, Aleksandr Brovarets

Production Companies: DRIFE Productions, Andrei Konchalovsky Producer Centre

Cast: Iuliia Vysotskaia (Ol´ga Kamenskaia), Christian Clauß (Helmut), Philippe Duquesne (Jules), Peter Kurth (Commandant Krause), Jakob Diehl (Dietrich Vogel), Viktor Sukhorukov (Heinrich Himmler), Vera Voronkova (Roza)

Andrei Sergeevich Konchalovsky (born 1937), also known as Andrei Mikhalkov-Konchalovsky, or simply as Andron, is a veteran Russian director and screenwriter, who made his feature debut with the highly acclaimed 1965 film *The First Teacher* (*Pervyi uchitel´*), adapted from a book by famous Kyrgyz author, Chingiz Aitmatov. After his follow-up project, made in a similarly neorealist vein, *The Story of Asia Kliachina* (*Asino schast´e / Istoriia Asi Kliachinoi, kotoraia liubila, da ne vyshla zamuzh*, 1967) was only given a limited release in a censored version, and shown in full twenty

years later, Konchalovsky changed direction, making films in a variety of genres such as literary adaptation of the classics, with *A Nest of Gentlefolk* (*Dvorianskoe gnezdo*, 1969), and *Uncle Vania* (*Diadia Vania*, 1970), patriotic rock musical with *Romance about Lovers* (*Romans o vliublennykh*, 1974), and historical epic in *Siberiade*, (*Sibiriada*, 1979).

Konchalovsky then moved to the United States, and became the only major Soviet director to forge a successful career in Hollywood (although matched by Timur Bekmambetov in the post-Soviet era). There he shot a variety of films from the more critically successful *Runaway Train* (1985) to the undistinguished commercial blandishments of *Tango and Cash* (1989), and finally a depiction of Stalin and his entourage in *The Inner Circle* (1992). This versatility has meant that Konchalovsky is hard to pin down as a director with a distinctive style, theme, or authorial sensibility, and a certain elusiveness also characterizes the films he has made since returning to Russia from the US in the 1990s. These films include an attempt to continue the story of *Asia's Happiness* in *The Chicken Riaba* (*Kurochka riaba*, 1994), which made little impact in the chaotic context of 1990s Russian cinema, where the protectionist Soviet distribution network had collapsed and the new Russian system had not yet taken shape, making it particularly difficult for Russian films. Subsequently, Konchalovsky made a version of Homer's *Odyssey* for US television (1997), before beginning to explore a more art house and festival-oriented approach notably with his idiosyncratic take on the Chechen war, *House of Fools* (*Dom durakov*, 2002). While he continued to make commercially oriented films for the US market throughout these years, Konchalovsky seems to have given up on that strategy after the universal derision and box-office death of *The Nutcracker in 3D* (2010).

While he also has written a number of volumes of his memoirs and directed plays and operas, most recently Konchalovsky returned to cinema with a new vigor and artistic ambition. Thus, paradoxically, this director who lacks a distinctive directorial style has pursued and excelled at the art house model of filmmaking, oriented toward festival accolades rather than ticket sales. This is true in particular of his most recent films: *The Postman's White Nights*

(*Belye nochi pochtal´ona Alekseia Triapitsyna*, 2014), and *Paradise*, both of which won the Silver Lion (effectively best director prize) at the Venice film festival. This career makes Konchalovsky unusual in that he has successfully migrated between three distinct industrial modes of cinema: the state-controlled system of the Soviet Union, the Hollywood system, and the European art house cinema.

An important context for understanding Konchalovsky's success in adapting to and thriving in shifting industrial contexts for cinema, is his family background. He is the son of Sergei Mikhalkov, popular children's poet with an aristocratic background, and author of the words to the Soviet national anthem, in its original 1943 and 1977 post-Stalin versions, further adapting the same song as the Russian national anthem in 2000, for the Putin era. Konchalovsky's younger brother, Nikita Mikhalkov (who took their father's rather than mother's name, because he was the first to gain prominence in the cinema), has been no less successful in negotiating post-Soviet Russia's ideological, industrial, and artistic shifts, although in contrast to Konchalovsky, his political power as chair of the Russian Cinematographers' Union and outspoken defense of President Putin have tended to inform the overt patriotism of his recent films so as to make them primarily palatable to the domestic spectator, if anyone. These political and economic family connections not only inform Konchalovsky's skill at finding his feet in new situations but also make it easier for him than most to finance and retain authorial control over his films.

Plot

Set during the Second World War, *Paradise* follows the fate of Ol´ga Kamenskaia, an émigré Russian aristocrat and member of the French Resistance, from her arrest in Paris for hiding Jewish children from the collaborationist French police in Autumn 1942 to her death in the gas chambers at Auschwitz in January 1945. Ol´ga's life and death are contrasted with two other characters: a venal French collaborationist policeman Jules who is initially put in charge of her interrogation and agrees to spare Ol´ga in exchange for sex. His execution by the Resistance means Ol´ga is sent to

Auschwitz anyway. The second foil to Ol′ga is Helmut, a Nazi true believer from a German aristocratic background. He had fallen in love with Ol′ga in 1933, and when he sees her in the camp, makes her his domestic servant with the intention of making her his lover.

As the Nazis' imminent defeat becomes evident, Helmut offers Ol′ga to escape with him to a German colony in Paraguay. She decides not to save herself, but instead to take the place of her fellow prisoner Roza in the gas chamber, saving Roza and the Jewish twins for whom she had initially incurred arrest. The final scene shows Roza and the twins walking to freedom.

Alongside the narrative, the film presents a series of interviews with Jules, Ol′ga and Helmut, in which they address a static camera, sit at a table, wearing drab prison-like uniforms. Although they start by giving their name and date of birth, responding to questions that we do not hear, they then reflect on their actions, unexpressed thoughts and motivations in the conventional episodes, verbalizing a depth at best hinted at there.

Analysis

Despite anxieties as to whether the Holocaust can or cannot be represented visually, films of the Holocaust have existed from the very period when its central events unfolded, as the Nazis employed film to humiliate their victims and liberators to document the barely credible crimes. Since then, film has become an important element in depicting and commemorating the Holocaust, leading to the formation of a genre of Holocaust cinema, with its own canon and aesthetic norms.[1] Konchalovsky's *Paradise* is a conscious polemic with and contribution to that genre. However, it is a genre that is not really Russian, and rather more significant in Europe, Israel, and the US.

The word "Holocaust" is a relatively recent addition to the Russian language, entering usage at the end of the Soviet era, as

[1] See, for example, Annette Insdorf, *Indelible Shadows: Film and the Holocaust* (Cambridge: Cambridge University Press, 1989).

the dominant Soviet interpretation of the war, the "cult of victory" in the Great Patriotic War began to fragment, along with the state it supported. Thus, while the central, most murderous phase of the Holocaust had begun with the invasion of the Soviet Union in June 1941, with Soviet Jewry its first target and initial victims, the Soviet story of the war that took shape by the conflict's end focused on common heroic victory and conscious and meaningful sacrifice. This means that the Holocaust—the mass murder of Jews specifically because of their ethnicity—was, while never exactly denied, always ignored, marginalized, or subsumed within that other narrative. There were occasions and places when it nevertheless became difficult to avoid mentioning the Nazis' mass murder of the Jews, especially the central site of the mass shootings on Soviet territory, at Babyi Iar in Kiev, and in depicting the Nazi concentration camps. Even here, however, as Olga Gershenson has argued, the Soviets adopted two strategies with which to assimilate the Jewish narrative in such a way as not to undermine the monolithic Soviet one: universalization and externalization.[2] With universalization, the Nazi crimes against the Jews are depicted, such as mass shootings and the gas chambers, but the fact that Jews were the primary victims is not mentioned. Instead, if they are mentioned, it is usually as part of list of ethnicities, and the figures for civilian and military are all combined to produce an undifferentiated figure of twenty million, revised upwards to twenty-seven million at the end of the Soviet era.

The other strategy was that of externalization, which depicted the Holocaust, even quite explicitly mentioning Jewish victimhood as central, but located the action outside the Soviet Union, usually in Poland. This had the further advantage for Soviet filmmakers of avoiding thorny issues such as that of Soviet citizens, even Russians, not only in their canonical roles as resisters and liberators, but also as collaborators, and of course meant Soviet film could also mobilize the enormous symbolic force of camp imagery. However, as Gershenson points out, this impeded the development of

[2] Olga Gershenson, 223–24, in Further Reading.

a specifically Soviet imagery of the Holocaust on Soviet territory, a distinct experience that differed significantly from that of the camps, since Soviet Jewry were usually killed near to their home towns, usually shot, rather than gassed, and their corpses buried in pits, rather than cremated.[3] Thus, *Paradise*, as a Russian representation of the Holocaust set in France and in the camps, for all its merits, does very little to advance the cause of distinctly Russian and former Soviet Holocaust representation, and largely conforms to a pattern established in the Soviet past for containing and muting such representations. At the same time the film is interesting in that it represents a point of intersection between Russian and wider tendencies in the representation of the war and Holocaust—the two strands co-exist, in an uneasy tension, in the film. Neither entirely prevails, and the effect is something of a hybrid text.

As a contribution to the genre of Holocaust film, *Paradise* strives to emphasize the extent to which the Holocaust lays bare the superficial nature of European sophistication, culture, and civilization. These form a mask that can be torn off at any time to reveal a barbarous brutality, seems to be the implication, and it is this perspective that ultimately explains the film's frequent focus on the physicality of the various objects, the material culture of the wartime world. The cigarette lighters, fans, radios and gramophones, and the buttons and clasps of the period clothes all alluringly conceal the violence that underpins this world: its torture and murder (Fig. 1). With Helmut, the focus is less on the allure of the things that surround him, and more on his intellectual sophistication, his command of Russian and love for Anton Chekhov. There is a parallel to be drawn of course with brother Nikita's Oscar-winning *Burnt by the Sun* (*Utomlennye solntsem*, 1995), where the Merchant Ivory-like elegance is a veneer ultimately torn down by the ineluctable intrusion of terror. In both cases there is a scopophilic pleasure in contemplating this world, but the director overturns and undermines this fascination, using it as a metaphor for a sense of the "lost-ness" of this would-be paradise.

3 Ibid.

Fig.1. Jules, at breakfast with his family.

The same tension is explored in the sexual fascination Ol′ga exerts on the two principal male characters: she tries to exploit her captors' sexual desires and vanity to save herself and mitigate the pain she will suffer as a prisoner at the mercy of the Nazi system. There are hints here at films like Liliana Cavani's *Night Porter* (*Il Portiere di notte*, 1974), associated with the notion of "fascinating fascism," and widely condemned for its portrayal of the sado-masochistic sexual relationship between a Nazi guard and prisoner.[4] However, having hinted at such possibilities, Konchalovsky then shifts to more cerebral ground as Ol′ga's outward erotic appeal is echoed by an intellectual curiosity shared between Ol′ga's male admirers, Jules and Helmut, and also ultimately the film's viewers as to her inner world, her motivations: what compels her to attempt to save the Jewish children at the cost of her life? The question, as posed by anti-Semites in the film, is troubling on another level as it implies an anti-Semite's difficulty in understanding why any non-Jew, and a Russian aristocrat in particular, would want to help a Jew. Ol′ga

[4] Daniel H. Magilow and Lisa Silverman, *Holocaust Representations in History: An Introduction* (London: Bloomsbury, 2015), 84–87.

Fig. 2. Ol'ga entering paradise.

struggles to address this question in her final interview, saying that a greater force pushed her, and that this was an affirmation of love, of a belief that life and ethics possess a higher meaning. This is an assertion of a different kind of heaven, one that rewards the act of self-sacrifice in the afterlife, rather than the earthly one connected to the violent destruction of enemies that we see Helmut affirming elsewhere in the film. Her view is vindicated when, in answer to her assertion that she has nothing to fear apart from God, we hear a voice from beyond the frame, that of St. Peter, guardian of the gates of heaven by Christian tradition, or possibly of God, saying that she has nothing to fear. This is followed by a kind of divine light, and we have the sense that she really does now enter paradise (Fig. 2).

Although it is not quite spelled out, this is an implicitly Christian ethical stance, and relates to the fact that Ol'ga is the only one of the characters to assert not just her Russian ethnicity, but also her religion—Orthodox Christianity. A key factor in her motivation, then, is Ol'ga's Russian Orthodox identity. Ultimately, despite this being a film about the Holocaust, we end up somewhere near brother Nikita's nostrum from *The Barber of Siberia* (*Sibirskii tsiriul'nik*, 1998): "He's Russian and that explains a lot." Using the Holocaust

to affirm Christianity and Russian identity as stable points for a moral compass, one that permits a narrative of meaningful sacrifice and redemption applied to the Holocaust, is deeply problematic and relates to a wider Russian politics of memory and attitudes to which this article will return. First, we need to consider in more detail the film's portrayal of the Holocaust through the metaphor of "paradise" that informs the motivations of the perpetrators and the hellish world of the camps they create.

The question as to what motivated the Nazis has been central in representations of the Holocaust from the Nuremberg Tribunal's formulation that those who killed were following "superior orders," to Hannah Arendt's coinage of "banality of evil" to refer to Adolf Eichmann's bureaucratic form of murder, to Christopher Browning's notion of "ordinary men."[5] While many of these conceptualizations of the Nazis' motivations downplay the role of ideology as causes of the Holocaust, its role is widely accepted, even in the case of Eichmann, as a crucial factor.[6] *Paradise* stresses this ideological dimension above all, by contrasting the true believer Helmut with the banal inner world of the collaborator, Jules, who is motivated by creature comforts and concerned to keep up appearances. Jules initially appears to be a dutiful father and loving husband, but he is willing to betray his wife and let down his son without a second thought. He is a functionary who denies being involved in the rounding up of Jewish children when questioned by his wife, and makes a distinction between his work and that of the Gestapo, although what we see of it suggests it is identical in method and purpose.

The contrast between Jules and Helmut is also social: while the former is a *petit bourgeois*, the latter is an aristocrat, an intellectual

[5] Henry T. King Jr., "The Legacy of Nuremberg," *Case Western Journal of International Law* 34 (Fall 2002), 335; Christopher R. Browning, *Ordinary Men: Reserve Police Battalion 101 and the Final Solution in Poland* (New York: HarperCollins, 1992); Hannah Arendt, *Eichmann in Jerusalem: A Report on the Banality of Evil* (London: Faber and Faber, 1963).

[6] David Cesarani, *Eichmann: His Life and Crimes* (London: W. Heinemann, 2004).

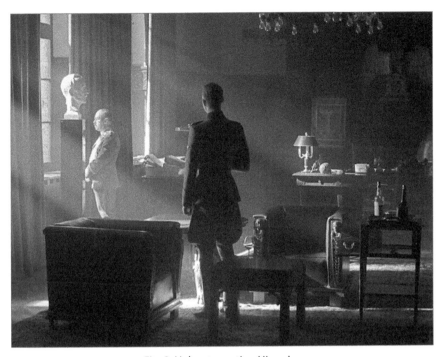

Fig. 3. Helmut meeting Himmler.

with a degree in Slavic and Law from the University of Heidelberg, where he developed his love of Chekhov. Such is his devotion to the Nazi cause, he sells his ancestral home to pursue a career in the SS, the elite, most highly motivated core of the Nazi party. He does this even as others are already concluding the war cannot be won in late 1942, during the Battle of Stalingrad. Thus, the metaphor of "paradise" refers in part to Helmut's idealism: a member of the party since 1933, he is committed to Nazism as a great or grandiose idea, to the building of a new world, a paradise on Earth. We see him in conversation with Himmler (played by Viktor Sukhorukov, famous for his role as the older brother in Aleksei Balabanov's eponymous film). The mise-en-scène and shot construction underline his belief, Himmler and Helmut stand by a bust of Adolf Hitler, the former gazing out of the window into the light, their faces illuminated dramatically, and the latter in *contre-jour* (Fig. 3). Indeed, Himmler claims that Hitler sees Helmut as a potential leader and successor.

Helmut's belief in Nazism encompasses outspoken anti-Semitism, and despite significant moments of doubt and psychosomatic nausea during the meeting with Himmler and when first arriving at the camp, he reaffirms these beliefs in his last interview, from the fictional space beyond the grave: they did not succeed due to human shortcomings and unworthiness. This profound conviction as to the power of ideas leads Helmut to expresses his admiration for his political foes, the Bolsheviks, because they too live for an idea, and for Stalin, because he is an exceptional individual. He muses that he may have become a Communist had he been born in Russia, because they too want to create a heaven on earth. This comment, echoing the film's title, clearly invites a comparison between Nazism and Communism as ideologically underpinned political systems, a comparison usually rejected in contemporary Russia, where pride in the war, Stalin, and the Soviet Union, restrict the appeal of such an approach. This invitation to reflect upon possible similarities between the two systems is subtle, however, and not expressed in a crudely direct or political way. Consequently, Konchalovsky is able to retain a sense of the metaphor here.

While the aspiration to create a German racially pure "heaven" on Earth is unsuccessful, the fully realized camp system is referred to as a hell through the prisoner reciting Dante's *Inferno*, and Krause, the Commandant, who says it is connected as the sordid flip side of Helmut's pure ideals. Indeed, Helmut is sent to the concentration camp to fight corruption, but its corrupt world destroys him, pulling him with it in its collapse, just as it had so many others. This is the confusing, apparently amoral world of the camp, familiar from literary accounts such as that of Primo Levi, in which hunger, brutality, and the indifference to death reign supreme.[7] Ol'ga's experience of this world, of life in the barracks and the warehouse where the effects of the dead are sorted out, are shown at the moment she undergoes it, and she simply lives it, doing her best

[7] See Primo Levi, *If This Is a Man,* translated by Stuart Woolf (London: Abacus, 2006).

to survive. Some of the imagery here evokes the famous newsreel images taken by Soviet cameramen at Majdanek and Auschwitz, showing the piles of spectacles and of children's potties. Through the eyes of someone who works in the camp and has to sort these items into the famous piles, we are brought closer to such images; it heightens their possibly waning emotive power. However, we also see Ol'ga reflecting on the camp experience afterward, commenting, for example, upon her hunger, in the interviews from beyond the grave. Through visual quotation and reflection, the experience of the camp is somewhat mediated, and contrasts, for example with the direct and experiential tenor of another Holocaust film, *Son of Saul* (László Nemes, 2016).

The fragility of Helmut's idealism and the degrading effects of the camp on Ol'ga are startlingly revealed when he offers her the chance to escape with him to Paraguay. She begins to affirm not only her delight at his ingenuity but also a belief in his ideals, in the German race's superiority and right to do what they want with anyone. In this strange episode, Ol'ga appears to experience a moral collapse and identification with the oppressor of the kind associated with survivor Levi's term of the "grey zone."[8] However, the effect of this strange would-be conversion is to rile Helmut, for whom this escape would also travesty his probity and ideological purity, and who cannot bear to hear his own beliefs articulated by Ol'ga. It may be that he himself no longer believes them. Certainly, this was not the romantic elopement he had envisaged, and after this scene, both characters decide not to leave the camp, but to face death there.

The to-camera addresses also relate to the context of the camps, in part because the front-on static photography, initial responses, and unkempt, uniformed appearance of the characters are redolent of a prison situation, but this is a different, higher, ideal justice, that contrasts sharply with its travesty in the Nazi penal system. This is perhaps another possible meaning of the title: the place from

8 Primo Levi, *The Drowned and the Saved*, translated by Raymond Rosenthal (London: Abacus, 1988).

which the characters speak at the end, and where they are finally given a proper hearing, scrutinizing their own consciences, comes at the moment of the final judgment, prior to possible entry into paradise.

An important element of the aesthetic strategy employed to represent the Holocaust in *Paradise* is the use of black and white film, an approach famously adopted by Spielberg in the enormously influential *Schindler's List* (1993) in part to signal moral seriousness, and a certain visual asceticism. Konchalovsky has stated that his choice of black and white was motivated by the desire to create the look of a documentary film.[9] This evocation of a pseudo-documentary aesthetic, and its implicit pretensions to authenticity, and realist associations, are perhaps reminiscent of the kinds of things he was able to film in the 1960s, such as *The Story of Asia Kliachina*.

At the same time, the choice of black and white is also born of a desire to make the film look like it might have been made at the time: thus, Konchalovsky has argued that there is something stylized or artificial about color depictions of the camps.[10] This feel of a period document is also implied by the film's texture, especially in the to-camera interview scenes, where the images are marked by scratches, streaks, blemishes, and jump-cuts, as well as the sound of the cameras whirring. At the same time, in these episodes, the physically concrete sense of the analogue filmic surface contrasts with their impossible setting in a time and space beyond death, a kind of "paradise."

Shot by Aleksandr Simonov, who was the Director of Photography for Balabanov's films and Konchalovsky's previous film, *The Postman's White Nights*, the camerawork was widely praised in reviews. As Neil Young, in *Hollywood Reporter* puts it, Simonov's cinematography not only has a deliberately period feel, but is also intended to evoke the moral atmosphere of the camps:

[9] Andrei Konchalovskii, in Further Reading.
[10] Ibid.

. . . [it] works chiaroscuro wonders with what the end credits identify as a combination of 35mm and 16mm stock (projected digitally at Venice), his 4:3 black-and-white images and complex lighting set-ups often harking back to golden-age monochrome cinematography. The look is a neat fit for the 1942–4 period during which most of the narrative unfolds, the boxy ratio serving to emphasize the harsh constrictions of wartime and later, the infernal claustrophobia of the hideously crowded death camps.[11]

The use of the old, pre-widescreen, ratio combines with the use of black and white in its innate symbolic evocation of stark moral choices, of a polarized world of good and evil, also explicitly foregrounded by the film's title. Finally, the use of black and white is an act of aesthetic self-restraint, connected to Konchalovsky's refusal to depict violence directly (although he does show one of the characters, Helmut, looking at still photographs of the work of the Auschwitz concentration camp—these too are very similar to the images of the camps shown at the Nuremberg International Military Tribunal of Major Nazi War Criminals). [12] As Konchalovsky puts it: "I did not make a film about physical suffering, there are no severed heads or piles of dead bodies in it. My film is about the most important thing: about human relationships."[13] This description of the imagery he is avoiding recalls most of all the documentary footage taken by Soviet, British, and US cameramen following the liberation of Nazi concentration camps in 1944–45. In those famous images of Majdanek, Auschwitz, Bergen-Belsen, and other sites,

[11] Neil Young, "'Paradise (Rai),' (Film Review, Venice 2016)," *Hollywood Reporter*, accessed February 22, 2018, https://www.hollywoodreporter.com/review/paradise-rai-925714.

[12] Jeremy Hicks, *First Films of the Holocaust: Soviet Cinema and the Genocide of the Jews, 1938–1946* (Pittsburgh, PA: University of Pittsburgh Press, 2012).

[13] Andrei Konchalovskii, "V kino trudno byt' svobodnym," interview with Tat'iana Rozenshtain, *Ogonek*, September 19, 2016, accessed February 22, 2018, http://www.konchalovsky.ru/press/interviews/v-kino-trudno-byt-svobodnym/.

,hown in newsreels and at the Nuremberg tribunal as evidence before being repeatedly reused in documentary compilation films and museum exhibitions, the piles of dead bodies are shown as part of a striving to document the Nazis' criminal brutality, contempt for human life, and mass murder; film is used as a means of recording evidence. Although there have since been films that continue to depict the violence of the Holocaust explicitly, sometimes for shock value or with dubious ethical aims, more recent films have tended to do this less than that initial footage, since the world has long accepted the overwhelming evidence of these crimes. Instead, filmmakers have adopted other strategies and emphases, such as tending to reflect on the world of the concentration camps from new angles: evoking the experiences of the Sonderkommando crematorium in *Son of Saul*, for instance, or scrutinizing and comparing the motivations of a murderer, collaborator, and a resister, as with Konchalovsky's film.

With its initially confusing, apparently fragmented narrative organization—in which the episodes furthering the plot are interspersed with the main characters' to-camera reflections from a space, the location and timeframe of which we are initially unsure about (wondering whether it belongs to a flash-forward or a flashback), but which we ultimately gather is beyond the grave— *Paradise* makes a formally daring gesture. It seems to evoke the widely-held view that there is something unrepresentable about these events, something beyond the reach of realist aesthetics.[14] At the same time, however, its narrative sequences, despite the single flashback to a 1933 Italian vacation and the beyond the grave ruminations, are filmed and narrated in a realist mode, with great, almost fetishistic, attention to period detail. Thus, while the form is reflexive and apparently fragmentary, it simultaneously conforms to highly conventional representational norms.

[14] Aaron Kerner, *Film and the Holocaust: New Perspectives on Dramas, Documentaries, and Experimental Films* (New York: Continuum, 2011); Libby Saxton, *Haunted Images: Film, Ethics, Testimony and the Holocaust* (London: Wallflower Press, 2008).

More than one Russian critic has argued, rather cynically, that in making a film about such an important period as the Holocaust, Konchalovsky, perceived in Russia as a "westernizer," that is, someone who frames Russian identity as a dialogue with the West, was seeking primarily to win international acclaim, so as to merit comparison with the most prominent Western directors such as Andrzej Wajda, Roman Polanski, or Spielberg.[15] However, when thinking of films that may have influenced Konchalovsky it is hard not to think of fellow Russian director Alexander Sokurov's 2015 film *Francofonia*, a French-German-Dutch co-production. There are some obvious differences, however. *Paradise* does not contain the figures of Marianne or Napoleon, for example. Nevertheless, the similarities are significant: *Francofonia* is also largely set in occupied war-time France, contains a multiplicity of languages (French and German with Russian as the master voice and implicit, ultimate meaning-conferring instance), displays a similar attention to the materiality of the film stock and the stylizing of newsreel images, and includes a scene that smacks of the world beyond the grave, in which the main characters are informed of their ultimate fates by Sokurov himself.

While, it is hard to be sure of Konchalovsky's true motivations, it is certainly true that, like Sokurov's film, *Paradise* was shown at the Venice film festival, but even though it was more successful, it is more derivative. While, *Paradise* strives to emulate the stylistic norms of European film, nowhere more so than in the way its main characters exist in a multi-lingual environment of French and German, ultimate moral and linguistic authority, however, rests not only with a Russian-speaking character but also ultimately with a Russian historical sensibility. Ol′ga's moral superiority, her choice to sacrifice herself for the Jewish Roza and the twins rather than to escape with Helmut makes this a film that ultimately

[15] Denis Kataev, in Further Reading; Viktor Marakhovskii, "Kino pobezhdennykh. O luchshem fil′me goda v Rossii," *Na linii* (March 20, 2017), accessed February 22, 2018, https://www.nalin.ru/kino-pobezhdyonnyx-o-luchshem-filme-goda-v-rossii-5252.

needs to be seen in its Russian, rather than European contexts. As a representation of the Holocaust, despite being a Russian-German co-production, it subverts the dominant subtext of the genre for Western thinking, instead presenting a vision of the Shoah in which Jews are peripheral, and where Russians are central.

While Konchalovsky is seen as a "westernizer" in Russia, fluent in the cinematic language of Europe and Hollywood, he is nevertheless an openly declared political conservative, who does not believe in the universal relevance or applicability of democracy, arguing that Russia, in particular, is not ready for it.[16] This view is informed by a sense that culture and history determine and limit the scope for political change, rather than being subject to it, as he characterizes the liberal worldview, which he opposes.[17] The liberal perspective, however, informs, and is informed by, a reading of the Holocaust as a key event and common moral touchstone in world history that triggered a response by democratic nations, both in the war itself, often characterized as the triumph of democracy over systems hostile to it, but more crucially in the shape of the post-war system of international relations informed by a concern for universal human rights and international law.[18] For liberal democracy, recognizing the importance of the Nazis' mass murder of the Jews in the Holocaust is thought to be central to European identity, especially since the end of the Cold War in 1989–91, and references to it have framed thinking about humanitarian military interventions.[19]

From the Russian vantage point, however, this view is deeply flawed. First of all, the Nazis were not defeated by democracies;

[16] Andrei Konchalovskii, "Nedomolotaia muka russkoi istorii. Kliuchevoi vopros: gotova li Rossiia k demokratii?" *Rosiiskaia gazeta*, July 2, 2012, accessed February 22, 2018, https://rg.ru/2012/02/07/konchalovski.html.

[17] Andrei Konchalovsky, "Interview with Zeinab Badawi," *BBC Hardtalk*, August 5, 2014.

[18] Peter Duignan and L. H. Gann, *United States and the New Europe, 1945–93* (Malden, MA: Blackwell, 1994).

[19] Michael R. Marrus, "Holocaust Bystanders and Humanitarian Intervention," *Holocaust Studies* 13, no. 1 (2007): 1–18.

the decisive moments in the Nazis' defeat were on the Eastern front, and were struck by the Soviet Union, which was not a liberal democracy. If victory in the Second World War vindicates democracy for Western liberals, then for Russians it vindicates their state and with it, Stalin's authoritarian rule and possibly the Soviet system or Russian nation. Moreover, while the Soviets also played an important role in the Nuremberg tribunal, the notion that it established norms of universal human rights and international law is not one that ever gained widespread currency in the Soviet Union, or in post-Soviet Russia, especially since such ideas only became prominent at the end of the Cold War, informing humanitarian military interventions that Russia took no part in or disagreed with. Consequently, Konchalovsky's approach to the subject of the Holocaust is not informed by its centrality for a wider understanding of the need to uphold universal human rights, or a desire to appeal to a liberal subject. Indeed, if the film is addressed to a liberal subject, its purpose is to remind such a viewer that the redemptive moment of triumph over the Nazis was achieved through *Russian* (not even Soviet) sacrifice. The focus of the beyond the grave interviews in *Paradise*, of the three central characters occupying three paradigmatic positions—the self-interested collaborator, the idealistic perpetrator, and the selfless resister—leaves no room for the expression of the Jewish experience, be it as passive victim or active resister. The Jews are recipients of acts of violence or kindness, but do not undertake any actions on their own behalf. This harks back to rather traditional Soviet-era tendencies in the representation of the Holocaust, in which separate Jewish agency is denied, and where the Soviet Red Army is shown to play the central role in the dramatic narrative of the Holocaust: liberating and saving Europe, the world, and Jews.[20]

Nevertheless, the emphasis is different because, although it is dedicated to Russian resisters in France, and there were indeed

[20] Vladimir Putin, "Speech at the Jewish Museum and Tolerance Centre," January 27, 2015, accessed February 22, 2018, http://en.kremlin.ru/events/president/news/47529 .

Russians in the French resistance such as the historical figure of aristocrat Vika Obolenskaia, these people were not especially honored by history, neither by the French nor Russians. Indeed, Russians who hid Jewish children were not a category of participants in the Great Patriotic War whose deeds were even honored in the Soviet Union, because those who found themselves under Nazi occupation were expected to resist violently rather than by saving lives. Thus, even if some such cases came to light, such stories went unrecorded or untold for the most part. In this sense, the film has a different emphasis than the habitual one.

However, such subtle shifts and distinctions were of little interest to the Russian film-going public, few of whom went to see the film, and it recouped a fraction of its budget. As one critic put it, the film is too European, concerns "someone else's neuroses," and is consequently of no interest to Russians because they bear no guilt and are trauma-free and "historically healthy."[21] A number of critics also suggest *Paradise* concerns a tried and tested theme, and contrast it negatively with *The Postman's White Nights*, which was more innovative and influential for Russian cinema.[22]

For Konchalovsky this is of little concern, since he now claims to be in a position where producers are willing to fund his films despite knowing that they will not make any money and are likely to lose their investments. This is the second such film and the current project (as I write in February 2018) *Michelangelo,* is also being made on the same basis. The director has represented this new direction as a kind of refusal to go along with the shift in US cinema toward youth audiences: he is only interested in making films for adults. This may be the case, but was not always so: Konchalovsky's Hollywood films were pretty lightweight. There is perhaps something of a return to the old Soviet way of making films for ideological purposes first and foremost, without regard for the box office: this was, after all, the backdrop to Konchalovsky's initial forays into cinema, even if *Paradise* is far from didactic.

21 Marakhovskii, "Kino pobezhdennykh."

22 Kataev, "Dorogu k raiu."

Yet for all their lack of popularity with the Russian public, Konchalovsky's films in general, and *Paradise* in particular, have received exposure and acclaim in his homeland. It garnered numerous film prizes, including three Russian national cinema academy awards (NIKAs). Nevertheless, Konchalovsky's key goal was probably international acclaim, the prize he attained with the nomination for best foreign film Oscar and Silver Lion at the Venice film festival in 2016. This followed his Silver Lion for *The Postman's White Nights*. Indeed, it should be noted that this was also the scene of his first triumph in cinema, where he won an award for a short in 1962. This was of course overshadowed by the Golden Lion won that year by his one-time collaborator, Andrei Tarkovsky, for *Ivan's Childhood* (*Ivanovo detstvo*).

In the wake of the recent wave of international acclaim, Konchalovsky's work has also received a prestigious retrospective at the 2017 Moscow film festival, and *Paradise* was released in the US in 2018, with subtitles instead of the dubbing in a single Russian monotone, which cinema viewers in the West would have found a distraction and obstacle to appreciation.[23] Similarly, the post-synch dubbing is something that US trade reviews perceive as inauthentic and unacceptable.[24] Once subtitled, it remains to be seen whether this film can appeal to art-house audiences, overcoming Konchalovsky's reputation for "philosophizing and 'psychologizing' at the expense of plot and pacing [that has] bored American audiences."[25] The film is to be commended if it succeeds; however, the film's attempt to reconcile the Holocaust theme with conservative Russian sensibilities about the war is not aesthetically successful, since it externalizes Russian memory by shifting it to France and Auschwitz, or intellectually successful since it stresses

[23] Guy Lodge, "'Paradise.' Russian veteran Andrei Konchalovsky is on robust form in this richly monochrome, perspective-rotating Holocaust drama," *Variety*, September 8, 2016, accessed February 22, 2018, http://variety.com/2016/film/reviews/paradise-review-2-1201854654/.

[24] Young, "'Paradise (Rai).'"

[25] Denise J. Youngblood, in Further Reading.

meaningful sacrifice and the ethical code of Christianity to represent the mass annihilation of innocent, often powerless Jews. A Russian film that produced a compelling and influential picture of the particularly Russian and Soviet dimension of the Holocaust in the occupied territories, integrating it with Russian war memory, has yet to be made. Such a reconciliation of the two strands of collective memory is an artistic and political project that still awaits an adequate synthesis and resolution.

Jeremy Hicks

Further Reading

Craps, Stef, and Michael Rothberg. "Introduction: Transcultural Negotiations of Cultural Memory." *Criticism (Detroit)* 53, no. 4 (2011). Accessed July 6, 2018. https://digitalcommons.wayne.edu/criticism/vol53/iss4/1.

Gershenson, Olga. *The Phantom Holocaust: Soviet Cinema and Jewish Catastrophe.* London: Rutgers University Press, 2013.

Kataev, Denis. "Dorogu k raiu pokazhete? 'Rai', rezhisser Andrei Konchalovskii." *Iskusstvo kino* 10 (2016). Accessed February 22, 2018. http://kinoart.ru/archive/2016/10/dorogu-k-rayu-pokazhete-raj-rezhisser-andrej-konchalovskij.

Konchalovskii, Andrei. "Mne interesna soblaznitel′nost′ zla," BBC Russian Service, interview with Aleksandr Kan, February 25, 2017. Accessed February 22, 2018. http://www.bbc.com/russian/features-38936459.

Youngblood, Denise J. "The Cosmopolitan and the Patriot: The Brothers Mikhalkov-Konchalovsky and Russian Cinema," *Historical Journal of Film, Radio and Television* 23, no. 1 (2003): 27–41.

CONTRIBUTORS

A literary historian, film critic and translator, **Anthony Anemone** teaches Russian and Comparative literature, cinema, and literary translation at The New School in New York City. The editor of *Just Assassins: The Culture of Terrorism in Russia* (Northwestern UP, 2010) and, with Peter Scotto, the editor and translator of *'I am a phenomenon quite out of the ordinary': The Notebooks, Diaries, and Letters of Daniil Kharms* (Boston: Academic Studies Press, 2013), he is writing the first study in English of the life and films of Mikhail Kalatozov.

Greg Dolgopolov is a Senior Lecturer in Film Studies at the University of New South Wales, Sydney, and teaches film production and Australian Cinema. He is the artistic director of The Vision Splendid Outback Film Festival (the largest Australian film festival in the world), The Russian Resurrection Film Festival (the largest Russian film festival outside of Russia), and the Short+Sweet Film Festival.

Critic **Anton Dolin** is the editor in chief of *The Art of Film* (*Iskusstvo kino*) and the author of numerous articles on contemporary film. His books include *Lars fon Trier. Kontrol'nye raboty: Analiz, interv'iu. Dogvill': Stsenarii* (Moscow: NLO, 2004), *German. Interv'iu. Esse. Stsenarii* (Moscow: NLO, 2011), *Ottenki russkogo: Ocherki otechestvennogo kino* (Moscow: Redaktsiia Eleny Shubinoi, 2018), and *Takesi Kitano. Detskie gody* (Moscow: NLO, 2018).

Professor of Slavic at OSU, **Helena Goscilo** writes on whatever engages her in Russian and Polish culture, right now focusing chiefly on visual genres: art, graphics, and film. She regularly teaches sci-fi, post-Soviet film, and Russian folklore to undergraduates, as well as devising graduate seminars in The Novel and Bakhtin, Nineteenth-Century Poetry, Socialist

Realism, and Forbidden Books, in addition to a course on Roman Polanski.

Julian Graffy is Professor Emeritus of Russian Literature and Cinema at University College, London. He has written widely on Russian film and is the author of *Bed and Sofa: The Film Companion* (London: I. B. Tauris, 2001) and *Chapaev: the Film Companion* (London: I. B. Tauris, 2010). He is currently completing a study of the representation of foreign characters in a century of Russian film.

Jeremy Hicks is Professor of Russian Culture and Film at Queen Mary University of London, where he teaches courses on Russian film and literature. He is the author of numerous articles and three books on this subject, including *First Films of the Holocaust: Russian Cinema and the Genocide of the Jews, 1938–46* (Pittsburgh: University of Pittsburgh Press, 2012).

Ilya Kukulin is Associate Professor at the Department of Cultural Studies of the National Research University-Higher School of Economics (HSE, Moscow) and Senior Researcher at the International Center for the History and Sociology of World War II and Its Consequences (HSE). He is a scholar of cultural history and literature and has authored the monograph *Mashiny zashumevshego vremeni: kak sovetskii montazh stal metodom neofitsial'noi kul'tury* (Moscow: NLO, 2015).

Mark Lipovetsky is Professor of Russian Studies at the University of Colorado–Boulder. He is the author of nine books and more than one hundred articles on various aspects of Soviet and post-Soviet literature and culture.

Tatiana Mikhailova, Senior Instructor of Russian Studies at the University of Colorado–Boulder, authors articles on such diverse subjects as gender issues in Soviet and Russian cinema, post-Soviet glamour culture, media representations of Putin, and contemporary political caricature.

Liliia Nemchenko is an Associate Professor in the Department of Philosophy of the Ural Federal University and teaches courses in aesthetics, twentieth-century culture, and the language of the arts. Her professional interests include the philosophy of art, aesthetic problems of the theory and practice of cinema, contemporary artistic practice, and arts criticism. She is the author of more than eighty critical articles, theatre and film reviews, and is the director of Kinoproba, the international festival-practicum for film schools.

Steven M. Norris is the Walter E. Havighurst Professor of Russian History and the Director of the Havighurst Center for Russian and Post-Soviet Studies at Miami University (OH). His work studies propaganda, film, visual culture, and politics in modern Russia and he is the author, most recently, of *Blockbuster History in the New Russia: Movies, Memory, Patriotism* (Bloomington, IN: Indiana University Press, 2012).

Serguei Oushakine teaches in the Department of Anthropology and the Department of Slavic Languages and Literatures at Princeton University, where he also directs the Program in Russian, East European, and Eurasian Studies. His research interests include the history of Russian formalism and constructivism, studies of memory and remembrance, and the postcolonial approach to Soviet history. He recently published "How to Grow out of Nothing: The Afterlife of National Rebirth in Postcolonial Belarus," *Qui Parle* 26, no. 2 (December 2017): 423–90, and "Translating Communism for Children: Fables and Posters of the Revolution," *Boundary 2*, 43, no. 3 (2016): 159–219.

Alexander Prokhorov is Associate Professor of Russian at the College of William and Mary. He is co-author of *Film and Television Genres of the Late Soviet Era* (London: Bloomsbury, 2017) and editor of *Springtime for Soviet Cinema: Re/viewing the 1960s* (Pittsburgh, PA: Russian Film Symposium, 2001). His articles and reviews have been published in *Journal of Film and Video*, *Kinokultura*, *Russian Review*, *Slavic Review*, *Slavic and East*

European Journal, Studies in Russian and Soviet Cinema, The Art of Film (Iskusstvo kino), and *Wiener Slawistische Almanach*.

Elena Prokhorova is Associate Professor of Russian at the College of William and Mary, where she also teaches in the Film and Media Studies program. Her research focuses on identity discourses in late Soviet and post-Soviet film and television. She is the editor of the section on television series in *Directory of Russian Cinema 2* (2015), as well as co-author of *Film and Television Genres of the Late Soviet Era* (London: Bloomsbury, 2017), and her publications have appeared in *Slavic Review, Slavic and East European Journal, Kinokultura, Russian Journal of Communication*, and as chapters in edited volumes.

Tom Roberts is Assistant Professor of Russian, East European, and Eurasian Studies at Smith College. His research interests include nineteenth-century Russian literature, Russian and Soviet cinema, and Russian Orthodoxy. He is currently completing his first book, on the aesthetic modalities of transcendence in nineteenth-century Russian prose fiction.

Rimgaila Salys is Professor of Russian Studies Emerita at the University of Colorado–Boulder and is the author/editor of eight volumes and various articles on nineteenth- and twentieth-century Russian literature, film and art history. Her most recent publications are on Grigory Aleksandrov's *Vesna* and the Soviet career of Liudmila Gurchenko.

Elena Stishova is a film critic and reviewer for *The Art of Film (Iskusstvo kino)*, and is the author of books and numerous articles on contemporary Russian and Central Asian film. Her most recent book is *Rossiiskoe kino v poiskakh real'nosti. Svidetel'skie pokazaniia* (Moscow: Agraf, 2013).

Vlad Strukov is Associate Professor in film and digital culture at the University of Leeds. He is the author of *Contemporary Russian Cinema: Symbols of a New Era* (Edinburgh: Edinburgh University

Press, 2015), and many other publications on Russian culture in the twenty-first century.

Justin Wilmes is an Assistant Professor of Russian Studies at East Carolina University. His primary research examines post-Soviet cinema and culture, but extends also to Russian drama, translation, and Polish culture.

Denise J. Youngblood is Professor of History Emerita at the University of Vermont. Author of seven books and numerous articles on the history of Russian cinema from 1908 to the present, her research and publications in the past decade have focused mainly on Russian World War II and Cold War films.

INDEX

CPSIA information can be obtained
at www.ICGtesting.com
Printed in the USA
LVHW080728010222
709865LV00010B/827